GARDENS ON PAPER

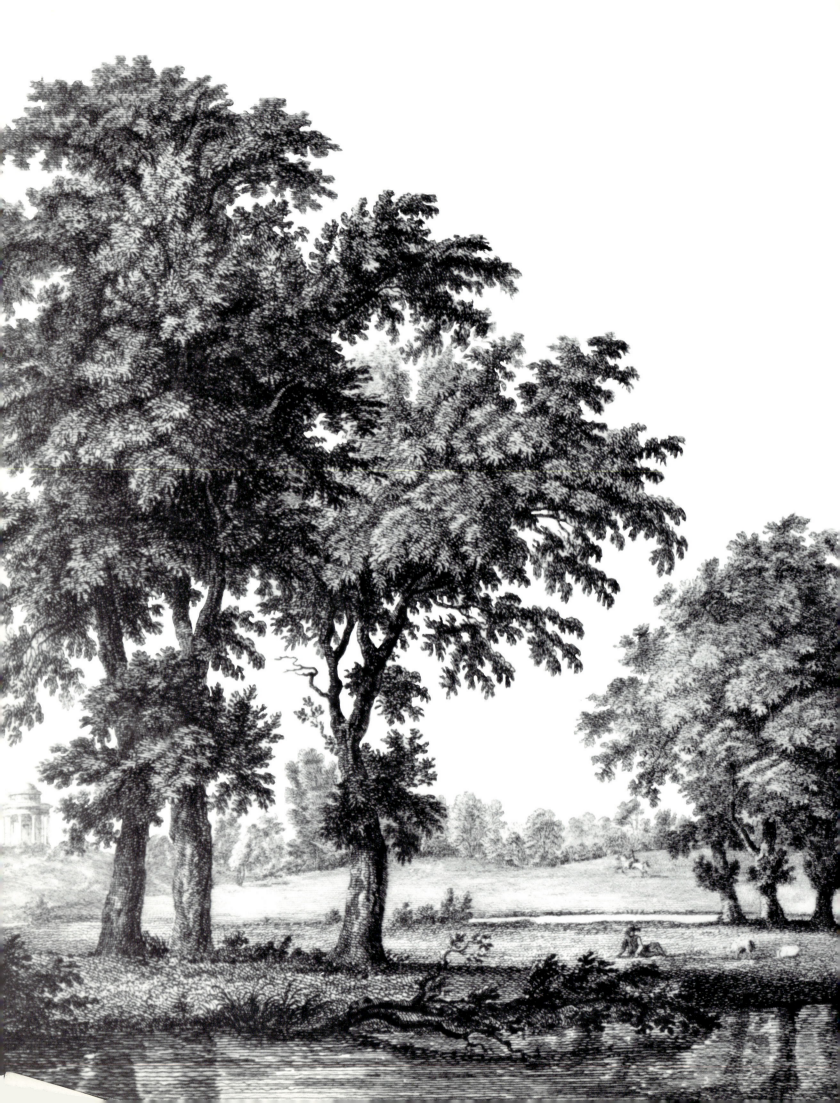

GARDENS ON PAPER

Prints and Drawings, 1200–1900

Virginia Tuttle Clayton

National Gallery of Art, Washington

Distributed by the
University of Pennsylvania Press

Support for the exhibition has been generously provided by Estée Lauder Inc.

Exhibition dates
1 April–22 July 1990

This book was produced by the editors office, National Gallery of Art. Editor-in-Chief, Frances P. Smyth. Designed by Chris Vogel. Edited by Frances P. Smyth, Ulrike Mills

Typeset in Sabon and ITC Fenice by BG Composition, Inc., Baltimore, Maryland. Printed by Schneidereith and Sons, Baltimore, Maryland

Dimensions are given in millimeters, followed by inches in parentheses; height precedes width

Library of Congress Cataloging-in-Publication Data

Clayton, Virginia Tuttle, 1946
 Gardens on paper : prints and drawings, 1200–1900 / Virginia Tuttle Clayton.
 p. cm.
 Includes bibliographical references.
 ISBN 0-89468-148-6 softcover
 ISBN 0-8122-8260-4 hardcover
 1. Gardens in art—Exhibitions.
2. Art—Exhibitions. I. Title.
 N8217.G36C57 1990 90-5560
 760'.04436—dc20 CIP

FRONT COVER: Cat. no. 96, Mary Cassatt, *Gathering Fruit* (detail), c. 1893.

BACK COVER: Cat. no. 81, attributed to Alexis Nicolas Perignon the Elder, *Vegetable Garden (Potager) of the Château Valentinois, Passy* (detail), 18th century

TITLE PAGE: Cat. no. 74, Paul Sandby, after William Marlow, *A View of the Lake and Island at Kew* (detail), 1763

Distributed by the
University of Pennsylvania Press, Blockley Hall
418 Service Drive, Philadelphia, PA 19104

ISBN 0-8122-8260-4

CONTENTS

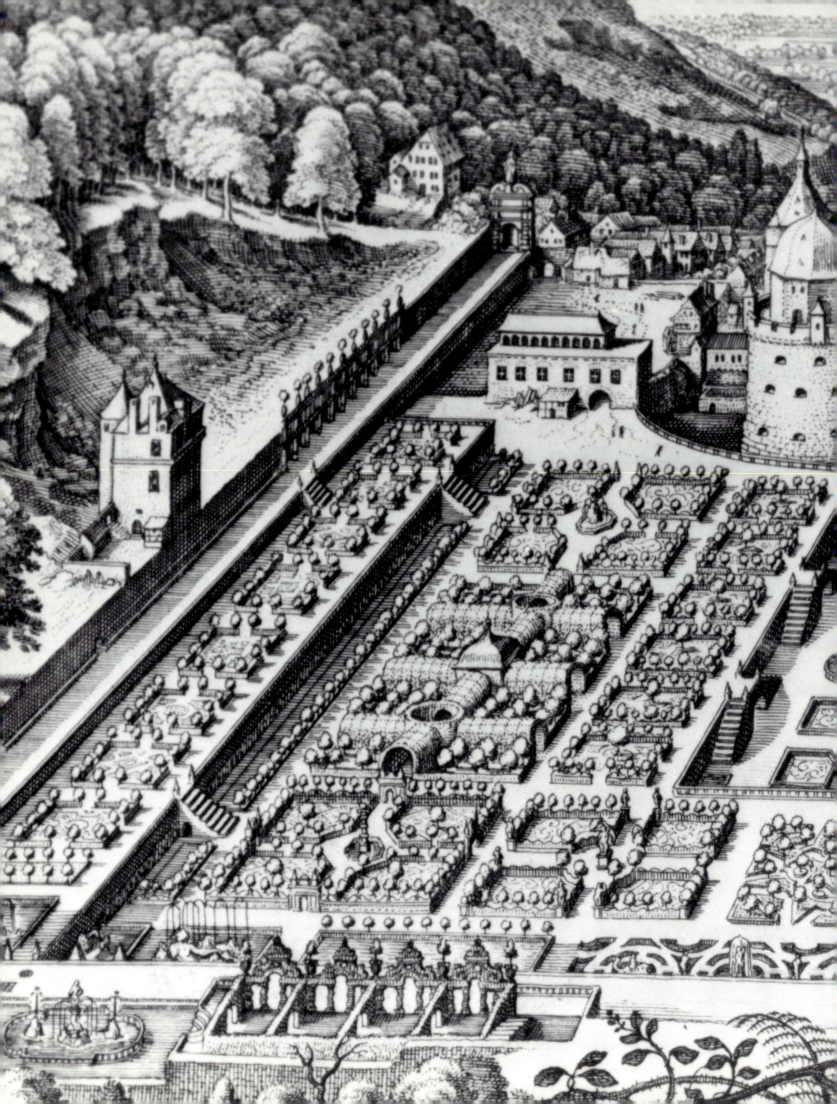

FOREWORD

Given the transience of the living materials which compose them, gardens are bound necessarily by time. Vistas, grottoes, parterres, and allées are remarkably fragile creations, only too prone to change with the vagaries of weather and human stewardship. Thus the student of garden history long has relied on verbal and visual sources to reconstruct the many styles and comprehend the variety of reasons behind man's attempts, in a garden context, to impose his own order on nature.

The exhibition, *Gardens on Paper*, and the book inspired by it explore the garden theme in works of art on paper. Garden evolution is traced through fifteenth-century codices, early engravings, drawings, books, and topographical plans as well as through images of allegorical, secular, and even imaginary gardens. From anonymous illuminators of medieval manuscripts to well-known impressionist painters, the garden is revealed as a rich and consistent source of inspiration for artists.

Thanks to the generosity of such friends as Lessing J. Rosenwald and Mark J. Millard, the National Gallery has a very fine collection of graphic images of gardens. We have, therefore, been able to rely almost entirely upon our own collection of prints, drawings, and illustrated books for the exhibition, borrowing just eight works from other collections. The Library of Congress, Amherst College's Mead Art Museum, the Whitney Museum of American Art, and the Yale Center for British Art have provided loans; we are grateful to them and to our private lenders who prefer to remain anonymous. Special thanks are due to Virginia Tuttle Clayton whose knowledge and love of gardens is evident in these pages, and to the many members of the National Gallery staff who have contributed their expertise to make possible this exhibition and book.

J. Carter Brown
Director
National Gallery of Art

Cat. no. 38, detail

ACKNOWLEDGMENTS

At the conclusion of this project, it is a pleasure to acknowledge the assistance I have received along the way from colleagues and friends. At all stages of my work, Andrew Robison, Senior Curator and Curator of Prints, Drawings, and Photographs, has provided excellent advice and support, without which the exhibition could not have gone forward. The staff of the Department of Graphic Arts has also patiently assisted me in many tasks during the preparation of the show. Gaillard Ravenel, Mark Leithauser, and Gordon Anson made important suggestions regarding the exhibition design, and John Olson attended to the many arrangements necessary for installing the exhibition. I have also frequently benefited from the help and advice of Hugh Phibbs and Pia Desantis Pell. Heather Reed coordinated numerous important details, including loan requests. Frances Smyth, Mary Yakush, Ulrike Mills, and Benjamin Reiss have all helped edit my text, and Chris Vogel designed the book. Dean Beasom photographed most of the works, and Margaret Cooley helped in ordering the prints. Therese O'Malley generously read the entire manuscript, and Professor Franklin Ludden, H. Diane Russell, Donna Mann, and Margaret Grasselli each read chapters, all making many helpful suggestions. My special thanks extend to Mark Cross, ASLA, my partner in Cross, Clayton, and Associates, who not only has tutored me in the subtleties of landscape architecture but also endured with patience the extended absence from our landscape business necessary to complete this book. Most of all, however, I wish to thank my husband, Michael Clayton, and my parents, Mr. and Mrs. Robert Tuttle, who have been invaluable and unfailing allies through all the difficult moments.

Virginia Tuttle Clayton
Assistant Curator
Department of Prints and Drawings

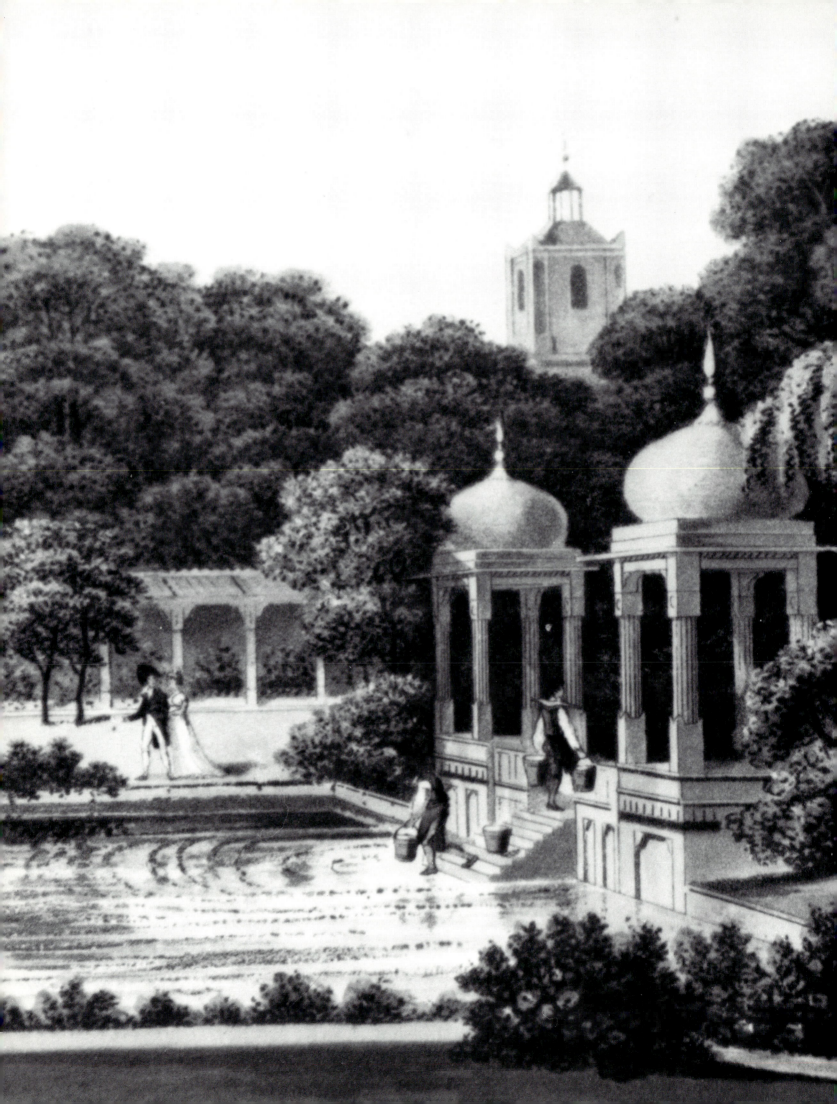

INTRODUCTION

Throughout the history of Western art, artists have made exquisite renderings of gardens, works that would be fondly cherished for centuries to come. While the tremendous appeal of gardens has remained constant, the manner in which artists have portrayed them has changed dramatically from one era to the next, as well as from country to country, generally reflecting cultural attitudes toward man's relationship with the natural world. This study is concerned exclusively with works on paper: prints, drawings, and illustrated books, and all but eight works in the exhibition are from the National Gallery's own collection. Garden images are particularly prevalent in the graphic arts, and they have been a major vehicle for widely disseminating information about gardens, both to record and to form taste in garden design. Produced in multiple impressions, prints and books circulate especially broadly and, in the case of prints, generally have had a more popular audience than other art forms. As direct reflections of commonly held cultural preoccupations, printed images are particularly accurate informants on such issues as the place that gardens held in the popular imagination at any given moment in history, what kinds of garden scenes were most in demand, and how prevailing conventions of artistic style af-

fected the representation of gardens—perhaps even how actual gardens were viewed. It is this fascinating evolution of symbolic concepts, thematic contexts, and stylistic forms in the artistic representation of gardens that *Gardens on Paper* will examine. Although the history of garden design constantly figures in the interpretation of works included in this survey, it is the graphic work of art, rather than the horticultural work of art portrayed therein, that is of primary interest here.

The historical and cultural variations in artists' treatment of gardens suggest different approaches to the art of each of the five periods under consideration. In the Middle Ages, the garden was a powerful as well as multifarious symbol, but little importance was attached to the accurate delineation of existing gardens; the examination of garden images from this age will therefore focus on the garden's diverse allegorical and anagogical meanings. Renaissance artists, on the other hand, took delight in secular subjects and depicted gardens with a keen verisimilitude; the art of this era for the first time portrayed actual gardens and scenes of everyday life in garden settings. The Renaissance chapter will address the appearance of these new themes in prints, drawings, and illustrated books, first in northern Europe and then Italy. Baroque artists perfected the use

of gardens and their representations in art in order to publicize the magnificence of princely realms. The section of this survey on the baroque period will analyze Italian, French, English, and Netherlandish garden images that attest to such aggrandizing purposes and were collected by patrons who hoped to imitate the grand style of gardening. The Cult of Nature had a formative influence on eighteenth-century art in general and garden design in particular. This study will examine English books, whose garden theory and illustrations associated nature with ancient republican virtues, and French prints and drawings that expressed a nostalgic desire to retreat and seek solace in an unspoiled idyll of nature. In the nineteenth century, the effects of industrialization and the more widespread democracy that had evolved during the previous century inspired the development of an entirely new garden iconography; public parks and gardens belonging to the middle and lower classes, rather than great, aristocratic estates, became the preferred subjects of artists, and these will be surveyed in the context of British, French, and American graphic art.

For all the changes that have occurred in artists' portrayal of gardens throughout history, contemporary gardeners can nonetheless understand and appreciate the charm and importance of these beloved, cultivated spaces. The urge to create a perfect and beautiful place in the world and the desire to immortalize the evanescent splendor of a garden in a work of art—whatever further purposes that garden and that work might serve—remain fundamentally the same. And if perfect bliss derives from the diligent maintenance of one's fragile paradise against the natural forces of destruction, these gardens on paper commemorate one of the more inspiring aspects of human nature.

Note

1. In recent years, garden historians have produced some splendid exhibitions and catalogues chronicling the history of gardens—most of which vanished long ago—through their portrayal in works of art. The most inclusive of these was *The Garden, A Celebration of One Thousand Years of British Gardening*, at the Victoria and Albert Museum, London, in 1979. In 1988–1989, the Rijksmuseum Paleis at Het Loo and Christie's in London jointly presented a major exhibition, *The Anglo-Dutch Garden in the Age of William and Mary*. Three exhibitions that have studied the motif of the garden in works of art from specific periods are: *Down Garden Paths: The Floral Environment in American Art*, Montclair Art Museum, Montclair, New Jersey, 1983; *Gardens of Earthly Delight: Sixteenth and Seventeenth-Century Netherlandish Gardens*, Frick Art Museum, Pittsburgh, 1986; *Earthly Delights: Garden Imagery in Contemporary Art*, Fort Wayne Museum of Art, Fort Wayne, Indiana, 1988.

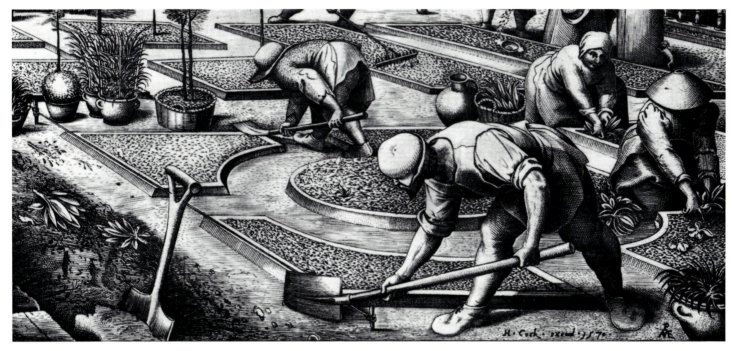

Cat. no. 27, detail

GARDENS IN MEDIEVAL ART

The earliest garden images in the National Gallery's graphic arts collection are single-leaf illustrations from late medieval manuscripts and fifteenth-century prints. Manuscripts were precious objects, laboriously written by hand and sometimes decorated with sumptuous illuminations. Although some secular texts, such as scientific treatises and encyclopedias, were illustrated throughout the Middle Ages, most illuminated medieval manuscripts were religious works. Until the thirteenth century, they were primarily produced in monastic scriptoria either for use in church services or for monastic libraries. Later, secular workshops began to make manuscripts, but the costliness of their production meant that only the most wealthy laypersons could hope to own them. While this favored group of well-to-do, secular patrons created a demand for such profane texts as the *Roman de la Rose*, the most popular type of manuscript was still religious: the Book of Hours, a prayerbook personalized to suit the individual patron.

Perhaps because the preponderance of medieval manuscripts were religious texts, there was no tradition among illuminators for the depiction of identifiable, contemporary gardens.[1] Instead, these artists lavished their considerable skills on the portrayal of

such sacred precincts as the Garden of Eden, Heavenly Paradise, and the *hortus conclusus*—the enclosed garden of the Song of Solomon, closely identified with the Virgin Mary. Even in secular literary works commissioned by lay patrons, garden illustrations did not document the appearance of specific, existing gardens, but represented garden types such as the pleasure garden or garden of love. Whether sacred or secular, medieval manuscript illumination tends to present us with conceptual garden motifs rather than with images of real, living gardens. And yet, these motifs, however fanciful or allegorical, frequently offer wonderful insights into the medieval dream of perfect horticultural bliss, gorgeous enclaves resplendent beyond anything in our earthly experience.

During the early fifteenth century, artists began to employ newly invented and much less expensive mechanical techniques of reproducing pictures. These techniques, which eventually rendered the art of manuscript production obsolete, involved printing on a sheet of paper an image that had been carved into a wood block or incised on a metal plate. Using these processes, artists could produce multiple copies of the same image or text, thus allowing the wide dissemination of pictorial or written information. Printed pictures were sufficiently

inexpensive to be easily acquired by common people, and the greatest percentage of early prints, especially woodcuts, were created with this audience in mind. Most often, the images were very unsophisticated in both style and content.

Although the invention of print-making revolutionized the process of learned communication and marked the beginning of the modern world, the "informational capacity" of prints was not recognized for nearly one hundred years.[2] The humble people for whom early, single-leaf prints were made preferred portrayals of saints, Biblical scenes, and moralizing allegories to vehicles of secular knowledge.[3] The earliest printed representations of gardens, therefore, occur mainly within the context of objects of religious veneration. The exciting potential for transmitting information about specific, contemporary gardens—their overall design, what plants grew in them, what architectural features adorned them—would not be realized until the next century of print-making.

The same garden subjects found in manuscript illuminations reappear, usually in much simpler form, in fifteenth-century woodcuts and engravings. In all cases, there is a delightful appeal in their direct, unaffected approach to garden imagery and great interest in the opportunity they provide to observe a highly symbolic world view, so remote from our own.

Although neither medieval manuscript illuminations nor early prints provide us with documentary evidence concerning identifiable gardens, they are still one of our best sources for general knowledge of medieval gardens.[4] Five types of medieval garden have been identified: the kitchen garden, the medicinal or herb garden, the patrician garden, the cloister garden, and the pleasure garden; a list of 225 documented species of cultivated plants has been compiled.[5] Visual and written sources indicate that the medieval garden was rigidly geometric, either square or rectangular in form—an inward-looking *hortus conclusus*, surrounded by walls, with paths and raised planting beds subdividing it internally into a rectilinear pattern.[6] The architectural elements that embellished the medieval garden conformed to and reinforced its geometry. For a central feature, at the intersection of the paths, the garden might have a square or rectangular fountain, pool, or well.[7] The paths, which frequently divided the garden into quadrants, might be partially shaded by wooden, vine-covered pergolas.[8] Similar wooden structures would sometimes shelter benches, providing not only shade but a bit of privacy. These seats, one of the most common man-made elements in the gardens, were typically made of plank sides filled with soil and planted with sweet-smelling herbs.[9] Their rectangular shape fit nicely into the "framed chessboard" format of the garden.[10]

Since the content of medieval garden images differs from that of later periods, the arrangement of this chapter and its analysis of the garden depictions will also be somewhat different from succeeding chapters. Instead of organizing the medieval works of art according to nationality, and examining various aspects of their content and style, they will be discussed according to their themes.

Biblical Gardens

The most important episodes in the history of human salvation transpired in garden settings. It was, first of all, in a garden that human history began with the Creation and Original Sin:

> God planted a garden in Eden which is in the east, and there he put the man he had fashioned. God caused to spring up from the soil every kind of tree, enticing to look at and good to eat, with the tree of life and the tree of knowledge of good and evil in the middle of the garden. A river flowed from Eden to water the garden, and from there it divided to make four streams.[11]

The garden of Eden, the place of perfect felicity on earth, was forbidden to Adam's descendants after the Fall, but medieval man believed that it still existed in some undiscoverable location in the world.[12] The idea of earthly paradise was also closely identi-

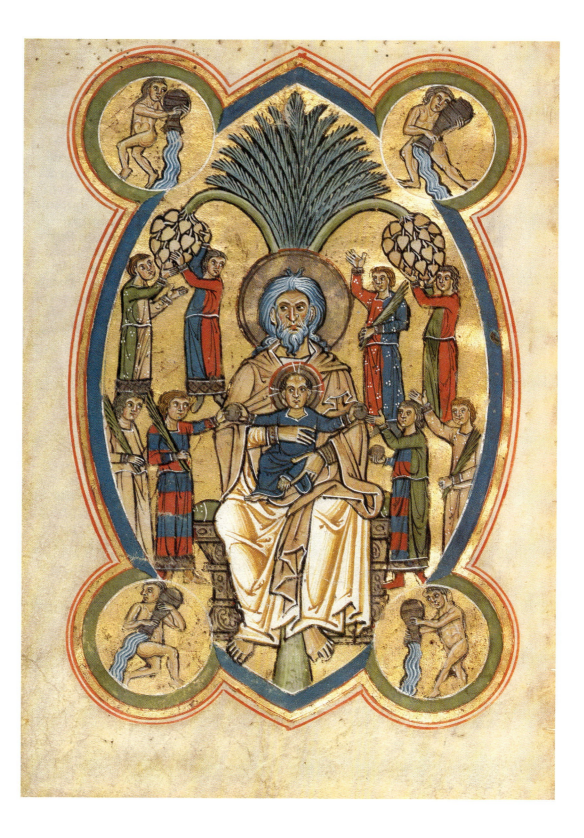

1. Anonymous German 13th
Century (Lower Saxony), *Heav-
enly Paradise with Christ in the
Lap of Abraham*, c. 1239, tem-
pera and gold leaf on vellum,
224 x 157 (8 7/8 x 6 1/4). National
Gallery of Art, Rosenwald Col-
lection 1946.21.11

17

fied with that of heavenly paradise, the joyful abode of the righteous dead at the end of time.[13] The existing, earthly garden was thus a symbol of the heavenly paradise to come, the paradise toward which all human endeavor should rightly aspire.

Heavenly paradise, as described in the Bible and medieval writings, was a garden with the same essential features as Eden—the tree of life and a supernatural source of waters.[14] A thirteenth-century miniature from the Rosenwald Collection (cat. 1) shows a highly schematic celestial paradise with Christ seated in the lap of Abraham.[15] This illustration derives mainly from The Revelations of Saint John the Divine. A river flows from under the throne on which Abraham sits, and the tree of life—a fruit-bearing palm—grows directly behind the throne. This motif derives from Revelation 22:1–2 and 14: "And he showed me a pure river of the water of life . . . proceeding from the throne of God . . . on either side of the river was the tree of life which bore twelve fruits . . . Blessed are those who do His commandments, that they may have the right to the tree of life." Four of the eight figures beside the throne hold palm branches; these represent the palm-bearing martyrs described in Revelation 7:9–17, who reach out to take the fruit offered them by Christ: "To him who overcomes I will give to eat from the tree of life."[16] In addition to the imagery from Revelations, there is also reference to Genesis and the Garden of Eden. In each of the four corners of the miniature, a figure pours water from a large vessel, representing the four rivers that flowed from Eden, as described in Genesis 2:10–14. This reference to Eden in the context of a depiction of the heavenly realm exemplifies the conflation of terrestrial and celestial paradise in medieval thought.

An intriguing record of the medieval notion of the physical layout of the world and the position of Eden within it is presented in a hand-colored, woodcut map that was probably printed in Augsburg around 1480 by Hans Sporer the Younger (cat. 2).[17] Fifteenth-century scholars familiar with the latest concepts in geography and cartography would have considered this image of the

world outdated, but the map apparently was intended for distribution as a broadsheet among a less educated audience.[18] It provides an index to some of the salient medieval ideas about the arrangement of the earth. The whole world is, for example, surrounded by an ocean filled with islands; England ("engenland") is the island to the left of center on the bottom, immediately off the coast of Spain ("hispania"). The map follows the medieval convention of locating east, not north, at the top. The large body of water in the lower portion of the circle is the Mediterranean, with Venice ("venedig") in a bay to the left. Europe is on the left side of the earth, with Rome ("Rom") approximately at its center and Africa to its right. Asia is at the upper left, and the land of Gog and Magog is surrounded by mountains. Jerusalem is situated at the center of the world, where it is usually found in medieval maps; the location of Augsburg nearby is, however, decidedly eccentric.

The walled garden of Eden crowns the earth. The tree of the knowledge of good and evil grows in the center of the garden, and Adam and Eve stand to either side, about to pluck and eat the fateful apple. The four rivers of the earth, from which all other waters are derived, flow copiously from four openings in the wall of paradise. The Nile is on the right, then the Tigris, the Phison, and finally, on the left, the Euphrates. These rivers often figure prominently in medieval images of paradise because they represented the four Evangelists who carried the Word of God to all parts of the earth.[19]

Among other alluring attributes of paradise recounted by medieval authors were groves of beautiful trees, many of them fruit-bearing, meadows carpeted with flowers, soft breezes, and an ineffably sweet fragrance—the primary ingredients of an ideal garden.[20] These garden components are depicted or suggested in the image of paradise in The Warburg Hours (cat. 3), a small Flemish prayer book made toward the end of the fifteenth century.[21] A grove of perfect trees constitutes the background of this brilliantly colored miniature of the Fall, and the *felix culpa* is enacted on a splendid, flowering meadow. As is common in Books

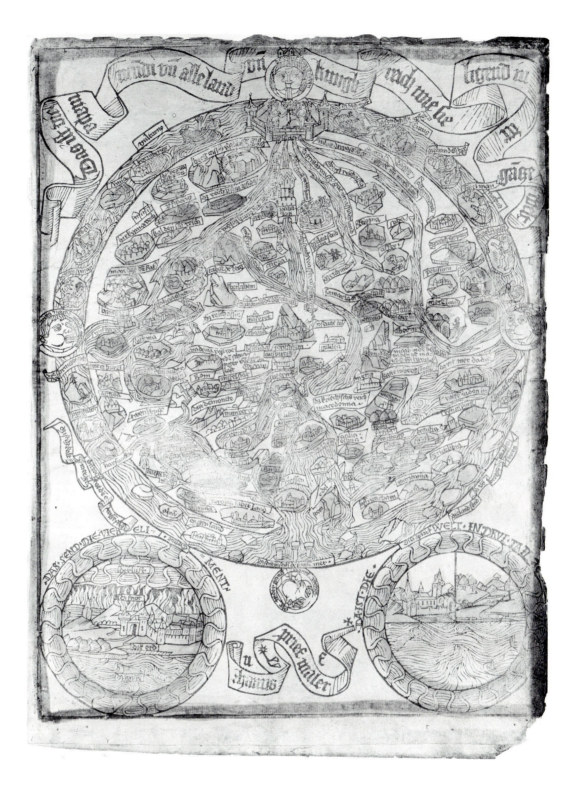

2. Anonymous German 15th Century (Augsburg?), *Map of the World*, c. 1480, hand-colored woodcut, 273 x 190 (10 3/4 x 7 7/8). National Gallery of Art, Rosenwald Collection 1943.3.645

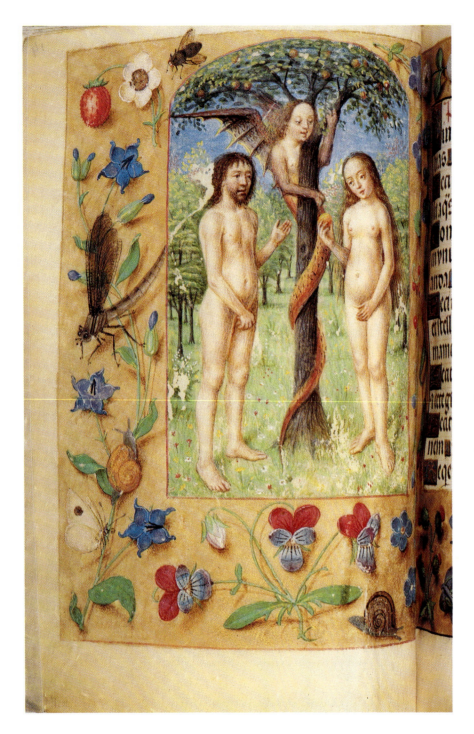

Altogether, the illumination of these pages creates a wonderfully pleasant sensation of a beneficent, sweet nature: a yearning, medieval vision of the lost garden of paradise.

The medieval garden has been portrayed as both the starting point of human existence and its longed-for culmination. It was also a significant feature at the pivotal moment in the drama of human salvation. The Passion of Christ began with Christ's arrest in a garden and ended with his burial and resurrection in another garden.[22] The Fall of man, the loss of the garden, made necessary Christ's sacrifice; the sacrifice gives us hope that we may regain the joyful, flowering realm. This connection between the Fall and the Passion explains their frequent alignment in medieval art. The content of the Oxford Passion, a series of twenty-three small metalcuts made in Cologne between 1460 and 1480, is one example of this juxtaposition.[23] The subject of the set is the Passion of Christ, but in accordance with medieval ideas on the extratemporal connection of certain sacred events, the history of Christ's Passion is introduced with the Fall of man and the Expulsion from the garden (cats. 4, 5).[24] The exceedingly small scale of these works allows for the illustration of only the most meager details of Eden in the two scenes: the tree of knowledge and the gate of paradise.

Christ and his disciples went to the Garden of Gethsemane to pray following the Last Supper. While Judas betrayed him and the others slept, Christ first asked that the "bitter cup" of his impending sacrifice be taken from him, but then acquiesced to the will of his Father.[25] Judas entered the garden with the arresting soldiers, Christ was taken, and the events leading to the Crucifixion began. The Oxford Passion (cat. 6) shows Christ in the garden kneeling in prayer before the cup. That this event occurs in a garden is indicated by the wattle fence in the background. The depiction of this most common type of medieval garden fence was enough to inform a medieval viewer that a scene was taking place in a garden.[26] The same fence is used in the background of the *Christ Appearing to the Magdalene as a Gardener* (cat. 7), the scene following

3. Anonymous Flemish 15th Century, *The Fall of Man*, tempera on vellum, 101 x 80 (4 x 3 1/8), in *The Warburg Hours*, late 15th century. Library of Congress, Washington, D.C., Rare Books and Special Collections Division

of Hours of this period, the margins are elaborately ornamented and are perhaps as brilliant a feature in the decoration of the page as the miniature. Among the flowers illustrated as botanical specimens on the gold-leaf background are daisies, violets, strawberries, thistles, and columbines; butterflies, snails, a fly, and a dragonfly enliven the borders as they busily attend the flowers.

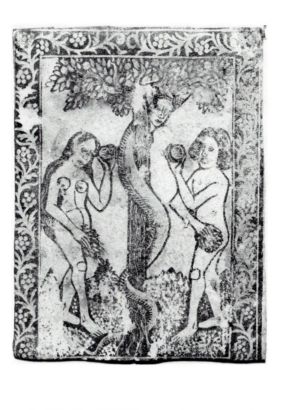

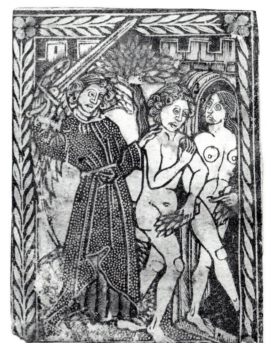

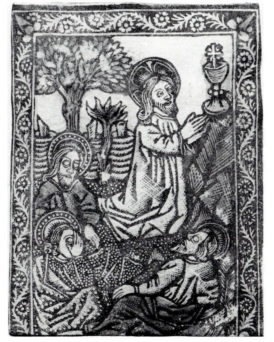

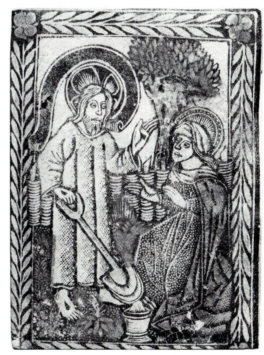

4. Workshop of the Master of the Borders (German, 15th Century), *The Oxford Passion: The Fall of Man*, 1460/1480, metalcut, 62 x 47 (2 3/8 x 1 3/4). National Gallery of Art, Rosenwald Collection 1943.3.680

5. Workshop of the Master of the Borders (German, 15th Century), *The Oxford Passion: The Expulsion from the Garden of Eden*, 1460/1480, metalcut, 64 x 48 (2 1/2 x 1 3/4). National Gallery of Art, Rosenwald Collection 1943.3.681

6. Workshop of the Master of the Borders (German, 15th Century), *The Oxford Passion: Christ in the Garden of Gethsemane*, 1460/1480, metalcut, 63 x 48 (2 1/2 x 1 3/4). National Gallery of Art, Rosenwald Collection 1943.3.688

7. Workshop of the Master of the Borders (German, 15th Century), *The Oxford Passion: Christ Appearing to the Magdalene as a Gardener*, 1460/1480, metalcut, 63 x 47 (2 1/2 x 1 3/4). National Gallery of Art, Rosenwald Collection 1943.3.676

Christ's resurrection. Here Mary Magdalene, having come to the garden where Christ was buried, at first mistakes the risen Christ for a gardener. The artist has provided Christ with a spade to emphasize this confusion of identity and to represent Christ as the second Adam who was to cultivate his garden, the Church, as Adam had been in-

structed to care for the Garden of Eden.[27] In a late fifteenth-century French woodcut of the *Christ Appearing to the Magdalene*, Christ again holds his shovel (cat. 8). The shovel is carefully and accurately delineated, showing an iron shoe nailed onto the wooden scoop.[28] A tree is positioned between the two figures and a flowering

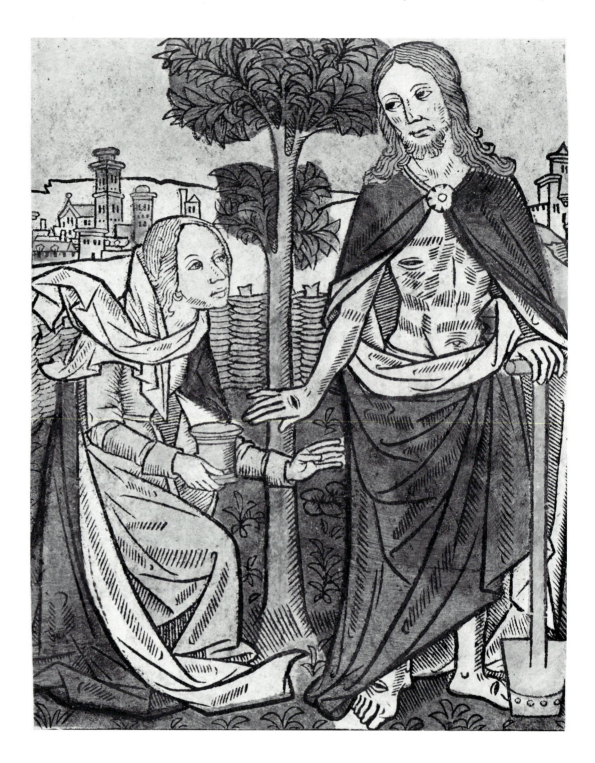

8. Anonymous French 15th Century, *Christ Appearing to the Magdalene*, c. 1500, hand-colored woodcut, 200 x 150 (7 7/8 x 5 7/8). National Gallery of Art, Rosenwald Collection 1943.3.497

meadow is suggested by the presence of a few flowers in the grass, though these were not individually treated by the woodcut's colorist.

A mid-fifteenth century hand-colored woodcut of German origin (cat. 9) presents another scene of Christ in the Garden of Gethsemane. Again, a wattle fence denotes

the garden; there is also a garden gate, although the connection between it and the fence is impossible to fathom. This structural problem and the fact that the fence stops abruptly to give Saint Peter room to lie down indicate that the gate and fence are mere props, included to emphasize that the event takes place in a garden.

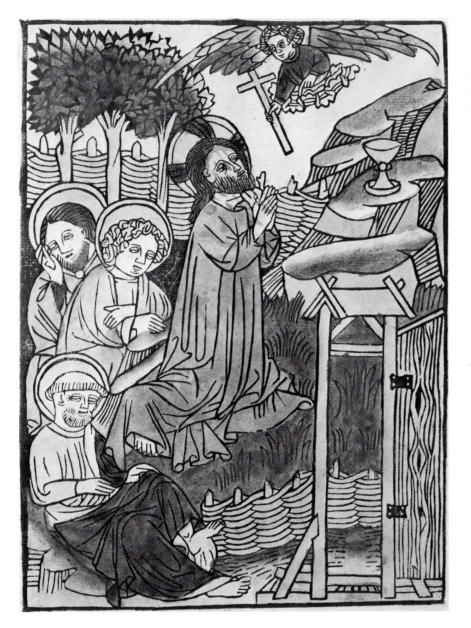

Gardens of the Virgin and the Saints

Terrestrial paradise was, as shown above, closely identified with heavenly paradise. The paradise garden, both earthly and celestial, also signified the Church.[29] The purified, paradisiacal space that enclosed the community of the Elect that made up the Church was the intermediary through which mankind, fallen from grace, was offered the eternal reward of celestial paradise.

A major source for the representation of the Church as a garden was the medieval interpretation of the Song of Songs, specifically the verse in which the bridegroom described his beloved: "A garden enclosed is my sister, my spouse, a spring locked, a fountain sealed . . ."[30] Medieval commentators on the Song of Songs thought of the bridegroom as a symbol of Christ and the bride as a figure of the Church and the Virgin Mary. In the fourth and fifth centuries, St. Ambrose and St. Jerome were the first to interpret the bride as both the Church and the Virgin.[31] It was, however, in the twelfth century—when the great veneration of the Virgin began—that the connection of the Virgin with the bride and, hence, the garden was finally and completely fixed.[32] Honorius Augustodunensis, in his commentary on Song of Songs 2:1, explained that the "lily among the thorns" is the Virgin, who exceeds all others in the beauty of her chastity and sweetness of her sanctity.[33] St. Bernard of Clairvaux called her the *hortus conclusus*, the garden enclosed, and her womb the *hortus deliciarum*, the garden of delights; "you are," he wrote, "truly the paradise of God because you brought into the world the tree of life, of which he who eats will live eternally."[34] By this time, the entire text of the Song of Songs was read in the liturgy of the Virgin's two major feast days: half on Assumption day and half on the octave of the Virgin's Nativity.[35]

As a result of this new and clear identification of the Virgin as the bride, the enclosed garden of the Song of Songs, there was a "rapidly increasing use of titles from the Song of Songs for Mary in preaching and popular devotion during the fourteenth and fifteenth centuries" and a proliferation of a new sacred image: the Virgin in an enclosed garden.[36] The flowers that appear in these gardens most often include the lily—the symbol of the Virgin's chastity—and the rose—the symbol of her love.[37]

Because the rose had been the symbol of Venus in pagan antiquity, the early Church Fathers reviled it and cautioned Christians not to wear chaplets of roses on feast days.[38] Eventually, though, the beauty of the rose and its enduring popularity led to its acceptance as a symbol of the Virgin, the embodiment of Christian love, or *caritas*. It was again in the twelfth century that the connection of the rose and the Virgin became com-

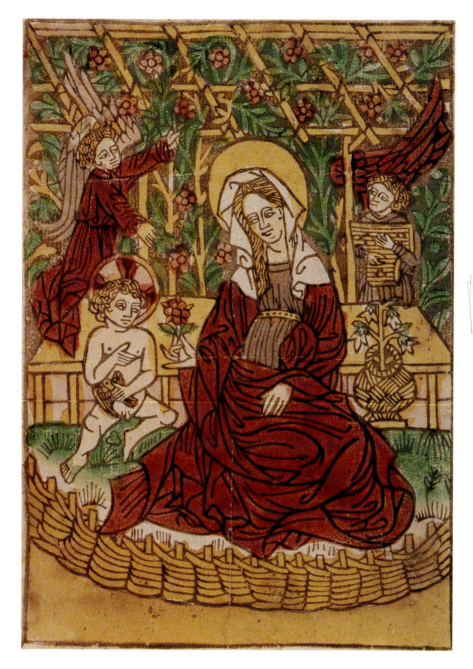

picture of the Virgin in a walled garden.[42] The Virgin is seated on the ground in front of a garden bench; she is thus a Madonna of Humility, a type that gained popularity in Italy in the mid-fourteenth century.[43] The garden is clearly demarcated with a wattle fence, made low to allow the viewer to see the scene inside. The Child holds a bird, probably a goldfinch, which, because it eats thorns and thistles, was a common symbol of Christ's Passion.

Among the various fourteenth- and fifteenth-century images of the Madonna in a garden, one type referred to a specific event in her life: the Annunciation. This particular image became popular only after 1430 and appears to have been of German origin.[44] A leaf from a choir book illuminated by Belbello de Pavia (cat. 11), probably between 1450 and 1460, has a magnificent representation of this scene in a large, historiated initial.[45] The initial begins the text of Luke 1:26–27, which describes the Annunciation: "The angel Gabriel is sent to Mary." Instead of depicting the scene in Mary's bedchamber or in a chapel, as was traditional, Belbello instead placed it out-of-doors, in a garden, on a carpet of grass sparkling with heavenly light. A wall and a wattle fence behind the Virgin indicate that the garden is enclosed. The Virgin again sits upon the ground, this time on a cushion, as the Madonna of Humility. Gabriel stands before her, and God the Father appears in the sky above, surrounded by angels as he releases the Dove. The divine light from the celestial figure spreads across the landscape below, illuminating it with a golden radiance. Across the bottom of the page, four roses grow from a spiraling vine, symbols of the Virgin above.

The close association of the Virgin and the rose led to the development of another, related image of the Virgin in the late Middle Ages: the Madonna and the rosary (cat. 12).[46] Tradition holds that St. Dominic introduced the rosary to Christendom after the Virgin appeared to him in a vision and gave him a rosary, explaining that he would be more successful in his conversion of the Albigensians if he used the prayer beads.[47] It seems, however, that the rosary actually

mon. St. Bernard, the first to sponsor the connection fervently, compared the Virgin to both white and red roses: "Mary was the white rose because of her chastity and the red rose because of her love;"[39] he also called her the "violet of humility, the lily of chastity."[40] In the next century, both St. Bonaventure and Albertus Magnus followed Bernard in rhapsodizing on the Virgin as a perfect, thornless rose.[41]

Madonna in a Closed Garden (cat. 10), a hand-colored, German woodcut of about 1450/1460, is an especially charming

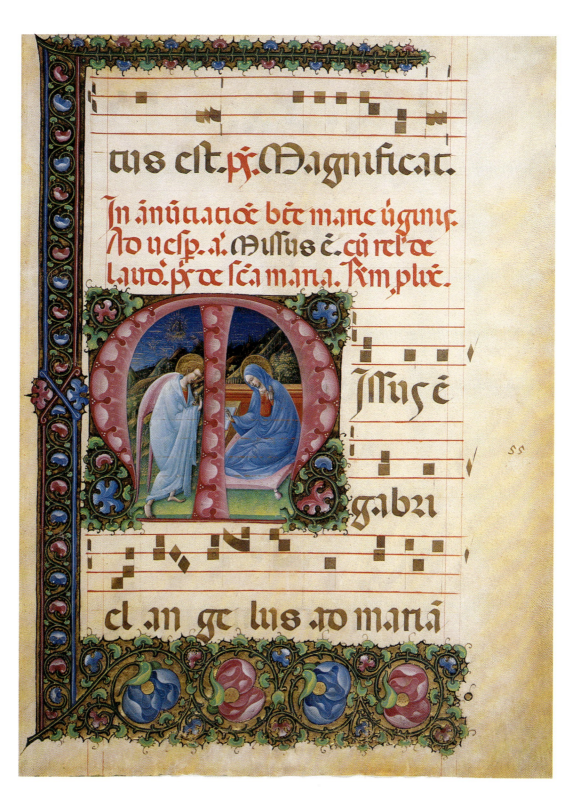

11. Belbello de Pavia (Italian, active 1448/1462), *Annunciation to the Virgin*, 1450/1460, tempera and gold leaf on vellum, 589 x 425 (23 1/8 x 16 3/4). National Gallery of Art, Rosenwald Collection 1948.11.21

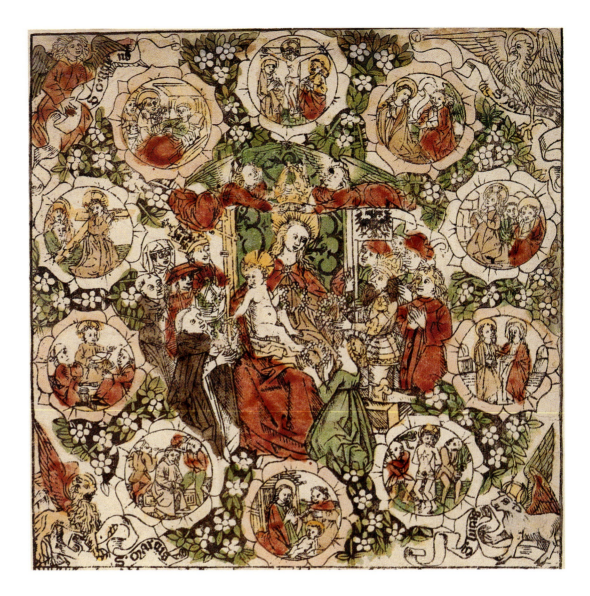

12. Anonymous German 15th Century (Ulm, Augsburg, or Cologne), *Madonna with the Rosary*, 1485, hand-colored woodcut, 372 x 248 (14 5/8 x 9 3/4). National Gallery of Art, Rosenwald Collection 1943.3.564

developed its present form over several centuries. In the twelfth century, pious devotees of the Virgin began to recite groups of Hail Marys, believing that it gave the Virgin pleasure to hear repeated the words that the Angel Gabriel used to address her at the Annunciation. A group of fifty Hail Marys was called a chaplet or garland, indicating an early connection between these prayers and the Virgin's floral image. By the early fifteenth century, the devotion took the form of fifteen decades of Hail Marys divided by fifteen Our Fathers; during the recitation of each decade, the votary would meditate

upon an event or "mystery" from the life of the Virgin. Although the mysteries were not standardized until the sixteenth century, three series of five mysteries were most frequently used: the joyful; the sorrowful; and the triumphant.[48]

The name "rosary" probably dates from at least as early as the fourteenth century. Prior to the fifteenth century, the mysteries were grouped in multiples of fifty. Because there were too many to be memorized, they were recorded in texts from which the pious could read and pray. This type of written text was known as a *rosarium*, or rose garden, fol-

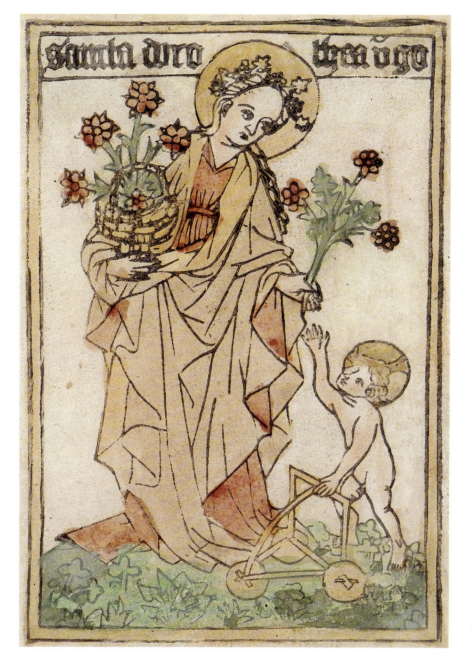

13. Anonymous German 15th Century (Upper Rhine ?), *Saint Dorothy*, 1440/1460, hand-colored woodcut, 186 x 125 (7 1/4 x 4 7/8). National Gallery of Art, Rosenwald Collection 1943.3.600

phlet written by Jacob Sprenger, *The Institution and Approbation of the Confraternity of the Most Holy Rosary, which was first erected at Cologne on 8 September in the year 1475.* This pamphlet describes Sprenger's foundation of a confraternity dedicated to the rosary that enlisted multitudes of members, including the Emperor. In the upper part of the woodcut, Mary is enthroned as the Queen of Heaven with the Child on her lap; on either side are groups of figures representing the various stations of lay and clerical life. Ten small circles surround this scene, with clusters of roses between them. Five of the circles have white ornamental borders and contain the five sorrowful mysteries of the Virgin; the other five have pink borders and show the five joyful mysteries. Since the series of mysteries was not fully codified by the fifteenth century, it is not surprising to find just ten presented, rather than all fifteen. The four symbols of the Evangelists appear in the four corners.

Roses also play a part in the legend of one of the patron saints of gardening, St. Dorothy.[51] This Virgin Saint was born in Cappadocia and martyred for her faith in 304. A miracle occured during her martyrdom: although it was winter and no flowers were in bloom, she was able to send her pagan oppressor, Theophilus, a bouquet of roses that were delivered to her from paradise by angelic messenger, thus proving that her descriptions of the ever-flowering garden were true. A late fifteenth-century hand-colored woodcut from the upper Rhine (cat. 13) shows the elegant Dorothy, graciously accepting a basket of roses from the cross-haloed Christ Child and handing one back to him for delivery to Theophilus.

Another patron saint of gardening, St. Alto, is portrayed in a delightful, hand-colored woodcut from the Rosenwald Collection (cat. 14).[52] The style of the work is so unusual—crude but decidedly charming—that it has been difficult to date and assign a place of origin. Richard Field has suggested that it was probably made by an untrained monk or nun in the middle of the sixteenth century in Altomünster, the saint's own monastery.[53] Alto is shown clearing the forest to build his monastery on land donated

lowing a medieval tradition for calling a collection of written material a garden or bouquet.[49] The name *rosarium* was, of course, particularly apt for a collection of prayers to the Virgin because of her association with the rose. Eventually, the name was used for the prayer beads on which the votary counted off each segment of the devotion.

A hand-colored woodcut from the Rosenwald Collection, *Madonna with the Rosary* (cat. 12), made in 1485 in the Middle or Lower Rhine, shows an especially complex version of this image.[50] The bottom part of the sheet presents a portion of a pam-

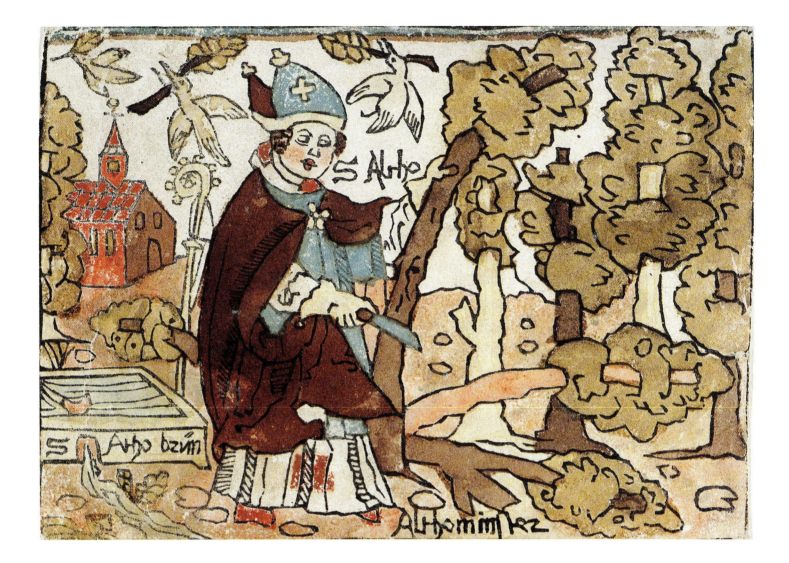

14. Anonymous German 15th Century (Bavarian), *Saint Alto*, c. 1500, hand-colored woodcut, 135 x 185 (5 1/4 x 7 1/4). National Gallery of Art, Rosenwald Collection 1943.3.580

to him in 750 by Pippin the Short, Charlemagne's father. This saintly landscaper is receiving divine assistance in his work. As reported in his legend, trees fell as soon as he touched them with his blade and a much-needed fountain miraculously appeared where he struck the earth with his crozier. According to the legend, the local birds also lent what assistance they could; in this print they are busily carrying away felled branches.

No saint is more closely associated with nature than St. Francis of Assisi. According to his biographer Thomas of Celano, "He commanded that a little place be set aside in the garden for sweet-smelling and flowering plants, so that they would bring those who look upon them to the memory of the Eternal Sweetness."[54] The same author claimed

that when St. Francis found "an abundance of flowers, he preached to them and invited them to praise the Lord as though they were endowed with reason."[55] St. Francis' doctrine was carried on by his disciples, the Franciscans, who became a great preaching order in the Middle Ages.

One of St. Francis' followers, Pelbartus of Temesvar, is portrayed seated at his desk in an enclosed garden, an orchard, in a woodcut that was once the title page to a collection of Pelbartus' sermons (cat. 15).[56] The motif of the enclosed garden relates to the title of the work, *Pomerium sanctis*, or *Orchard of the Saints*, published in Augsburg in 1502. Pelbartus, a Hungarian, was born in 1440 and died in 1504. This woodcut was made in an unusual manner, in reverse of the normal process. The lines, rather than the

28

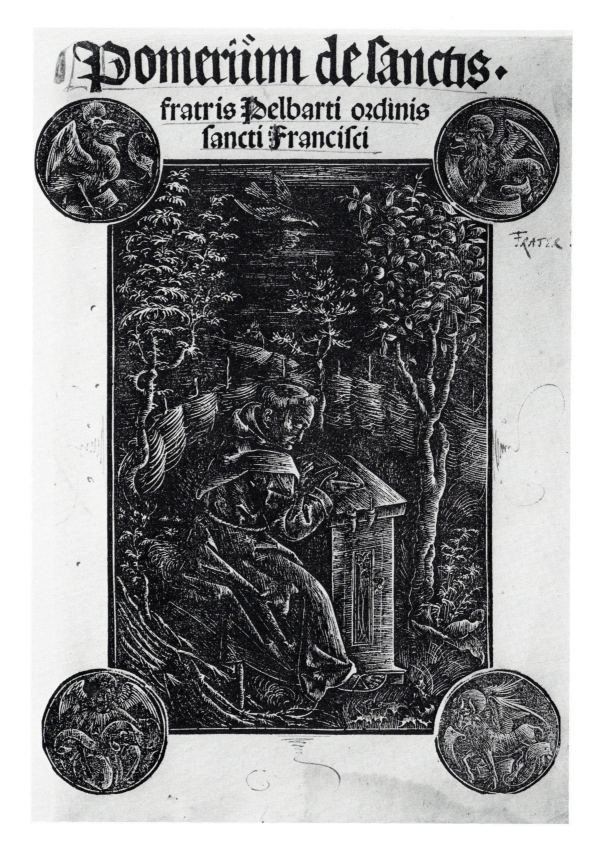

15. Anonymous German 15th Century (Augsburg?), *The Franciscan Pelbartus of Temesvar in a Garden*, c. 1500, woodcut, 178 x 117 (7 x 4 5/8). National Gallery of Art, Rosenwald Collection 1943.3.658

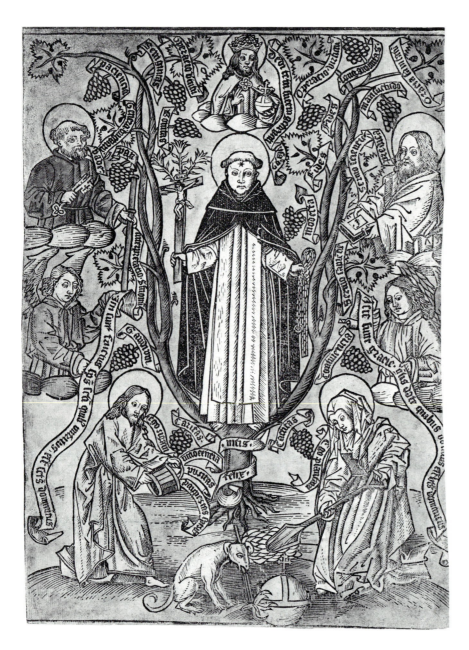

Genealogical Tree of the Dominicans (cat. 16), must represent the idea of an especially zealous Dominican concerning St. Dominic's position in the Church.[58] A large figure of St. Dominic stands firmly upon the crux of a powerful grape vine, holding in one hand a crucifix that sprouts three lilies and in the other, what has been identified as either a rosary or a Franciscan cordelier.[59] Christ and the Virgin are somewhat smaller in scale, relegated to the position of gardeners working at the base of the vine. Christ waters it, pouring "innocence," "purity," and "poverty" from a bucket, while the Virgin cultivates the earth around the roots with a shovel. A scroll reading "happy vine" is wrapped around the trunk, and the fruits and leaves are labeled as virtues. At the foot of the vine sits a dog holding a torch in its mouth, next to an orb of the universe. This refers to a dream that Dominic's mother reportedly had before his birth. This image was interpreted as predicting that her unborn son would become the universal guardian of the Church. The star on Dominic's forehead derives from the same dream.[60] God appears in the clouds above and blesses the scene. On the left side are an angel and a figure of St. Peter, and on the right are another angel and St. Thomas Aquinas, the greatest and most renowned Dominican scholar. The Virgin's speaking scroll says "I planted it"; this identifies the vine as a metaphor for the Church, brought into being by Christ, born to the Virgin. Throughout the Middle Ages, the "mystical vine" was associated with the Passion of Christ, the blood of his sacrifice, and the Eucharist, the fundamental sacrament of the Church.[61]

The grape vine signifying the Church appears again in a woodcut that was probably printed in Altomünster around 1500 (cat. 17).[62] The work commemorates the rededication in the late fifteenth century of St. Alto's monastery to the Brigittines. Portraits and coats of arms of the donors who established the new monastery, Georg der Reiche and his wife Hedwig, appear at the bottom corners of the print. The mystic St. Bridget, ensconced in the monastery now dedicated to her and called Mariamünster, is listening

space between them, were cut away to print the image as white on black. This apparently was not intended to be a night scene; the same white-on-black technique was used in a title page with a depiction of the Virgin for another book by Pelbartus published in the same year.[57]

Garden Motifs in Religious Allegories

The Dominicans were another great preaching order of the Middle Ages. A particularly interesting and complex woodcut, *The*

to the voices of Christ and the Virgin, who speak to her from the clouds. St. Alto stands between the donors, accompanied by the coat of arms of Scotland, his homeland. The vine, a metaphor for the Church, grows up from the bottom of the page and St. Alto is carefully pruning it.[63]

The Tree of Jesse is another botanical symbol of the process of human salvation.[64] The source of this familiar image is Isaiah 11:1, in which the prophet tells of a future king who will come to save his people: "A shoot will spring from the root of Jesse, and from his trunk a flower will come forth." The third-century writings of Tertullian first explained the passage as a reference to the advent of Christ; the shoot from Jesse, who was the father of King David, symbolized the Virgin and the flower was Christ. Subsequent Christian writers repeated this interpretation and beginning in the eleventh century, the Tree of Jesse became an exceedingly popular image in art.[65] An engraving by Israhel van Meckenem (cat. 18), an extremely productive printmaker of the second half of the fifteenth century, shows the Tree of Jesse in the form of a curving vine.[66] Jesse lies sleeping as a stem rises from his chest and circles around thirteen figures. Immediately above Jesse, King David sits playing his

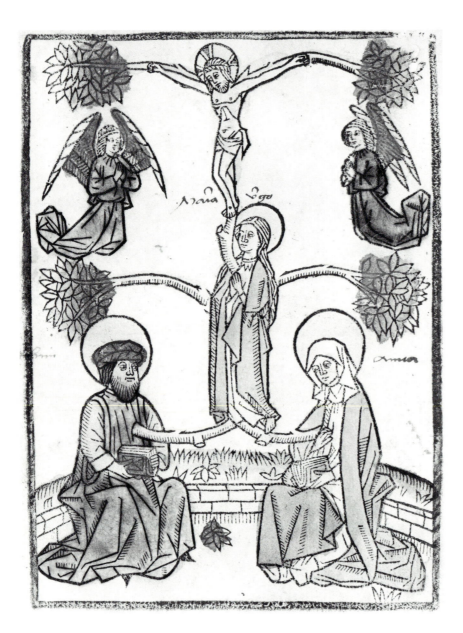

19. Anonymous German 15th Century (Ulm), *Genealogical Tree of Christ*, c. 1470, hand-colored woodcut, 178 x 126 (7 x 5). National Gallery of Art, Rosenwald Collection 1943.3.865

harp; above him, the crowned Virgin is seated with the infant Christ on her lap. Most of the other eleven figures, the kings of Judea, are extremely animated, gesturing dynamically and moving vigorously within the vine.[67]

Genealogical Tree of Christ (cat. 19), a German woodcut of c. 1470, shows the Virgin as a focal point or supporting member of the tree that culminates in Christ. Instead of rising out of Jesse, however, this tree grows from the hearts of Joachim and Anna, the parents of the Virgin Mary, who are seated on a turf garden bench. This abbreviated representation of the lineage of Christ

may reflect the increased veneration for the Virgin and her parents in the later Middle Ages.[68] From Mary's breast the trunk of the tree reaches upward and turns into the cross upon which Christ is crucified. This work combines the image of the sacred genealogical tree with that of the tree of life, the tree that grows in paradise and that supplied the wood for Christ's sacrifice to save mankind. The connection of the Tree of Jesse with the tree of life, or the cross, was made as early as the eleventh century in the work of Peter Damian. In a sermon on the Holy Cross, he wrote: "From the tree of Jesse we arrive at the tree of the cross, and the beginning of redemption we conclude in the end."[69]

The Tree of Jesse graphically depicts mankind's ascent to salvation through the intermediary of the Virgin. Jacob's ladder is a related symbol of upward mobility.[70] From the Early Christian period, Jacob's ladder was a metaphor for spiritual ascent and was clearly understood as a symbol of the Virgin.[71] As one of the Church Fathers explained: "Jacob foresaw thee, O Virgin, as a ladder to raise us to heaven above when sunk and lost in the depths of evil."[72] In medieval art, Jacob's ladder became a ladder of virtue that the pious, usually portrayed as monks or nuns, could climb to their heavenly reward. A late fifteenth-century German woodcut presents a climb toward heavenly salvation through rocks and thistles on the slopes of a steep mountain (cat. 20).[73] The prospective climber is a nun who kneels in prayer before the mountain. Two instruments of flagellation lie on the ground before her. God the Father, accompanied by an angelic orchestra, awaits her on top of the mountain, holding her crown of virtue.

Secular Garden Themes

Although the garden of paradise was a profoundly sacred concept in the Middle Ages, it also had a profane mirror image: the false paradise, or garden of earthly delights.[74] This garden of temptation is the most familiar setting for illicit and improvident assignations in medieval love lyrics and the visual

20. Anonymous German 15th
Century (Augsburg), *The Way to
Salvation*, c. 1490, hand-colored
woodcut, 262 x 181 (10 ¼ x
7 ¹/₈). National Gallery of Art,
Rosenwald Collection 1943.3.640

John Fleming wrote, "an important recapitu-
lation or echo, reflex or response, imitation
or parody of the greatest of all gardens in
Western literature, the Garden of Eden."[77]
The garden in the *Roman* is the perfect *locus
amoenus*; it delights the senses so much that
it even *appears* to be paradise, but it is
fraught with temptation and in it sin will in-
evitably occur.

In the poem, the sleeping Lover dreams
that in the "amorous" month of May he fol-
lows a stream through a meadow to find its
source and discovers that it flows from an
enclosed garden. He is admitted through its
gate by Idleness, "a radiant maid" who
informs him that the garden belongs to her
dearest friend, Pleasure. At first sight of the
garden, the Lover believes that it is "truly a
terrestrial paradise;" it looks "heavenly," "a
better place than Eden." He finds Pleasure
dancing with his friends, accompanied by
the God of Love, who to the Lover "an angel
seemed, descended from the sky."[78] Wander-
ing through the garden, followed by the God
of Love, the Lover eventually comes upon
the fountain of Narcissus. In the fountain
are two crystals that reflect the entire con-
tents of the surrounding garden. Here the
Lover sees reflected and becomes infatuated
with a rosebush enclosed by a hedge; he
rushes to the Rose—here a profane
symbol of an earthly woman— and as he
approaches it the God of Love shoots him in
the heart with the golden arrow of Beauty.
The remainder of the poem describes at
length the Lover's protracted and compli-
cated quest to possess the Rose, and his ulti-
mate success.

Despite the great length of the work, nei-
ther of the two poets offers much detailed
description of the garden. They merely note
in passing that it is square, walled, filled
with singing birds, planted with exotic trees,
provided with a fountain, and carpeted with
short, thick grass embellished with flowers
—the basic components of many medieval
gardens.[79] This paucity of descriptive detail
probably reflects that it is only the *idea* of
the garden as a most appealing but also most
dangerous place that is important in the
moralizing allegory. Although the text of the
poem is frustratingly inattentive to horticul-

arts. In these delicious, perilous bowers, lov-
ers succumb to the promptings of the flesh
and indulge in the pleasures of carnal love,
turning away from their pursuit of spiritual
union with the Divine in the true paradise.
Like the Garden of Eden, the secular love
garden in medieval literature is typically de-
scribed as a secluded place, with such ap-
pealing features as perpetual springtime,
fountains, fruit-bearing trees, flowers, pleas-
ant breezes, and sweet fragrance. The differ-
ence between the two apparently similar me-
dieval gardens is, as A. Bartlett Giamatti
succinctly explained, that "one *is* what the
other *seems to be*."[75] One is the epitome of
all that is truly good and worthy of desire;
the other is a false and enticing *mis en scène*
of carnal love.

The quintessential garden of love in medi-
eval literature is the setting of the *Roman de
la Rose*, a poem begun by Guillaume de
Lorris in 1237 and finished by Jean de Meun
in about 1277.[76] This "poetic garden" is, as

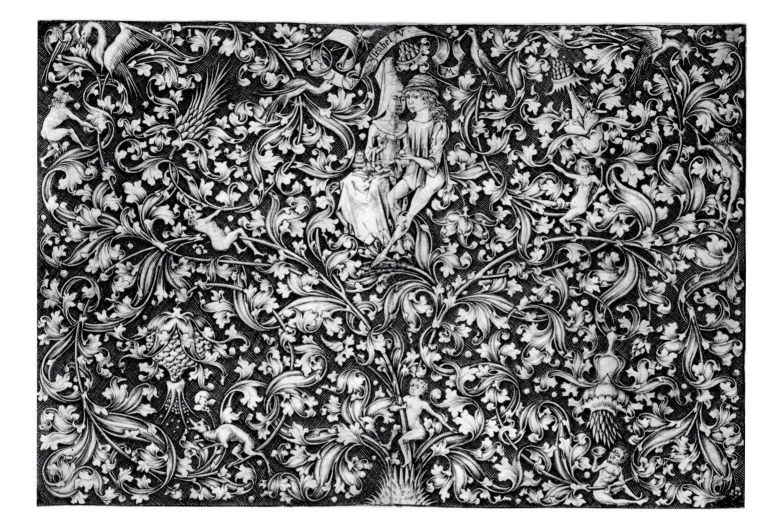

tural particulars and landscape design, the artists who illustrated it were sometimes more generous in filling in the missing visual details. These images of the literary love garden are probably fairly accurate representations of the appearance of actual pleasure gardens of the period.[80]

A late fifteenth-century edition of the *Roman de la Rose* in the Rosenwald Collection at the Library of Congress was printed on a press and illustrated with woodcuts, but made to look like an illuminated manuscript by the publisher, Antoine Verard (cat. 21). Verard's shop added ruled lines in red ink to the printed text to imitate the ruling that was drawn on a manuscript page prior to hand lettering by scribes; the woodcuts were painted with opaque pigments and gold highlights. The last illustration in the book shows the Lover finally picking his Rose. As in the illustrations of the Passion discussed

above (cats. 6–9), the artist here has included a fence and gate to emphasize the garden setting, even though, according to the text, the rosebush was surrounded by a hedge, not a fence, and the walls that enclosed the garden proper were not so close to the Rose. The Lover holds the bright red rose in one hand and the stem from which it has been torn in the other. One can see the typical square planting beds amidst trees shimmering with gold-highlighted leaves.

Four engravings by Israhel van Meckenem (cats. 22–25) include some common features of the medieval love garden, such as lush vegetation, fruit-laden vines, benches, musical instruments, and wine. The *Ornamental Panel with Two Lovers* (cat. 22), which was probably made as a pattern for a goldsmith or silversmith to follow in decorating a small box, shows a pair of lovers engaged in intimate conversation among the leaves of a

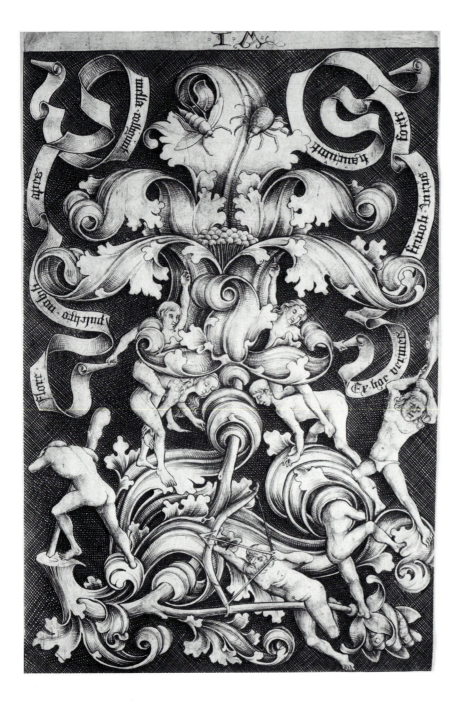

with promiscuous abandon in the forests.[83]

In Meckenem's *Ornament with Flower and Eight Wild Folk* (cat. 23), an enormous, overblown flower, opened to reveal its reproductive parts, is the setting for a scene of violent strife as pairs of lovers ascend through the leaves to the opened petals.[84] Rising above the battling figures below, two naked couples successfully make their climb; on one side, a man rides on the back of a woman, on the other, a woman is on the back of a man. The riding figures each point upward toward their goal, perhaps to encourage their lovers. The inscriptions on the banderoles read "Noble bees take honey from the beautiful flower; Frivolous vermin extract more potent juices from this one." Illustrating the point, a bee and an aphid are drawn to the flower's nectar.

Meckenem's *Circular Ornament with Musicians Playing near a Well* (cat. 24) presents a more decorous love garden scene.[85] Because music was thought to stimulate lewd behavior, such music-making couples were an emblematic motif for the sin of lust in medieval, moralizing art.[86] One of the two potted plants on the bench is cut in topiary form, a technique favored by medieval gardeners. The bench angles around a fountain in whose cooling waters a wine flask floats. Like music, drinking wine was commonly associated with the sin of lust.[87]

Music and lust are also connected in Meckenem's *Ornament with Morris Dancers* (cat. 25).[88] In a composition that resembles medieval images of the Tree of Jesse, the courtly lady standing at the crux of the vine-like tree holds an apple which she will present as a reward to the best dancer among the six men who gyrate wildly around her in the branches of the vine. The singing court jester and the musician below provide music for the event. The morris dance, popular in fifteenth-century courts, was performed as a mock chivalric contest and was parodied in contemporary drama as an *exemplum* of the folly of love.[89] Meckenem has used a leafy setting for his morris dance, further associating the fête with the garden of love.

Wenzel von Olmütz's *The Lovers* (cat. 26) is an engraved copy of a drypoint by the

23. Israhel van Meckenem (German, c. 1445–1503), *Ornament with Flower and Eight Wild Folk*, c. 1490/1500, engraving, 200 x 131 (7 7/8 x 5 1/8). National Gallery of Art, Rosenwald Collection 1943.3.173

proliferating, fruiting vine, one of the leaves of which reaches up to stroke the young man's leg.[81] She has given a piece of fruit to her companion, a suggestive gesture that seems to be gratefully accepted. On her lap is another piece of fruit, and a small, fluffy dog, frequently an erotic symbol in medieval art.[82] The vine is inhabited by birds (whose seductive songs were an indispensable feature of the love garden), a dog, and naked wildmen and wildwomen. According to medieval lore, these uncivilized, uninhibited folk lived

24. Israhel van Meckenem (German, c. 1445–1503), *Circular Ornament with Musicians Playing near a Well*, c. 1495/1503, engraving, diam. 174 (6 7/8). National Gallery of Art, Rosenwald Collection 1943.3.163

25. Israhel van Meckenem (German, c. 1445–1503), *Ornament with Morris Dancers*, c. 1490/1500, engraving, 114 x 265 (4 1/2 x 10 1/2). National Gallery of Art, Rosenwald Collection 1947.7.186

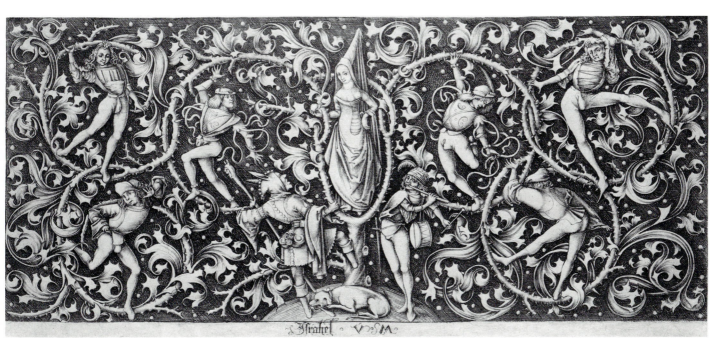

37

Housebook Master that depicts a charming scene of an amorous couple viewed through an arch.[90] Two vines are trained over the arch, their flowers reaching out to grasp each other at the center, directly over the couple's joined hands. This pair is somewhat less forward than the others; although he gazes intently at her, she demurely lowers her eyes. A pot of carnations, symbolic of love, and a wine basin rest to either side of the lovers.[91]

Representations of gardens in medieval art were typically symbolic—not living, growing gardens but abstract ideas reflecting the Middle Ages' heightened concern for the spiritual rather than the natural world. The works illustrated in this chapter were not created as documents to show actual gardens; they depicted gardens because the medieval imagination habitually associated certain devotional images, and their profane counterparts, with gardens settings. We shall see an entirely different approach to gardens in the art of the Renaissance.

26. Wenzel von Olmütz (German, active 1481/1497), after the Housebook Master, *The Lovers*, c. 1490, engraving, 171 x 113 (6 3/4 x 4 1/2). National Gallery of Art, Rosenwald Collection 1943.3.8324

Notes

1. There was not, in fact, a tradition for creating independent landscape, and the accurate, topographical representation of specific places is extremely rare. On this subject, see Charles Talbot, "Topography as Landscape," in *The Early Illustrated Book: Essays in Honor of Lessing Rosenwald*, ed. Sandra Hindman (Washington, D.C., 1982), 106–107.

2. William M. Ivins, Jr., *Prints and Visual Communication* (Cambridge, Mass., 1953), 28–38.

3. There were some early printed sheets, such as the woodcut map by Hans Sporer the Younger (cat. 2), that served a more secular, didactic purpose. However, this map also involved religious imagery in its depiction of the Garden of Eden. "Informational" illustrated books, such as printed herbals and other scientific, travel, and history books, began to be published in the late fifteenth century (see Ivins 1953, 31–38). On these early books, see the essays in Hindman 1982.

4. On medieval gardens, see Marilyn Stokstad and Jerry Stannard, *Gardens of the Middle Ages* [exh. cat., Spencer Museum of Art, University of Kansas] (Lawrence, KS, 1983); Elisabeth B. MacDougall, ed., *Medieval Gardens* (Washington, 1986); Frank Crisp, *Mediaeval Gardens* (London, 1924).

5. Jerry Stannard, "Medieval Gardens and their Plants," in Stokstad and Stannard 1983, 38, 42–49, and "Alimentary and Medicinal Uses of Plants," in MacDougall 1986, 75–78, 80. See also Paul Meyvaert, "The Medieval Monastic Garden," in MacDougall 1986, 25–53.

6. The enclosed cloister garden in the medieval monastery was the quintessential garden of this type. See the special issue of *GESTA* 12 (1973), devoted to studies on the medieval cloister.

7. Marilyn Stokstad, "Gardens in Medieval Art," in Stokstad and Stannard 1983, 30; on medieval fountains, see Naomi Miller, "Paradise Regained: Medieval Garden Fountains," in MacDougall 1986, 137–153.

8. Howard M. Colvin, "Royal Gardens in Medieval England," in MacDougall 1986, 14. See also Christopher Thacker, *The History of Gardens* (Berkeley, 1979), 84; Marie Luise Gothein, *A History of Garden Art*, trans. Mrs. Archer-Hind, vol. 1 (New York, 1979), 187.

9. Stokstad, "The Garden as Art," in MacDougall 1986, 182; Stokstad, in Stokstad and Stannard 1983, 29. See also Thacker 1979, 85; Gothein 1979, 194.

10. Stokstad, in MacDougall 1986, 184.

11. Genesis 2:8–10.

12. Howard Rollin Patch, *The Other World According to Descriptions in Medieval Literature* (Cambridge, MA, 1950), 134, 143–155.

13. Patch 1950, 141; Derek Pearsall and Elizabeth Salter, *Landscapes and Seasons of the Medieval World* (Toronto, 1973), 56–75; Johan Chydenius, "The Typological Problem in Dante," in *Commentationes Humanarum Litterarum*, tomus XXV.1 (Helsingfors, 1958), 91–109.

14. See Miller, in MacDougall 1986, 137–138.

15. The Rosenwald miniature is remarkably similar to a miniature that was in the *Hortus Deliciarum*, a twelfth-century encyclopedia compiled by Herrad of Landsberg that was destroyed in the Franco-Prussian War; fortunately, tracings had been made of its illustrations prior to its destruction. See Aristide D. Caratzas, trans. and ed., "Abraham's Bosom," in *Herrad of Landsberg: Hortus Deliciarum*, commentary and notes by A. Straub

and G. Keller (New Rochelle, N.Y., 1977), pl. LXXVII. For bibliography and provenance of the Rosenwald miniature, see Carra Ferguson, David S. Stevens Schaff, and Gary Vikan (under the direction of Carl Nordenfalk), *Medieval and Renaissance Miniatures from the National Gallery of Art*, ed. Gary Vikan [exh. cat., National Gallery of Art] (Washington, D.C., 1975), 119–125.

16. Revelation 2:7.

17. Richard S. Field, *Fifteenth Century Woodcuts and Metalcuts from the National Gallery of Art* [exh. cat., National Gallery of Art] (Washington, D.C., 1965); Leo Bagrow, "Rust's and Sporer's World Maps," *Imago Mundi* 7 (1950), 32–36.

18. Field 1965, 280; Elizabeth Baer, Lloyd A. Brown, and Dorothy E. Miner, *The World Encompassed; an Exhibition of the History of Maps* [exh. cat., Baltimore Museum of Art] (Baltimore, 1952), no. 23.

19. Rabanus Maurus, "Allegorice quatuor paradise flumina quatuor sunt Evangelia ad praedicationem in cunctis gentibus missa," *De Universo*, printed in *Patrologiae Cursus Completus . . . Series Latina* (hereafter *PL*), ed. J. P. Migne, CXI, 334. Concerning medieval maps, see George H. T. Kimble, *Geography in the Middle Ages* (London, 1938), 181–204.

20. Patch 1950, 150–153. The ultimate source for the literary description of the paradisical *locus amoenus* has been traced to classical antiquity: see A. Bartlett Giamatti, *The Earthly Paradise and the Renaissance Epic* (Princeton, 1966), 15–85; Ernst Robert Curtius, *European Literature and the Latin Middle Ages*, trans. Willard R. Trask (New York, 1963) 183–202.

21. Library of Congress, Washington, D.C., Rare Book Collection, MS 139; Stokstad and Stannard 1983, no. 1, 98–99.

22. Stokstad, in Stokstad and Stannard 1983, 22.

23. There were originally about 32 or 33 scenes but some have been lost from all surviving sets; see Field 1965, 296–315.

24. Concerning this extratemporal connection of sacred events, see V.A. Kolve, *The Play Called Corpus Christi* (Stanford, 1966), 101–123.

25. Matthew 26:36–46; Mark 14:32–42; Luke 22:39–46; John 18:1.

26. Stokstad, in MacDougall 1986, 182.

27. Compare to Stokstad and Stannard 1983, no. 8.

28. Concerning medieval shovels, see Stokstad and Stannard 1983, no. 8.

29. St. Augustine, the Venerable Bede, and Rabanus Maurus all made this connection. In his commentary on Genesis, Bede, for example, explained that terrestrial paradise was "the symbol of either the temporal Church or its future homeland" ("*vel Ecclesiae praesentis, vel futurae patriae typum tenet*"), transcribed in Chydenius 1958, 102.

30. The Song of Songs 4:12.

31. Chydenius 1958, 126; Brian E. Daley, "The 'Closed Garden' and the 'Sealed Fountain': Song of Songs 4:12 in the Late Medieval Iconography of Mary," in MacDougall 1986, 260.

32. Chydenius 1958, 126; Daley, in MacDougall 1986, 263.

33. *PL* 172, 502.

34. "Vere paradisus Dei tu es, quia lignum vitae mundo protulisti, de quo qui manducaverit, vivet in aeternum,"

39

Ad Beatam Virginem Deiparam, PL 184, 1011–1012. This sermon may not, in fact, have been written by Bernard himself but another twelfth-century theologian; it is published with Bernard's sermons in *PL* 184 with a note concerning authorship.

35. Daley, in MacDougall 1986, 264.

36. Daley, in MacDougall 1986, 267. See also Stokstad and Stannard 1983, nos. 10–13; in reference to no. 13, the authors write: "The Virgin and Child surrounded by roses is one of the major devotional images of the late Gothic period."

37. For a discussion of the rose as a symbol of the Virgin, see Barbara Seward, *The Symbolic Rose* (New York, 1960); 18–24; Stokstad and Stannard 1983, nos. 10–13.

38. Seward 1960, 19.

39. "Maria autem rosa fuit candida per virginitatem, rubicunda per charitatem," *PL* 184, 1020.

40. "O Maria, viola humilis, lilium castatis, rosa charitatis," *PL* 184, 1012.

41. Seward 1960, 23.

42. Field 1965, 167. See also Ewald M. Vetter, *Maria im Rosenhag* (Düsseldorf, 1965), 16–17. Compare to the *Madonna in the Rose Arbor* of Stefan Lochner, illus. in Stokstad and Stannard 1983, 41.

43. Millard Meiss, *Painting in Florence and Siena after the Black Death* (New York, 1951), 132–156.

44. Daley, in MacDougall 1986, 274–275.

45. Ferguson, Schaff, and Vikan 1975, no. 20, 66–69.

46. See Field 1965, 169; Franz Michel Willam, *The Rosary: Its History and Meaning*, trans. Rev. Edwin Kaiser (New York, 1952); Eithne Wilkins, *The Rose Garden Game: The Symbolic Background of the European Prayer-Beads* (London, 1969).

47. The origin of this legend is now commonly attributed to Alan de la Roche in the fifteenth century; see Wilkins 1969, 38.

48. The Joyful: The Annunciation, the Visitation, the Nativity, the discovery of Christ with the Doctors in the Temple, and the Death of the Virgin; The Sorrowful: The Agony in the Garden, the Flagellation, the Crowning with Thorns, the Way to Calvary, and the Crucifixion; The Triumphant: The Resurrection, the Ascension of Christ, the Descent of the Holy Spirit, the Assumption of the Virgin, and the Coronation of the Virgin.

49. The titles of the two great encyclopedias of the twelfth century were the *Hortus Deliciarum* (*Garden of Delights*) and the *Liber Floridus* (*Book of Flowers*). Lambert of St. Omer, the author of the latter work, explained that he had entitled his work the *Book of Flowers* because he had gathered in it information about the world "like a bouquet of flowers from the celestial meadow" so that earnest seekers of knowledge could more easily learn about God's great work; see Albert Derolez, ed., *Lamberti S. Audomari canonici Liber Floridus, codex autographus bibliothecae universitatis Gandavensis* (Ghent, 1967), folio 3v; Virginia Tuttle, *The Structure of the Liber Floridus* (Ph.D. diss., The Ohio State University, 1979).

50. Field 1965, 169. See also Erwin Panofsky, *The Life and Art of Albrecht Dürer* (Princeton, 1971), 110–111, fig. 157.

51. Stokstad, in MacDougall 1986, 178.

52. Field 1965, 184; Stokstad and Stannard 1983, no. 21.

53. Richard S. Field, "Woodcuts from Altomünster," *Gutenberg Jahrbuch* (Mainz, 1969), 183–212.

54. Marion A. Habig, ed., *St. Francis of Assisi, Writings and Early Biographies: English Omnibus of the Sources for the Life of St. Francis* (Chicago, 1972), 495.

55. Habig 1972, 297.

56. Field 1965, 291.

57. Field 1965, 290.

58. Field 1965, 256. The title is not quite accurate for the work, which shows a grape vine, not a tree, and has nothing to do with genealogy.

59. The object in his left hand was identified as a rosary in Stokstad and Stannard 1983, no. 16; Field thought it might be a Franciscan cordelier, the rope used to bind their garments.

60. Field 1965, 256; Stokstad and Stannard 1983, no. 16.

61. See a sermon entitled "Vitis Mystica seu Tractatus de Passione Domini super, 'Ego sum vitis vera' " by an unidentifed author (*PL* 184, 635–740); St. Bonaventure's "The Mystical Vine; Treatise on the Passion of the Lord," *The Works of Bonaventure*, I, trans. Jose de Vinck (Patterson, NJ, 1960), 97–144.

62. Field 1965, 185; Stokstad and Stannard 1983, no. 15.

63. This is the plausible interpretation of the print offered in Stokstad and Stannard 1983, no. 15.

64. See Arthur Watson, *The Early Iconography of the Tree of Jesse* (London, 1934); Gertrude Schiller, *Iconography of Christian Art*, trans. Janet Seligman (Greenwich, CT, 1972), vol. 1, 15–22.

65. Watson 1934, 3–6 cited passages from the writings of the Church Fathers, medieval hymns, and poems likening the Virgin to the shoot from the root of Jesse and Christ to the flower.

66. Alan Shestack, *Fifteenth Century Engravings of Northern Europe from the National Gallery of Art* [exh. cat., National Gallery of Art] (Washington, 1967–1968), 248.

67. This animation is more characteristic of the prophet figures sometimes found with the Tree of Jesse. The kings tend to be more subdued and dignified (Watson 1934, 55).

68. Stokstad and Stannard 1983, no. 4.

69. Transcribed in Watson 1934, 53.

70. Genesis 28:10–13.

71. Watson 1934, 49–51; Adolf Katzenellenbogn, *Allegories of the Virtues and Vices in Medieval Art* (New York, 1964), 22–26.

72. This passage from Josephus Hymnographus is transcribed and translated in Watson 1934, 50.

73. Field 1965, 270; Elizabeth Mongan and Carl O. Schniewind, *The First Century of Printmaking* [exh. cat., The Art Institute of Chicago] (Chicago, 1941), no. 31. Mongan translated the inscriptions on the steps as faith, charity, modesty, steadfastness, justice, strength, determination, temperance, patience, obedience, humility, and love of God. The banderoles explain that one must overcome the vices to climb the mountain and reach God.

74. On medieval love gardens, see Peter Dronke, *Medieval Latin and the Rise of the European Love Lyric* (Oxford, 1968); Roberta Smith Flavis, *The Garden of Love in Fifteenth Century Netherlandish and German Engravings: Some Studies in Secular Iconography in the Late Middle Ages and Early Renaissance*, Ph.D. diss., University of Pennsylvania, 1974; Derek Pearsall, "Gardens as Symbol and Setting in Late Medieval Poetry," in MacDougall 1986, 237–251.

75. Giamatti 1966, 5; also see 53–57.

76. *Le Roman de la Rose*, ed. Felix Lecoy, 3 vols. (Paris, 1965).

77. John V. Fleming, "The Garden of the *Roman de la Rose*: Vision of Landscape or Landscape of Vision?" in MacDougall 1986, 201; see also Fleming, *The Roman de la Rose: A Study in Allegory and Iconography* (Princeton, 1969).

78. Guillaume de Lorris and Jean de Meun, *The Romance of the Rose*, trans. Harry W. Robbins (New York, 1962), 19.

79. *Romance of the Rose*, 11–16, 27–29.

80. Stokstad and Stannard 1983, 203.

81. Shestack 1967–1968, 245.

82. See Flavis 1974, 139.

83. Timothy Husband, *The Wild Man: Medieval Myth and Symbolism* [exh. cat., Metropolitan Museum of Art] (New York, 1980).

84. Shestack 1967–1968, 249.

85. Shestack 1967–1968, 246; Stokstad and Stannard 1983, no. 65.

86. Music in the love garden is discussed by Flavis 1974, 142–143.

87. Sebastian Brant, "And drinking leads to fornication," *The Ship of Fools*, trans. Edwin H. Zeydel (New York, 1962). See also Keith Moxey, "Master E. S. and the Folly of Love," *Simiolus* II (1980), 138–141.

88. Shestack 1967–1968, 247.

89. Moxey 1980, 144.

90. Shestack 1967–1968, 124. Another copy of this print, made by Israhel van Meckenem, is discussed in Stokstad and Stannard 1983, no. 32; for the original, see Jane Hutchison, *The Master of the Housebook* (New York, 1972), 63–64; Flavis 1974, 105–106; *The Master of the Amsterdam Cabinet, or the Housebook Master, ca. 1470–1500*, compiled by J. P. Filedt Kok (Princeton, 1985), published in conjunction with an exhibition at the Rijksprentenkabinet, Amsterdam, 1985, 173–175.

91. This image is sometimes identified as an engagement portrait (Flavis 1974, 105–106) because carnations, as symbols of love, often appear in such portraits: see Flavis 1974, 155, n. 252; Robert Koch, "Flower Symbolism in the Portinari Altar," *Art Bulletin* 46 (1964), 73. However, the faces of the lovers in this print are not sufficiently specified to look like portraits (compare, for example, to Shestack 1967–1968, 244), and details such as the wine flask, the lapdog, and the way he rests his hand on her leg do not seem appropriate for an engagement portrait. In any case, the present work is a copy of the Housebook Master's original print and therefore was probably not intended to be sold as a portrait of specific people, but merely an image of two lovers.

Cat. no. 11, detail

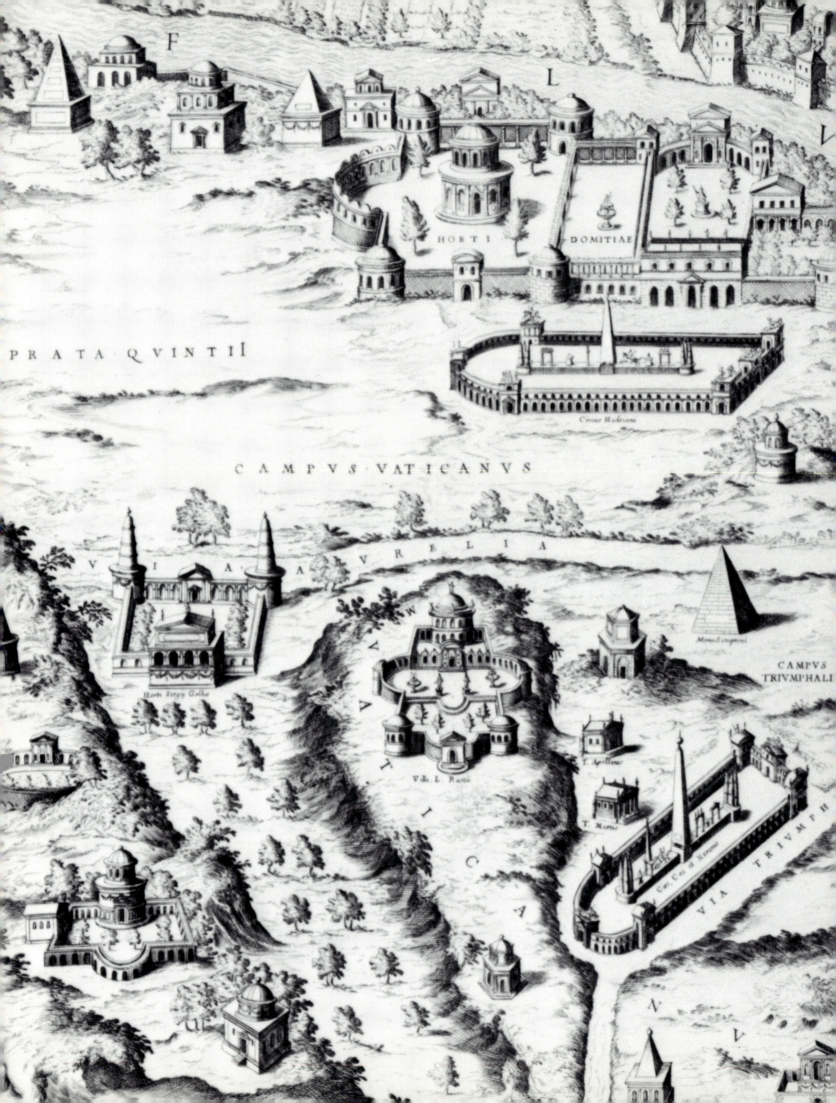

F

L

V

PRATA·QVINTII

HORTI DOMITIAE

Circus Hadriani

CAMPVS·VATICANVS

VIA·A·VRELIA

V

A

T

I

C

A

N

V

S

Horti Sergii Galbae

Villa L. Rustici

T. Apollinis

T. Martis

Mons Serapeni

CAMPVS
TRIVMPHALI

Circ. Caii et Neronis

VIA·TRIVMPH

N

V

Chapter II

RENAISSANCE AND MANNERIST GARDENS

In the Renaissance, there was a tremendous, new interest in the natural world, and works of art began to include closely observed and naturalistically rendered images of real gardens. Artists developed a new concern for verisimilitude in depicting the wonderful diversity of nature and human activity in the garden. Concurrently, discoveries in the science of linear perspective allowed a new accuracy in depicting space as a three-dimensional continuum, which in turn permitted the first clearly descriptive views of gardens. Gardens and garden-related imagery began to appear in the context of new or increasingly important subjects: genre, topographical views of contemporary and ancient sites, and classical mythology and allegory. These various depictions provide insight into how gardens were used, document the appearance of gardens, and demonstrate that the Renaissance fascination with classical forms and mythology extended into the domain of landscape design and horticultural lore.

The growing curiosity about the natural world was answered by a new availability of visual information, both through the establishment of print publishing businesses and the growing production of illustrated books. The earliest print publishing houses were founded in Italy during the first third of the sixteenth century; their Netherlandish counterparts were active by the 1550s. Together, they affected a wide distribution of prints whose subjects publishers deemed worthy of commercial interest; among these, garden views and other images that included garden motifs were very popular. The publication of illustrated books began in the fifteenth century and flourished by the early sixteenth. Illustrated treatises on architecture and garden design, and travel books that frequently included views of gardens, were especially in demand. Both prints and illustrated books helped create a broad dissemination of printed garden views throughout Europe beginning in the sixteenth century, and this was an important factor in the development of Renaissance and mannerist garden design.

The evolution of landscape design during this period coincided with that of the pictorial arts in its allegiance to the classical past, its desire to create views into the distance, and—in parts of the garden deliberately made to look rustic—its effort to imitate the appearance of nature. The Renaissance and mannerist garden was closely integrated with its house, visually related to the surrounding countryside, and filled with allusions to antiquity. No longer comprised of simple, rectilinear shapes, these gardens displayed a more complex geometry, with separate spaces integrated by axes and cross axes, and by such architectural and sculp-

Cat. no. 43, detail

tural elements as terraces, stairways, and fountains—all typically based on classical forms and precedents.

Although these new ideas in garden design arose in the second half of the fifteenth century, it was only in the sixteenth and early seventeenth centuries that they were fully developed. Through most of the fifteenth century in Italy, and the sixteenth century in northern Europe, gardens retained many of their medieval attributes. We will begin by considering representations of the less stylistically advanced gardens of northern Europe before turning to works that show the more highly developed gardens of Italy, gardens that eventually served as exemplars of the new Renaissance style for the rest of Europe.

Prints and Drawings of Netherlandish Gardens

The most important print publishing workshop in Antwerp was the *Quatre Vents*, owned and operated by Hieronymus Cock, who was himself a printmaker.[1] By the late sixteenth century, largely through the efforts of Cock's workshop, Antwerp had become the leading city in the production of prints in Europe; enormous quantities of finely executed prints from Antwerp were shipped throughout Europe, and even to America and the East. It was the *Quatre Vents* that established in the Netherlands a successful system for a division of labor among artists who provided original designs for prints, those who made reproductive engravings after them, and the craftsmen who performed the printing operations. It was also the artists working in this shop who developed the engraving techniques that would later become the standard not only in northern Europe but Italy. Six of the Netherlandish graphic artists whose work appears in this section—Pieter Bruegel the Elder, Hans Vredeman de Vries, Philipp Galle, Hendrick Goltzius, Frans Floris, and Cornelis Cort—worked in Cock's shop at some time in the course of their careers.

Bruegel provided Cock with drawings for his engravers to follow in making prints. Among his best-known works are landscapes and scenes of peasant life. One of his many portrayals of peasants engrossed in everyday activities is his 1565 drawing *Spring*.[2] This drawing was engraved by Pieter van der Heyden in 1570 (cat. 27).[3] Ten hearty workers toil in an ornamental garden, located beside a barnyard. The inscription that Bruegel added to the bottom of his drawing reads: "Spring: March, April, May." The publisher has embellished this somewhat on the print: "March, April, May are the months of spring. SPRING; comparable to childhood. In spring golden Venus rejoices in flowering garlands."[4] The gardeners are digging, straightening the edges of raised beds, raking the surfaces smooth, setting out plants, watering them, and sowing seed. To the right, two workers prune grape vines and beside them, in the barn, sheep are being sheared. In the background, an outdoor party is in progress at a two-storied garden pavilion in front of a castle; an amorous couple floats along a river on a boat laden with tree branches.

Bruegel's landscape extends into the distance along a precipitous diagonal axis emphasized by the edges of the beds. This and the rapid diminution of figures along the oblique line, from the substantial forms in the foreground plane to the miniatures beyond the river, heighten the effect of spaciousness in the scene. The figures in the extreme foreground have a sturdy balance in the powerful motion of their massive forms that is worthy of contemporary Italian works; comparison has been made between the gardener straightening the paths in the right foreground and Michelangelo's Noah in the Sistine Ceiling.[5] The artist has subtly incorporated the lessons of Italian Renaissance art into a northern world view that is minutely attentive to the commonplace. And yet, as John Hand perceived, although "Bruegel's depictions of the natural world . . . are absolutely convincing as observation . . . they surpass what might be called ordinary reality;"[6] they attain a universality beyond the ken of all but the greatest artists.

Gardeners like those in Bruegel's *Spring* often appeared in depictions of the seasons or months and were among the secular subjects enjoying an increased popularity in Re-

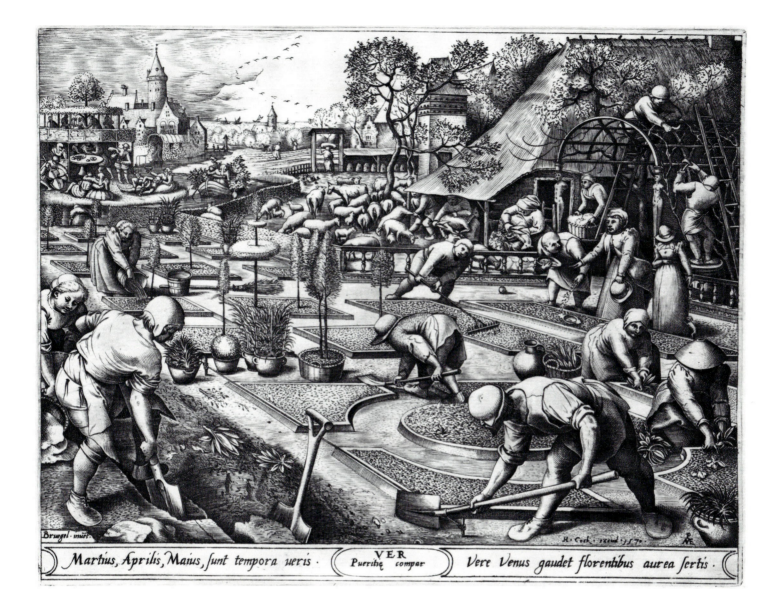

Martius, Aprilis, Maius, funt tempora ueris · VER Puerilię compar · Vere Venus gaudet florentibus aurea fertis ·

27. Pieter van der Heyden (Flemish, 1551–1572), after Pieter Bruegel the Elder, *Spring*, 1570, engraving, 228 x 287 (9 x 11 3/8). National Gallery of Art, Rosenwald Collection 1980.45.235

naissance art. Gardeners were sometimes portrayed in the same context in medieval art, but not with the keen sense of reality that we find in later works.[7] Spring may be the subject of Sebastian Vrancx's *Three Revelers and a Gardener*, made in Antwerp in the early seventeenth century (cat. 28).[8] The three figures on the left, one masked, holding a fiddle and a bell, and the others with a frying pan and a waffle, probably represented the festivities of Carnival in the early spring while the gardener, on the right, may have signified the labors appropriate somewhat later in the season. This gardener carries the tools of his trade—the same implements that Bruegel's gardeners used: string and stakes to lay out straight edges on gar-

den beds, a shovel, a pruning hook, and shears. The figures move with ease and spirit, acutely observed characters from early seventeenth-century peasant life.

The garden on which Bruegel's peasants so steadfastly labor is a fine example of those popular in the Netherlands at the time. It is laid out as a series of interlocking, geometric shapes, later identified by the French term *parterre*.[9] Small pruned trees are being planted in the centers of each shape. The arbor is supported on columns with carved figures. These elements of the garden, as well as the two-story pleasure pavilion and arbored pathway near the castle, all have their cognates in the illustrations of Hans Vredeman de Vries' *Hortorum viridariorumque*

45

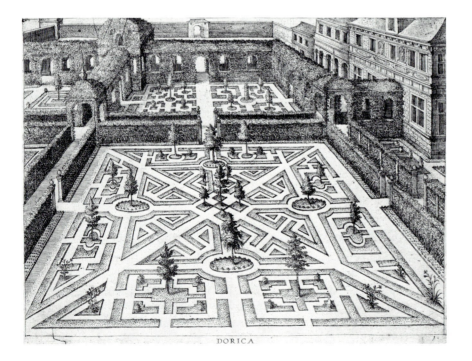

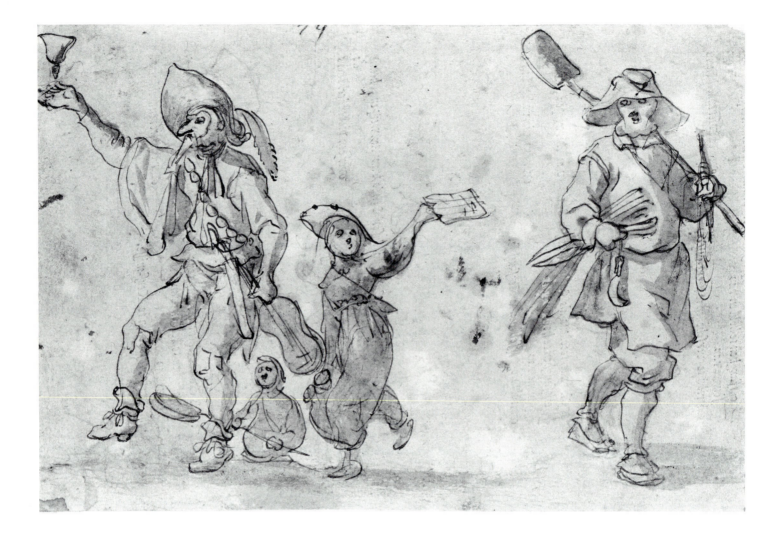

28. Sebastian Vrancx (Flemish, 1573–1647), *Three Revelers and a Gardener*, 1600/1650, pen and brown ink with brown wash over black chalk, 172 x 250 (6 3/4 x 9 7/8). National Gallery of Art, Julius S. Held Collection, Ailsa Mellon Bruce Fund 1984.3.71

Fig. 1. Philipp Galle (Flemish, 1537–1612), after Hans Vredeman de Vries, *Doric*, etching and engraving, 191 x 250 (7 1/2 x 9 3/4), in *Hortorum Viridariorumque elegantes et multiplicis formae* (Antwerp: Philipp Galle, 1583). National Gallery of Art, Mark J. Millard Architectural Collection, David K. E. Bruce Fund 1985.61

elegantes et multiplicis formae of 1583 (fig. 1).[10] Like Vrancx's engraving of *Spring*, de Vries' book was published in Antwerp. De Vries—an architect, painter, and designer of ornament as well as gardens—is credited with being the first Netherlander to approach gardening as a fine art. His *Hortorum viridariorumque* was extremely influential throughout northern Europe; it both reflected and helped to formulate a mannerist taste for intricacy and artifice in garden design.[11] The illustrations were etched by the book's publisher, Philipp Galle, after de Vries' designs.[12] Galle had worked as an engraver in Cock's workshop, and after Cock died he began his own publishing business. The illustrations in de Vries' book present patterns or models that one could follow in laying out a tasteful, up-to-date garden. His perhaps excessive allegiance to Vitruvian definitions of ideal architectural forms, involving harmony, balance, and proportion, is manifest in his effort to make each design conform to the criteria of one of the three classical orders of architecture. The illustration included here shows the Doric order.

De Vries' illustrations depict relatively small, town gardens, but the same principles of design and selection of garden features could be applied to more spacious grounds. David Vinckboons' drawing *Venetian Party in a Château Garden* of c. 1602 (cat. 29) shows a splendid and expansive version of the Flemish mannerist garden.[13] Like the more compact town gardens in *Hortorum viridariorumque*, it is subdivided into square compartments separated by hedges and arbored pathways; this aspect conforms to the medieval aesthetic of separation and enclosure that persisted in northern Europe long after it had disappeared in Italy. The beds are simple squares, and they probably would have been filled with some of the exotic horticultural specimens so dear to the hearts of contemporary Netherlanders.[14] There is a post in the center of one of the beds, which may be the center point of a floral sundial, its numerical divisions made of floral plantings, and a two-tiered gazebo with a spiral staircase leading to the second level.[15] The turf in the center, used here for dancing, was a frequent feature in Netherlandish gardens of this period, as were the canals that ran between the various parts of the garden, expanding to a boating pond in front of the château.[16] Venetian gondolas—apparently quite popular in the Netherlands at this time—carry party guests along the canals and into the pond.[17]

Vinckboons was born in Flanders in 1576 and lived in Antwerp from 1579 until 1586 when his family moved to Holland. The art of Bruegel and Vrancx, both of whom worked in Antwerp, may have been familiar to him from when he first studied painting in Antwerp under his father. The outdoor "merry company" scenes of these artists served to inspire Vinckboons, who further developed this increasingly popular genre in the early seventeenth century.[18] The subject of the elegant garden party probably derived from the medieval garden of profane love and from scenes of the prodigal son wasting his substance. There may indeed have been some lingering moralizing impulse in this drawing; the artist has included a fool among the figures in the center foreground.[19] Like many of Vinckboons' drawings, this one was made as a study for a print.[20] The broad, deep vista of the garden party is filled with minute and intriguing details, an indication that this is a relatively early drawing.[21] Vinckboons' figures are drawn with swift accuracy and perfect confidence in his consummate skill with the pen and brush. To contain the potentially overwhelming amount of detail, the artist constructed a clear and decisive composition.

Together with a new realism in the representation of gardens, depictions of pagan deities and mythological figures associated with gardens became increasing popular in the Renaissance. One particularly brilliant mannerist image of a classical deity is Hendrick Goltzius' *Persephone* (cat. 30), a color woodcut dated about 1594.[22] This work emphasizes Persephone's connection with horticulture and the garden by providing her with a wealth of fruit and flowers, which she gathers up and lifts above her head. Pluto, the god of the underworld, abducted Persephone and made her the queen of Hades. He allowed her to return to the realm of the living for six months each year, however,

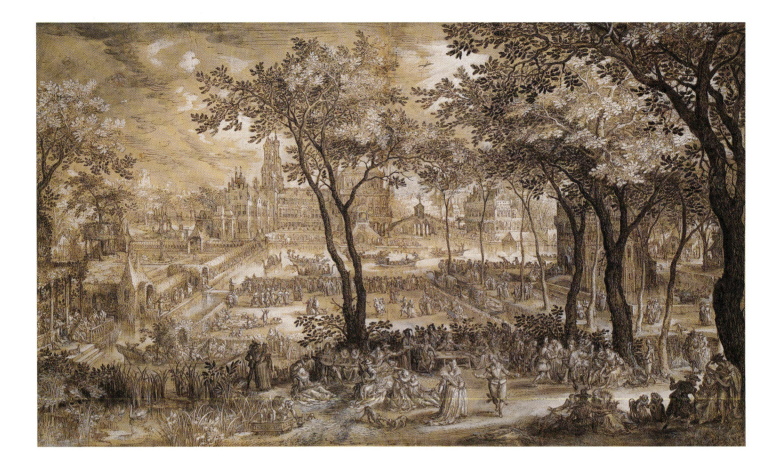

29. David Vinckboons (Dutch, 1576–c. 1632), *Venetian Party in a Château Garden*, c. 1602, pen and brown ink, brown and gray wash, with white heightening, 425 x 705 (16 3/4 x 27 3/4). National Gallery of Art, Gift of Robert H. and Clarice Smith 1986.76.1

and she became a symbol of the regeneration of the earth each spring, the return of flowers from dormant seed. *Persephone* is part of a series of woodcuts that Goltzius probably made soon after his return from a trip to Italy between 1590 and 1591; he may have made the preliminary drawings for the prints before he left Italy. Walter Strauss has suggested that Goltzius may have derived the subject of the prints from an Italian carnival parade with a theme of pagan nature deities.[23] There are seven woodcuts in the series, each of which alludes in some way to the forces of nature and the legend of Persephone. *Persephone* is the culmination of the cycle and the most accomplished woodcut as well; here Goltzius—or the member of his workshop who did his cutting—relied much less on the black line block to define the figure's form and more on the two tonal blocks.

Another splendid Netherlandish print with an allegorical, floral theme is Cornelis Cort's engraving *Odoratus* (cat. 31) from his

series depicting the five senses, based on drawings by Frans Floris. A large-scale, classically attired female figure lovingly arranges a bouquet of mixed flowers. Carnations, among the most deliciously scented flowers, grow in a pot on the parapet. The fragrance emitted by the mixed bouquet must be magnificent; even the dog is overcome with delight and takes a hearty sniff. The dog is probably included in *Odoratus* because of the species' acute sense of smell. Below the image, an inscription explains the transmission of odors from nose to brain.

Cort was one of the most brilliant of Cock's engravers. He excelled at representing figures strongly suggestive of solid form, like that in *Odoratus*, and he often served as engraver for Floris' designs. Floris, one of the leading exponents in northern Europe of the sculpturesque, Italian Renaissance style, provided Cort with drawings that would challenge Cort's skill in engraving powerfully monumental figures. It is the remarkable vigor and discipline of Cort's lines, his

30. Hendrick Goltzius (Dutch, 1558–1617), *Persephone*, probably c. 1594, chiaroscuro woodcut, oval, 345 x 255 (13 5/8 x 10). National Gallery of Art, Print Purchase Fund (Rosenwald Collection) 1982.70.1

IN CARVNCVLIS NARIVM ODORATVS CONSISTIT SENSORIVM, VNDE NERVI AD CEREBRVM PERTINCVNT·

31. Cornelis Cort (Flemish, 1533–1578), after Frans Floris I, *Odoratus*, 1561, engraving, 205 x 268 (8 1/4 x 10 5/8). National Gallery of Art, Andrew W. Mellon Fund 1975.70.3

exceptional ability to purposefully vary their width as they curve in strict, parallel formation to describe the substance and weight of his figures, that allowed him to achieve his characteristically heroic monumentality.[24]

Gardens in French Prints

The garden views of Bruegel, de Vries, and Vinckboons represent the current landscaping style in northern Europe and depict a variety of contemporary garden activities. Despite the realism of their presentation, however, these are imaginary scenes, not portraits of real and present gardens. But at this time, the first "portraits" of gardens be-

gan to appear. The etchings in Jacques Androuet Du Cerceau's *Les plus excellents bastiments de France* (cat. 32), first published in 1576 and 1579, comprise one of the earliest efforts to record the appearance of existing gardens.[25] Du Cerceau made the preparatory drawings for his book in the course of two brief intervals of peace—1563 to 1566 and 1570 to 1572—among the almost unremitting religious wars in France in the second half of the sixteenth century. The difficulties of his task during this troubled time were nearly insurmountable, and he was forced to petition Charles IX for assistance in completing the project. The occasional discrepancies in details between the preliminary drawings and the finished etchings have been attrib-

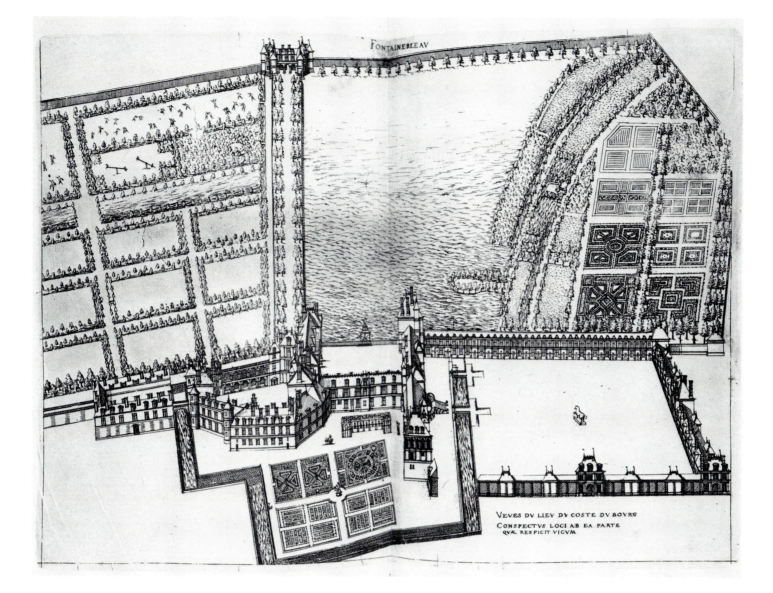

FONTAINEBLEAV

VEVES DV LIEV DV COSTE DV BOVRG
CONSPECTVS LOCI AB EA PARTE
QVÆ RESPICIT VICVM

32. Jacques Androuet Du Cerceau I (French, 1510/1512–in or after 1584), *Fontainebleau*, etching, 405 x 665 (16 x 26 ¹/₄), in *Le premier (et second) volume de plus excellents bastiments de France* (Paris, 1607). National Gallery of Art, Mark J. Millard Architectural Collection 1985.61

uted to the problematic circumstances under which the enterprise was undertaken.[26]

The precision of Du Cerceau's etching technique permitted a new accuracy in the depiction of gardens and architectural monuments, and served as an inspiration to other printmakers; his book was the progenitor of an important new genre of prints, that of etched architectural and garden surveys.[27] Du Cerceau's work provides excellent documentation of sixteenth-century French gardens. The châteaux and gardens that he illustrated reflected the taste for Italian design that was imported to France in the late fifteenth and early sixteenth centuries, following the invasion of Italy by Charles VIII. Charles conquered Naples in

February of 1495. While there, he was astonished by the beauty and splendor, the "tangible magnificence," of the gardens he encountered; on his departure, he enlisted a group of Italian artists to return with him to France and help renovate his château and gardens at Amboise in the new Italian style.[28] Charles died in 1498, before he was able to achieve these goals; his contribution to the history of architecture and garden design must be assessed as the introduction of his countrymen, specifically those who went with him to Naples, to Italian Renaissance design. His immediate successors, Louis XII and François I, carried on his building projects and initiated some of their own. Perhaps the most impressive of these is François' conver-

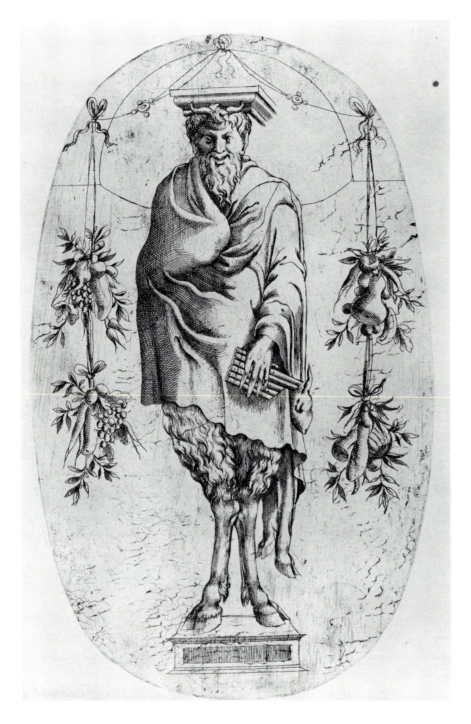

(cat. 32) shows the disposition of the château after the renovations of François and some alterations by Catherine de Medici.[30] François directed the construction of the trapezoidal lake, the dominant feature of the site, in front of his Cour de la Fontaine. The Allée Royale, a grand promenade lined on both sides with elm trees, formed the western border of the lake. On the other side of the Allée Royale was the Grand Jardin, intersected by a broad canal. The Jardin des Pins, which was indeed planted with pine trees as well as with vegetables, was across the lake. Parterres comprised part of this space and the Jardin de la Reine on the north side of the château. François' architects also built a gallery along the north side of the Jardin des Pins. At the end of this gallery was a pavilion with a grotto inside, known as the Grotto de Pins, which is attributed to Primaticcio; it may be the earliest grotto in France.[31]

An etching by Jean Mignon (cat. 33), one of the most important graphic artists in residence in Fontainebleau, represents what was probably the prevailing style of architectural and sculptural decoration in and around François' garden.[32] It shows a column with a statue of Pan, a mythological figure associated with gardens, and with bouquets of fruit hanging to either side. Such allusions to classical mythology, sometimes quite subtle, were frequent in the decoration of Fontainebleau.

Jacques Callot's single-leaf etching, *The Palace Gardens at Nancy* (cat. 34), is one of the best-known graphic images of a garden from this period.[33] Callot was a grand master of the etching technique, first used in the sixteenth century, and an innovator of important refinements to this printmaking process.[34] His portrayal of the ducal gardens in 1625 was dedicated to Nicole, Duchess of Lorraine. A long, flattering inscription at the bottom of the print compares the duchess to spring.[35] Callot's etching shows the two main parts of the garden, the upper and lower parterres. The duchess appears under a parasol at the end of the central walk, accompanied by her courtiers and four small dogs. In the back of the lower parterre, a grand double stairway connects the two gar-

33. Jean Mignon (French, active 1543–c. 1545), *Pan*, 1543/1545, etching, oval, 243 x 147 (9 1/2 x 5 3/4). National Gallery of Art, Rosenwald Collection 1964.8.865

sion of the old hunting lodge at Fontainebleau, a reconstruction effort that lasted from 1528 to 1547. It was to this château that he invited such leading Italian artists as Vignola, Serlio, Rosso, and Primaticcio, whose presence led to the development of the School of Fontainebleau, the French adaptation of Italian mannerism.[29]

Du Cerceau's illustration of Fontainebleau

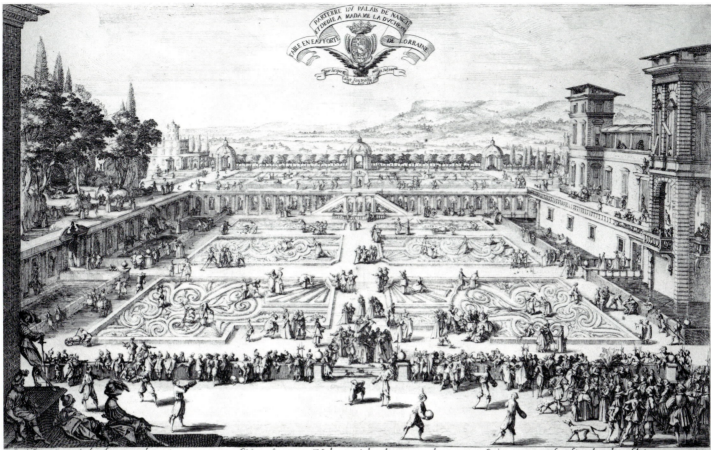

Ce dessein façonne des honneurs des printemps,
Enioliue d'obiectz de diuers passetemps;

C'est uostre aage, Madame où les douceurs encloses
Nous sont autant de fleurs, ou Rosiers precieux

Qui pousseront sans fin des doux flairantes roses
Dont l'odeur aggrera aux hommes et aux Cieux

Ias. Callot secundit Nancy

34. Jacques Callot (French, 1592–1635), *The Palace Gardens at Nancy*, 1625, etching, 255 x 381 (10 x 15). National Gallery of Art, Gift of Miss Ellen T. Bullard 1941.4.2

den levels. This stairway was constructed in the reign of Nicole's father, Duke Henri II, and adorned with sculpture by Simeon Drouin in 1616.[36] The parterres shown in the lower garden are no longer rigid, geometric patterns, like those in Van der Heyden's print, *Spring* (cat. 27), but flowing, curvilinear designs known as *parterres de broiderie* because of their resemblance to embroidered work.[37] The upper parterre was built in the reign of Nicole's grandfather, Duke Charles III, who was particularly fond of flowers and sent his gardeners to Paris and Fontainebleau to collect rare specimens.[38] At the back of the upper parterre were three pavilions connected by a double row of trees.

In his etching, Callot embellished the ducal gardens with a few ideas of his own, creating a *capriccio* that combined the real garden with imaginary elements reflecting contemporary Italian garden design.[39] Callot would have become familiar with the most

recent Italian garden styles while he was court artist of the Medici duke in Florence. Christian Pfister, in his history of Nancy, described the ducal palace complex and how it developed during the reigns of each of the various dukes who successively modified it.[40] His account of the palace and garden during the reign of Charles III, 1545–1608, corresponds in nearly all details with a 1641 etching of the complex by Claude Deruet, but not with Callot's, made during the intervening years.[41] This demonstrates that Callot's work is indeed the product of his imagination and not reflective of changes made after the reign of Charles III.

The degree to which Callot incorporated imaginary Italianate elements in both the gardens and surrounding structures becomes clear upon examining Christian Pfister's description of the palace and gardens in the late sixteenth and early seventeenth centuries.[42] On the north side of the lower par-

53

terre, which is on the left side of the print, Callot changed the existing gallery by adorning it both with a series of sculpture niches and what appears to be the entrance to a grotto, a popular garden feature in Italy.[43] In Callot's print, the passageway in the center of this gallery does not lead to a courtyard and the rest of the palace complex, as described in documents and Deruet's print.[44] Indeed, the whole north side of the composition has changed. On the other side of Callot's gateway, a curving flight of stairs leads up to a grove of trees on the level of the upper parterre. This type of grove was a frequent and important element in Italian gardens of the day.[45] Callot also changed the south side of the garden; instead of showing the Orangerie, built in 1579, which in fact formed the southern side of the lower parterre, he depicted a grand Italianate structure that, according to Pfister, never existed.[46] He also omitted the fountain that documents show was in the center of the lower parterre; this alteration was not reflective of contemporary Italian garden design, in which fountains were given great prominence. Records exist concerning the construction of this fountain by Jacob Menusier and Mansuy Gauvain and its reconstruction in marble by Robert Mesnard in 1596; it does appear in Deruet's 1641 etching and was presumably also in the garden during the intervening period when Callot worked.[47] The same fountain figures in an early seventeenth-century sketch of the garden by Inigo Jones.[48]

Among Callot's approximately 1430 works is a series of small etchings entitled *Lux Claustri* that illustrates a system of sacred symbols. It includes several gardening scenes, one of a gardener grafting a tree—an allegory for directing oneself toward virtue at the earliest moment—and the other a gardener contemplating a flowering lily—a symbol of the virgin birth (cats. 35 and 36).[49] These works are of interest not only for their symbolic significance but because they provide a direct glimpse of contemporary gardeners diligently employed in ordinary tasks and, in the case of the second etching, pausing to appreciate the beauty that their work creates.

The garden party theme that appeared in Vinckboon's *Venetian Party in a Château Garden* (cat. 29) also was part of the repertoire of garden images in France during the Renaissance. *Banquet in the Garden of a French Château* by Master HS (cat. 37), an etching dated about 1550, shows an outdoor "merry company" scene, although on a more intimate scale than that in Vinckboons' drawing. This party takes place in a small, enclosed space with a limited cast of characters. The didactic roles of the participants in this fête seem less ambiguous than those in Vinckboons' work, perhaps because the moralizing themes are clearly presented in the major motifs, not camouflaged within a vast and complex scene. The amorous couple, the wine flask cooling in a basin beside them, the feasting revelers, and the fool who cavorts among them are all stock performers from medieval moralizing scenes, reappearing in this Renaissance setting. Here, however, they are able to act their parts in the viable atmosphere of a real garden space.[50]

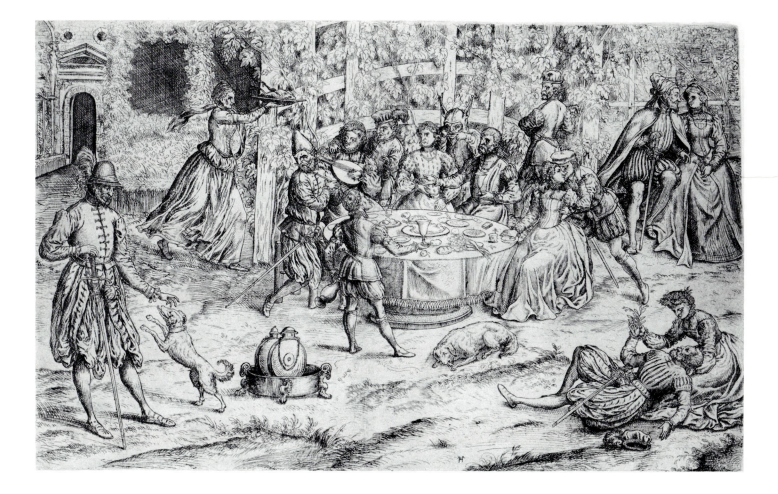

37. Master HS (French, active 1566), *Banquet in the Garden of a French Château*, c. 1550, etching, 219 x 287 (8 5/8 x 11 3/8). National Gallery of Art, Rosenwald Collection 1961.17.62

Garden Views in German and English Illustrated Books and Prints

Although no compendium of garden views comparable to that of Androuet Du Cerceau (cat. 32) was produced in any northern European country during the Renaissance, representations of important gardens do occur in the context of illustrated travel books and topographical views of landscape. In Germany, the demand for travel books and prints depicting actual sites expanded rapidly during the sixteenth century as German humanists became increasingly interested in the geography of their own country as well as that of other European nations. In England, a taste for landscape became pervasive among print collectors during the seventeenth century.[51] Although this demand for landscapes was mainly met through the importation of prints from other countries—notably the Netherlands—there were also printmakers in England who specialized in this subject.

Among the great commercial enterprises to respond to the increased demand for topographical prints and travel books in Germany was the series of *Topographia* volumes of Matthaeus Merian the Elder.[52] Merian acted both as the director of an international print-publishing business, which he had inherited from his father-in-law, Theodore de Bry, and as an artist overseeing a workshop of printmakers. According to one early source, Merian—presumably with the help of his shop—"etched the most prints of views of places in Germany of any man that ever was."[53] The many copiously illustrated volumes of the *Topographia* in fact describe not only Germany but Italy, the Netherlands, and France. Famous gardens were among the sites that Merian included in his coverage of a region. Merian was clearly a practical man and made thrifty use of existing prints by other artists whenever they were available. His illustration of the ducal garden at Nancy was, for example, copied from Jacques Callot's etching, not executed

55

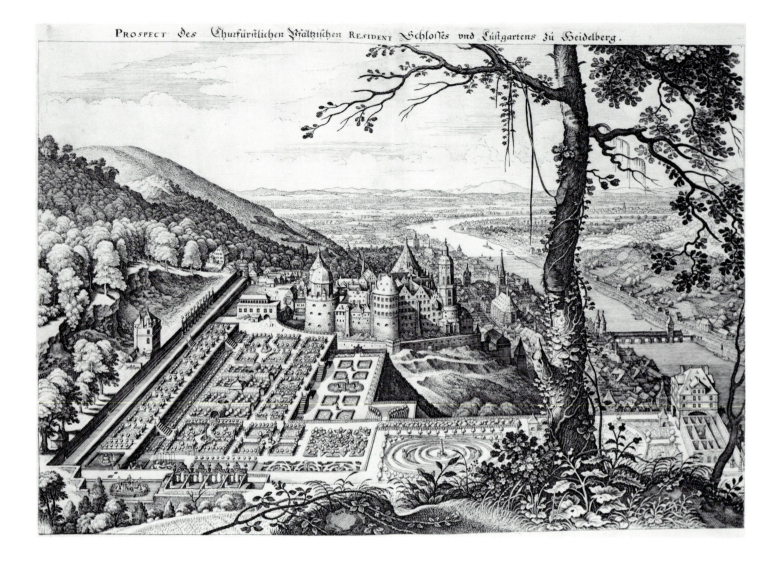

38. Matthaeus Merian the Elder
(German, 1593–1650), *Hortus Pa-
latinus*, etching, 249 x 349 (9 ³/₄ x
13 ³/₄), in *Topographia Palatina-
tus Rheni et Vicinarum Re-
gionum* (Frankfurt, 1645). Na-
tional Gallery of Art, Mark J.
Millard Architectural Collection,
David K. E. Bruce Fund 1985.61

from the site itself.[54] In his *Topographia Pa-
latinatus Rheni* of 1645, Merian reprinted an
etching he had himself originally made for
Salomon de Caus' book on the Palatine gar-
dens in Heidelberg, *Hortus Palatinus* (cat.
38).[55] It presented a dramatic view, looking
down at the gardens from a great height. It
has been plausibly suggested that Merian in-
cluded the oak tree and weedy hillock in the
foreground of this scene in order to contrast
its unkempt, common growth to the artful
perfection of the garden in the back-
ground.[56] This technique of placing a bit of
landscape in the near foreground to help es-
tablish a sense of depth is frequent in late
sixteenth- and early seventeenth-century
prints.

De Caus designed the Palatine gardens at
the behest of Elizabeth Stuart, daughter of
King James I of England and wife of Frie-
drich V, Elector of the Palatinate. Work be-
gan in 1615 and ceased, before completion,
in 1619 when the events of the Thirty Years
War forced Friedrich into exile in the Neth-
erlands. In conformity with the precipitous
terrain, there were five levels of terracing.
The garden was one of the great marvels of
the day. The site was grand in its dimensions
and consisted of a series of individual spaces
decorated with vine-covered arbors, par-
terres, a maze, grottoes, music-making
fountains—for which de Caus himself com-
posed the scores—and a mechanical speak-
ing statue.[57] It may be that de Caus designed
the gardens according to a recondite scheme
involving complex allusions to Platonic, Eu-
clidean, and Pythagorean philosophy; this
scheme refers to the achievement of univer-

56

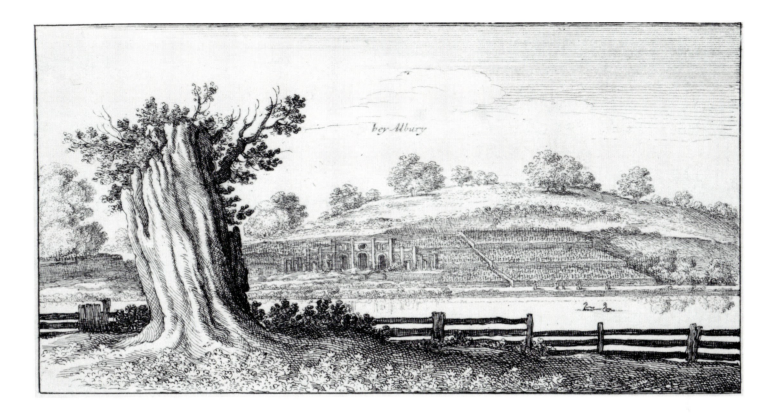

Fig. 2. Wenceslaus Hollar (Czechoslovakian, 1607–1677), *Albury Gardens*, 1645, etching, 84 x 155 (3 3/8 x 6 1/8). National Gallery of Art, Rosenwald Collection 1943. 3.4932

sal harmony and the advent of a new golden age under the governance of Friedrich V.[58] De Caus' virtuosity with water and his automata in this garden relate to his publication of a book on hydraulics, *Les Raisons des forces mouvantes*, in 1615.[59]

Two of the most renowned landscape artists to depict gardens in England during the seventeenth century were Wenceslaus Hollar and David Loggan. Hollar, a Czechoslovakian-born artist who was employed in England as printmaker to the Earl of Arundel from 1636 to 1642, was remarkably adept in the portrayal of topographical landscape. He probably acquired this skill as a young artist in the workshop of Matthaeus Merian in Frankfurt and later managed to perfect it to such a degree that he raised the genre to an independent branch of the pictorial arts and originated the English tradition of etched views of country houses.[60] He was also capable of acute sensitivity to nature in his smaller, more intimate views. Albury Park in Surrey was the favorite residence of the Earl of Arundel, who once stated that he would "have sold any Estate he had in *England* (*Arundel* excepted) before he would

have parted with this Darling *Villa*."[61] During the Commonwealth period, Arundel lived, and eventually died, in self-imposed exile in the Netherlands. In 1645 he commissioned Hollar to execute a series of etchings of his beloved Albury.[62] Since Hollar was also in the Netherlands at this time, he must have produced the etchings based on drawings he had made in the 1630s at Albury.[63] One of the six etchings of Albury (fig. 2) looks across a lake to a hillside faced by an Italianate structure with grottoes, attributed to Inigo Jones.[64] On the basis of this view, Albury has been called the first garden in England to show the influence of Italian Renaissance garden design.[65] This etching reveals the expressive variability of Hollar's lines, his quick, restless hooks and curves combined with more languid strokes that contrast to describe the difference in texture between a tree trunk and a distant vineyard.

In 1663, David Loggan began work on his *Oxonia Illustrata*, an illustrated book on the colleges of Oxford and their gardens that was published in 1675.[66] Although the date of publication would seem to identify this as a baroque work, both the style of the illus-

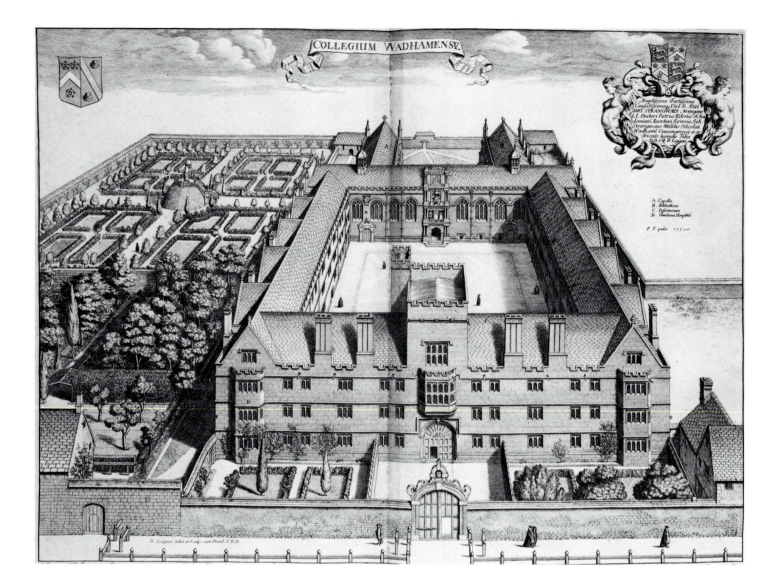

COLLEGIUM WADHAMENSE

39. David Loggan (German, 1633/1635–1692), *Wadham College*, etching and engraving, 346 x 422 (13 5/8 x 16 5/8), in *Oxonia Illustrata* (Oxford, 1675). National Gallery of Art, Mark J. Millard Architectural Collection, David K. E. Bruce Fund 1985.61

trations and the gardens they portray clearly relate to the early seventeenth century. The Renaissance gardens of the colleges at Oxford had hardly changed from the beginning of the century and maintained many of their decidedly old-fashioned elements, such as wooden galleries and raised beds.[67] At the center of the garden at Wadham College, laid out in 1651, is a man-made hill, or mount, with a statue of Atlas on top (cat. 39). The mount was a common element in Renaissance gardens that figured in the design of other college gardens at Oxford.[68] Not apparent in this image but, according to documents, included in this garden were various scientific "curiosities," such as waterworks to make rainbows, transparent beehives, and a speaking statue.[69]

While travel books and topographical prints offered portrayals of existing gardens in Germany and England, contemporary architectural treatises often presented idealized images of gardens for the edification of designers and architects. Wendel Dietterlin's *Architectura von Ausztheilung Symmetria und Porportion der Funff Seulen*, published in Nuremberg in 1598, was an important example of this type of publication in Northern Europe.[70] Dietterlin's text was extremely influential and so frequently used—and indeed worn out—in workshops that few volumes have survived in good condition.[71] Dietterlin organized his work around the classical orders, adding the Tuscan and Composite to the Doric, Ionic, and Corinthian. For each order he offered an introduc-

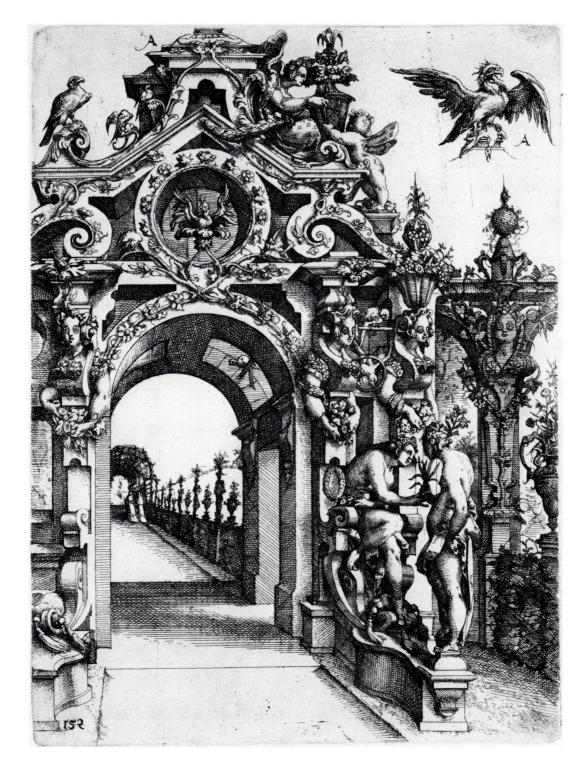

tory explanation of its salient features and then demonstrated what fantastic and wonderful creations one might make by elaborating imaginatively on them in the style of the Italian mannerists. Dietterlin's work has been called "grotesquely exaggerated" and his designs found to "squirm with erotic in-tensity."[72] The characterization is certainly appropriate for the design of an arched gateway to a garden that Dietterlin included in his fourth book, on the Corinthian order (cat. 40).[73]

Joseph Fürttenbach the Elder of Ulm spent ten years studying architecture in Italy;

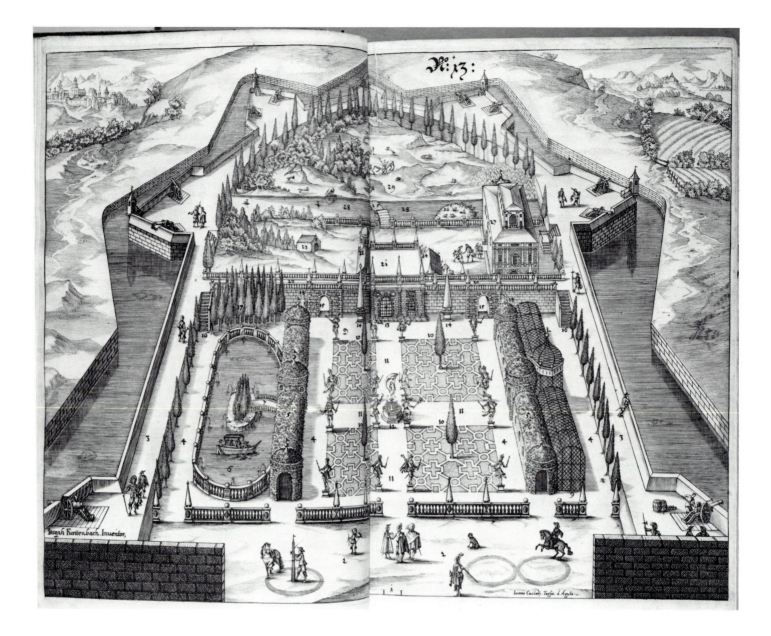

41. Jacob Custodis (German, active 1600–1650), after Joseph Fürttenbach the Elder, *Pleasure Garden with Park for Animals*, etching and engraving, 285 x 370 (11 1/4 x 14 1/2), in Joseph Fürttenbach the Elder, *Architectura Civilis das ist Eigenlich Beschreibung wie Man nach Bester Form und Gerechter Regul* (Ulm: Jonas Sauer, 1628), plate 13. National Gallery of Art, Mark J. Millard Architectural Collection, David K. E. Bruce Fund 1983.49.22

when he returned home, he regaled his countrymen with splendid volumes of idealized architectural and garden designs, including the *Architectura Civilis* published in 1628.[74] His fantasy *Pleasure Garden with Park for Animals* (cat. 41) was a quintessentially Renaissance garden with all the necessary elements neatly arranged within mighty fortifications. There is both a formal area, with parterres, fountains, and statues, and an informal park where the animals range freely among the groves of trees and meadowland. For clarity, he numbered each feature and provided an explanation of it in his text.

Gardens in Italian Prints and Illustrated Books

By the mid-sixteenth century, increasing numbers of tourists from northern Europe began to visit Rome to see its great monuments and gardens. Magnificent private gardens were open to the public, the better to display the owners' wealth and beneficence.[75] These early visitors established a vigorous new market for souvenir prints and illustrated books.[76] In response, print-publishing firms were founded in Rome and began to flourish by the second half of the

sixteenth century. Topographical views of the major sites, both ancient and contemporary, were among the first prints issued. Artists and antiquarians had studied and made sketchbooks of drawings of the monuments beginning in the early sixteenth century, and these frequently served as the basis of later printed views. Prints were sold individually, in series, and bound in volumes. Tourists could also have their individually purchased prints bound with a title page.[77] As part of the new market for printed views, there was a great demand for etchings and engravings of gardens—again, both ancient and contemporary—and these were also sold as single leaves, in series, or in bound volumes. Most illustrated books of architectural monuments included views of gardens, as did guidebooks to Rome that referred to the locations of gardens.

This rapidly expanding production of books and prints of garden views coincided with and was in part caused by the development of the new, Renaissance style of landscape design in Italy, a style based on the precepts of classical antiquity. At the close of the Middle Ages, Italians began to construct luxury country villas to which they could retreat from the congestion of the towns. Here they could enjoy the seclusion and pleasures of a bucolic setting that also provided agricultural supplies. The Renaissance garden grew up around these villas and was an intregal part of them, architecturally and psychologically. Frequently a place for humanist discussion and entertainment, the garden was meant to provide not only sensuous but also intellectual pleasures.[78] The visitor could decipher iconographic programs in the mythological subjects of the sculpture and fountains, examine and marvel at the ingenious workings of the fountains, and contemplate what Elisabeth B. MacDougall identified as the two "chief intellectual concerns of the Renaissance in regard to gardens, that is, the paradox of a work of art made of living materials, and the contrast between man-made objects and the creations

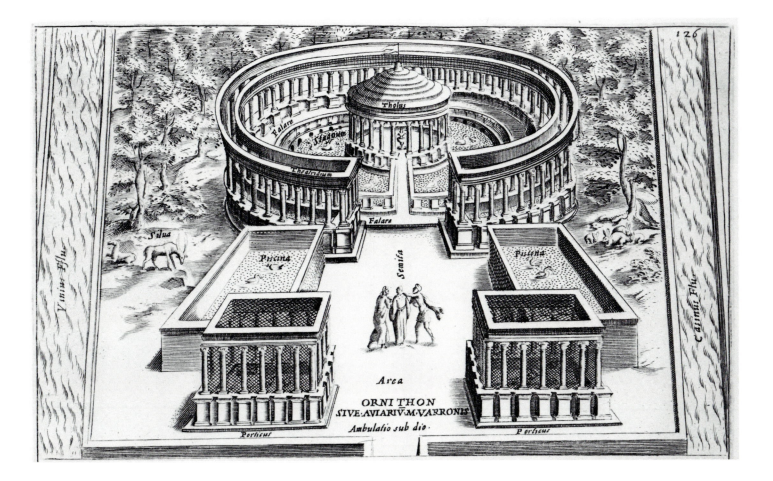

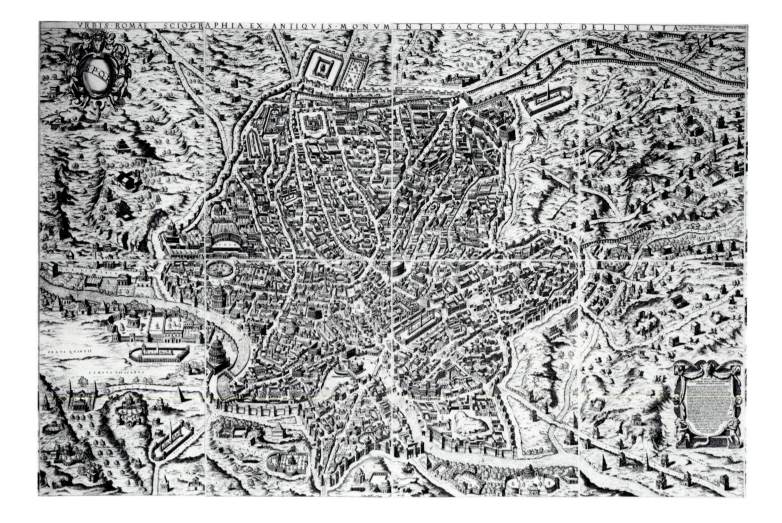

43. Etienne Du Pérac (French, c. 1525–1604), *Map of Ancient Rome*, etching and engraving, 1058 x 1558 (41 5/8 x 61 3/8). National Gallery of Art, Mark J. Millard Architectural Collection, David K. E. Bruce Fund 1985.61

of nature."[79] As a participant in the cultural mentality that cherished the prototypes of classical antiquity, the visitor would be alert to garden elements that had precedents in the ancient world. These elements and their antecedents were made familiar by archaeological ruins, such as Hadrian's Villa, and two important texts that set forth the basis of classical principles for the aesthetic theory of Italian garden design: Leone Battista Alberti's *De re aedificatoria* and Francesco Colonna's *Hyperotomachia*.

Giacomo Lauro's *Antiquae Urbis Splendor*, published in 1612, is typical of the genre of illustrated books of sites produced in Italy during the late sixteenth and early seventeenth centuries in that most of the monuments he reproduced were ancient. One of the book's illustrations is a reconstruction of the aviary that Varro described as part of his villa in *De Agricultura*, III, v. 9–17 (cat. 42).[80] This aviary was built for its owner's

pleasure and the entertainment of his guests. The two square, colonnaded structures at the entrance to the complex held birds; nets were stretched between the columns and over the roof to keep the birds inside. Behind these structures were two fish pools. The domed building in the back, inside the circular colonnade, was a dining room where songbirds were kept, behind netting. The main feature of this dining room was its revolving table that carried the various dishes and warm and cold water spouts for each of the guests seated around it. Lauro, in his reconstruction, endeavored to follow Varro's rather difficult text in all details but one: the circular colonnade and moat around the domed dining area. Varro's description in no way alluded to these features, which seem instead to derive from a similar island structure called the Marine Theater, at Hadrian's villa in Tivoli.[81]

Representations of the gardens of ancient

Fig. 3. Sebastiano Serlio (Italian, 1475–1554), *Parterre Patterns*, engraving, 165 x 143 (6 ¹/₂ x 4 ¹/₈), in *De Architectura Libri Quinque* (Venice: Franciscum de Franciscis Senensem and Joannem Chriegher, 1569). National Gallery of Art, Mark J. Millard Architectural Collection, David K. E. Bruce Fund 1985.61

Fig. 4. Sebastiano Serlio (Italian, 1475–1554), *The Exedra of the Cortile de Belvedere*, engraving, 165 x 143 (6 ¹/₂ x 4 ¹/₈), in *De Architectura Libri Quinque* (Venice: Franciscum de Franciscis Senensem and Joannem Chriegher, 1569). National Gallery of Art, Mark J. Millard Architectural Collection, David K. E. Bruce Fund 1985.61

Rome also figure prominently in a map of that city, made by Etienne Du Pérac in 1574; this map was sufficiently popular to be reprinted several times, first by the publisher Giovanni Giacomo de' Rossi in the seventeenth century (cat. 43).[82] Du Pérac, an architect as well as printmaker who lived in Rome from 1559 to 1582, was well versed in Roman antiquities, and made a series of prints of ancient monuments. This map illustrates the density of gardens in ancient Rome, a fact of great interest to the Renaissance. The garden of Caesar is shown near the lower edge, to the right of center, with Martial's also at the lower edge, left of center, and Domitian's, an especially large garden, on the left side, just below the middle.

Sebastiano Serlio is important to the history of architecture primarily for his five-volume *Tutte l'opere d'architettura*, published between 1537 and 1547. Significantly, these were the first architectural books to be illustrated by their author, and they were of great influence in carrying the image of Italian Renaissance architecture across Europe.[83] The fourth volume contains patterns for parterres and may have been the source for the introduction of this garden feature into France (fig. 3). His third book, *De Anti-*

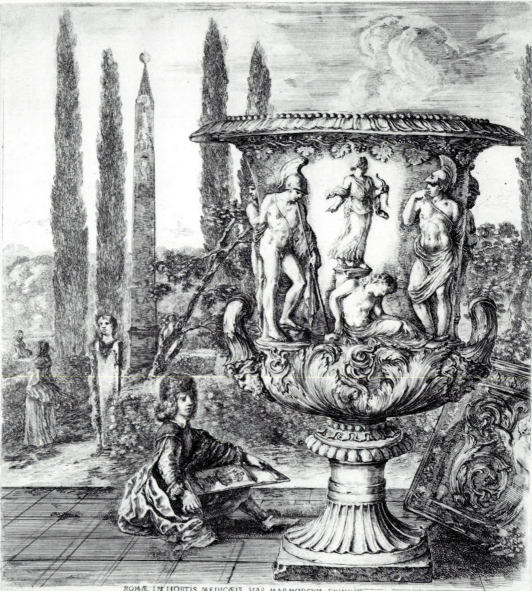

ROMÆ IN HORTIS MEDICÆIS. VÀS MARMOREVM EXIMIVM

44. Stefano Della Bella (Italian, 1610–1664), *The Vase of the Medici*, 1656, etching, 305 x 275 (12 x 10 7/8). National Gallery of Art, Andrew W. Mellon Fund 1977.12.2

quitatibus, covered the study of ancient monuments; curiously, at the end of this book he discussed a contemporary garden, Donato Bramante's Cortile del Belvedere in the Vatican, built for Pope Julius II beginning in about 1505 (fig. 4). The sixteenth century did, in fact, understand this garden in the context of ancient architecture because Bramante based it so closely upon classical principles, both in structural details and grandeur of scale.[84]

James Ackerman perceived the Cortile del Belvedere as the starting point of Renaissance garden design, as the first instance of

architecture reaching out to control and rationalize the outdoors.[85] The immense court served to connect the Villa Belvedere and Saint Peter's, to house Julius II's collection of ancient sculpture, and to provide a setting for theatrical entertainment. For the first time in a Renaissance garden design, an axial arrangement necessitated and controlled visual movement through the space. Bramante responded to the sloping site by organizing it into a series of three terraces. The culminating stairway leading up to the exedra, the garden's focal point, was based on Bramante's inventive reconstruction of the

64

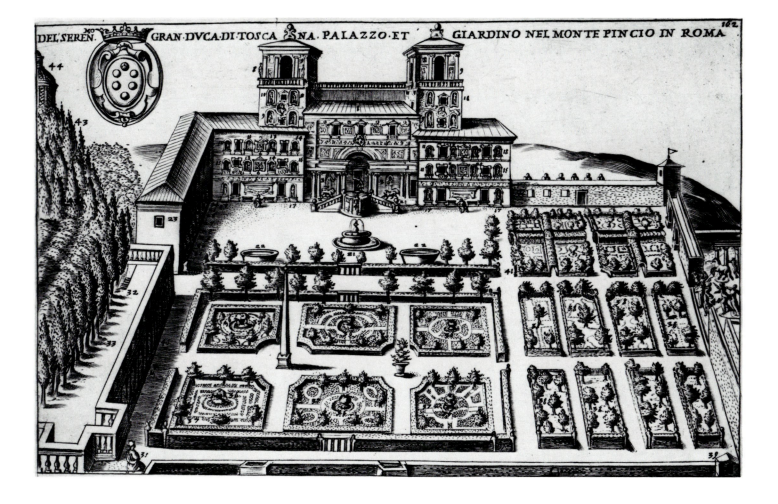

Fig. 5. Giacomo Lauro (Italian, c. 1550–1605), *Medici Garden in Rome*, etching and engraving, 178 x 234 (7 x 9 ¼), in *Antiquae Urbis Splendor hoc est praecipua eiusdem Templa Amphitheatra, Theatra Circi, Navachiae, Arcus Triumphales, Mausolea, Aliaque, Sumptuosiora Aedificia Pompae, Item Triumphalis et Colossae Arum Imaginum Descriptio* (Rome, 1612). National Gallery of Art, Mark J. Millard Architectural Collection, David K. E. Bruce Fund 1985.61

ultimate stairway in the ancient Temple of Fortuna at Praeneste; these stairs, illustrated in Serlio's book (fig. 4), in turn became the model for stairs in numerous gardens during succeeding centuries.[86]

Stefano Della Bella was among the most important graphic artists to depict etched views of Italy and France. He was born in Florence in 1610, during the time that Jacques Callot was prospering as a court artist of Duke Cosimo de' Medici II.[87] By the 1620s, Della Bella had himself attained the sponsorship of Lorenzo de' Medici, uncle of the Grand Duke. He studied under Remigio Cantagallia, who had also instructed Callot, and as part of his education he made copies of Callot's work.

In 1656, Della Bella produced a series of six etched views of Rome. One of these etchings, *The Vase of the Medici* (cat. 44), shows an antique vase that was part of Cardinal Ferdinando de' Medici's collection of ancient art kept in his garden at the Villa Medici in Rome.[88] The vase is shown resting on a paved surface with an artist at work drawing it. Behind the artist, an obelisk stands amidst four cypress trees. A topographical view of the Medici gardens in Lauro's *Antiquae Urbis Splendor* (fig. 5) may help determine the position of the vase in the garden at the time that Della Bella portrayed it. Lauro's view locates the obelisk in the garden's six-part parterre, at the point where the main axis, which runs from south to north, crosses the intersecting path to the south.[89] The position of the obelisk relative to the vase in Della Bella's etching suggests that the vase was on an elevated path east of the parterre.[90]

On the south side of the Medici garden's parterre, a large retaining wall was embellished with a series of sculpture niches and there were several grottoes underneath. On the upper level of the garden, behind the retaining wall, was a grove of trees, or *bosco*, with an artificial mount in the center, which

65

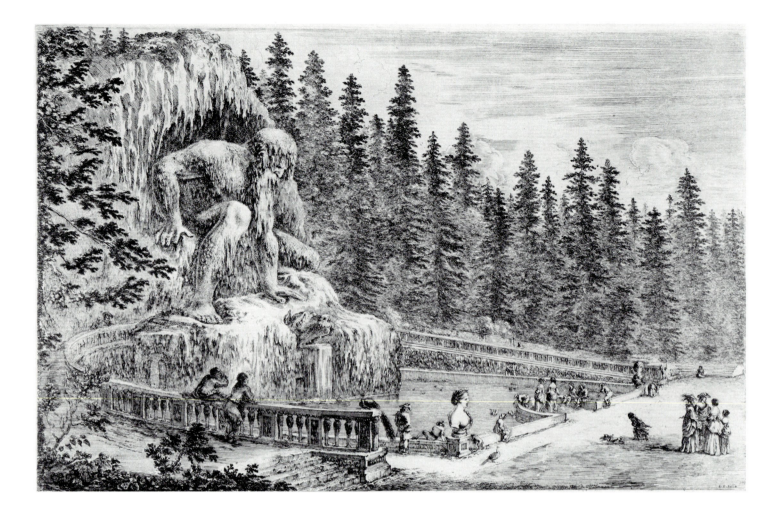

was called "Parnassus."[91] The primary purpose of the mount was to extend the already grand views into the surrounding landscape. A small, circular building with a fountain inside stood on top of the mount. The stairway leading up the mount had a channel along the side, through which water ran down and fed the fountains in the lower gardens. The *bosco*, whose natural informality complemented the refined formality of the rest of the garden, and the construction of the mount to create broad views, were two typical Renaissance features of the Villa Medici.[92] Another aspect of the gardens that was characteristic of Renaissance landscape design was the presentation of a comprehensive iconographic program in fountains and statues that attests to the power and magnificence of its owner. Here, the Cardinal is associated with Apollo and the villa with Parnassus.[93]

Della Bella also etched a series of six views

of the hillside garden of the Villa of Pratolino near Florence, designed by Bernardo Buontalenti for Duke Francesco de' Medici between about 1569 and 1581.[94] One of these etchings (cat. 45) shows a colossal statue by Giovanni da Bologna, personifying the Apennine mountains; it is the only part of the garden that has survived.[95] According to contemporary descriptions, there were rooms with mineral-encrusted walls and a fountain inside the Colossus.[96] Pratolino was the most famous and the most frequently described garden in Italy during the late sixteenth and seventeenth centuries. Michel de Montaigne, for example, gave a vivid account of the gardens in 1580.[97] The garden's renown derives chiefly from its extraordinary collection of grottoes, automata controlled by hydraulics, and trick fountains that soaked unsuspecting visitors.[98] These delights of the garden were dispersed in a seemingly random manner throughout the

66

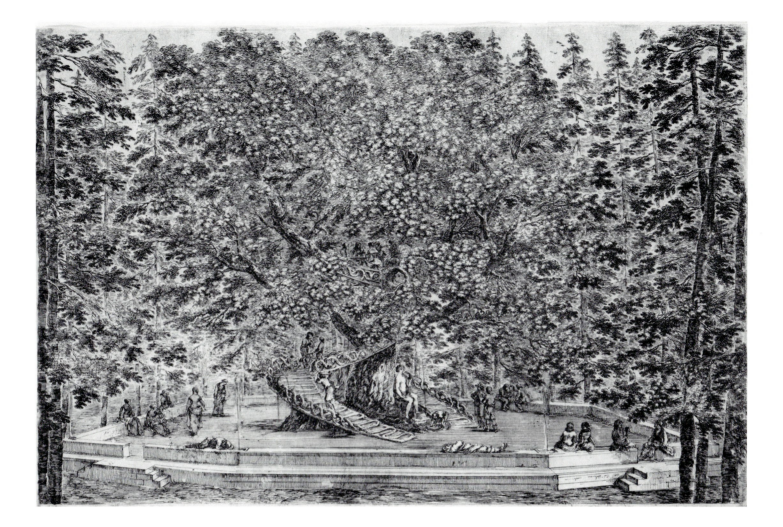

site, which was mostly wooded.[99] Since the various attractions were visually separated from one another by the woods, a visitor would have to move from one part of the garden to the next in order to see them. This sequential viewing, a characteristic of High Renaissance and mannerist gardens, suggests that there may have been a planned itinerary for visitors to follow and perhaps an iconographic theme that they might decipher as they moved along this route, from fountain to fountain, though none has as yet been discovered.[100]

Another etching in Della Bella's Pratolino series shows a remarkable tree house that must have been one of the most entertaining features of the garden (cat. 46).[101] Here the heavily wooded aspect of the garden is clearly seen, with the abundant, leafy branches of the immense oak tree that accommodates the tree house commanding nearly the entire space of the composition.

A wonderfully lush, enclosed garden provides the setting for Annibale Carracci's etching of c. 1590–1595, *Susanna and the Elders* (cat. 47). This compelling image convincingly portrays a rich, moist atmosphere and the appealing effects of sunlight sparkling among dense foliage. The spouting fountain is thrust into the foreground, immediately before the viewer's eyes, making nearly perceptible the sound and humid smell of splashing water—always an important element in Italian Renaissance gardens. Typical of Annibale's work, this etching conveys a strong emotional content along with a clear delineation of three-dimensional mass and fidelity to natural forms, all within a complex compositional structure consisting of intersecting diagonal lines, summarized in the design of the gate. This work most successfully evokes the sensations that one would experience in the type of garden depicted in the more topographical works of

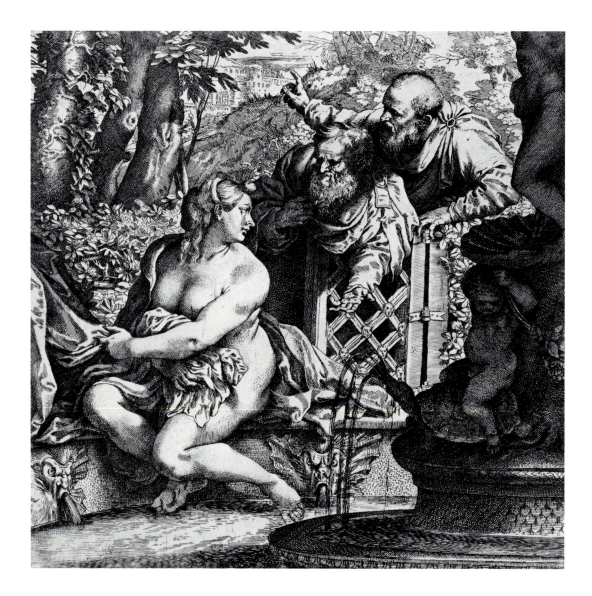

the period and affords some insight into the overwhelming charm of such exquisitely cultivated, irrigated spaces.

Pirro Ligorio has been seen as the most erudite antiquarian of the sixteenth century whose importance in the history of landscape architecture cannot be overestimated.[102] In the course of his career, Ligorio produced fifty manuscripts on the antiquities of Rome, although only one was published.[103] Among his works is a map of ancient Rome showing architectural sites and gardens.[104] A drawing by Ligorio (cat. 48) shows a collection of architectural motifs that constitute an ancient Roman villa's imaginary garden, inhabited by two possibly unconnected groups of figures. Such fanciful, composite reconstructions of Roman ar-

chitecture and gardens are typical of Ligorio for whom, according to James Ackerman, "antiquity was a storehouse of motives rather than a source of architectural principles."[105] The garland draped across the architectural structure in the back appears in Roman paintings of garden facades. Ligorio noted the presence of sculpture in the garden and made a detailed study of some decorative grill-work. Several trees of diverse species appear to have been incorporated into the architectural façade.

Pirro Ligorio is best known today for his role in the design of the garden at the Villa d'Este in Tivoli for the cardinal of Ferrara, Ippolito II d'Este, in the third quarter of the sixteenth century.[106] The enormous fame of this garden has continued to the present.

48. Pirro Ligorio (Italian, c.
1513–1583), *A Party in a Roman
Villa*, pen and brown ink, 280 x
213 (11 x 8 3/8). National Gallery
of Art, Ailsa Mellon Bruce Fund
1986.38.1a

The spread of this notoriety throughout Europe in the sixteenth and seventeenth centuries was partly due to the accessibility of printed images of the garden. The most important of these was an etching by Etienne Du Pérac that presents a bird's-eye view of the Villa d'Este.[107] The clarity of Du Pérac's etching and the popularity of the garden led to the production of many copies of his view over the course of the next two centuries. When Giovanni Giacomo de' Rossi published a volume of etchings of major sites of interest in Rome, Tivoli, and Frascati, he included in it a copy by Francesco Corduba of Du Pérac's etching (cat. 49).[108] Du Pérac's view, and its copies, look across the gardens from the northwest toward the villa on a hill to the southeast; the terrain rises up in the

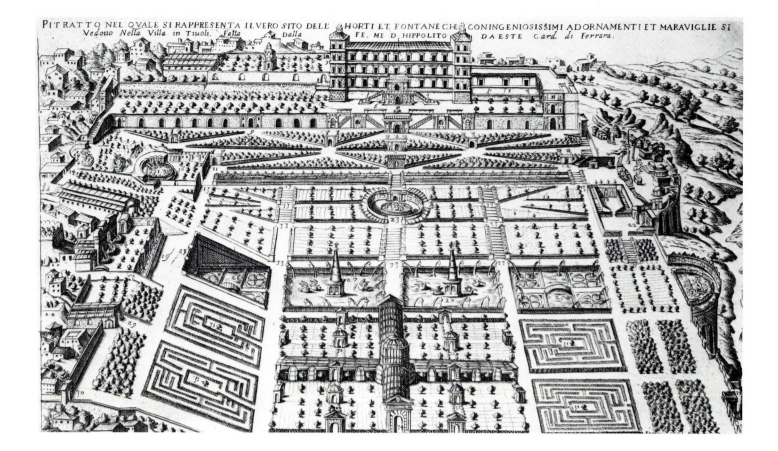

49. Francesco Corduba (Italian, 17th Century), after Etienne Du Pérac, *Villa d'Este*, etching, 237 x 347 (9 1/4 x 13 5/8), in *Nuova Rocolta di Fontane che si Vedano nel Alma Citta di Roma Tivoli e Frascati* (Rome: Giovanni Giacomo de' Rossi, 16th century). National Gallery of Art, Mark J. Millard Architectural Collection, David K. E. Bruce Fund 1985.61

northeast, or left, side of the print, and falls off sharply in the southwest, or right.

The original entrance to the gardens was on the northwest. The principal axis through the grounds began here and culminated at the villa. Upon entering, the visitor would walk under a vine-covered pergola that was crossed by another pergola, forming the central, crossed axis of a square herb garden. To either side were two labyrinths.[109] Beyond this area, a series of crosswalks intersected the main axis and led to the extravagant and ingenious fountains for which the Villa d'Este is justly renowned.[110] These cross axes added complexity and variety to the visitor's experience of the garden. As in the garden of Pratolino, one could not see the whole from a single viewpoint on the level of the garden; instead, one's "experience of the gardens becomes a much more subjective one of continuous exploration and surprise, unified by the constantly varying sound of water."[111]

The wonders of the site included the Water Organ, on the left side of the first cross axis, which dazzled spectators by playing hydraulically-produced music. When water rushed into its two empty enclosures, the air was forced out and into pipes that produced musical sounds. Steps known as the "Bubbling" or "Boiling" Stairs, because a spout on each step sent a jet of water into a basin on the step below, led up to the circular Fountain of the Dragon on the main, central axis. At the right end of the intersecting axis that crossed the Fountain of the Dragon was the Fountain of the Owl, inside an enclosed area. Here, to the delight of visitors, mechanical bronze birds perched on artificial tree branches twittered and sang until, at intervals, a mechanical owl appeared and hooted at them. Behind and beyond the Fountain of the Owl was the Fountain of Rome, a miniature model of Rome and Tivoli with water running through to represent the Aniene and Tiber rivers. On the plan, the Fountain of Rome looks like a series of tiny buildings. There were four trick water

spouts hidden in this area to soak the un-wary tourist. The Oval Fountain was on the other side of the garden, connected to the Fountain of Rome by the Lane of a Hundred Fountains, which ran along the foot of the wooded, southeast hill. The three-tiered fountain along this lane included plaques decorated with scenes from Ovid's *Metamorphoses*. Grottoes were constructed in the wooded hillside at the ends and crossings of the paths. The villa on top of the hill had a sweeping, panoramic view of the garden and the surrounding countryside.

As in the gardens at Pratolino and the Villa Medici, a symbolic meaning underlies the decoration of the garden at the Villa d'Este. David Coffin interpreted this as the triumph of virtue over vice, focusing on the labors of Hercules and reflecting the virtue of the Cardinal:

> *the dominant theme penetrating all the iconography of . . . the garden fountains . . . is that of immortality. Like the ancient Hercules the Cardinal of Ferrara was to achieve immortality through his virtuous life of chastity, temperance, and prudence . . . and through his good works and munificent patronage of the arts at Tivoli and Rome.*[112]

In the Renaissance, there was a complete change in the way gardens were depicted in works of art. No longer abstract symbols, gardens were now represented as part of the real world that began to be portrayed in this period with increasing facility. Renaissance artists rendered the earliest topographical illustrations of the great gardens of the day, and the beginnings of an active trade in printed images of gardens developed, a trade that was to flourish in the baroque period.

Notes

1. On the *Quatre Vents*, see Timothy A. Riggs, *Hieronymus Cock: Printmaker and Publisher* (New York, 1977), 222–223.

2. The drawing is reproduced in Walter Koschatzky et al., *Old Master Drawings from the Albertina* [exh. cat., International Exhibitions Foundation] (Washington, D.C., 1985), no. 24.

3. On Bruegel's *Spring*, see Charles de Tolnay, *The Drawings of Pieter Bruegel the Elder* (New York, 1952), 31–32; Kahren Jones Hellerstedt, *Gardens of Earthly Delights: Sixteenth and Seventeenth-Century Netherlandish Gardens* [exh. cat., The Frick Art Museum] (Pittsburgh, 1986), 8–9; Riggs 1977, 99.

4. On the Renaissance notion of the relationship of the seasons, planets, and ages of man, and on the derivation of the last part of this inscription, see Ilja M. Veldman, "Seasons, Planets and Temperaments in the Work of Maarten van Heemskerck: Cosmo-Astrological Allegory in Sixteenth-Century Netherlandish Prints," *Simiolus* 2 (1980), 149–176, especially 159–160; Hellerstedt 1986, 6–19.

5. De Tolnay 1952, 31–32; Fritz Grossman, "Notes on Some Sources of Bruegel's Art," *Album Amicorum J. G. van Gelder* (The Hague, 1973), 147. See also John Oliver Hand, "The Sixteenth Century," in Hand, J. Richard Judson, William W. Robinson, and Martha Wolff, *The Age of Bruegel: Netherlandish Drawings in the Sixteenth Century* [exh. cat., National Gallery of Art] (Washington, D.C., 1986), 8. Bruegel visited Italy between 1552 and 1553.

6. Hand et al. 1986, 9.

7. On seasons in medieval art, see Rosemond Tuve, *Seasons and Months* (Paris, 1933); J. C. Webster, *The Labors of the Months* (Chicago, 1938).

8. The suggestion that the figures represent February and March appears in Laura Giles, Elizabeth Milroy, and Gwendolyn Owens, *Master Drawings from the Collection of Ingrid and Julius S. Held* [exh. cat., Williams College Museum of Art] (Williamstown, MA, 1979), 19–20.

9. These interlocking, geometric beds are a simplified form of what Kenneth Woodbridge and Patrick Goode called *parterre de pièces coupées* (cut-work parterre): "Parterre," *The Oxford Companion to Gardens*, ed. Sir Geoffrey Jellicoe, Susan Jellicoe, Patrick Goode, and Michael Lancaster (Oxford, 1986), 424; Florence Hopper, "Hans Vredeman de Vries," *The Oxford Companion to Gardens*, 142, cited this kind of parterre as the major contribution of Hans Vredeman de Vries to European garden design (see below, fig. 2, for a later depiction of *parterres de pièces coupées* by de Vries).

10. Gothein 1979, vol. 2, 18–24; Elisabeth B. MacDougall and Naomi Miller, *Fons Sapientia: Garden Fountains in Illustrated Books, Sixteenth-Eighteenth Centuries* [exh. cat., Dumbarton Oaks] (Washington, D.C., 1977), no. 35; Hellerstedt 1986, no. 31. See also Florence Hopper, "De Vries" and "Netherlands," in *The Oxford Companion to Gardens* 1986, 141–142, 390–391; Riggs 1977, 181–183.

11. Hopper 1986, 141, 390–391.

12. On Phillip Galle, see F. W. Hollstein, *Dutch and Flemish Etchings, Engravings and Woodcuts ca. 1450–1700*, vol. 7 (Amsterdam, 1952), 74–83.

13. Hand et al. 1986, no. 119. Compare the Vinckboons garden to those illustrated in Gothein 1979, 3–47;

Thacker 1979, 122–129. The drawing was made as a study for a print by Nicholas de Bruyn; see Hellerstedt 1986, no. 16; Mac Griswold, *Pleasures of the Garden* (New York, 1987), 47, 68.

14. Gothein 1979, 23; Thacker 1979, 126–129; Hopper 1986, 391.

15. Griswold 1987, 68, suggested that the pole in the flower bed is a sundial.

16. When they were no longer required for defensive purposes, existing medieval moats were often transformed for decorative uses in Renaissance gardens.

17. See, for example, the gondola in a print by Hendrick Hondius II after Vinckboons, in Hellerstedt 1986, no. 4, and another in a preparatory drawing for a tapestry by A. Caron, Kenneth Woodbridge, *Princely Gardens: The Origin and Development of the French Formal Style* (New York, 1986), fig. 82.

18. Peter C. Sutton and Christopher Brown, *Masters of Seventeenth-Century Dutch Genre Painting* [exh. cat., Philadelphia Museum of Art] (Philadelpia, 1984), 348–351.

19. Sutton and Brown 1984, 331, 349–351.

20. The print, by Nicholas de Bruyn, is reproduced in Hellerstedt 1986, no. 16.

21. Robinson, in Hand et al. 1986, 298.

22. Walter Strauss, *Chiaroscuro: The Clair-Obscur Woodcuts by the German and Netherlandish Masters of the XVIth and XVIIth Centuries* (Greenwich, CT, 1973), no. 139; Walter Strauss, *Hendrick Goltzius 1558–1617: The Complete Engravings and Woodcuts* (New York, 1977), 424.

23. Strauss 1977, 740.

24. Riggs 1977, 89–94.

25. On Du Cerceau, see Le Baron Henry de Geymuller, *Les Cerceaux: Leur Vie et leur Oeuvre* (Paris, 1887), 1–27; William Howard Adams, *The French Garden 1500–1800* (New York, 1979), 9–10; Woodbridge 1986, 87–95; Kenneth Woodbridge, "Du Cerceau," in *The Oxford Companion to Gardens* (Oxford, 1986), 147.

26. Woodbridge 1986, 89.

27. A. Hyatt Mayor, *Prints and People: A Social History of Printed Pictures* (Princeton, 1980), 362; Thacker 1979, 121.

28. Gothein 1979, 391–392; Terry Comito, *The Idea of the Garden in the Renaissance* (New Brunswick, NJ, 1978), 1–24; Adams 1979, 9–13; Woodbridge 1986, 39–40.

29. Henri Zerner, *The School of Fontainebleau* (New York, 1969).

30. Du Cerceau's plan is oriented with north on the lower side of the page, in reverse of modern expectations. On Fontainebleau, see Gothein 1979, vol. 1, 400; Woodbridge 1986, 41–61; Kenneth Woodbridge, "Fontainebleau," in *The Oxford Companion to Gardens* (Oxford, 1986), 193–194.

31. Naomi Miller, "The Domain of Illusion: the Grotto in France," in *Fons Sapientia: Renaissance Garden Fountains*, ed. Elisabeth B. MacDougall (Washington, 1978), 177–198; Naomi Miller, *Heavenly Caves: Reflections on the Garden Grotto* (New York, 1982), 52.

32. Zerner 1969, 26–30, J.M. 21.

33. J. Lieure, *Jacques Callot* (Paris, 1927), no. 566; Howard Daniel, *Callot's Etchings* (New York, 1974), no. 196; H. Diane Russell, *Jacques Callot: Prints and Related Drawings* [exh. cat., National Gallery of Art]

(Washington, 1975), no. 16.

34. Russell 1975, xix-xxii.

35. The inscription is in Lieure 1927, vol. 2, texte, 64; Russell 1975, 28.

36. Christian Pfister, *Histoire de Nancy* (Paris, 1909), vol. 2, 43.

37. See Adams 1979, 50; Woodbridge 1986, 95, on the introduction of the *parterres de broderie* to France by Etienne Du Pérac and Claude Mollet.

38. Pfister 1909, vol. 2, 44.

39. These changes also appear in the preliminary drawings he made for the print (see Russell 1975, no. 15, fig. 18).

40. On the garden during the reign of Charles III, see Pfister 1909, 43–45.

41. Pfister 1909, vol. 2, reproduced Deruet's etching. One new feature in Deruet's view was the double stairway added during the reign of Henri II.

42. The documents do not help explain Callot's motive for the fantasy additions. Perhaps he was flattering the duchess by showing her garden finished according to the most up-to-date Italian style.

43. Pfister 1909, vol. 2, 43, described the wall on the north side of the parterre in the time of Charles III as a simple gallery.

44. This courtyard, described in Pfister 1909, vol. 2, 45, contained the palace latrines and the treasury of the charters of Lorraine, built by Charles III in 1595.

45. Elisabeth B. MacDougall, "*Ars Hortulorum*: Sixteenth Century Garden Iconography and Literary Theory in Italy," in *The Italian Garden*, ed. Elisabeth B. MacDougall (Washington, 1972), 39–59. The north gallery—with sculpture niches and grotto—which serves as a retaining wall for a second level with a forest, can be compared to a similar arrangement at the Villa Medici in Rome (see below, fig. 5); the appearance of a grove alongside a formal garden may also be compared to the arrangement of the gardens of the Villa Lante in Bagnaia (illustrated in MacDougall 1972, fig. 1).

46. Pfister 1909, vol. 2, 43–44.

47. Pfister 1909, vol. 2, 43.

48. Inigo Jones' drawing was for a theatrical stage set. See S. Orgie and Roy Strong, eds., *Inigo Jones, the Theatre of the Stuart Court*, vol. 1 (Berkeley, 1973), 519; John Dixon Hunt, *Garden and Grove: The Italian Renaissance Garden in the English Imagination, 1600–1750* (Princeton, 1986), 115, 144.

49. Lieure 1927, nos. 624, 635.

50. On the outdoor party scene in sixteenth- and seventeenth-century art, see Hellerstedt 1986, 44–73.

51. Henry V. S. Ogden and Margaret S. Ogden, *English Taste in Landscape in the Seventeenth Century* (Ann Arbor, Mich., 1955), 94–97.

52. Arthur M. Hind, *A History of Engraving and Etching from the Fifteenth Century to the Year 1914* (New York, 1963), 110, 118, and 124. On early topographies and travel books from the late fifteenth and sixteenth centuries, see Karen S. Pearson, "The Multimedia Approach to Landscape in German Renaissance Geography Books," 117–135 and Charles Talbot, "Topography as Landscape in Early Printed Books," 105–116, both in Hindman 1982. On Merian, see Lukas Heinrich Wuthrich, *Das druckgraphische Werk von Matthaeus Merian dem Aelteren* (Basel, 1966).

53. Quoted in Richard Pennington, *A Descriptive Catalogue of the Etched Work of Wenceslaus Hollar, 1607–1677* (New York, 1982), xx.

54. Merian included all the imaginary aspects of the garden that Callot invented for his print (see above, cat. 34).

55. He also included a copy of de Caus' etching of one of the grottoes of the Palatine gardens.

56. Richard Patterson, "The 'Hortus Palatinus' at Heidelberg and the Reformation of the World. Part I: The Iconography of the Garden," *Journal of Garden History* 1 (1981), 68.

57. Roy Strong, *The Renaissance Garden in England* (London, 1979), 110. On the garden, see also Gothein 1979, vol. 2, 37–40; MacDougall and Miller 1977, nos. 5, 8; Thacker 1979, 134; Ursula Gräfin zu Dohna, "Hortus Palatinus," in *The Oxford Companion to Gardens* (Oxford, 1986), 261–262.

58. Patterson 1981, 67–104; Richard Patterson, "Part II: Culture as Science," *Journal of Garden History* 1 (1981), 179–201.

59. MacDougall and Miller 1977, nos. 6, 7; see also Strong 1979, 75–78.

60. On Hollar's work with Merian, see Pennington 1982, xlix; Antony Griffiths and Gabriela Kesnerova, *Wenceslaus Hollar: Prints and Drawings* (London, 1983), 7. On the importance of his topographies, see Griffiths and Kesnerova 1983, 24; John Harris, *The Artist and the Country House* (London, 1981), 12–13, 30–31.

61. Quoted in Hunt 1986, 148.

62. David Howarth, *Lord Arundel and his Circle* (New Haven, 1985), 123.

63. Pennington 1982, nos. 937–942; Griffiths and Kesnerova 1983, 96 a–f.

64. Pennington 1982, no. 940; Griffiths and Kesnerova 1983, 96.

65. Harris 1981, 30.

66. Richard T. Godfrey discussed Loggan in *Printmaking in Britain* (London, 1978), 26–7. He concluded that "although Loggan was an accurate draughtsman, he did not possess the delicate feeling for atmosphere that separates the topographer from the artist."

67. Mavis Batey, *Oxford Gardens: The University's Influence on Garden History* (London, 1982), 52.

68. Strong 1979, 113–116.

69. Batey 1982, 43–47.

70. John Summerson, *Architecture in Britain, 1530–1830* (Baltimore, 1970), 41; MacDougall and Miller 1977, no. 11.

71. Elizabeth Glassman, *Reading Prints: A Selection of 16th- to Early 19th-Century Prints from the Menil Collection* (Houston, 1985), no. 116.

72. Summerson 1970, 41.

73. Dietterlin included numerous designs for fountains in his book; one of these is illustrated in MacDougall and Miller 1977, no. 11.

74. For Fürttenbach, see Gothein 1979, vol. 2, 9–10, 24–27; MacDougall and Miller 1977, no. 18; Thacker 1979, 135–136.

75. David Coffin, "The 'Lex Hortorum' and Access to Gardens of Latium during the Renaissance," *Journal of Garden History* 2 (1982), 201–232.

76. Concerning the publication of these prints and books in Italy and their impact on the tourists who purchased them, see Mayor 1980, 368–369; Emily Berns et al., *The Origins of the Italian Veduta*, [exh. cat., Bell Gallery, Brown University] (Providence, 1978); Elizabeth L. Eisenstein, *The Printing Press as an Agent of*

Change (New York, 1982); Hunt 1986, 15–22. Also, see above (p. 44, 55), regarding print publishing in northern Europe.

77. Bates Lowry, "Notes on the *Speculum Romanae Magnificentiae* and Related Publications," *Art Bulletin* 34 (1952), 46–50.

78. Elisabeth B. MacDougall, "Introduction," in Mac-Dougall 1978, 3–7.

79. MacDougall 1978, 7.

80. MacDougall and Miller 1977, no. 20. Varro's aviary is described in Thacker 1979, 19–21. See also Pierre Grimal, *Les Jardins Romains* (Paris, 1969), 289–290, 364–367.

81. MacDougall and Miller 1977, no. 20. On the Marine Theater, see Georgina Masson, *Italian Gardens* (New York, 1961), 23. Naomi Miller further suggested that Lauro's interpretation of Varro's square, colonnaded aviaries may have been based on the sixteenth-century aviaries that were once next to the two pavilions at the Villa Lante in Bagnaia (MacDougall and Miller 1977, no. 20.)

82. See Amato Pietro Frutaz, *Le Piante di Roma*, vol. 1 (Rome, 1962), 67.

83. Mayor 1980, 238.

84. James S. Ackerman, *The Cortile del Belvedere* (Rome, 1954), 121. Ackerman pointed out that "innumerable contemporary draftsmen . . . completed their sketchbooks of antiquities with drawings after Bramante," and that Serlio and his colleagues credited Bramante with both continuing the tradition of ancient architecture and initiating Renaissance architecture.

85. Ackerman 1954, 121–122.

86. The English architect and garden designer, Sir Edwin Lutyens (1869–1944), made frequent use of this stairway design.

87. Alexandre de Vesme and Phyllis Dearborn Massar, *Stefano Della Bella* (New York, 1971), 3.

88. De Vesme and Massar 1971, no. 832. The Villa Medici is on the Pincian Hill, which was the Hill of Gardens in ancient Rome. On the villa's gardens, which are partially preserved, see Gothein 1979, 300–302; Thacker 1979, 98–100; Glenn M. Andres, *The Villa Medici in Rome* (New York, 1976); Hunt 1986, 18. The vase, which is nearly six feet tall and carved with a scene of the sacrifice of Iphigenia, is now in the Uffizi (Andres 1976, 244, n. 657; de Vesme and Massar 1971, 128). It was one of the first works of art that the Cardinal acquired for his collection.

89. The obelisk appears in the same place in Giovanni Battista Falda's view of c. 1683, reproduced in Masson 1961, fig. 85. The obelisk came from the Temple of Isis in the Campus Martius (Andres 1976, 297). The four cypress trees were not there when Lauro drew his plan; they are present in Falda's view. The herm that appears between the artist and the obelisk in Della Bella's etching is not in Lauro's view.

90. This elevated walk is visible in Falda's view. The vase was moved from place to place within the garden and the palace before it was taken to the Uffizi; see Andres 1976, 307.

91. Andres 1976, 291. An ancient nymphaeum was buried underneath the mount. Lauro's plan exaggerated the proximity of the mount to the terrrace; it is actually set back, away from the terrace.

92. Elisabeth B. MacDougall has discussed the significance of the *bosco* in Renaissance gardens; the contrasts of formal and informal, of art and nature, were particularly appealing to the Renaissance sensibility (MacDougall 1972). Views of the distant countryside, advocated by Alberti, were also an important consideration in the design of Renaissance gardens.

93. Andres 1976, 291–293.

94. De Vesme and Massar 1971, 838–843. On the gardens, see Gothein 1979, vol. 2, 281–286; Webster Smith, "Pratolino," *Journal of the Society of Architectural Historians* 20 (1961), 155–168; MacDougall and Miller 1977, no. 2, and Hunt 1986, 54–55.

95. Della Bella's etching shows the figure emerging from an icy cave, which is now destroyed.

96. Smith 1961, 156.

97. See Smith 1961, 155.

98. On "joke fountains," see Thacker 1979, 113–114.

99. Smith 1961, 155, 166.

100. MacDougall 1972, 46. John Dixon Hunt suggested that illustrated editions of Ovid's *Metamorphoses* may have served as a source for the fountains and statues (Hunt 1986, 55).

101. Sue Welsh Reed and Richard Wallace, *Italian Etchers of the Renaissance and Baroque* [ex. cat., Museum of Fine Arts] (Boston, 1989), no. 124.

102. See Sir Geoffrey Jellicoe, "Ligorio," in *The Oxford Companion to Gardens* (Oxford, 1986), 338.

103. On Ligorio's study of antiquities, see Erna Mandowsky and Charles Mitchell, *Pirro Ligorio's Roman Antiquities* (London, 1963).

104. A detail of this map is reproduced in Hunt 1986, fig. 81.

105. Ackerman 1954, 139.

106. There are no documents substantiating Ligorio's role as designer of these gardens; he was, however, the Cardinal's "Antiquarian" during this period and, according to David Coffin, Ligorio was the only person who "combined a profound knowledge of classical antiquity with the artistic ability and imagination that were necessary for the creation of the gardens," David R. Coffin, *The Villa d'Este at Tivoli* (Princeton, 1960), 94.

107. Coffin 1960, fig. 1.

108. The dates of publication of Rossi's volume and of Corduba's print are unknown. Rossi compiled the book from different sources and only two of the prints are dated, both to 1618.

109. Only two of these were built (Coffin 1960, 17). On labyrinths, see Thacker 1979, 115–119.

110. Water for these fountains was abundantly supplied by two aqueducts.

111. Coffin 1960, 15.

112. Coffin 1960, 90.

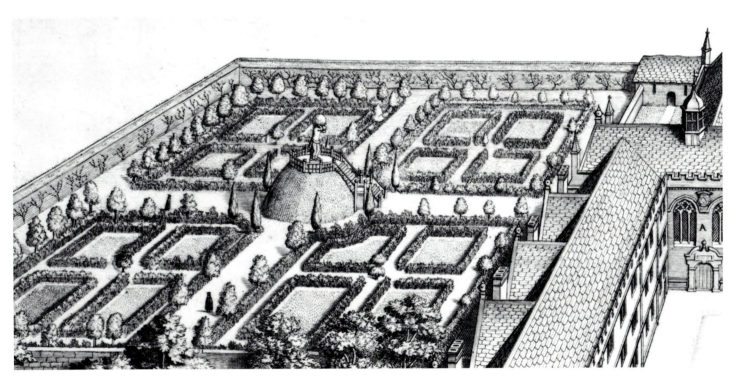

Cat. no. 39, detail

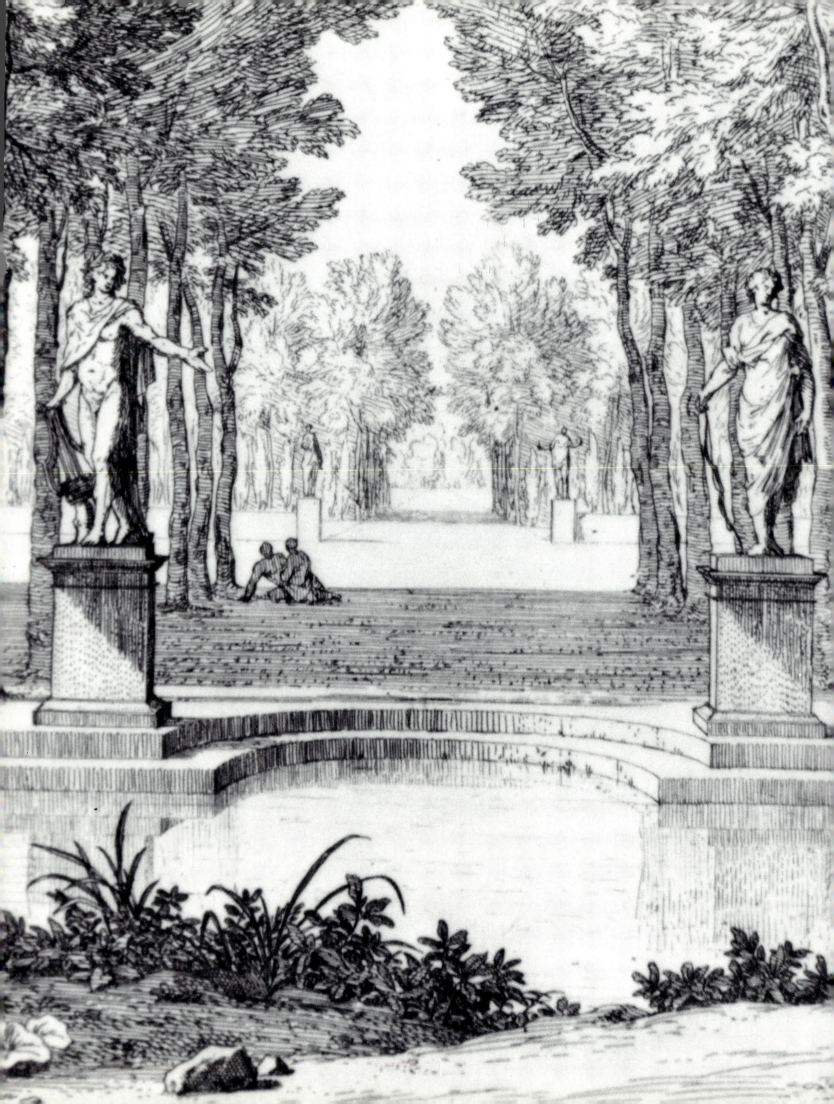

BAROQUE GARDENS

During the first half of the seventeenth century, the mannerist style gradually gave way to the baroque and its heightened sense of grandeur and drama. The printed images of gardens created during this period frequently have an increased scale and depict vast stretches of space, far beyond the scope of Renaissance perspectival rendering. Renaissance artists used perspective to imitate the appearance of the three-dimensional, natural world; baroque artists employed it seemingly to extend the viewer's visual penetration to infinity, thus submitting great expanses of nature to the vision and mind of man. The grandeur of scale and prospect prevalent in baroque art may reflect both the unprecedented expansion of royal power in the seventeenth century and the new mastery man felt over his environment, based on advances in the exact sciences and supported by the tenets of contemporary philosophy.

Garden aesthetics and the artistic styles used to depict gardens underwent a parallel development toward a classical baroque expression during the seventeenth century. We will begin by examining etchings of Italian gardens in which both the garden portrayed and the manner of its portrayal reveal a decidedly unclassical exuberance and spontaneity that make both the gardens and the

prints some of the most delightful works of art created during this period. At the same time, both Italian gardens and their printed images served increasingly to display the spectacular wealth and power of the gardens' owners. Turning next to prints of French gardens, we will examine the full development of a garden style that represents unqualified magnificence as well as control over nature. Contemporary French printmakers depicted these formal, majestic gardens with an exquisite refinement and restraint, suitable to the grandeur of their subjects. French formal gardens, as well as the elegantly disciplined style of depicting them in graphic art, exerted a tremendous influence on the gardens and garden imagery of other countries, as will be shown in the final works considered in this chapter. Netherlandish and English printed views demonstrate the international supremacy of not only the "grand style" of gardening, but the classical manner of representing the gardens produced in this grandiloquent mode.

Print publishing firms, established in the sixteenth century, continued to flourish and grow in the seventeenth century.[1] Architectural and horticultural volumes were even more popular, as more patrons began to collect books and prints. The age of the Grand Tour began, and greater numbers of tourists visited Rome and purchased individual

prints and bound volumes illustrating its monuments and gardens. In France, publishers associated with the court of Louis XIV reproduced for international distribution beautifully etched and engraved views of the royal gardens. Leading Netherlandish graphic artists visited not only Italy but France, where they were thoroughly imbued with the French classical sensibility and became part of the active print publishing business in that country. At the same time, English publishers produced the first volumes to survey with copious illustrations a broad range of contemporary architecture and gardens; these volumes were tremendously successful, which encouraged further publications of the same type. The internationally expanding and prospering trade in the publication of printed garden images produced a far greater abundance of topographical views of specific sites than had been brought forth in preceding periods.

Printed Views of Italian Gardens

The great publishing houses of the seventeenth century, such as that of the de' Rossi family in Rome, met the rapidly growing demand for prints of Italy's horticultural and architectural monuments by commissioning etched and engraved copper plates directly from graphic artists, rather than merely buying existing plates and prints. In this way, they were able to produce great quantities of prints that could later be sold individually or bound as sets. The large collections of plates they amassed were reworked—often to the detriment of the original image—when they became too worn to print clear impressions. Occasionally, publishers bound together series of prints that included impressions from both original and recut plates.

Giovanni Battista Falda was one of the artists most frequently commissioned by the de' Rossi publishing firm for garden views. Falda was born in 1648 near Milan but spent his adult life in Rome, employed as an etcher of topographical views.[2] His hatching lines show great precision; as a topographer, accuracy in perspective and in the depiction of monuments were naturally of paramount importance to him. His style did vary, however, from one work to the next, the degree of formality and control changing to suit the subject at hand. Probably his best-known work is the illustration of the first two volumes of a four-volume series depicting the fountains of Rome and vicinity: *Le Fontane di Roma*, published by Giovanni Giacomo de' Rossi in 1675. The second volume of this series covers the fountains in the gardens of Frascati, a hillside near Rome renowned for its villas and gardens since ancient times. One of the plates in Falda's second volume on Frascati, *Le Fontane delle Ville di Frascati* (cat. 50), shows the famous Water Theater of the Villa Aldobrandini. Although Falda maintained his customary precision in rendering the architectural elements, the technique is somewhat looser and more spirited in describing this country garden set in a heavily wooded hillside than, for example, in his delineation of the city fountains of Rome in the first volume of the series.[3] The visitors enjoying the water theater are quickly and spontaneously drawn; the mass of foliage that surrounds the architecture is executed with a pleasing variety of textures and contrast of lights and darks. Falda demonstrates his skill in rendering atmospheric perspective in his very light etching of the background of this scene, the upper cascades barely seen between the "Pillars of Hercules," two colossal columns at the top of the water stairs.

Falda's lively, exuberant style was eminently appropriate for a depiction of the Villa Aldobrandini's water theater, the main feature in one of the most characteristically baroque gardens in Italy. Giacomo della Porta, a student of Michelangelo, designed the garden for Cardinal Pietro Aldobrandini, nephew of Pope Clement VII, and it was built between 1598 and 1604.[4] The water theater was a massive, partly curved retaining wall punctuated by fountain niches and small rooms with elaborate waterworks. Its fountains operated on a torrent of water that cascaded down the steeply sloped, wooded north side of the Tusculum hill. The main, central niche held a statue of Atlas supporting the world with a figure of Hercules attempting to relieve him of his burden.[5] Wa-

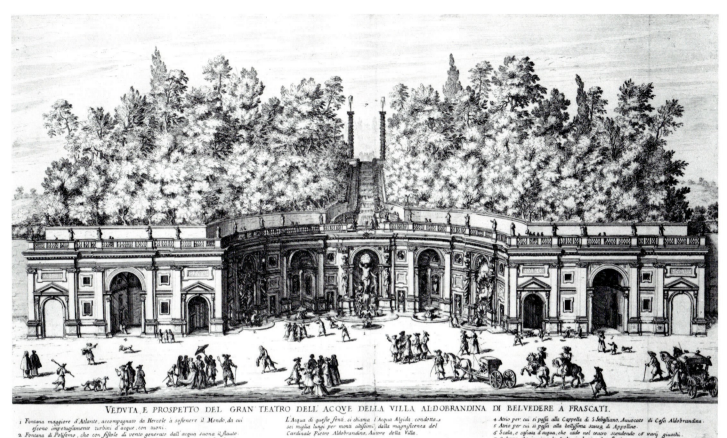

VEDVTA E PROSPETTO DEL GRAN TEATRO DELL' ACQVE DELLA VILLA ALDOBRANDINA DI BELVEDERE A FRASCATI.

1 Fontana maggiore d'Atlante, accompagnato da Hercole à sostenere il Mondo, da cui escono impetuosamente turbini d'acque, con tuoni.
2 Fontana di Polifemo, che con fistole di vento generato dall'acqua suona il flauto.
3 Fontana del Centauro, che suona la buccina, sentiendosi il tuono quattro miglia lungi, con altre fonti, e giuochi diversi, che all'improviso bagnano i riguardanti.

L'Acqua di queste fonti, si chiama l'Acqua Algida condotta, sei miglia lungi per monti alissimi, dalla magnificenza del Cardinale Pietro Aldobrandino, Autore della Villa.

4 Atrio per cui si passa alla Cappella di S. Sebastiano, Avuocato di Casa Aldobrandina.
5 Atrio per cui si passa alla bellissima stanza di Appolline.
6 Scala, e cascata d'acqua, che cade nel teatro scendendo cō varij giuochi.
7 Colonne, che in cima la Scala inalzano due fonti.

Gio Batta Falda del et sculp

Gio Jac Rossi le stampa in Roma alla Pace et Priu del S.P.

50. Giovanni Battista Falda (Italian, 1648–1678), *Water Theater, Villa Aldobrandini*, etching and engraving, 246 x 395 (9 3/4 x 15 1/2), in *Le Fontane delle Ville di Frascati, nel Tusculano, con li loro prospetti* (Rome: Giovanni Giacomo de' Rossi, 1675–c. 1690). National Gallery of Art, Mark J. Millard Architectural Collection, David K. E. Bruce Fund 1985.61

ter sprayed from Atlas' globe and, overhead, from a star, the symbol of the Aldobrandini family. The current arrived at the water theater after rushing down a water stairway; it poured onto the stairway from the tops of the Pillars of Hercules. There were three more cascades beyond and above the theater, each one progressively more rustic than the one below; the ultimate source of the garden's water on the uppermost level was designed to look like a natural spring arising from the woods.[6] This carefully contrived transition from formality near the house to rusticity at the edge of the garden was a frequent stylistic feature in baroque gardens. John Dixon Hunt called it "a witty surrender by art to a natural domain which it had nonetheless created."[7]

Falda successfully described the contrast of the hard-edged, man-made architecture to the soft, natural foliage of the wonderfully thriving *bosco*. It is in part this emphatic

contrast that defines the Villa Aldobrandini's garden as a baroque work of art. A Renaissance garden, such as the Villa Medici in Rome, might have included a naturalistic *bosco* within a contained space to complement its more pervasive formality. In this baroque garden, the juxtaposition of man and nature was more dramatic; deeper and wilder woods are allowed to oppose unsuccessfully the forces of human reason, represented by the architecture.[8] Dramatic effects also prevailed in the spectacular course of the water down the hillside. Water shooting out of the tops of the Pillars of Hercules and gushing down their sides may have been one of the most impressive—and most baroque—features in any seventeenth-century Italian garden. The organization of the Aldobrandini garden was similarly baroque so that it could be viewed comprehensively from a single, dominant viewpoint. Christopher Thacker perceived that this su-

79

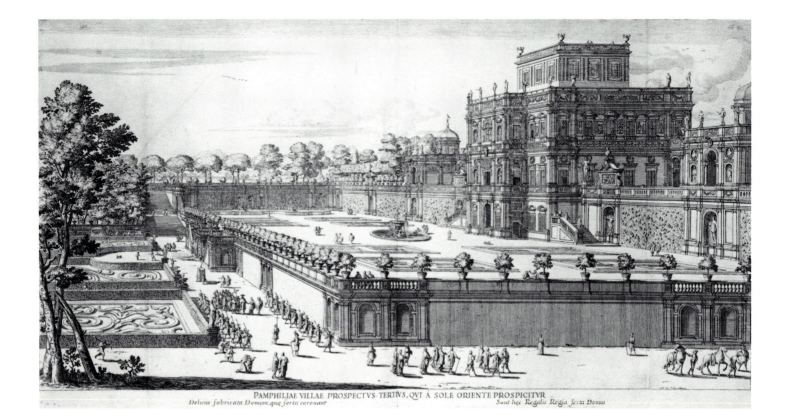

PAMPHILIAE VILLAE PROSPECTVS TERTIVS, QVI A SOLE ORIENTE PROSPICITVR

Deliciis fabricata Domum, quæ serta coronant *Sunt hic Regalis Regia serta Domus*

preme vantage point was center of the villa's *piano nobile*, the floor that contained the owner's private chambers, and that this arrangement was meant to show "the authority of the owner, whose power extends from his house, and characteristically from the principal and central viewpoint of his house, out over the gardens and the countryside."[9] Falda, clearly attuned to this important concept, elevated himself to this vantage point—directly opposite the Aldobrandini star over the central niche—for his view of the water theater.

Falda produced etchings for another magnificent folio volume, *Villa Pamphilia*, which was published by the de' Rossi firm around 1660. The Villa Pamphili, designed in the 1640s by Alessandro Algardi for Camillo Pamphili, nephew of Pope Innocent X, housed the family's extensive art collection.[10] The grounds were enormous, nearly six miles in circumference. The villa was not, however, intended to serve as a residence for the family, but merely as a place to entertain—an extravagance truly baroque in scale. It is, indeed, this propensity for splen-

dor and expansiveness that identifies the Villa Pamphili as a product of the baroque era.

The third plate at the beginning of *Villa Pamphili* focuses on the secret garden behind the villa (cat. 51). The garden was elevated on a terrace and surrounded by potted fruit trees. Formal parterres and a fountain embellish the space, and fruit trees are espaliered against the south-facing walls beside the villa. Stairs to either side of the fountain of Venus lead down to the open flower garden. A small but majestic procession indicates Falda's delight in pagentry. Falda's baroque sensibilities are also revealed in his emphasis on the great depth of this space, which conveys the sense of grandeur that he clearly found appropriate to his subject. He has combined some engraving with his etching; a few touches of the engraver's burin help make the shading on the foreground tree especially deep.

Northern artists who traveled to Italy also made sketches of Italian baroque gardens. The Grand Tour was a compulsory part of a gentleman's education in the seventeenth

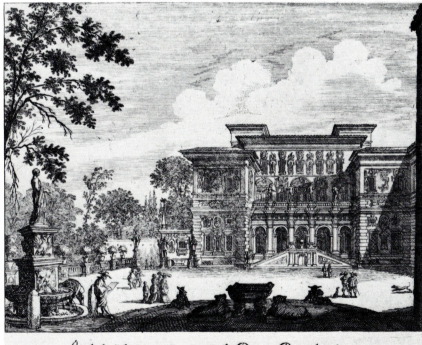

52. Melchior Küsell I (German, 1626–c. 1683), after Johann Wilhelm Baur, *Underschidliche Prospecten: Title Page*, 1636, etching and engraving, 105 x 115 (4 ¹/8 x 4 ¹/2), National Gallery of Art, Ailsa Mellon Bruce Fund 1975.23.8

53. Melchior Küsell I (German, 1626–c. 1683), after Johann Wilhelm Baur, *Underschidliche Prospecten: Villa Borghese*, 1636, etching and engraving, 105 x 115 (4 ¹/8 x 4 ¹/2). National Gallery of Art, Ailsa Mellon Bruce Fund 1975.23.12

and eighteenth centuries, and it was also an indispensible part of an artist's training. The German artist Johann Wilhelm Baur went to Italy in 1626 and stayed for about ten years. During this time, he became acquainted with the work of Callot and Della Bella. In 1636 he published a series of six etchings of gardens in Tivoli, Frascati, and Rome. Apparently, he also made a more extensive collection of drawings because in 1681—the height of the baroque period—another German artist, Melchior Küsell, portrayed a series of forty views entitled *Underschidliche Prospecten* that are based on drawings by Baur. The title page explains that Küsell etched the "various prospects" after drawings that Baur made from life during his trip to Italy (cat. 52). These prospects include port scenes of Naples and Venice, and views of Italian gardens.

Although Küsell's views are technically well-executed, they are not accurate representations of the sites they purport to show. A number of the titles below the scenes incorrectly identify their gardens; for example, the print labeled "Villa Aldobrandini, Frascati" actually shows part of the Villa d'Este in Tivoli. Even where the title does correspond with the image, as in the view of the Villa Borghese (cat. 53), there are usually significant errors in the representation of the architecture or the layout of the garden.[11] Perhaps Küsell made these errors because Baur's sketches were not clearly labeled and not finished or detailed enough to serve as the basis of accurate topographical views. In any case, one must regard these etchings as *capricci,* charming works of art that are interesting visual documents of what a later seventeenth-century German artist believed to be the essential elements of Italian gardens.

Küsell's view of the Villa Borghese is closer to reality than any of the other depictions of gardens in this series. The gardens of the villa of Cardinal Scipione Borghese, begun in 1605, were one of the most popular sites for tourists and artists in the seventeenth century.[12] Küsell showed the sculpture and a free-standing fountain in an enclosed area behind the house. An artist leans on a baluster beside the fountain and

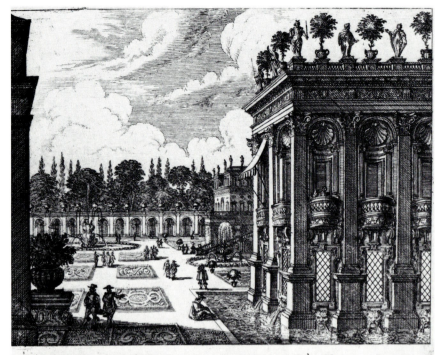

Prospect deß Lustgarten dem Duca d' Altems.

14.

54. Melchior Küsell I (German, 1626–c. 1683), after Johann Wilhelm Baur, *Underschidliche Prospecten: Garden of Duke of Altems*, 1636, etching and engraving, 105 x 115 (4 1/8 x 4 1/2). National Gallery of Art, Ailsa Mellon Bruce Fund 1975.23.23

55. Melchior Küsell I (German, 1626–c. 1683), after Johann Wilhelm Baur, *Underschidliche Prospecten: Garden of Duke of Sora*, 1636, etching and engraving, 105 x 115 (4 1/8 x 4 1/2). National Gallery of Art, Ailsa Mellon Bruce Fund 1975.23.16

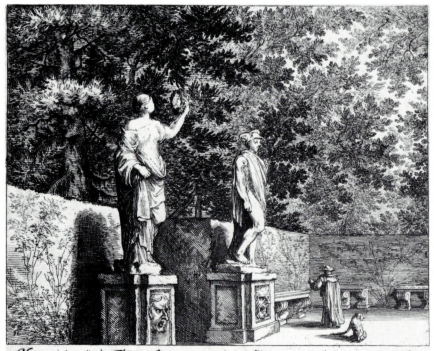

Mercurius und Flora Statuæ, vor dem Eingang in den garten deß Duca di Sora zu Frascati.

7.

sketches the scene. As with the Villa Pamphili, the most baroque aspects of the Villa Borghese were its enormous scale and the conspicuous luxury of its use merely to entertain guests and house an art collection. The garden's transition from formality near the house to "more or less natural park land" farther away, has been identified as another baroque characteristic.[13]

Two of the other garden scenes from *Underschidliche Prospecten* supposedly illustrate the Villas Ludovisi and Sora in Frascati. Scipione Borghese was responsible for the creation of the garden at the Villa Ludovisi. He purchased this villa in 1607 and sold it to Duke Giovanni Angelo Altemps in 1614, after the garden had been completed.[14] It is probably this garden that Küsell attempted to represent in his etching entitled "Prospect des Lustgarten Duca d. Altems" (cat. 54). The representation of the retaining wall in the background of Küsell's view generally agrees with the actual appearance of the side wall of the garden; it is pierced with niches and topped with urns.[15] Before the wall, a font vigorously spews forth jets of water in the center of a series of square parterres. Küsell's view of a garden attributed to the Duke of Sora (cat. 55) shows an appealing vignette of an enclosed, baroque sculpture garden.

A growing interest in hydraulics was part of the increasingly scientific outlook of the seventeenth century. Carlo Fontana's *Utilissima Trattato dell'Acque Correnti*, published in Rome in 1696, is one of numerous illustrated books that endeavored to satisfy the curiosity of this age in the natural laws of fluids in motion. Fontana's theories evolved from an ancient Roman book on hydraulics, Fontinus' *De Aquaeductibus Urbis Romae*, and the contemporary works of Benedetto Castelli and Evangeliste Torricelli.[16] Fontana empirically described the force and movement of water under various circumstances, its reaction to traveling through pipes and apertures of different sizes and to rising against gravity to different heights.[17] His illustrations were not only models of clarity but were also beautifully etched and engraved. The effect of the height to which water must rise on the velocity with which it

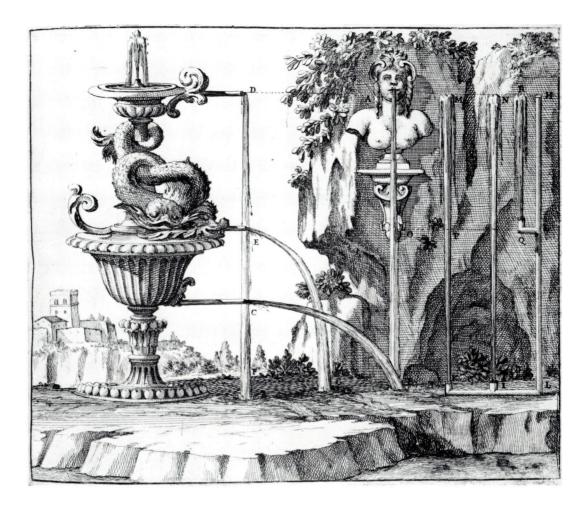

56. Carlo Fontana (Italian, 1634–1714), *Fountain*, etching and engraving, 383 x 545 (15 ⅛ x 21 ½), in *Ultilissima Trattato dell'Acque Correnti* (Rome: Giovanni Francesco Buagni, 1696). National Gallery of Art, Mark J. Millard Architectural Collection, David K. E. Bruce Fund 1985.61

will flow is set forth in a wonderfully lucid illustration (cat. 56). On the left, a fountain demonstrates that the higher the water must rise, the less forward thrust it will have when released.

Printed Views of French Gardens

Louis XIV of France ruled from 1661 until 1715, making his one of the longest reigns in French history. His sovereignty also marked the apex of French absolutism; he exercised complete control over all aspects of his government and ruled as one whose authority derived from divine sanction. Under Louis XIV, France gained international ascendancy in the art of garden design, perfecting a baroque style that reflected its absolutist and rationalist principles. The gardens associated with Louis XIV, designed by André Le Nôtre, are perhaps the clearest visual manifestations of the political philosophy of this age of grandeur.

Residents of Louis' court eagerly commissioned and collected illustrated volumes and prints that recorded the unmatched splendor of contemporary architecture and gardens. Foremost among the graphic artists who produced topographical depictions of French baroque gardens was Israel Silvestre, nephew of Israel Henriet, one of the leading print publishers in France at this time.[18] Silvestre probably studied printmaking in Henriets' workshop while Stefano Della Bella was there, a contact that would have a great influence on him. Henriet published prints by both Callot and Della Bella and owned a large collection of prints by these two artists. When his uncle died in 1661, Silvestre inherited both his publishing business and his collection of prints.

Silvestre spent fifteen years in Italy, from 1640 to 1655, where he developed his skills

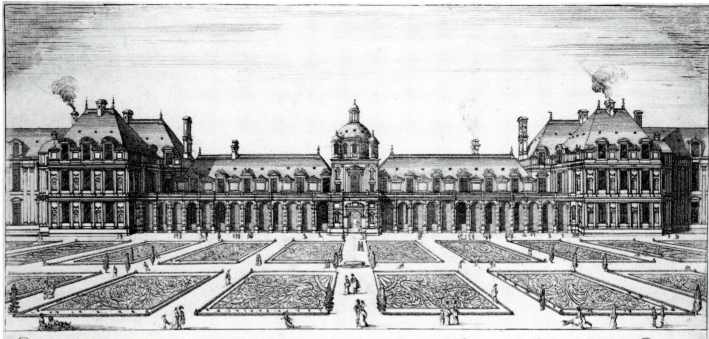

Palais de la Reyne Catherine de Médicis, dit les Tuilleries basty l'an 1564. et augmenté l'an 1600. par Henry quatre qui fit faire le Jardin dudit Palais.

Ifrael ex.

57. Jean Marot (French, probably 1619–1679), after Israel Silvestre, *The Tuileries*, 1666/1671, etching and engraving, 124 x 244 (5 x 9 5/8). National Gallery of Art, Gift of Robert H. Thayer 1981.69.24

and his reputation in topographical representation. During this sojourn, his style changed; he no longer worked with the freedom and expressiveness that he learned from Della Bella, he now exerted a greater control over his execution and worked in a more systematic, less spontaneous manner. When he returned home, his renown as a graphic artist was such that he began to receive important commissions from the royal court. In 1662 he became the official draftsman and printmaker to the king. His work was in such high demand that he employed a number of other artists to help produce prints; sometimes these artists made prints from Silvestre's drawings and sometimes they worked with him directly on his plates. Most of the prints of French gardens seen in this chapter are products of such collaborations between Silvestre and other artists.

The results of one of these joint efforts can be seen in a view of the Tuileries (cat. 57), part of a series of twelve made before the garden was redesigned by André Le Nôtre between 1666 and 1671.[19] The drawing was made by Silvestre and the etching by Jean Marot, a specialist in architectural views who helped record the splendid monuments

that were being constructed during the second half of the seventeenth century. As the title on this print proclaims, the garden was first built under the direction of Catherine de' Medici, between 1564 and 1572, and later restored by Henry IV, between 1594 and 1609. This view shows the parterres west of the palace. Known as Le Petit Jardin, it was part of Catherine's original plan. The simple, rectangular divisions in Silvestre's view remain unchanged from the first design, but the plantings and ornaments within have been considerably altered; Henri IV himself designed a section of the parterres, the execution of which was carried out by Jean Le Nôtre, father of André, landscape architect of Versailles.[20] Silvestre's depiction of the garden, upon which the print is based, presents an interesting and important view, but Marot's etching is somewhat rigid and lacks Silvestre's sense of movement and vitality.

A view of the "Petites Cascades," or "Grille d'Eau," at Vaux-le-Vicomte is a more successful work and was the result of the partnership of Silvestre and Adam Perelle (cat. 58).[21] Perelle and his father Gabriel were remarkably prolific printmakers, pub-

lishing approximately thirteen hundred works, mainly topographical views of landscape, in a "masterfully classical manner."[22] Perelle's execution is extremely rigorous in its precise hatching and consistently drawn lines. The figures in the foreground are shaded with carefully executed parallel lines; the same exactitude is seen in the rendering of shadows throughout the scene and even in the clouds overhead. Compared to the flourishing *bosco* in Falda's view of the Villa Aldobrandini (cat. 50), the more classically presented foliage in Perelle's depiction of Vaux seems rather formulaic and regularized.

Le Nôtre was surely one of the most brilliant and innovative garden designers of all time; his principles of design were, however, the product of a long development that took place over several generations. He was born in 1613 in his father's house in the Tuileries gardens; Claude Mollet, head gardener of the Tuileries, and Jacques Boyceau, who had

written a treatise establishing the basic premises of French landscape design for the seventeenth century, also had houses in the Tuileries and were closely allied with the Le Nôtre family. Le Nôtre's father, Jean, was chief gardener for King Louis XIII, and his grandfather, Pierre, had been gardener for Catherine de' Medici. André Le Nôtre was the worthy recipient of the collective experience and knowledge of the greatest gardeners of the century. Following the precepts of Boyceau concerning the ideal education of a landscape designer, which stipulated that the student should acquire a variety of skills and arts, Le Nôtre received training as a painter in the workshop of Simon Vouet. During this time, he apparently became familiar with contemporary theories on optics, studies that would prove useful in his subsequent career. By 1635, Le Nôtre was employed as a landscape architect by Louis XIV's brother and by 1657 he was named "controleur gen-

58. Adam Perelle (French, 1638–1695), after Israel Silvestre, *The Petites Cascades at Vaux le Vicomte*, c. 1650, etching, 120 x 203 (4 3/4 x 8). National Gallery of Art, Gift of Robert H. Thayer 1981.69.36

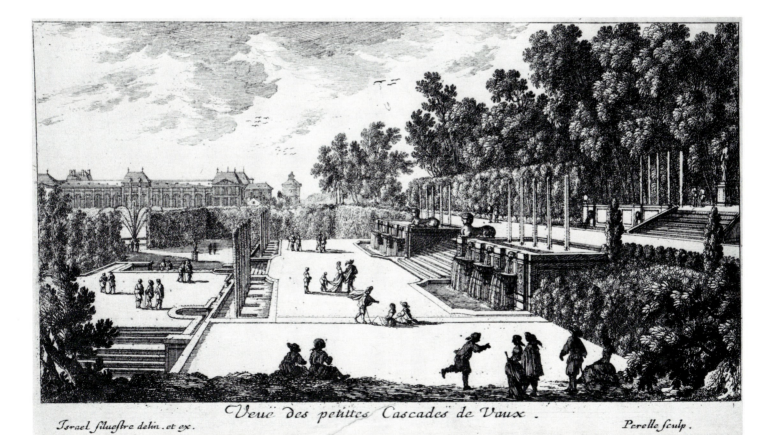

Israel Siluestre delin. et ex.

Veuë des petites Cascades de Vaux.

Perelle sculp.

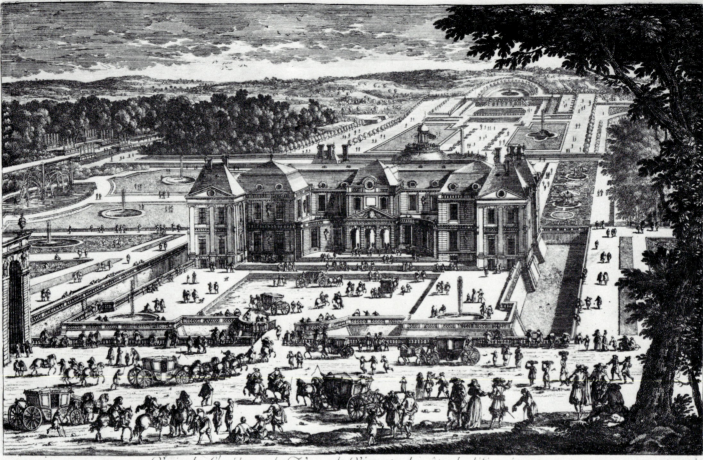

Veüe du Chasteau de Vaux le Vicomte du côte de l'Entrée
A Paris chez I. Mariette Rue St Iacques à la Victoire et aux Colonnes d'Hercules fait par Perelle.

Fig. 6. Adam Perelle (French, 1638–1695), *View of Vaux-le-Vicomte*, etching and engraving, 190 x 278 (7 1/2 x 11), in *Views of Paris* (Paris: I. Mariette, 17th century). National Gallery of Art, Mark J. Millard Architectural Collection 1985.61

eral des bâtiments, jardins, tapisseries, et manufactures de France."

Vaux was the first monumental garden designed by André Le Nôtre in the grand style that would become synonymous with the age of Louis XIV. In 1656, Nicolas Fouquet, finance minister for Louis XIV, hired Le Nôtre to design a garden for Vaux-le-Vicomte, the château he had inherited in 1640. The results of this enormous effort, which was left near completion in 1661, have been called the "ultimate achievement of French classical garden design."[23] An etching by Perelle shows a topographic view of the grounds at Vaux (fig. 6). In preparation for the gardens, the land of this enormous property was entirely restructured—an extraordinary accomplishment in an age in which soil could only be moved by shovel and wheelbarrow—creating level changes that allowed the designer to manipulate the view-

er's perception of the garden. Thus, from the outset, nature was completely reformed to submit to the will of man. The entry to the château was designed for the maximum dramatic effect, and the first, partial glimpse of the gardens, from inside the château, was arranged as "pure baroque theatre."[24]

The garden was designed along a compelling central axis that runs nearly 2400 feet from the back of the château to a colossal statue of Hercules. Along the perimeters, clipped hedges hold back an unruly forest. The entire composition appears to be comprehensible from the back of the château. This is, however, an optical trick that Le Nôtre carefully arranged by means of his level changes. The garden's most exciting features are in fact hidden from one's initial view and only reveal themselves as one progresses through it. The Grille d'Eau, for example, surprises visitors who discover it to

86

the left as they approach the first cross axis (cat. 58). Here, three levels of stairs bordered by water jets lead up the sloping left flank of the garden. The most dramatic surprise, however, is the gradual appearance of a huge canal that crosses the central axis two-thirds of the way from the house to the statue of Hercules, and of the thundering Grandes Cascades immediately before it. Finally, when the viewer has reached the end of the garden and turned back toward the château, the character of the garden seems to change completely; it now appears as a rectilinear design directly related to the structure of the château, and the vista changes continuously as one moves closer to the château.[25]

On 17 August 1661, Fouquet invited the king and most of the royal court to a grand fête staged in his nearly completed gardens. The king was given a complete tour of the gardens and was duly impressed by their vastness and splendor—but also by their implied message of overwhelming political power. In the evening, after the tour was complete, the area of the Petites Cascades was converted to a theater for the performance first of a ballet and then of a play written especially for the occasion by Molière. The spectacle of the evening's entertainment, which included a dazzling display of fireworks, made a profound impression on the king. Three weeks later, he had Fouquet arrested and accused of misappropriating state funds. Fouquet spent the remainder of his life in prison. Louis confiscated much of the sculpture and the orange trees from Vaux and quickly arranged for Le Nôtre to begin work improving his own gardens, including those of Versailles.

In the late sixteenth century, the forests of the village of Versailles were a favorite hunting place of King Henry IV, the first Bourbon king of France. His son, Louis XIII, also enjoyed hunting at Versailles and by 1634, he built a hunting lodge there with a relatively small garden. After Louis XIII's death, Louis XIV began to make frequent hunting trips to Versailles. Early in his reign, he decided to expand the accommodations of his father's hunting lodge. At first the plan seems to have been a modest one, merely to make the lodge large enough to serve as a place to en-

tertain on a suitably royal scale, but soon he was directing most of his architects' and garden designers' attention to this site. By the end of his reign, he had enlarged the château to a vast complex—the center of the French government—completely redesigned and greatly expanded the gardens, and transformed Versailles into an international symbol of absolute monarchy. The plan of Versailles evolved over many years and with frequent revisions, modifications, and additions. Preparations for the work began in the autumn of 1661, just months after Fouquet's ill-fated celebration, and by 1663, construction was under way.

There was an eager audience in the seventeenth century for printed views of Versailles; these works document the gardens in their original state. Jean Mariette published a collection of views of Versailles, etched and engraved by Adam Perelle, entitled *Veues des plus beaux endroits de Versailles.* These views include a plan of the gardens that shows the essential east-west axis starting with the parterre beneath the garden façade of the château and stretching west to the end of the mile-long, cross-shaped canal (fig. 7). A *patte d'oie*—literally, goose's foot—of three diagonal avenues leads toward the center of the front of the château; another five-part *patte* radiates out from the base of the canal, with the canal serving as the central line. The grand central axis extending off to infinity and the *patte d'oie* became two of the hallmarks of French baroque garden design and were copied in late seventeenth- and early eighteenth-century gardens throughout Europe. The fountain closest to the château is that of Latona, mother of the sun god, Apollo. The view from the western side of the parterre, over the Latona fountain, extends dramatically down the grassy expanse of the Allée Royale, on to the Apollo fountain that stands near the point where the canal begins, and from there to the horizon. The wooded area to either side of the Latona fountain and the Allée Royale is divided into geometric spaces by paths that run either parallel or perpendicular to the main axis. These spaces contain *bosquets*, the enclosed, more private spaces into which visitors could withdraw

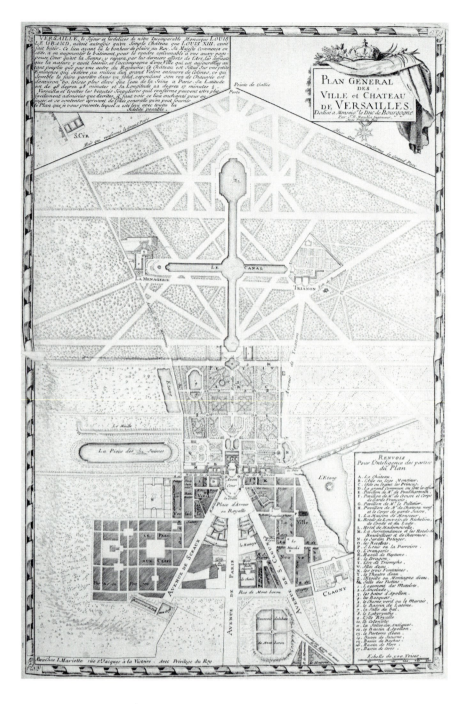

Fig. 7. Adam Perelle (French, 1638–1695), *Plan of Versailles*, etching and engraving, 500 x 321 (19 3/4 x 12 5/8), in *Veues de plus beaux endroits de Versailles* (Paris: I. Mariette, 17th century). National Gallery of Art, Mark J. Millard Architectural Collection 1985.61

from the intimidating monumentality of the garden's open area.

The grand, detailed plan demonstrates the nearly unfathomable expanse of land that the garden encompasses. It is not merely the gargantuan scale that is so astonishing, however, but Le Nôtre's singular success in forcing nature to conform to the laws of geometry and his unerring ability to achieve the most awe-inspiring and felicitous views through manipulation of space according to

the rules of optics.[26] Perelle's plan also illustrates an overall unity of design embracing the whole space and an exciting diversity of details throughout the garden. The garden's features were meant to be viewed in a certain sequence; Louis himself wrote instructions explaining which route visitors should follow to see Versailles to its best advantage.[27] Louis' reign marked the beginning of a new era of classicism and refinement in the arts of France, and his garden at Versailles epitomized this aesthetic in landscape design. The formality and austere grandeur of this garden, its classical proportions and symmetry, created a model toward which gardens throughout Europe and even America were to aspire for nearly a hundred years.

Although Louis was by no means an avid reader, he did enjoy collecting luxury volumes, especially those that reproduced works of art and architectural views. His new finance minister, Jean Baptiste Colbert, was a great bibliophile, devoted to acquiring fine books for the royal library. Between 1665 and 1667, Colbert devised a scheme to produce on the royal presses a series of sumptuous volumes, later called the *Cabinet du Roi*, that illustrated royal architecture and art collections as well as plants and animals. At first, the books were produced exclusively for Louis' own library and for presentation as royal gifts; eventually, Colbert arranged for them to be sold at a modest price through book dealers.[28] Their purpose was in part to magnify the grandeur of the kingly realm and to disseminate this image throughout France and Europe. Among the volumes in the series were several that commemorated the great festivals that Louis held at Versailles, apparently still eager to outstrip the memory of Fouquet's magnificent hospitality.[29]

One of the primary purposes of the garden at Versailles was to serve as the setting for the extravagant entertainments that Louis regularly staged for the court and important visitors. He held his first great fête in the gardens of Versailles in 1664. It was *Les plaisirs de l'Isle enchantée*, a five-day entertainment unofficially dedicated to Louis' mistress, Louise de la Vallière, and based upon scenes from Ariosto's *Orlando Furi-*

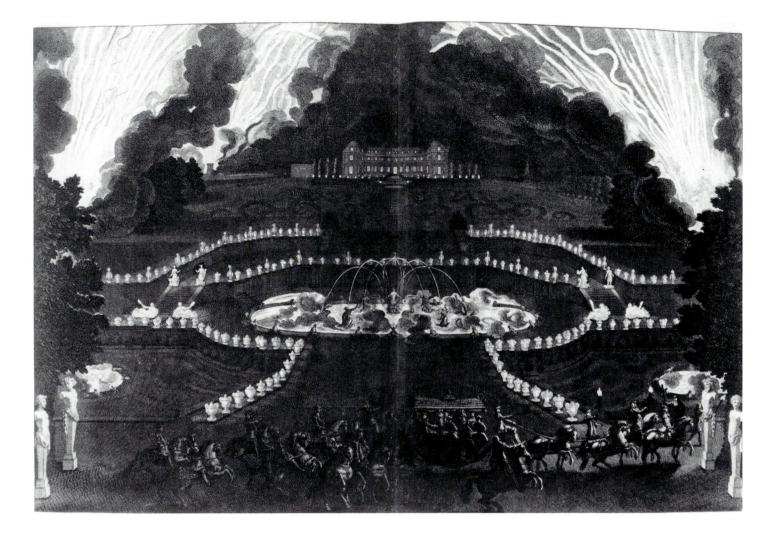

59. Jean Le Pautre (French, 1618–1682), *Fireworks at the Versailles Festival of 1668*, etching and engraving, 302 x 417 (11 7/8 x 16 3/8), in André Félibien, *Relation de la Feste de Versailles* (Paris: Cabinet du Roi, 1679). National Gallery of Art, Mark J. Millard Architectural Collection 1985.61

oso. In 1673, the royal press published a book describing the event with a text written by André Félibien, first secretary of the French Academy of Architecture, and with etchings by Israel Silvestre.[30] Another great theatrical entertainment was held in 1668, for which another volume was prepared as part of the *Cabinet du Roi: Relation de la Feste de Versailles*, published in 1679. Félibien again wrote the text and, this time, Jean Le Pautre made the illustrations. Le Pautre is best known for his etchings and engravings of ornament and is believed to have developed the style of ornament that is usually associated with the court of Louis XIV.[31]

The basic scheme of the garden's design was well established by the time Le Pautre executed his illustrations of the second Versailles fête.[32] One of his prints of the festival (cat. 59) shows a brilliant fireworks display, a striking and unusual example of a night

scene produced in etching and engraving.[33] The château appears in the center background with its parterre immediately before it. The parterre, which is viewed to best advantage from the windows of the château, relates perfectly to the design and proportions of the garden façade. This balancing of parterre to structure is one of the innovations of seventeenth-century landscape design. The focal point of the scene is the fountain of Latona, its waters and the multitude of vases surrounding it aglow against the rich darkness of the night.[34]

The Latona fountain was not really complete in 1668, as Le Pautre's etching showed it, but the basin was in place and the sculpture partially finished.[35] The fountain had an important allegorical meaning, relating an incident in Louis' childhood to an episode in the infancy of Apollo. This correlation of the king to the sun god Apollo is a recurring

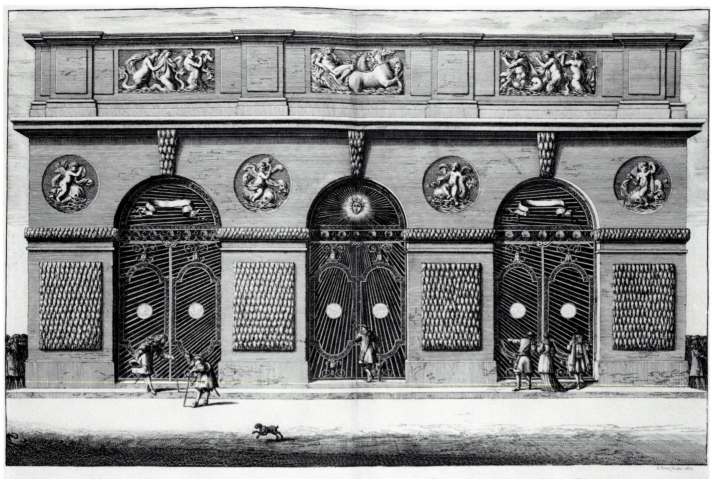

Veüe de la face exterieure de la Grotte de Versailles. Exterioris Versalianæ Cryptæ Prospectus.

60. Jean Le Pautre (French, 1618–1682), *Grotto of Versailles*, etching and engraving, 210 x 283 (8 1/4 x 11 1/8), in André Félibien, *Description de la Grotte de Versailles* (Paris: Cabinet du Roi, 1675–1685). National Gallery of Art, Mark J. Millard Architectural Collection 1985.61

theme throughout the garden.[36] The ancient myth tells of the distress of Latona and her children, Apollo and Diana, when the malicious peasants of Lycia muddied the waters that they had hoped to drink as they rested on a long, exhausting journey. Latona called the wrath of their father Zeus down upon the peasants and they were metamorphosed into frogs. The sculptural decoration of the fountain shows a circle of jeering peasants surrounding the three central figures while their fellows have been changed to frogs perched around the edge of the basin. The mythological event referred to the danger that the Fronde rebellion in Paris had posed to Louis' widowed mother, then regent of France, and her two children.[37]

The earliest monument to express clearly the association of Louis with Apollo, was the Grotto of Tethys, located to the north of

the château.[38] The grotto was of great interest to the visitors of Versailles, and in 1676 the court obligingly published a guidebook, *Description de la Grotte de Versailles*, also part of the *Cabinet*, with text by Félibien and illustrations by Le Pautre and others. Félibien explained that Versailles, where the king would rest after his arduous labors on behalf of France, represented the watery palace of Tethys beneath the sea where Apollo, the sun, would sink to rest after his day's toil illuminating the earth. The sculptural relief in the center of the upper level of the grotto's façade (cat. 60) showed the weary Apollo in his chariot; Tritons and Sirens in the two side panels greeted him. Below, the grille work on the doors represented the sun. Le Pautre has rendered the architecture with great precision, complemented by wonderful energy in the figures, human and sculptural.

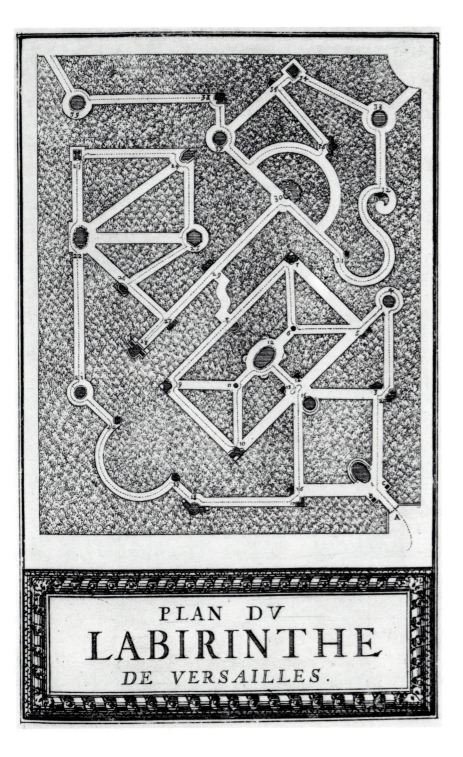

After 1668, Le Nôtre began to embellish
the garden with smaller and more intimate
areas surrounded by woods, where visitors
could retreat from the overwhelming, grand
scale and formality of the open spaces of
Versailles. It is because most of these en-
closed, more humanly proportioned *bos-
quets* have been destroyed that the garden

today seems so uncomfortable and austere.
One such place, the labyrinth, was com-
pleted between 1673 and 1674.[39] It consisted
of a series of paths running as a maze
through a dense forest. At intervals along
the paths were thirty-nine fountain-statues
illustrating Aesop's fables. The unifying
theme of the labyrinth and its sculpture was
love, the maze was a metaphor for love, in
which one could become lost, and each of
the fountain-statues conveyed a lesson to
lovers to help keep them on their correct
paths.[40] Charles Perrault prepared a guide-
book on the labyrinth, illustrated by Sebas-
tien Le Clerc, that was published as part of
the *Cabinet* in 1679, in which views of the
fountains and a map of the entire maze indi-
cated the locations of each (fig. 8).

During the early years of the development
of the gardens at Versailles, around 1662 or
1663, the king and Le Nôtre began to attend
to the gardens of another royal property, the
venerable Saint-Germain-en-Laye. Located
on a hill west of Paris overlooking the Seine,
Saint-Germain had been the favorite resi-
dence of Louis XIII.[41] An etched and en-
graved plate by Israel Silvestre from another
volume in the *Cabinet* series, *Les Veües des
Maisons Royales et des Villes conquises par
Louis XIV*, published between about 1675
and 1685, depicted a view of the Château-
Neuf from the river (cat. 61).[42] It is a mag-
nificent print in which the artist has created
a clear illusion of space by varying the
strength of his lines and the subtlety of his
presentation. In the foreground, deeply
etched, dark lines show great, open masses
of untamed foliage and the rough surface of
uncultivated land; horses gallop along the
river bank, their speed portrayed with rap-
idly executed strokes of the etching needle.
The treatment becomes progressively more
refined as the viewer's eye moves back in
space. Contrasting with the foreground's
vigorous activity, opposition of lights and
darks, and loose handling of line, motion
seems to subside and greater refinement to
prevail in proximity to the finely etched
château and its garden. In addition to creat-
ing a sense of space, this varied treatment
opposes wild, uncontrolled nature to the
work of art in which nature is mastered and

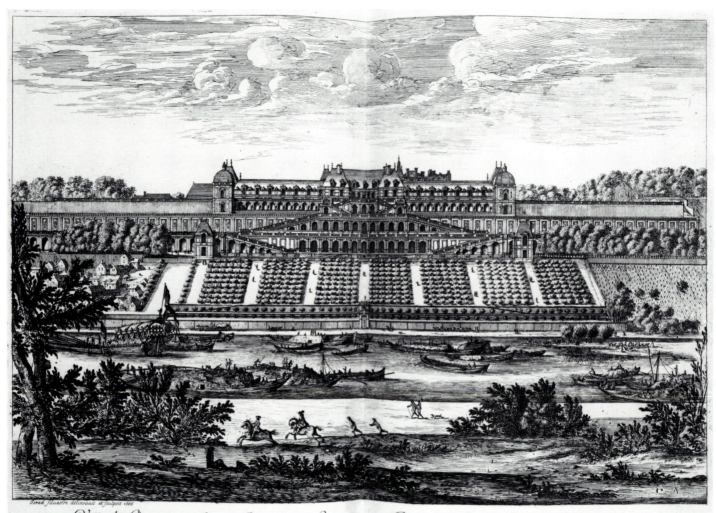

Veüe du Chasteau neuf de S.t Germain en Laye,
du costé de la Riuiere

Prospectus Regiæ nouæ S.ti Germani,
quà Sequanam spectat

61. Israel Silvestre (French, 1621–1691), *Saint-Germain-en-Laye*, etching and engraving, 520 x 750 (20 1/2 x 29 1/2), in *Les Veües de Maisons Royales et des Villes conquises par Louis XIV* (Paris: Cabinet du Roi, c. 1675–1685). National Gallery of Art, Mark J. Millard Architectural Collection 1985.61

perfected according to seventeenth-century aesthetics.

After Louis XIII's death, Saint-Germain suffered years of neglect, and by 1661 the upper level of the terracing that descended the hill to the river had collapsed. By the time Silvestre made this etching—probably between 1663 and 1664—Le Nôtre had already replaced the fallen terrace and created a new stairway, altering its form to present an appearance of greater unity within the architectural complex.[43] Increased monumentality and consistency of plan were, as always, among Le Nôtre's guiding principles. He also simplified the design of the Jardin en Pente, the sloping area with rectangular plantations of trees, from an earlier, more elaborate scheme. In its new form, it served

as a strong visual base for the architecture above. Saint-Germain-en-Laye has been called "the most Italianate of all French gardens," governed by the classical canons of balance, symmetry, and proportion that characterized the gardens of André Le Nôtre.[44]

Prints and Drawings of Netherlandish Gardens

The classical spirit that pervaded French art during the reign of Louis XIV also had great appeal for seventeenth-century Netherlanders. French prints, especially views of gardens, were in great demand in the Netherlands and helped convey the classical style to

92

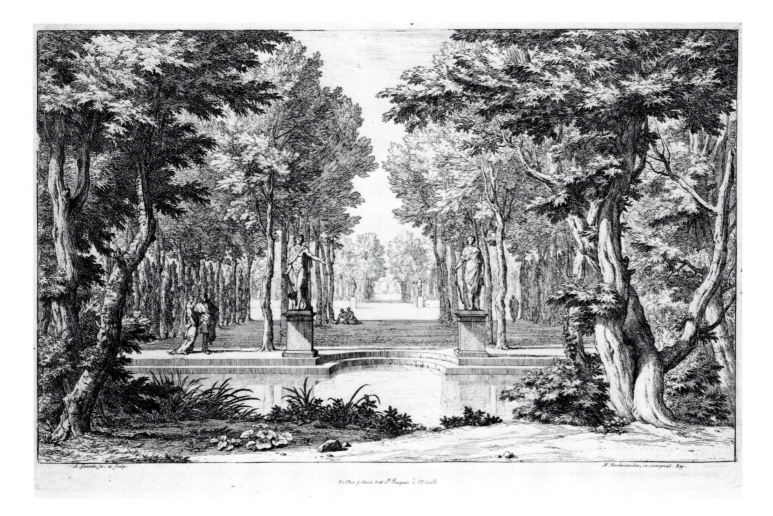

62. Abraham Genoels II (Flemish, 1640–1723), *The Two Statues*, 1665/1690, etching, 316 x 483 (12 3/8 x 19). National Gallery of Art, Andrew W. Mellon Fund 1978.25.5

a highly receptive audience there. Throughout this period, Dutch and Flemish artists made prolonged trips to study in both Italy and France. Abraham Genoels, a Flemish artist born in Antwerp in 1640, traveled to Paris in 1659 and stayed there until 1672; he became a member of the French Academy, the great bastion of French classicism, in 1665. After returning to Antwerp for two years, Genoels next journeyed to Italy, where he spent eight years. Throughout his career, he specialized in depictions of Arcadian landscapes and gardens filled with classical ruins and architecture, inhabited by figures dressed in ancient costumes.[45] His works had all the classical quotations and measured decorum prescribed by Nicolas Poussin, one of the chief exponents of the

classical style; his etching technique displayed the intricacy and precision of contemporary French prints. Adam Frans van der Meulen, another Flemish artist who lived in Paris from 1665 until his death in 1690, published a number of Genoel's etchings. Some of Genoel's drawings were etched by Adriaen Frans Boudewyns, yet another Fleming who resided in Paris during the 1660s, for publication by Van der Meulen.

In *The Two Statues* (cat. 62), Genoels presented a carefully coordinated, deep perspective view into a garden. The statues of Apollo and his sister Diana—which seem a possible reference to the iconographic program of Versailles—bid the viewer to look down the grand avenue flanked by straight rows of trees and another pair of statues.

93

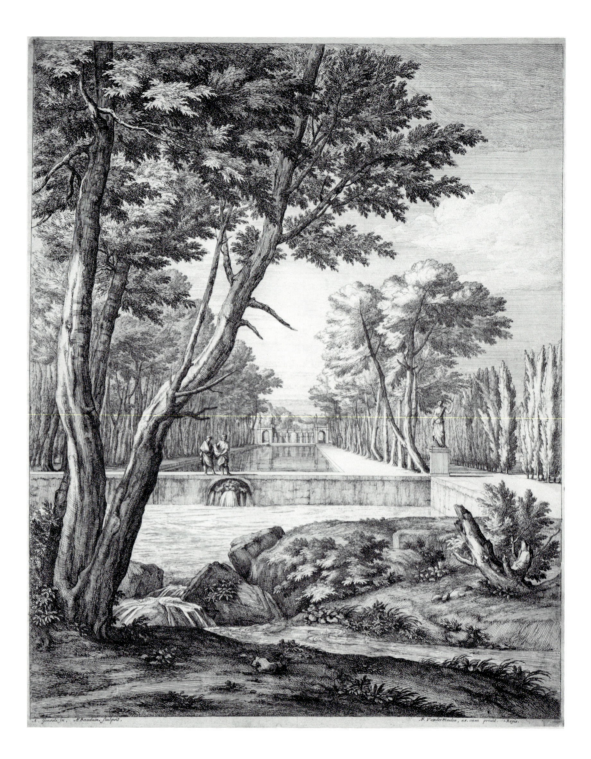

63. Adriaen Frans Boudewyns (Flemish, 1644–1711), after Abraham Genoels II, *Large Landscape—Two Men in a Garden*, 1665/1690, etching, 646 x 499 (28 3/8 x 19 5/8). National Gallery of Art, Andrew W. Mellon Fund 1976.20.1

The human figures in this garden wear Roman togas, indicating that it is not a portrait of a contemporary garden but an idealized recreation of a classical Roman garden. Boudewyns etched a similar depiction, entitled *Two Men in a Garden* (cat. 63), after a drawing by Genoels. Again, the view consists of a clearly-organized perspective into a seventeenth-century fantasy of an ancient Roman garden.

When Holland freed itself from Spanish dominion in 1609, a new style gained ascendancy in the graphic arts, a style of increased realism used primarily to describe newly popular scenes of the familiar Dutch countryside. By the end of the seventeenth century, however, there was an increased taste for artifice and, specifically, for representations of landscape in which nature was portrayed as a highly cultivated garden.[46]

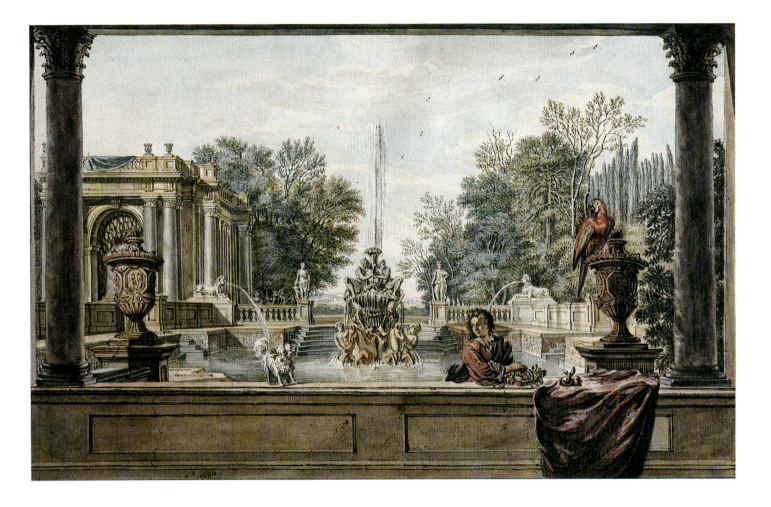

64. Isaac de Moucheron (Dutch, 1667–1744), *An Italianate Garden with a Parrot, a Dog, and a Man*, 1730s, pen and brown ink and watercolor over black chalk, 250 x 382 (9 7/8 x 15). National Gallery of Art, Gift of Anne Eustis Emmet in Memory of David E. Finley 1987.11.1

This change has been attributed to an infusion of French culture toward the end of the century and especially to the influence of André Le Nôtre's vast, horticultural programs in which the rational mind and decorative hand of man were so decisively imposed upon the earth.[47] David Freedberg cites Isaac de Moucheron as the chief exponent of this new genre in Holland, reflecting that de Moucheron's works were "not descriptions of nature, but prescriptions for it" and that the "century that had begun by describing the countryside ended by portraying the gardens of the rich."[48]

Isaac de Moucheron was born in 1667. His father, Frederick de Moucheron, was another artist who worked in an Italianate style and who preferred to represent park scenes and more cultivated views of nature.[49] Issac spent three years in Italy, from 1694–1697, and seems to have acquired a repertoire of motifs for future use. Typical

of his work is a charming and wonderfully fresh gouache drawing entitled *An Italianate Garden with a Parrot, a Dog, and a Man* (cat. 64). De Moucheron's garden is composed of a variety of classical motifs and rolling hills in the background that suggest that the scene is in Italy. This garden is similar to those in a series of drawings by de Moucheron now in the British Museum, some of which he later made into etchings.[50] Like others in the set, this scene is viewed through a foreground of architectural elements.

Around 1700, Petrus Schenk I, a leading publisher of the day as well as official printmaker to the court of the Elector of Saxony, published in Amsterdam an illustrated book of views along the Rhine entitled *Admirandorum Quadruplex Spectaculum*. The etched and engraved plates were the work of Jan van Call, a self-taught artist who executed many topographical drawings during

95

Tetius LOANI, regia villa PROSPECTUS latissimus. | *Vlak Gesicht van het geheele Loo.*

P. Schenck exc. Amstelod: cum Privil.

Fig. 9. Jan van Call I (Dutch, 1656–1703), after Isaac de Moucheron, *View of Het Loo*, etching and engraving, 130 x 167 (5 1/8 x 6 5/8), in *Admirandorum Quadruplex Spectaculum* (Amsterdam: Petrus Schenk I, c. 1700). National Gallery of Art, Mark J. Millard Architectural Collection 1983.49.103

an extended journey through Holland, Germany, Switzerland, and Italy. While in The Hague in the late 1680s, Call made prints from his own and other artists' drawings, to use in Schenk's publication. Such topographical volumes were extremely popular during the late seventeenth and early eighteenth centuries and Schenk, along with Nicolas Visscher II and Cornelis Dankerts III, met the demand by bringing forth a great number of books of engraved views.[51] One of the purposes of these texts was to publicize the splendor of the gardens of the court of William of Orange, as the prints of Silvestre, Perelle, and Le Pautre, and the *Cabinet du Roi* served to glorify the gardens of Louis XIV. In *Admirandorum Quadruplex Spectaculum*, a series of prints portrays the royal palace and gardens of Het Loo (fig. 9), mainly designed by Jacob Roman, architect for William, Prince of Orange, between 1686 and 1699.[52] In 1699, Walter Harris, William's

physician, wrote a lengthy and minute description of the gardens which, he explained, "are become so famous and remarkable to all the Provinces near them, that Curious Persons from divers Parts of Germany, as well as out of all the United Provinces, do frequently resort thither to satisfy their Curiosity."[53] Like other great gardens constructed in Holland during the late seventeenth century, Het Loo has suffered greatly from the ravages of time. In the past decade, however, restoration has returned Het Loo to its original splendor, and it now stands as a monument to the great era of Dutch gardens.

When Jacob Roman first designed Het Loo as a hunting lodge for Prince William in 1686, its garden was fairly modest. There were parterres near the palace with a raised walkway in back, to the north, separating the parterres from the vegetable garden. A pair of canals and rows of oak trees flanked

LABYRINTHUS. *Het* Doolhof.

P. Schenck Exc: Amstelod: C.P.

65. Jan van Call I (Dutch, 1656–
1703), *Labyrinth*, etching and en-
graving, 130 x 167 (5 ¹/8 x 6 5/8),
in *Admirandorum Quadruplex
Spectaculum* (Amsterdam: Petrus
Schenk I, c. 1700). National Gal-
lery of Art, Mark J. Millard Ar-
chitectural Collection
1983.49.103

the walkway, which led to Oud Loo, the old castle on the western side of the palace grounds. When the prince was crowned King William III of England in 1688, Roman greatly increased the scale of both the architecture and garden at Het Loo, presumably to emulate the grandeur of Versailles. He gave the garden a typically baroque central axis extending from the palace across the lower garden, through the cross-axis of the old walkway, and through a new, ornamental upper garden where the vegetable garden had been. The old, raised walkway—which the king wished to preserve—interrupted the perspective from the castle; Roman attempted to compensate for this obstacle by

diminishing the width of the upper garden in a "basket arch" shape and by terminating it dramatically in a curved colonnade.[54] To the west, the garden continues with an aviary, a canal with water jets, a large pond, and many other intriguing features. Among the enclosed garden "rooms" in this area are mazes, one of which is illustrated in Schenk's publication (cat. 65).

Florence Hopper called Het Loo a "hybrid of the Renaissance and the baroque, Dutch in layout and French in ornamentation . . . the ultimate expression of William and Mary's gardening tastes in the Netherlands."[55] What she identified as the Renaissance element is the characteristically Dutch

adherence to Vitruvian and Albertian principles of symmetry and proportion in designing gardens.[56] She believed that the French baroque aspects of Het Loo were confined to the design of the parterres and garden ornament, the work of Daniel Marot, a French Huguenot employed by William.[57] There is, in fact, none of the overall unification and interpenetration of parts that typify contemporary French gardens. The space is neatly subdivided into separate areas by a rectangular grid.

English Gardens in Illustrated Books

In England, a combination of foreign influences dominated the arts, including garden design, following the restoration of Charles II in 1660 and through the early part of the eighteenth century.[58] John Dixon Hunt has analyzed the continuing fascination of English travelers with the gardens of Italy and the impact of Italian garden aesthetics on English landscape architecture during the seventeenth and eighteenth centuries.[59] Other garden historians have described the importance of French and Dutch styles on the English landscape of this period. Charles II was, after all, the first cousin of Louis XIV, and he spent part of the interregnum in France as well as in Holland. Leading French gardeners, such as André Mollet, came to work in England and English gardeners, notably John Rose, went to France to study landscape design. Charles II even tried to arrange for André Le Nôtre to travel to England and design a garden for him; however, Le Nôtre was preoccupied with his work at Fountainebleau and was unable to oblige the king. Dutch garden style, which had played a role in English design through most of the seventeenth century, increased in importance after the accession of Prince William of Orange and Queen Mary to the English throne in 1688. Dutch landscape architecture may, indeed, have had an even greater following than French in England.[60]

Perhaps it was this lively interaction of stylistic trends during the late seventeenth and early eighteenth centuries that began to stimulate interest in the publication of fine, illustrated volumes recording the history of English architecture and gardens. Although such broad surveys were produced as early as the sixteenth century in France and Italy, it was not until the opening years of the eighteenth century that they appeared in England.[61] The first compendium to present a pictorial survey of existing English architecture and gardens was *Britannia Illustrata*, a splendid volume with illustrations by two Dutch artists, Leonard Knyff and Johannes Kip. Knyff was born in Haarlem in 1650 and moved to England by 1681.[62] In around 1694 he began to make topographical studies of English country properties, although apparently not for the purpose of a bound publication. By 1702, Kip had etched sixty-nine of Knyff's completed drawings, and Knyff began selling subscriptions to a comprehensive series of a projected 100 etchings. Finally, in 1707, the publisher David Mortimer used these etchings for the first volume of *Britannia Illustrata*. Although Kip is sometimes credited merely with having made etchings after Knyff's drawings, he was also an accomplished artist who independently produced topographical representations of English country houses.

England was so enthusiastic in its reception of the first volume of *Britannia Illustrata* that Mortimer published a second volume in 1715 for which Kip produced both the drawings and the prints. Another clear measure of Kip and Knyff's success is that later publications reissued or copied their views. In 1716, Mortimer published *Nouveau Théâtre de la Grande Bretagne*, which reprinted the plates of *Britannia Illustrata* along with several other series of architectural prints.[63] At some time early in the eighteenth century, a similar compendium, entitled *Les Delices de la Grand Bretagne et de L'Irlande*, was published in Leyden; it includes reduced copies of both *Britannia Illustrata* and Loggan's *Oxford Illustrata* as well as other views of cities and architecture. The title page of the book credited Jan Goeree, a Dutch artist born in 1670, with preparing drawings for the illustrations.

A bird's eye view of the palace and gardens of Hampton Court, Middlesex, is one

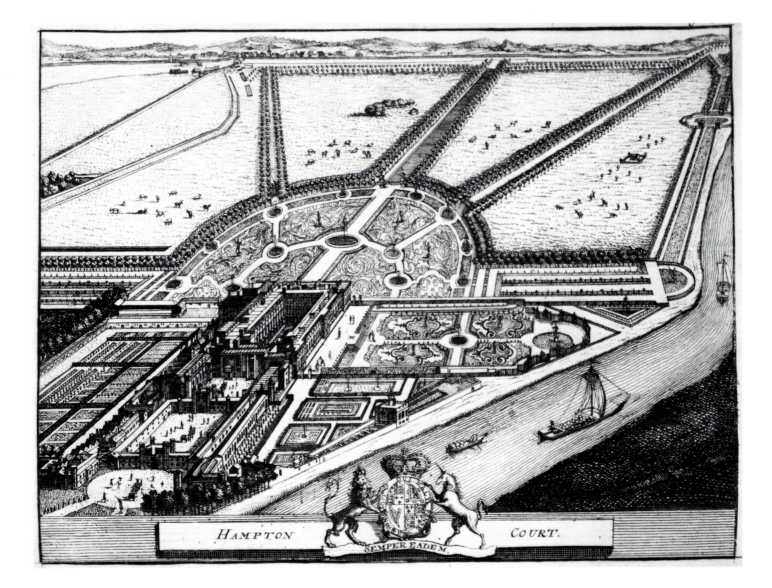

66. Jan Goeree (Dutch, 1670–1731), after Leonard Knyff, *Hampton Court*, etching, 130 x 156 (5 1/8 x 6 1/8), *Les Delices de la Grand Bretagne et de L'Irlande* (Leyden: Beeverell, c. 1707). National Gallery of Art, Mark J. Millard Architectural Collection, David K. E. Bruce Fund 1985.61

of the great views included in *Britannia Illustrata* and its various copies; Goeree's version is printed here (cat. 66). The existing grounds of Hampton Court were redesigned under Charles II, 1660–1685, in a decidedly French manner.[64] Three avenues radiated in a French baroque *patte d'oie* from a semi-circular courtyard; the central "avenue" was actually a grand canal. Double rows of lime trees lined all three radiating paths as well as the court. During the reign of William and Mary, 1688–1702, further revisions were made. William supervised the creation of a magnificent display known as the great fountain garden in the semi-circular court. Thirteen fountains decorate this space. The privy garden to the south of the palace, along the Thames, was dear to the heart of

Queen Mary and received her special consideration. Daniel Marot seems to have played a greater role in the design of Hampton Court than he had at Het Loo, designing the great fountain garden and perhaps the privy garden as well; there was a greater intricacy and a more sturdy character in his parterre designs here than in those of contemporary French gardens.[65] The great quantity of clipped shrubs in the Hampton Court garden and a certain rigidity of plan may have reflected a Dutch taste imported to England by the new monarchs.[66]

In 1715, the first volume of another important collection of views of contemporary architecture appeared: Colen Campbell's *Vitruvius Britannicus, or the British Architect*. Campbell made preliminary drawings for

99

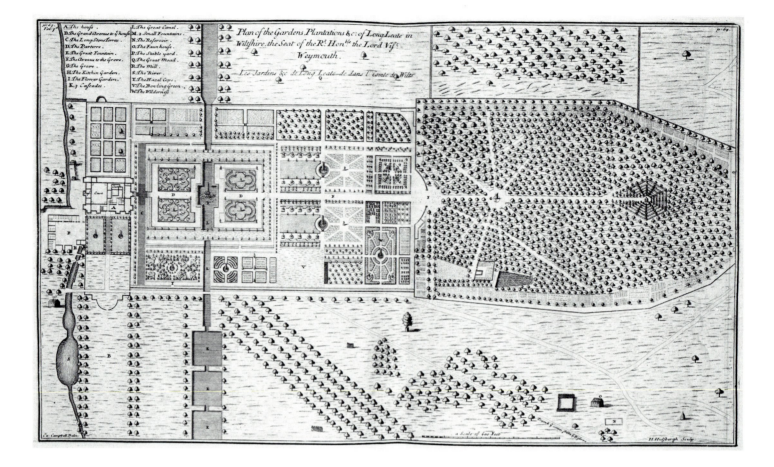

67. Henry Hulsbergh (Dutch, d. 1729), after Colen Campbell, *Plan of Longleat,* etching and engraving, 298 x 497 (11 3/4 x 19 5/8), in Colen Campbell, *Vitruvius Britannicus, or the British Architect* (London, c. 1735), vol. III, plate 63. National Gallery of Art, Mark J. Millard Architectural Collection, David K. E. Bruce Fund 1985.61

the illustrations, and Henry Hulsburgh prepared the etched and engraved plates.[67] As the title of his work suggests, Campbell conceived the project as a means of promoting his view that British architects should follow classical, Vitruvian principles, principles that had been revived in the Renaissance by Andrea Palladio and more recently by Inigo Jones, the architect referred to in the title as "the British Vitruvius."[68] At first, Campbell intended to produce just two volumes, but either there were more important buildings to represent than he had initially recognized, or his success was more resounding than he had hoped; in 1725, he brought forth a third volume. Altogether, his work illustrates 103 structures in plan, elevation, section, and perspective; it provides indispensable information on English architecture and landscape architecture of the late seventeenth and early eighteenth centuries.

The third volume is especially interesting to historians of landscape architecture because in it, Campbell began to include perspective views and plans of gardens as well as of architecture. One of the gardens that Campbell included in his third volume was that of Viscount Weymouth's Longleat House in Wiltshire (cat. 67).[69] Longleat is sometimes cited as having one of the foremost examples of a French-inspired garden in seventeenth-century England.[70] The garden was the creation, around 1690, of George London, a nurseryman and designer who was "one of the last of the great formalists" in English garden design.[71] London visited France and acquired a clear understanding of French baroque garden design, perhaps partly from his fellow Englishman, John Rose, a pupil of André Le Nôtre. In the plan of Longleat one sees, for example, a unifying system of perpendicular and diagonal avenues and the promise of diverse visual experiences as one moves through the garden. A *patte d'oie* radiated through a wood, and the grand canal and cascades were also typical of French baroque gardens. And yet, there was also a sense of obsessive orderli-

ness and even rigidity in the way the garden was divided and subdivided that was suggestive of a Dutch influence. Longleat should perhaps be understood as an archetypal product of a period in English landscape architecture when different foreign styles dominated the field, sometimes interacting to create unique, hybrid designs.

George London was invited to submit plans for another garden that was illustrated in volume three of *Vitruvius Britannicus*: the third Earl of Carlisle's Castle Howard. His plans included canals, radiating avenues, and circular lawns; they also called for the imposition of a star shape upon the Earl's cherished Wray wood, a venerable forest on a hill to the east of the Castle. Perhaps it was the proposed virtual destruction of his wild

forest that most displeased the Earl; in any case, he rejected London's plans and proceeded to develop his own design, a design that was to mark the direction in which landscape architecture would evolve in the second half of the eighteenth century.[72] The bird's eye view of Castle Howard in *Vitruvius Britannicus*, presumably based on an architect's drawing of about 1717, is taken from the north (cat. 68). Behind the castle one sees the thirty-one acre parterre with its immense "wilderness" of evergreen shrubbery. This "wood within the walls" has an asymmetric system of straight-walled corridors. Two obelisks mark the centers of the two sides, and a classical temple stands at the middle of the south end. Wray wood, where the Earl worked out the most signifi-

68. Henry Hulsbergh (Dutch, d. 1729), after Colen Campbell, *Castle Howard*, etching and engraving, 380 x 525 (15 x 20 5/8), in Colen Campbell, *Vitruvius Britannicus, or the British Architect* (London, 1725), vol. III, plate 5. National Gallery of Art, Mark J. Millard Architectural Collection, David K. E. Bruce Fund 1985.61

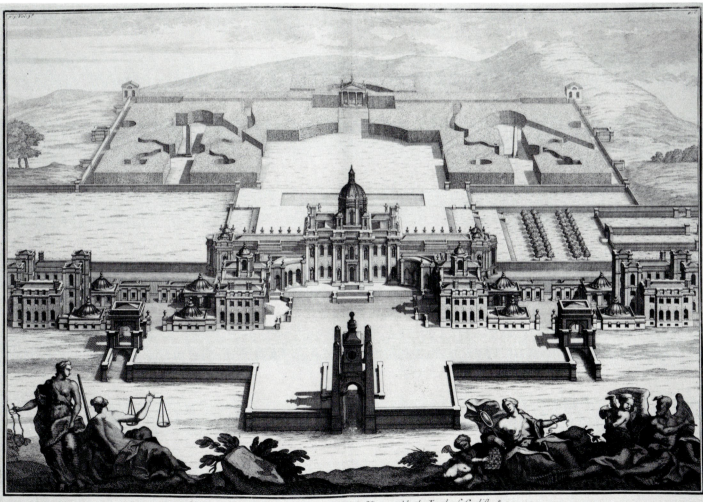

Castle Howard in Yorkshire the Seat of the Right Honourable the Earl of Carlisle &c :

cant and unique design—probably with the assistance of Stephen Switzer—lies to the east and is unfortunately not included in this view; perhaps that aspect of the garden most interesting to twentieth-century viewers was not immediately recognized for its innovative qualities.[73]

Castle Howard had one of the first "landscape gardens" to be created in England. A poem describing the garden, possibly written by Lady Irwin, the Earl of Carlisle's daughter, is filled with associations between the garden and ancient literary settings and deities. Of Wray Wood, the author wrote

> *Not greater Beauty boasts th'Idalian*
> *Grove,*
> *Tho' that sacred to the Queen of Love.*
> *Such stately Trees encircle ev'ry view,*
> *As never Dodanas Forest grew.*[74]

The Earl of Carlisle intended to evoke Elysium in his garden at Castle Howard, to "recreate the imagined scenery and atmosphere of 'the Golden Age.' "[75] This aesthetic goal became the primary motivating factor in the development of the landscape gardening style in Britain in the early eighteenth century.

Notes

1. On seventeenth-century books, see Philip Hofer, *Baroque Book Illustration* (Cambridge, MA, 1970); Marcus S. Sopher, with Claudia Lazzaro-Bruno, *Seventeenth-Century Italian Prints* [exh. cat., Stanford Art Gallery, Stanford University] (Stanford, 1978), 10.

2. Sopher 1978, 14, 34–35.

3. Sopher 1978, no. 41.

4. Della Porta died in 1602, and the work was completed by Carlo Maderna and Domenico Fontana. The gardens of the Villa Aldobrandini are discussed by Gothein 1979, vol. 1, 313–319; Carl L. Franck, *The Villas of Frascati* (New York, 1966), 115–132; MacDougall and Miller 1977, no. 13; Thacker 1977, 104–108; Patrick Goode, "Villa Aldobrandini," in *The Oxford Companion to Gardens* (Oxford, 1986), 6–7.

5. On the meaning of the sculpture of the water theater, see Ronald Martin Steinberg, "The Iconography of the Teatro Dell'Acqua at the Villa Aldobrandini," *Art Bulletin* 47 (1965), 453–463.

6. The water stairway and the second and third cascades are illustrated in Gothein 1979, vol. 1, figs. 246–247.

7. Hunt 1986, 45–48.

8. Woods abound at the Villa Pratolino (cat. 45), but here man-made garden features are fitted into a wilderness scheme rather than standing as an opposing, controlling force.

9. Thacker 1979, 104–108.

10. On the garden of the Villa Pamphili, see Gothein 1979, vol. 1, 337–339; Masson 1961, 155–157.

11. Other than some minor peculiarities that appear in Küsell's etching of the garden of the Villa Borghese, the architecture of the villa is incorrect: Küsell shows a nonexistent wing protruding at a right angle from the right side of the villa.

12. On the Villa Borghese, see Gothein 1979, vol. 1, 328–334; Masson 1961, 153–155.

13. Masson 1961, 153.

14. The garden is called the Villa Torlonia today; see Franck 1966, 81–95.

15. Compare Küsell's view to those reproduced in Franck 1966, figs. 81, 88.

16. MacDougall and Miller, no. 17.

17. According to Naomi Miller, these explanations are based on purely empirical evidence and are not accurate according to twentieth-century knowledge of hydraulics (MacDougall and Miller 1977, no. 17).

18. On Israel Silvestre, see L. E. Faucheux, *Catalogue raisonné de toutes les estampes qui forment l'oeuvre d'Israel Silvestre* (Paris, 1857). On the print-publishing business in Paris in the seventeenth century, see Jacques Kuhnmunch, "Le commerce de la gravure à Paris et à Rome au XVIIe siècle," *Nouvelles de l'estampe* 55 (1981), 6–17.

19. Faucheux 1857, 49:7.

20. Woodbridge 1986, 115.

21. Part of a series of fourteen views of Vaux (Faucheux 1857, 311), most of which were drawn by Silvestre and etched by Jean Le Pautre.

22. Marcel Rothlisberger, "The Perelles," *Master Drawings* 5 (1967), 283–286.

23. Woodbridge 1986, 184.

24. Franklin Hamilton Hazelhurst, *Gardens of Illusion: The Genius of André Le Nôtre* (Nashville, 1980), 24–29.

25. On this process, see Hazelhurst 1980, 38–41.

26. See Hazelhurst 1980, 88, 100, and 142–147 on the role of optics in the design of the garden.

27. Christopher Thacker has translated and edited these instructions and published them in *Garden History* 1 (1972), 49–69 and *Garden History* 6 (1978), 31–38.

28. These volumes are the subject of a study by Anne Sauvy, "Le Cabinet du Roi, l'illustration d'un regne et les projets encyclopédique de Colbert," *L'Art du Livre a l'Imprimerie nationale*, ed. Georges Bonnin (Paris, 1973), 104–127.

29. On the garden as a setting for theater, see Adams 1979, 63–73.

30. On the fête books of Louis XIV, see Edmond Pognon, "Les Livres de Fêtes," *L'Art du Livre a l'Imprimerie nationale* (Paris, 1973), 143–161.

31. Alvin L. Clark, Jr., *From Mannerism to Classicism* [exh. cat., Yale University Art Gallery] (New Haven, 1987–1988), 63; Mary Jackson and Cynthia Clow, *Inhabitants of the Enchanted Isle* [exh. cat., University Gallery, University of Minnesota] (Minneapolis, 1975), 36–37.

32. Hazelhurst 1980, 77.

33. On the subject of nocturnal scenes in the graphic arts, see Ruth Benedict, *Night Prints from the Fifteenth to the Twentieth Century* [exh. brochure, National Gallery of Art] (Washington, D.C., 1983).

34. Hazelhurst 1980, 73, n. 21, mentioned the appearance on the left of the Tour de Pompe, designed by Louis le Vau, from which the fireworks were exploded.

35. It was complete by 1671; see Robert W. Berger, *In the Garden of the Sun King* (Washington, D.C., 1985), 26 and n. 57.

36. Berger 1985, 20–28.

37. On the Fronde, see Woodbridge 1986, 181; Berger 1985, 27.

38. On the grotto, see Miller 1982, 72–76; Berger 1985, 20–22. The grotto was finished in 1664 but was destroyed in 1684 when the north wing of the château was expanded.

39. The labyrinth was begun in 1666, but its form changed substantially before it was finished, probably to accomodate the sculpture that was later made for it. See Hazelhurst 1980, 98 and Berger 1985, 28–40 for a thorough discussion of the labyrinth and the various guidebooks written about it.

40. Berger 1985, 31–40.

41. On Saint-Germain-en-Laye, see Hazelhurst 1980, 203–231.

42. Hazelhurst 1980, 207, 230, n.5

43. Hazelhurst 1980, 207.

44. Hazelhurst 1980, 203.

45. These are reproduced in Walter L. Strauss, ed., *The Illustrated Bartsch*, vol. 5 (New York, 1979), 296–362.

46. The gardens of this period are the subject of the exhibition, *The Anglo-Dutch Garden in the Age of William and Mary*, Rijksmuseum Paleis Het Loo, Apeldoorn, and Christie's, London, 1988–1989. The exhibition catalogue by John Dixon Hunt and Erik de Jong was also published in *Journal of Garden History* 8 (1988).

47. David Freedberg, *Dutch Landscape Prints of the Seventeenth Century* (London, 1980), 67. Walter Stechow characterized this late seventeenth-century style as "a cool classicism clearly nurtured by the study of Pous-

sin, Dughet and the late Claude" in *Dutch Landscape Painting of the Seventeenth Century* (New York, 1968), 148.

48. Freedberg 1980, 67.

49. Stechow 1968, 156. For an example of Frederick's work, see Hellerstedt 1986, no. 29.

50. See Peter Jessen, *Meister des Ornamentstichs* (Berlin, 1922–1924), vol. 2, 96–99; Arthur M. Hind, *Catalogue of Drawings by Dutch and Flemish Artists Preserved in the Department of Prints and Drawings in the British Museum* (London, 1931), 167, nos. 11–13; F. W. H. Hollstein, *Dutch and Flemish Etchings, Engravings and Woodcuts, ca. 1450–1700*, vol. 14 (Amsterdam, 1956), 94–95.

51. Hunt and de Jong 1988, 201.

52. On Het Loo, see Hunt and de Jong 1988, nos. 26–35. This view (fig. 9) was clearly based on a drawing by Isaac de Moucheron; see Hunt and de Jong, 26.

53. Walter Harris, *A Description of the King's Royal Palace and Gardens at Loo* (London, 1699), 4–5. See Hunt and de Jong 1988, no. 30.

54. W. Kuyper, *Dutch Classicist Architecture* (Delft, 1980), 147 and fig. 22.

55. Florence Hopper, "Het Loo," *Oxford Companion to Gardens* (Oxford, 1986), 254–255; see also Hopper, "The Dutch Regency Garden," *Garden History* 9 (1981), 119–121.

56. For a full discussion, see Florence Hopper, "The Dutch Classical Garden and André Mollet," *Journal of Garden History* 2 (1982), 25–40.

57. The contribution of Daniel Marot to Dutch garden design was the subject of her presentation (as Florence Hopper Boom) at the 1988 Dumbarton Oaks, Washington, D.C., symposium, *Dutch Gardens, 1650–1700.* This evaluation of the French influence at Het Loo differs from the traditional characterization of this garden as "the most French on Dutch soil" (Kuyper 1980, 147).

58. The literature on English gardens and their representation in works of art during this period includes B. Sprague Allen, *Tides in English Taste* (New York, 1958); Christopher Hussey, *English Gardens and Landscapes, 1700–1750* (New York, 1967); Gerda Gollwitzer, "Influence of Le Nôtre," in *The French Formal Garden*, Elisabeth B. MacDougall and F. Hamilton Hazelhurst, eds. (Washington, D.C., 1974), 71–87; David Jacques, "The

Formal Garden" under the entry for "England" in *The Oxford Companion to Gardens* (Oxford, 1986), 165–166.

59. Hunt 1986.

60. This is the opinion of John Dixon Hunt who, in his lecture "Who Does not Know What a Dutch Garden is" for the 1988 Dumbarton Oaks symposium (see n. 57), concluded that many of the features of seventeenth-century English gardens that currently might be identified as French were at the time considered Dutch.

61. Allen 1958, 124–125.

62. For further information on Knyff, see Hugh Honour, "Leonard Knyff," *Burlington Magazine* 96 (1954), 337–338.

63. The contents of *Nouveau Théâtre* vary from one copy to the next; see Harris 1985, 93.

64. On Hampton Court gardens, see Hunt and de Jong 1988, 213–216.

65. According to Florence Hopper Boom in her presentation "Daniel Marot: A French Garden Designer in Holland" for the 1988 Dumbarton Oaks symposium (see n. 57).

66. Gollwitzer, in MacDougall and Hazelhurst 1974, 80.

67. Hulsbergh was born in Amsterdam and came to England in the early eighteenth century.

68. Summerson 1954, 189–191; see also John Harris' foreword to Paul Breman and Denise Addis, *Guide to Vitruvius Britannicus: Annotated and Analytical Index to the Plates* (New York, 1972), v–ix.

69. This copy of *Vitruvius Britannicus* is a reissue dated about 1735; it has both French and English inscriptions. On Longleat, see Hunt and de Jong 1988, 249–250.

70. See, for example, David Leatherbarrow, "Character, Geometry and Perspective: the Third Earl of Shaftesbury's Principles of Garden Design," *Journal of Garden History* 4 (1984), 332.

71. David Green, "George London," *The Oxford Companion to Gardens* (Oxford, 1986), 342–343.

72. Hussey 1967, 115–125.

73. Hussey 1967, 124–125; Edward Hyams, *The English Garden* (London, 1964), 26–28.

74. John Dixon Hunt and Peter Willis, eds., *The Genius of the Place: The English Landscape Garden 1620–1820* (London, 1975), 228–232.

75. Hussey 1967, 115.

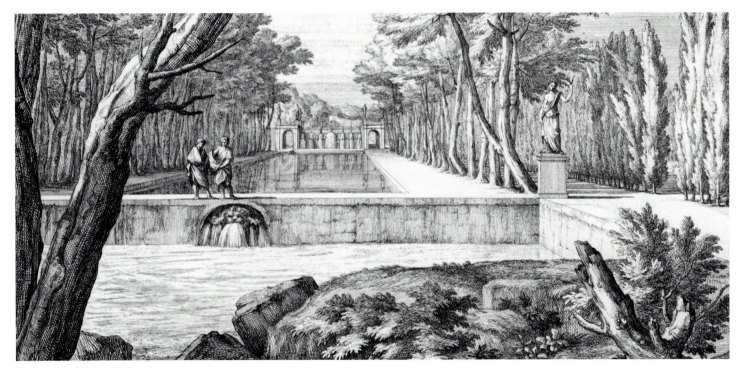

Cat. no. 63, detail

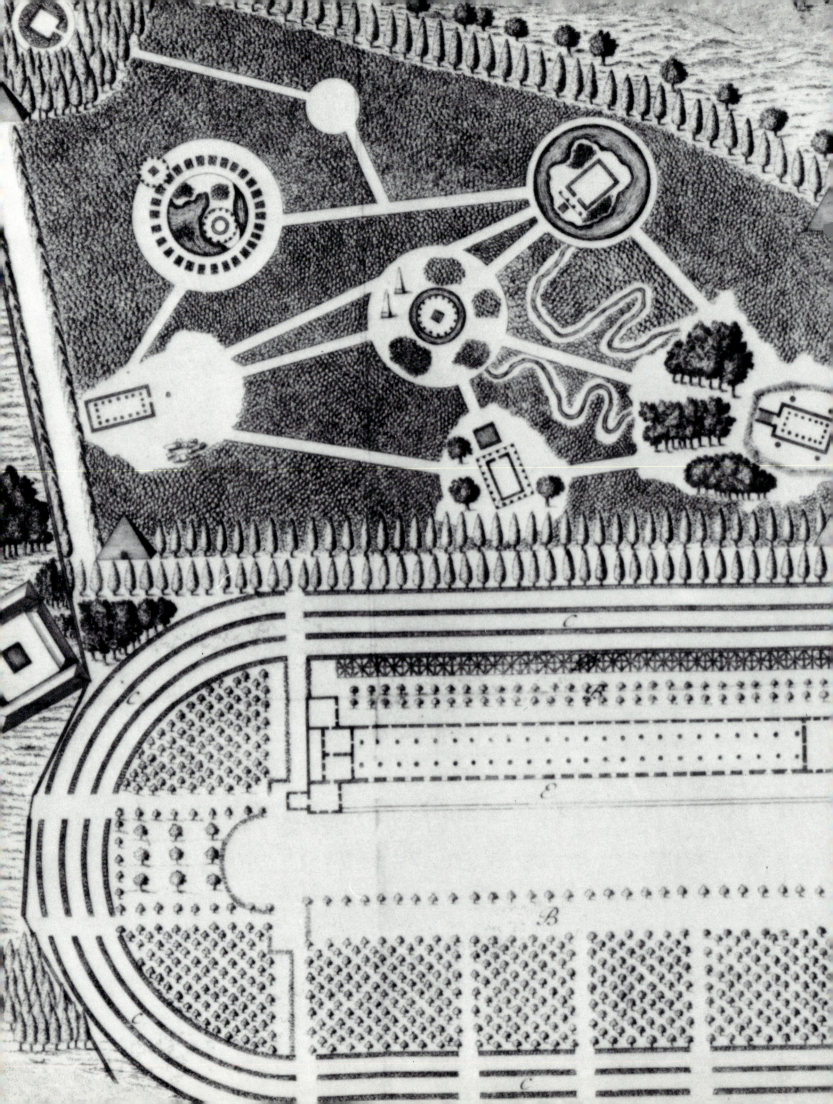

GARDEN IMAGES IN THE EIGHTEENTH CENTURY

A new concept of Nature as an essential force of universal goodness fired the imagination of artists in England and France during the eighteenth century, fundamentally affecting garden design and the representation of gardens in art. Both countries produced magnificent prints and drawings in which the workings of nature were clearly displayed in combination with human design. Different cultural and economic situations in the two countries led to variations in the way gardens were portrayed and the contexts in which these portrayals appeared. As French garden design was ascendant throughout Europe in the late seventeenth century, English garden design assumed international preeminence in the eighteenth century, with a more natural, and ultimately "picturesque," style that has been related to England's greatest contribution to the arts.[1] Publishers in England produced books whose plates represented prominent examples of gardens designed in the new style. An examination of these printed images and the writings that accompany them further indicates that there were political and cultural associations drawn between England and ancient Rome as it flourished during the republican period. Along with, and allied to, the new concept of Nature, this fascination with the ancient world contrib-

uted greatly to the character of both garden design and depictions of gardens in graphic art.

In France, the cultural climate was entirely different. Far from imagining themselves at the threshold of an era of prosperity and power comparable to that of ancient Rome, the French suffered an economic decline that made it impossible for them to maintain the splendor of the preceding century. There were illustrated books portraying contemporary gardens in the natural style, known as the *jardin anglais*, but the greatest works of art represented nostalgic images of the gardens of yesterday declining in a wonderful luxuriance of foliage—the succoring forces of nature enfolding and softening the fading glory of past years. These works showed not only the gardens of the Ancien Régime in France, but the old and often neglected gardens of Italy. French artists flocked to Rome to study its magnificent, crumbling ruins, and while they were there, they were irresistibly drawn to Italian gardens. The most splendid garden scenes of eighteenth-century France, like those of England, involved a heightened attention to both the benevolent charms of nature and the great antiquities of Rome.

Italy, both ancient and modern, was more than ever an inspirational force in the creative impulse of northern Europe. The work

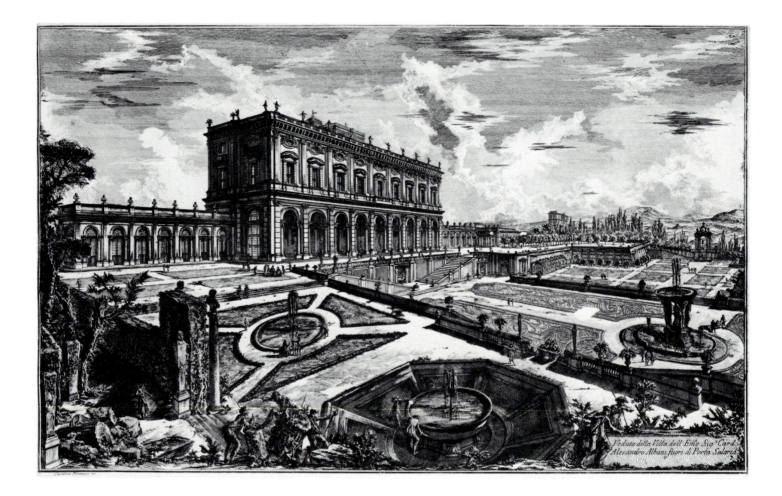

Veduta della Villa dell'Emo Sig Card.
Alessandro Albani fuori di Porta Salaria

Cavalier Piranesi inc

69. Giovanni Battista Piranesi
(Italian, 1720–1778), *View of the
Villa Albani*, 1769, etching and
engraving, 441 x 692 (17 3/8 x
27 1/4). National Gallery of Art,
Mark J. Millard Architectural
Collection, acquired with assis-
tance from the Morris and Gwen-
dolyn Cafritz Foundation
1985.61.108

of Giovanni Battista Piranesi is outstanding
among the type of printed garden scene that
was eagerly sought and collected by tourists
from northern Europe visiting Rome at this
time. Piranesi became closely acquainted
with art collectors, architects, and graphic
artists from both England and France, and
sometimes maintained contact with, and
continued to influence them after they re-
turned home.

Piranesi's Views of Italian Gardens

Since the Renaissance, artists in Italy had is-
sued increasing numbers of prints depicting
gardens, as well as other monuments, for the
tourist trade. This prospering business con-
tinued to grow in the eighteenth century as
the Grand Tour became even more essential
in the education of northern Europeans.
Piranesi was an artist of astonishing expres-

sive powers and the greatest printmaker of
this period to specialize in views of Rome.[2]
It was Piranesi who elevated the eighteenth-
century *veduta*, or view, from souvenir print
to brilliantly imaginative art. His etchings
and engravings of the sites of Rome formed
an indelible, awe-inspiring impression in the
minds of generations of Europeans and
Americans. The vision of Rome set forth by
Piranesi so emphasized the majesty of the
city that certain tourists who had seen
Piranesi's views were disappointed when
they finally confronted the actual sites.
Piranesi's work did fully partake of the ba-
roque sense of drama, but it also partici-
pated in the eighteenth-century spirit of ro-
mantic neoclassicism, offering eloquent
pictorial tribute to the splendor of Rome. He
had a passionate desire to communicate to
posterity his boundless admiration for
Rome, and printmaking was the medium of
his manifesto.

108

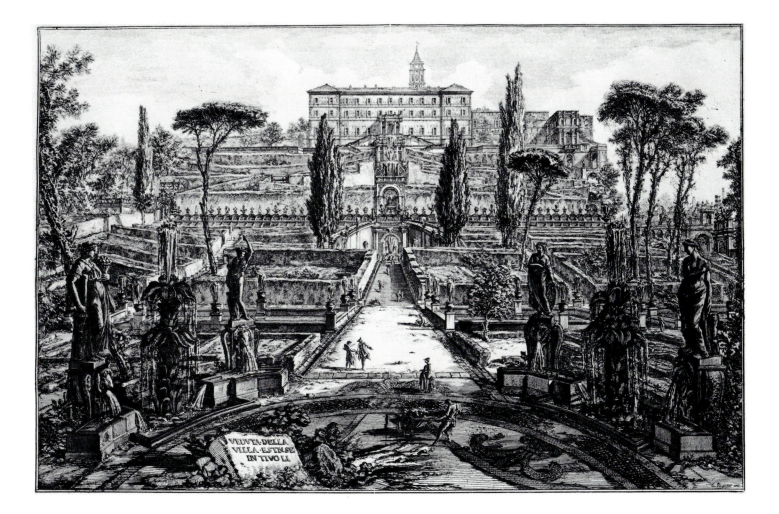

70. Giovanni Battista Piranesi (Italian, 1720–1778), *View of the Villa d'Este*, 1773, etching and engraving, 467 x 699 (18 3/8 x 27 1/2). National Gallery of Art, Mark J. Millard Architectural Collection, acquired with assistance from the Morris and Gwendolyn Cafritz Foundation 1985.61.108

In 1755, Piranesi moved into quarters near the French Academy in Rome, where he became acquainted with such French artists as Charles-Louis Clérisseau and Hubert Robert. Clérisseau and Robert shared Piranesi's enthusiasm for sketching ancient ruins, and the three artists seem to have worked together on occasion.[3] Piranesi also befriended the Scottish architect Robert Adam, and played an important role in inspiring the classical taste that would characterize Adam's work.

In 1745, Piranesi began etching views that Fausto Amidei published, along with prints by other artists, in a bound volume entitled *Varie Vedute di Roma Antica e Moderna*. This volume of plates was reissued in 1748 as *Raccolta di Varie Vedute di Roma* by the French bookseller Giovanni Bouchard, who became Piranesi's publisher until Piranesi started printing his own plates in 1761. In 1748, or earlier, Piranesi began working on

another series of views that would occupy him at intervals for the remainder of his life. This series, *Vedute di Roma*, eventually grew to 135 prints; the plates were enormous in scale and printed on the finest quality paper. The *Vedute di Roma*, along with *Antichità Romane*, another series he worked on during the 1750s, earned Piranesi international fame as an artist. The first 34 plates of the *Vedute di Roma* were published by Bouchard in 1751 as *Le Magnificenze di Roma*.

Among the views in the *Vedute di Roma*, there were gardens, both ancient and modern. In 1769, Piranesi etched a view of the Villa Albani (cat. 69), built in the mid-eighteenth century for Cardinal Allesandro Albani, a collector and dealer of ancient art, known today for the dubious quality of the "antiquities" he sold to unsuspecting tourists.[4] The Villa Albani became a symbolic center of the neoclassical aesthetic in Rome; in 1758 the Cardinal hired the highly es-

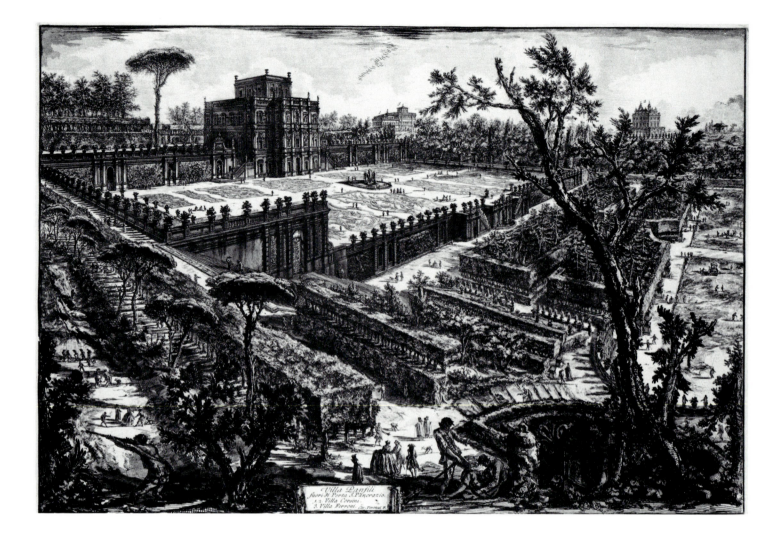

71. Giovanni Battista Piranesi (Italian, 1720–1778), *View of the Villa Pamphili*, 1776, etching and engraving, 486 x 700 (19 ¹/8 x 27 ⁵/8). National Gallery of Art, Mark J. Millard Architectural Collection, acquired with assistance from the Morris and Gwendolyn Cafritz Foundation 1985.61.127

teemed theoretician of ancient Greek art, Johann Joachim Winckelmann, to assist him with his collection, and Winckelmann's classicizing taste pervaded Albani's villa.[5] Piranesi portrayed the villa and garden from the southwest. The scene is spatially distorted, rather like a photograph taken with a wide-angle lens, creating a sense of vast spaciousness, laterally as well as in depth. Typically, Piranesi composed his view at an oblique angle, imparting visual drama with a series of crossing diagonal lines. There is strong contrast of light and dark, heightening the pictorial tension, and the small figures inhabiting the enormous space further enliven the scene with their expressive, gesticulating movements.

The Villa d'Este in Tivoli was the subject of a 1773 etching in the *Vedute* series (cat. 70). Here the view focused straight down the

central axis of the garden, and up to the villa in its commanding position on top of the hill. Although by this date some of the trees had grown beyond the scale of the original design, Piranesi showed that the various fountains, which furnished the garden with its exuberant spirit, were still in full operation.

In 1776, Piranesi etched an even more impressive view of the baroque Villa Pamphili (cat. 71).[6] Here he elevated his viewpoint far above the villa and garden, opening up a deep, breathtaking vista, so immense that the people strolling among the parterres are reduced to tiny figurines. The profundity of space in this view is emphasized by the tree placed in the foreground, giving the observer a foil against which to perceive the depth of the scene. Again, Piranesi chose an oblique view with intersecting compositional lines

for the greatest possible visual excitement. In this view, Piranesi's brilliant and vigorous technique of etching is clearly discernible. Throughout, there is a wide variation in the thickness of his rapidly-drawn, expressive lines, each of which conveys a sense of fierce emotion propelling the artist in the execution of his work; studying the details of this print, one can believe the report of Piranesi's early biographer, Jacques Guillaume Legrand, that Piranesi actually spoke out loud to his plates while he worked, feverishly imploring greater veracity of expression from each stroke of his etching needle.[7]

Garden Views in English Graphic Art

The publication in 1715 of Colen Campbell's *Vitruvius Britannicus*, whose illustrations of late seventeenth- and early eighteenth-century English gardens concluded the discussion of the baroque era in the previous chapter, marked the beginning of an important new trend in the production of illustrated books in England: there was a tremendous increase in the publication of texts on the aesthetic theory of architecture and landscape architecture, a kind of work that had previously been practically nonexistent in England.[8] Indeed, in all of Europe there had never before been so many texts on architecture and garden theory; the illustrated volumes discussed in earlier chapters were primarily pictorial surveys. Such surveys continued to appear, as will be shown below, but the greatest creative effort was now concentrated on the preparation of works on aesthetic theory. Richard Boyle, the third Earl of Burlington, was a central figure in these new developments. In 1715, the year that the first volume of *Vitruvius Britannicus* was published, Burlington had just returned from his first trip to Italy.[9] He seems to have read the book immediately following his arrival in England and it made a tremendous impression upon him.[10] It both inspired him with a life-long devotion to the classical, Palladian style of architecture that Campbell so vigorously championed, and bestowed upon him a clear sense of purpose: to foster a new renaissance of the arts in England.[11]

Burlington participated in the glad confidence of this period that England, following the establishment of a constitutional government in 1688, was the rightful heir to the political and cultural tradition of Rome of the republican period.[12] In the words of the third Earl of Shaftesbury,

When the free Spirit of a Nation turns itself this way, Judgments are formed, Criticks arise; the publick Eye and Ear improve; a right Taste prevails . . . Nothing is so improving, nothing so natural, so con-genial to the liberal Arts, as that reigning Liberty and high Spirit of a People.[13]

Burlington and his circle believed that ancient Rome of the republican period had adorned itself with buildings resplendent in the classical style and gardens filled with the "amiable simplicity of unadorned nature."[14] Both classical architecture and naturalistic landscaping thus became the marks of an enlightened, progressive attitude in the early eighteenth century, and the proper taste acquired nearly the authority of a religious conviction.

Burlington played an important role in the increased production of illustrated volumes on architecture and landscape architecture during this period, frequently offering direct financial support to their authors. One of the most influential books was Robert Castell's *The Villas of the Ancients Illustrated*, published in 1728 and dedicated to Burlington.[15] Castell attempted to reconstruct the appearance of the villas and gardens of ancient Rome, taking particular interest in the Tuscan and Laurentian villas of Pliny the Younger. Of course, his vision of Pliny's villas is more indicative of the garden style of early eighteenth-century England than of the actual appearance of ancient Roman gardens. Castell included—both in the original Latin and in English translation—Pliny's letters describing his two villas and their gardens, followed by extensive interpretations of the texts.

In the course of his exegesis, Castell set forth a theory of garden design, which, not surprisingly, fully conformed to the ideas of Burlington and his circle. Castell's aesthetic

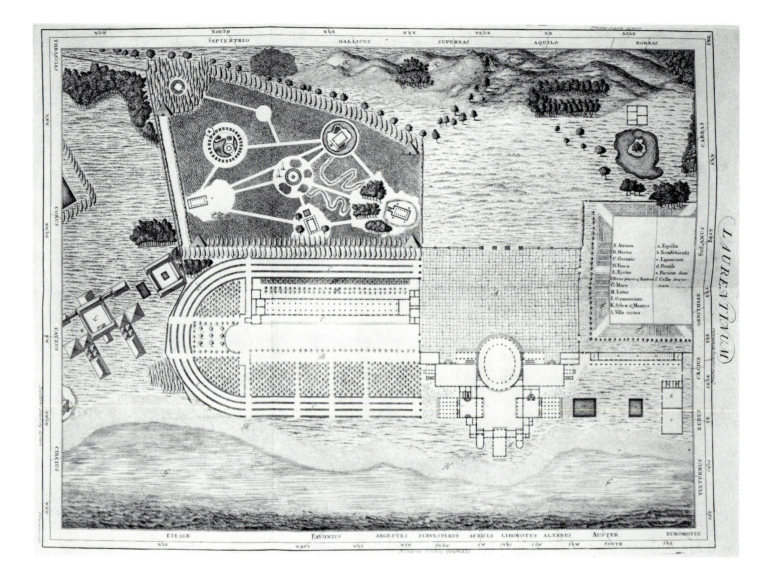

72. Pierre Fourdrinier (French, c. 1720–c. 1760), after Robert Castell, *Laurentium*, etching and engraving, 505 x 685 (19 7/8 x 27), in Robert Castell, *The Villas of the Ancients Illustrated* (London: Robert Castell, 1728). National Gallery of Art, Mark J. Millard Architectural Collection, David K. E. Bruce Fund 1985.61

principles are evident throughout his text but are perhaps most concisely stated in his discourse upon the Origin of Gardens, which explains how gardens evolved from the earliest times to the Roman republic—an evolution the eighteenth-century Englishman could surely see paralleled in his own time.[16] The first gardens, Castell writes, were naturally propitious sites in which early Romans chose to locate their homes: "Select, well-water'd Spots of Ground, irregularly producing all sorts of Plants and Trees." This "rough Manner" of relating to nature did not agree with the taste of later generations, though, who instead began to lay out gardens "by the Rule and Line, and to trim them up by an Art that was visible in every Part of the Design." The third and final style—the one that Castell clearly

preferred—combined the two earlier. "Art" now dictated the general layout of the garden, with symmetry and regularity evident in portions of the landscape. In other areas, however, nature appears to have prevailed, uncontrived and unfettered. The creation of pleasing views was of foremost concern, as were the effects of unexpected contrasts:

Through its winding Paths One . . . accidently fell upon those Pieces of a rougher Taste, that seem to have been made with a Design to surprize those that arrived at them, through such a Scene of Regularities, which . . . might appear more beautiful by being near those plain Imitations of Nature, as Lights in Painting are heightened by Shades.

None of Castell's textual passages, however eloquent, could possibly surpass the effect achieved by his grand, oversized illustrations.[17] In these pictorial declarations of correct taste, the eighteenth-century reader could fully grasp the essential tenets of classical garden design. The magnificent plate reconstructing Pliny's Laurentian villa (cat. 72) demonstrated, for example, the subordination of the landscape to an overall, geometric schema, and a clear juxtaposition of formal and informal areas in the garden. The basilica-shaped, highly controlled garden west of the atrium is in perfect contrast to the irregular space to the north, where paths wind or angle off seemingly at random

through the wilderness, terminating at little temples set near groves of trees or upon small islands. Imagining a walk through these gardens, one envisages a sequence of rewarding views.

After Burlington returned from Italy, and while he was vigorously promoting classical theory in architecture and garden design, he began improving the gardens of his estate at Chiswick in Middlesex.[18] This garden appears in a collection of etched and engraved views by Thomas Badeslade and John Rocque published in 1739 as *Vitruvius Brittanicus Volume the Fourth* (cat. 73). The title creates the impression that this text is a late addition to Campbell's series; the slight vari-

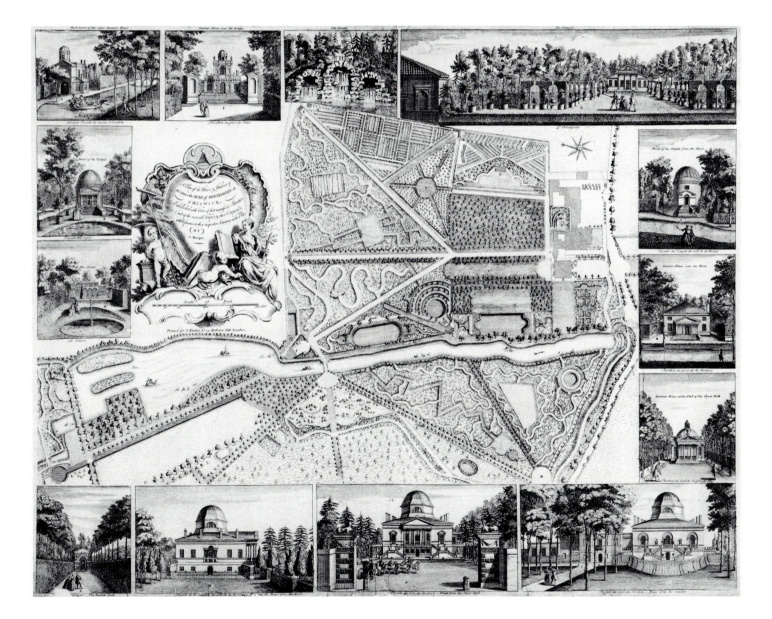

ation in the spelling of the second word—with two *t*'s rather than two *n*'s—is a meager indication that it is indeed an entirely separate endeavor.[19] Unlike Campbell's treatise, Badeslade and Rocque's did not set forth an aesthetic theory of architecture, but only presented views of great domestic buildings of the day. The work was, however, quite important in the history of English architecture and landscape architecture because it was the last of the great estate surveys to appear until the publication from 1779–1786 of William Watts' *Seats of the Nobility In a Collection of the most interesting and Picturesque Views*.[20] John Rocque, a French-born artist whose brother was a well-known gardener and florist in London, etched thirteen of the fifty-five plates in *Vitruvius Brittanicus Volume the Fourth*.[21] Rocque's career as an estate cartographer spanned most of the 1730s; he etched and engraved his plan of Chiswick in 1736. *Vitruvius Brittanicus* contains reprints of the individual commissions he completed during the 1730s. Rocque's contribution to the genre of estate cartography was the embellishment of his plans with "view boxes" surrounding the main plan that presented perspective vignettes of points of special interest in the estates. He typically included an elaborate, rococo cartouche for the title and dedication of his plans.

Rocque's plan of Chiswick shows the garden's clear relationship to the classical style defined in Castell's publication.[22] As in the reconstruction of Pliny's villa, a formal, geometric framework coincides with naturalistic spaces, and great attention is given to the creation of composed views.[23] The garden evolved in two stages. During the first, about 1715–1725, when Burlington's Palladian villa was begun, Burlington himself seems to have been responsible for the design, probably with assistance from Charles Bridgeman.[24] Bridgeman was instrumental in the early stages of the transformation of English garden design from a formal, geometric style to a more natural, irregular mode.[25] He was, for example, the first designer in England to use the ha-ha, a ditch concealing a wall or fence to keep livestock off lawns; this device allowed the garden to be visually opened up to the surrounding countryside, an important step in the development of the landscape garden. Bridgeman served as Royal Gardener to King George II and Queen Caroline from 1728 to 1738.

Jacques Carré described Chiswick as an "architect's garden," conceived as a series of felicitous settings for the small temples that Burlington erected on the site.[26] Each of these buildings is of course constructed in the classical, Palladian style that Burlington so enthusiastically endorsed.[27] Rocque's use of "view boxes" is especially appropriate in conjunction with the plan of Chiswick as they illustrate the very views whose concept motivated Burlington as he designed his garden. In considering Burlington's careful contrivance of tasteful architectural views, Carré further characterized Chiswick as a garden that intended "less to please than to teach" and describes it as "a kind of sacred enclosure in which the cult of Taste was celebrated, mainly through its prophets Palladio and Jones."[28]

The second phase of the garden's development took place during the 1730s under the guiding genius of William Kent, who has often been mistakenly credited with the very invention of the naturalistic landscaping style of the early eighteenth century.[29] Kent is certainly one of the most important designers in the history of English landscape architecture.[30] As a young man he traveled to Italy to study painting, and during the ten years that he remained there he became completely imbued with Italian culture and thoroughly familiar with Italian gardens.[31] Kent and Burlington were first acquainted during the latter's first trip to Italy and Burlington later brought Kent back to England where Kent eventually became Burlington's garden designer.[32] The two most important spaces designed by Kent for the garden at Chiswick are the exedra, where he set sculpture and seats into niches of pruned vegetation, and the rustic cascade that he made to replace a more formal construction by Burlington.[33] The cascade, presented in the center, top "view box" of the Rocque plan, is a quintessentially Kentian design in its playful, artificial rusticity and picturesque effect (fig. 10). It may have been inspired by one of the cas-

Fig. 10. John Rocque, *Rustic Cascade*, detail of cat. 73.

cades at the Villa Aldobrandini at Frascati.[34] To distinguish between the work of Burlington and Kent at Chiswick, Rudolf Wittkower suggested that "Whenever we find fanciful and witty ideas, disregard of reason and rule, odd escapades, we can be sure we have the real Kent before us."[35] As Burlington was obsessed with correctness and taste, Kent was a free spirit possessed of an unbridled and often comic imagination.

Frederick, the Prince of Wales, was the proprietor of Kew House and its garden, which were adjacent to the royal garden at Richmond in the early eighteenth century.[36] Frederick was attracted to exotic styles in architecture and sought to embellish his garden at Kew with a variety of fanciful structures. When he learned in 1748 that the architect William Chambers was returning from China with drawings of Chinese buildings, he asked him to design a summer house in the Chinese style, a structure that became known as the House of Confucius.[37] He may also have solicited further designs from Chambers, including a drawing for a Moorish pavilion.[38] When Frederick died in 1751, his consort Augusta, now the Dowager Princess, continued his work at Kew, maintain-

ing his taste for exotica. She employed Chambers to design garden architecture for Kew, a task he performed with great energy between 1757 and 1762.

The admiration for things Chinese peaked in England during the late seventeenth and early eighteenth centuries for the same reasons that respect for ancient Rome had become so great: like the Romans of the republican period, China's citizens were thought to enjoy the benefits of a benevolent, free society that Englishmen could compare to their own country since the establishment of a constitutional government. Around 1724, a Jesuit missionary, Father Matteo Ripa, brought to England a series of drawings he had made of the Imperial palaces and gardens at Jehol near Peking. These drawings proved that the garden style of the Chinese was as "natural" as that of the ancient Romans, which of course reinforced the popular idea that free people would prefer gardens in which nature had played a role at least equal to that of art.[39] England thus looked both to China and Rome as "guides to a free man's relation to nature," and landscape designers drew ideas from what they knew of both cultures.[40] Chambers was the architect most renowned for his knowledge of Chinese architecture and gardens, and his work at Kew, especially the construction of the Great Pagoda, stands as evidence of his appreciation for this style.

Although only part of his work at Kew has survived, Chambers' accomplishments are immortalized in the magnificent folio volume that he published in 1783: *Plans, Elevations, Sections, and Perspective Views of the Gardens and Buildings at Kew*.[41] The work was financed by King George III, and every effort was expended to insure its splendor. As John Harris wrote, "No gardening book has received such care and attention from author, printer, and engravers alike."[42] Indeed, some of the leading graphic artists of the day worked on the illustrations that accompanied Chambers' text. Plate 38, *A View of the Lake and Island at Kew, Seen from the Lawn* is one of the most beautiful of these scenes (cat. 74). True to the aesthetic preferences of Chambers, the bucolic scene is enlivened by views of the Great Pagoda,

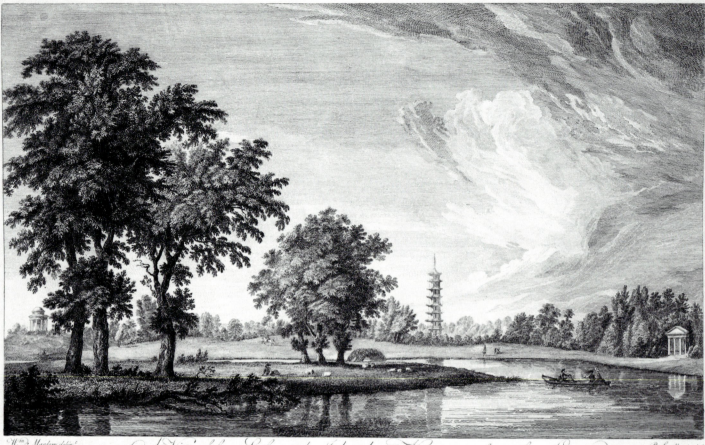

W^m Marlow delin.^t

A View of the Lake and Island at Kew: seen from the Lawn.
with the Bridge, the Temples of Arethusa, and Victory, and the Great Pagoda.

P. Sandby Sculp.^t

74. Paul Sandby (British, 1725–
1809), after William Marlow, *A
View of the Lake and Island at
Kew, Seen from the Lawn, with
the Bridge, the Temples of Are-
thusa, and Victory and the Great
Pagoda*, etching, 308 x 467 (12 1/8
x 18 3/8), in Sir William Cham-
bers, *Plans, Elevations, Sections
and Perspective Views of the
Gardens and Buildings at Kew in
Surrey, the Seat of Her Royal
Highness, the Princess Dowager
of Wales* (London: J. Haberkorn
for Sir William Chambers, 1763).
National Gallery of Art, Mark J.
Millard Architectural Collection,
David K. E. Bruce Fund 1985.61

along with the Temples of Arethusa and Vic-
tory and the Bridge.

Paul Sandby, whom Richard T. Godfrey
called "one of the most inventive and varied
of all English printmakers," etched this view
of Kew after a drawing by William
Marlow.[43] Sandby was one of the leading
landscape artists of his day and is well
known for his watercolors. As a printmaker,
he not only made very fine etchings but was
instrumental in introducing English artists to
the aquatint process, already in use in
France.[44] In the 1750s and 1760s, English
printmakers like Sandby had finally begun
to equal or even surpass the quality of their
French counterparts' work in the field of
landscape.[45] While making a topographical
survey of Scotland for the Board of Ord-
nance as a young man, Sandby had acquired
an unerring sense of perspective and an abil-
ity to record scenes with great accuracy. This

discipline combined well with the spontane-
ity of his approach to nature. The illustra-
tion of Kew reveals his mastery of spatial
representation through the strong variation
of light and dark—of quickly executed deep
and shallow lines—that infuses his etchings
with life. The depiction of foliage is some-
what formulaic, but the sky is dramatic with
the sun obscured behind clouds, and light
shimmers from the rippling surface of the
water. Sandby was an artist wonderfully
suited to represent the eighteenth-century vi-
sion of the perfect landscape in which art
and nature unite in rapturous beauty.

Chambers' chinoiserie and his concept of
artfully adorning a garden with interesting
architectural features were scorned by mem-
bers of the landscape movement that was to
dominate the field in England in the third
quarter of the eighteenth century. This new
vision of landscape design rejected the deco-

116

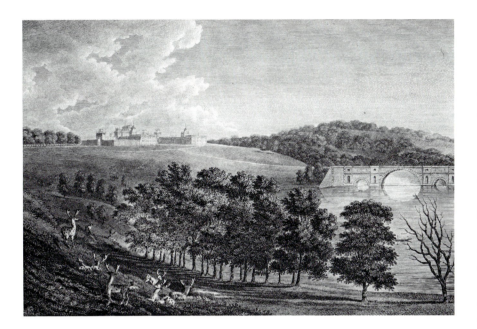

ration of nature and endeavored to make the hand of man indistinguishable in a completed landscape. Despite this desire to disguise the designer's contribution, tremendous alterations were in fact made to the land in the creation of the new landscape gardens; vast quantities of soil were moved as some hills were leveled and others raised, lakes were formed, forests planted, and enormous expanses of lawn spread across the land. In the end, though, the landscape was to appear to be the work of nature, unassisted by human intervention. Lancelot "Capability" Brown was the leader of this landscape garden movement.[46] Born in Northumberland in 1716, he had his first great opportunity in landscaping at Stowe in the 1740s, where he helped realize some of William Kent's designs. His nickname resulted from his habit of declaring that his prospective clients' land had great "capabilities." The liberal Whig segment of society that had earlier in the century championed Kent now became the great supporter of Brown and critic of Chambers, who was associated with the crown and the Tory party. The most important work celebrating Capability Brown was Horace Walpole's *On Modern Gardening* of 1780, in which Brown's work is described as the brilliant culmination of the liberating process that landscaping had undergone during the eigh-

teenth century. Chambers' 1772 *Dissertation on Oriental Gardening*, in turn, roundly condemned Brown's style as lacking in interest and as a dreadful waste of his clients' money, arguing that although his landscapes were created at great expense, they could not be distinguished from "common nature."[47]

One important source for illustrations of Brown's landscapes is the type of pictorial survey of estates that was produced in the last quarter of the century in response to the growing public interest in the natural scenery as well as the great houses and gardens of the English countryside.[48] As travel within England—especially to the Lake District and Wales—became extremely popular, there was an increased demand for illustrated books describing the landscape, its history, and its architecture.[49] One of the first books to specialize in views of estates was William Watts' *Seats of the Nobility and Gentry*, published in 1779–1786. This survey was continued in William Angus' *The Seats of the Nobility and Gentry in Great Britain and Wales, In a Collection of Select Views*, published in 1787. The illustrations include a scene of Blenheim Palace in Oxfordshire showing one of Capability Brown's most ingenious design ideas, the creation of two lakes that narrow to meet under the massive bridge built earlier in the century by Sir John Vanbrugh (fig. 11). Before Brown made the two lakes, the bridge had appeared out of scale with its setting and the rather diminutive River Glyme that it spanned; Brown provided the proper setting that made it seem a necessary, natural part of the scene.

What distinguished Angus' work and other contemporary texts of this genre from earlier architectural books was their emphasis on the "picturesque" settings of the structures they survey; in the scene of Blenheim, it is the lovely, rolling land, the majestic clumps of trees, the deer gathered in the foreground, and of course the splendid lakes that take pride of place.[50] In the late eighteenth century, the term "picturesque" became one of the most significant expressions in aesthetic theory, first in England and then in the rest of Europe.[51] David Watkin concluded that "the theory and practice of the

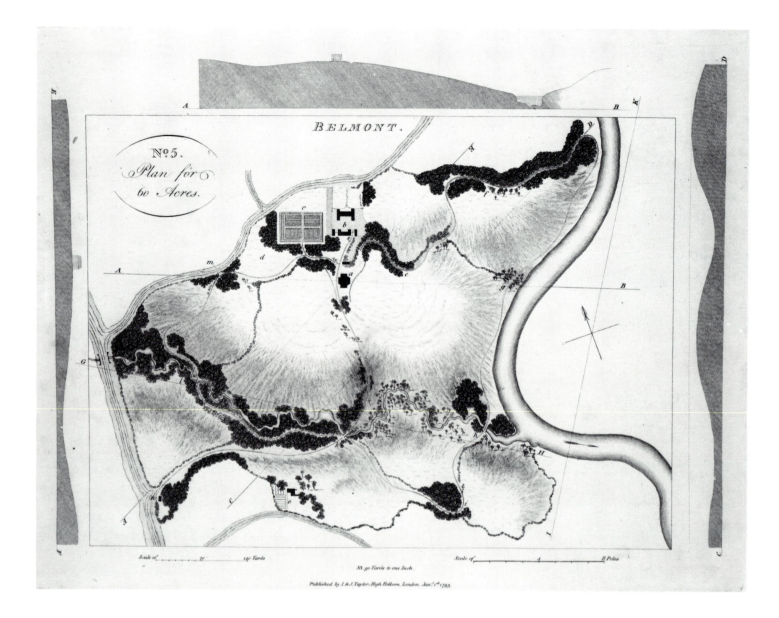

75.a, b George Isham Parkyns
(British, 1749/1750–1820), *Bel-
mont, Plan for 60 Acres*, and *Sec-
tional Geometrical Views*, etch-
ing, plan: 227 x 290 (8 7/8 x
11 3/8); sections: 202 x 272 (8 x
10 3/4), in *Six Designs for Im-
proving and Embellishing
Grounds. With Sections and Ex-
planations* (London: I. and J.
Taylor, 1793). National Gallery of
Art, Mark J. Millard Architec-
tural Collection 1983.61

Picturesque constitute the major English
contribution to European aesthetics."[52] By
"picturesque," contemporary writers referred
to the pictorial qualities of, for example, a
landscape or a garden. In judging the effec-
tiveness of either natural scenery or a gar-
den, an amateur critic of the picturesque
would consider whether the elements of the
landscape or garden were arranged in a
manner that made them resemble a land-
scape painting. Advocates of the pictur-
esque, such as Reverend William Gilpin, be-
lieved that the type of beauty in a landscape
painting by Claude Lorrain should be sought
in views of the natural landscape.[53] Gilpin's
theory was partly responsible for the popu-
larity of travel to the picturesque sites in En-

gland and for the formulation of a new ap-
proach to the representation of landscape in
art: "Gilpin provided a complete language of
landscape criticism, and consequently land-
scape painters began to revise their attitudes
towards their art."[54]

George Isham Parkyns' *Six Designs for
Improving and Embellishing Grounds*, pub-
lished in London in 1793 as an appendix to
Sir John Soane's *Sketches in Architecture*, is
an interesting variation on the picturesque
travel book.[55] Parkyns was a landscape
painter who had worked as a military sur-
veyor in Nottinghamshire from 1785 to 1790.
During his leisure time, he amused himself
by drawing imaginary landscape plans for
the estates in the region. The topography he

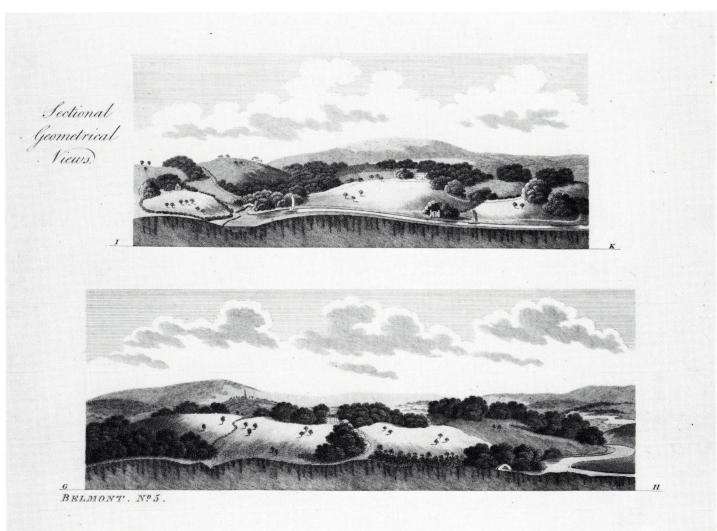

Published by I & J.Taylor, High Holborn, London. Jan.ʸ 1.ˢᵗ 1793.

75. b

depicted corresponded to that which was actually present on the sites, but the formation of woods, lakes, and rivers—all very much in the style of Capability Brown—are his own fanciful "embellishments." As in Angus' descriptive texts, there was an emphasis on picturesque views. In the passage discussing his plan and sectional views for Belmont (cat. 75a, b), Parkyns described a walk along a circumferential path, another Brownian feature, pointing out the various prospects along the way.[56] At point *e*,

> *the view is uncommonly picturesque: the river which hitherto has been discovered winding through the valley, is here seen to advantage: projecting trees*

confine the view, and the eye, after traversing the grounds and water, dwells upon a picturesque tower, at one mile distant, rising from the highest point of a beautiful hanging wood.

Comparing Parkyns' plan to Rocque's (cat. 73), one sees that the style of presentation is as different as that of the landscaping. Parkyns' etching is much simpler, more balanced, and open. There is a bold contrast of dark and light spaces in the densely drawn thickets of trees and the wide, open stretches of lawn. Hatched lines give the grassy spaces three dimensions, and the portrayal of individual specimens of trees is richly varied.

Although the most significant eighteenth-

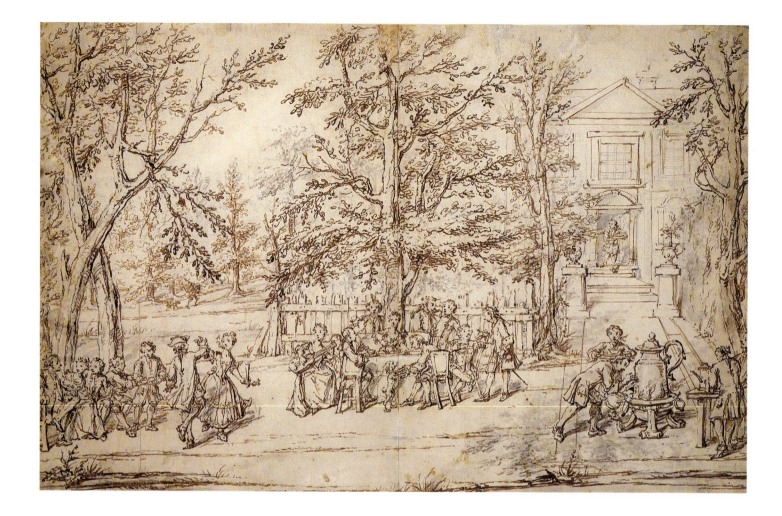

76. Marcellus Laroon II (British, 1679–1774), *Garden Party at a Country House*, 1771, pen and brown ink with gray wash over graphite, 471 x 693 (18 1/2 x 27 1/4). National Gallery of Art, Ailsa Mellon Bruce Fund 1981.23.1

century English illustrations of gardens were made for books, scenes of gardens continued to appear as single-leaf illustrations and to reflect the pleasurable pastimes of this period. Some particularly attractive representations of gardens attest to the prevailing spirit of the day, a spirit that J. H. Plumb described as essentially joyful in response to a world that was "increasingly radiant," filled with new material possessions and exciting new activities for its fortunate inhabitants: "The art of eighteenth-century England will not allow us to forget how delightful that world had become to those who had the means to enjoy it."[57]

Marcellus Laroon produced a drawing that epitomizes this spirit of good cheer, *Garden Party at a Country House* (cat. 76), signed and dated 1771, when the artist was ninety-two years old.[58] Laroon's usual vigor and spontaneity and his preference for fig-

ures in lively action with a "light, flickering, rococo line" were not diminished in his extreme old age.[59] Although his lines frequently quaver, the gaiety and sparkle of his work seem to increase from this tremulous quality. The garden here is adjacent to a country house whose proportions cannot be ascertained as only a corner is visible. The parklike landscape was the fashion of the day, whether indigenous or the result of rigorous landscape engineering. Although he has been called a satirist, Laroon is in fact not indulging in caricature or social criticism here. He seems instead to enjoy vicariously the fun he draws, perhaps deriving his theme from the tradition of Dutch low-life scenes that he knew well from his father, the artist Marcellus Lauron.[60]

The art of satire did thrive in England during the late eighteenth century, which may partly explain the great success of the

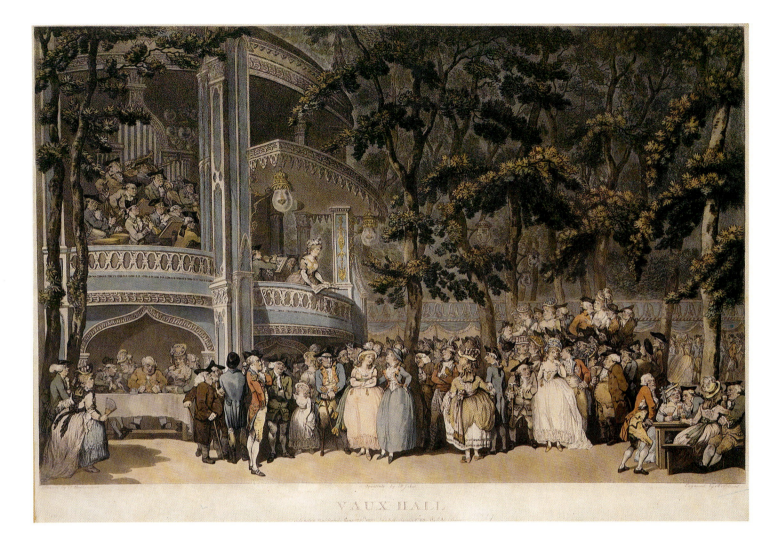

VAUXHALL

77. Robert Pollard (British, 1797–after 1859) and Francis Jukes (British, 1747–1812), after Thomas Rowlandson, *Vauxhall Gardens*, British, 1785, hand-colored etching and aquatint, 539 x 755 (21 1/4 x 29 3/4). Private collection

print market at this time.[61] Thomas Rowlandson was one of the most renowned satirists of his day, as well as a very accomplished artist.[62] He had an active career for fifty years, extending into the nineteenth century.[63] Because the garden is an environment in which people's foibles seem to exhibit themselves with special clarity, it is not surprising that the setting for Rowlandson's best-known work is Vauxhall Gardens, one of the immensely popular pleasure gardens in London at the time (cat. 77).[64] Vauxhall Gardens first opened in 1661 as the New Spring Gardens. Jonathan Tyers became proprietor in 1732 and began to offer his clientele concerts as well as "elegant supper boxes," pavilions illuminated with more than a thousand lights, and the opportunity to mingle with society along extended walks in the wooded groves.[65] Rowlandson— himself zealously committed to the pursuit

of pleasure—was a frequent visitor in the gardens. His friend Henry Angelo recalled that "Rowlandson the artist and myself have often been there, and he has found plenty of employment for his pencil;" he goes on to explain that in the print of Vauxhall, Rowlandson "introduced a variety of characters known at the time."[66] The ready identification of the figures in the print no doubt added to its popularity. The two well-dressed ladies in the center, for example, are the Duchess of Devonshire and her sister, Lady Duncannon, and the man watching them through his monocle is the gossip columnist, Captain Topham. To the right, the Prince of Wales flirts with his mistress, Perdita Robinson, while her husband glares suspiciously at them. The fat man eagerly gripping his eating utensils in the supper box may be Dr. Johnson, accompanied by Boswell, Mrs. Thrale, and Oliver Goldsmith.

The drawing from which this print was made was an early work, exhibited at the Royal Academy in 1784.[67] The print dates to 1785, a period in which Rowlandson had begun to sell large drawings on social themes to print publishers.[68] He sold his drawing of *Vauxhall Gardens* to the publisher John Raphael Smith, who employed Robert Pollard to etch the plate, which was then aquatinted by Francis Jukes; after printing, the work was hand-colored in the publisher's studio.[69]

As the English naturalistic garden evolved in association with the classical architecture of the Palladian revival in the early eighteenth century, most fine illustrations of gardens appeared in books presenting either the theoretical framework for the classical style, like Castell's *Villas of the Ancients*, or illustrated surveys of the great estates of the day, like Badeslade and Rocque's sequel to Campbell's *Vitruvius Britannicus*. The architectural and garden styles of this period seem to have derived from the optimism of a prosperous society that anticipated a new Golden Age and the restoration in contemporary England of the principles and culture of ancient Rome. Later in the century, the landscape gardens of Capability Brown and his followers gained ascendancy as did a new taste for travel to picturesque sites; books responding to the growing desire to see the English countryside often contained illustrations of gardens typical of the style of the second half of the eighteenth century. The demand for such printed views occurred, furthermore, at precisely the moment when English graphic artists began to develop the necessary technical skills for representing the natural world in all its appealing variety.

Eighteenth-Century Gardens in France

In France, there was no counterpart to Campbell's *Vitruvius Britannicus* and the Palladian revival that it heralded.[70] The economic circumstances and collective emotional state of France were completely different from those of England at this time. In 1715—the year that Lord Burlington's first trip to Italy and Campbell's first publication

jointly forecast a glorious future for English culture—Louis XIV died, leaving his country in desperate financial straits that were in part a result of his megalomaniacal garden-building. The mentality of the age began to change, and extravagant horticultural displays were no longer possible or even desirable; instead of exerting an overwhelming force upon nature, compelling it to submit to the rigors of human design, the artistic impulse now sought solace in the natural world, refuge in a bucolic dream of simplicity and peace far from the anxieties of civilized, courtly life.[71] It was for this reason that gardens in eighteenth-century France began to follow the precepts of natural design and that images of gardens in French art evoked the gentle serenity of an uncontrived, unsophisticated pastorale. The old gardens of the Age of Grandeur were quickly becoming overgrown as maintenance allowances disappeared. However, contemporary artists were not necessarily displeased with the new, more romantic appearance of these glorious spaces. Many of the major works of graphic art involving garden themes during this period are loving visual records of the slowly declining, ever softening gardens of the past, not documents of the appearance of recently constructed gardens. There was no equivalent in English art for these beguilingly beautiful drawings and prints of long-neglected gardens.

In the creation of new gardens, the aesthetic principles of French and English garden designers were similar, especially during the second half of the eighteenth century.[72] English books on the theory of garden design were well known in France after 1750 and seem to have had a profound effect on the development of French landscape gardens, which were known as *les jardins anglais*.[73] Thomas Whately's *Observations on Modern Gardening* was particularly influential in France. This work, which described the important landscape gardens in England, was translated into French in 1771, and it became "the standard treatise on gardens in the new style."[74] Whately's book may have inspired Claude-Henri Watelet in writing his *Essai sur Jardins* of 1774 and in the creation of Moulin-Joli, the most renowned

picturesque garden in France.[75] Watelet was
a friend of Jean-Jacques Rousseau—the
great apostle of the Cult of Nature—as well
as such artists as François Boucher, Hubert
Robert, and Jean-Claude Richard, the Abbé
de Saint-Non.[76] Boucher designed Watelet's
house at Moulin-Joli; Robert, whom Watelet
met in Rome in 1763, was later a guest at
Moulin-Joli.

An etching of Moulin-Joli by François
Denis Née (fig. 12) appears in Jean-Benjamin
de Laborde's *Voyage Pitturesque de la
France*, an important source for illustrations
of late eighteenth-century French gardens.[77]
Moulin-Joli was located on three islands in
the Seine and along one side of the river. Wa-
telet contrived to combine a formal, tradi-
tional layout, complete with radiating *allées*,
and an English-inspired, lush planting de-
sign in the natural style.[78] Horace Walpole
visited the garden in 1755 and wrote that "a
plenary indulgence has been granted to every
nettle, thistle and bramble. . .in one word,
[Watelet's] *island* differs in nothing from a

French garden into which no mortal has set
foot for the last century."[79] The view of
Moulin-Joli in Laborde's volume is appro-
priately titled "An English Garden." It shows
an especially naturalistic portion of the gar-
den with the rustic bridge that connected the
islands to the shore and the mill for which
the garden was named.

The Bagatelle of the Comte d'Artois, an-
other picturesque garden of the period, also
appears in the *Voyage Pitturesque de la
France* (fig. 13).[80] This etching, again by
Née, was based upon a gouache drawing by
Louis-Gabriel Moreau the Elder, a landscape
artist who is known especially for his bril-
liant depictions of nature.[81] Moreau was
born in Paris in 1739 and died in 1805. His
chief biographer, Georges Wildenstein, char-
acterized him as an artist dedicated with an
almost religious fervor to representing the
splendor of the French landscape.[82] Moreau
made frequent visits to the old château gar-
dens in and around Paris—Saint Cloud, Ver-
sailles, Saint-Germain-en-Laye—and re-

corded them in numerous drawings. He also
occasionally portrayed newer gardens, like
the Bagatelle, and some of these drawings
served as the basis for etchings in the *Voy-
ages Pittoresque*.

The Bagatelle pavilion, located in the Bois
de Boulogne, was constructed in three
months so that the Comte d'Artois could
win a wager he had made with his sister-in-
law, Marie-Antoinette, that he would enter-
tain her in his new pavilion when the court
returned to Versailles from its autumn visit
to Fontainebleau.[83] In 1777, the Scottish gar-
dener Thomas Blaikie began to design the
garden at the Bagatelle. Blaikie's typically
late eighteenth-century English landscape
plan was modified by François-Joseph Bé-
langer, the Comte d'Artois' architect, to
make it conform with the traditional French
fashion for straight *allées*.[84] As at Moulin-
Joli, *allées* occasionally were included in gar-
dens that were otherwise completely natural-
istic, in the English manner. Moreau's view
of the Bagatelle shows some of the most

common features of the eighteenth-century
French *jardin anglais*: a hermitage, a rustic
bridge, and rolling lawns with clumps of
trees.

Moreau represented another *jardin
anglais* in an early gouache entitled *Park
View* (cat. 78). The garden is unidentified,
but it was once believed to be that of the
Château de Betz.[85] Comparison of *Park
View* to a mature work by Moreau, *Terrace
of a Château*, clearly illustrates his develop-
ment by the late 1780s or 1790s (cat. 79).[86]
This later gouache portrays a monumental
stairway—a frequent feature in Moreau's
work—that has sometimes been identified
with the grand, terraced garden at Saint
Cloud. It is most likely an imaginative com-
position of landscape and architectural ele-
ments not intended to represent any specific
location.[87] This drawing reveals Moreau's
almost pointillistic technique for rendering
foliage. He applied his colors with just the
tip of his brush, creating wonderfully fresh,
shimmering nuances of light and shadow.

78. Louis-Gabriel Moreau the Elder (French, 1740–1806), *Park View*, 1806, gouache over graphite, 280 x 225 (11 x 8 7/8). National Gallery of Art, Samuel H. Kress Collection 1963.15.22

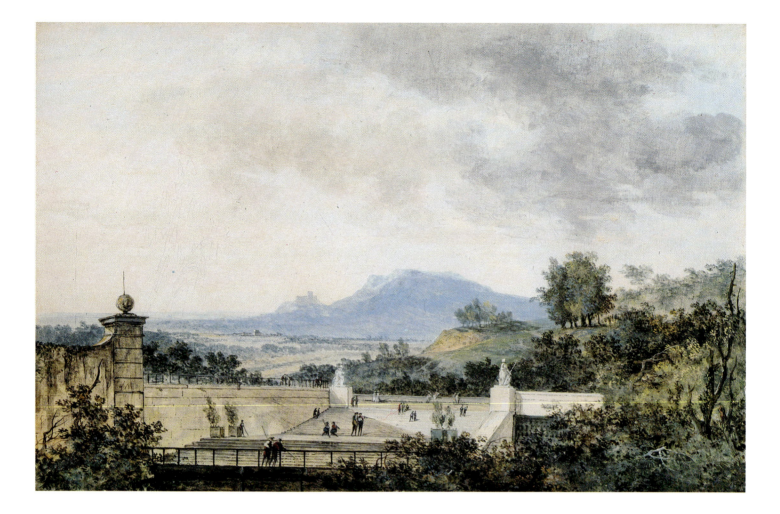

79. Louis-Gabriel Moreau the Elder (French, 1740–1806), *Terrace of a Château*, c. 1790, gouache, 310 x 464 (12 ¹/₄ x 18 ¹/₄). National Gallery of Art, Samuel H. Kress Collection 1963.15.20

80. Louis-Gabriel Moreau the Elder (French, 1740–1806), *Park with Terrace and a Balustrade with Statues*, after 1779, etching, 79 x 113 (3 ¹/₈ x 4 ¹/₂). National Gallery of Art, Rosenwald Collection 1964.8.1304

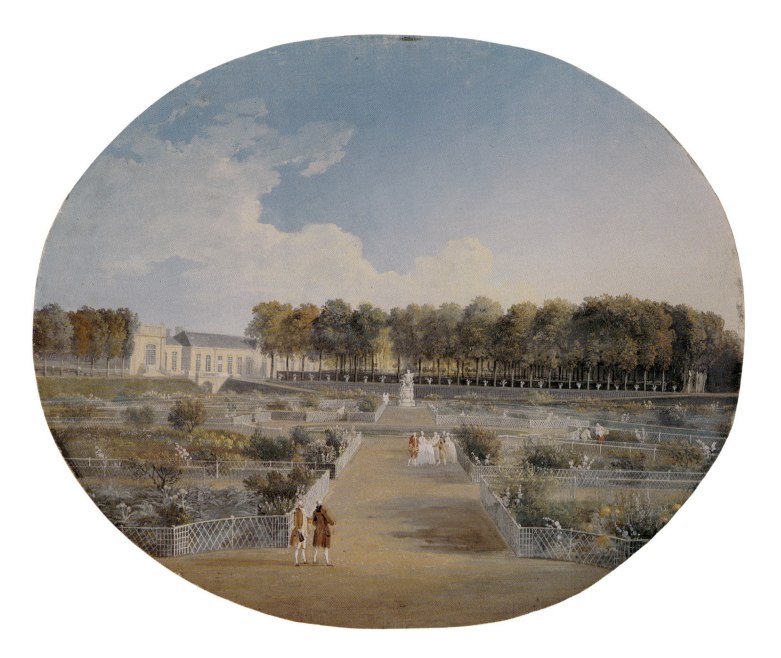

The horizon is low, as it often is in Moreau's landscapes, and a feeling of vast space is conveyed convincingly. Moreau's etching *Park with Terrace and a Balustrade with Statues* (cat. 80) also demonstrates his ability to compose a scene with ample, light-filled space.[88]

A gouache attributed to Alexis Nicolas Perignon the Elder portrays the *Vegetable Garden (Potager) of the Château Valentinois* in Passy, just outside Paris (cat. 81).[89] Perignon, an artist who specialized in topographical views, worked in both watercolor and prints. Here he has depicted a lovely garden laid out in a decorative, geometric pattern in which vegetables and ornamental flowers grow inside lattice fences. The Château Valentinois was owned by Jacques Donatien Le Ray de Chaumont, who generously housed Benjamin Franklin there during his ambassadorship to France.[90]

Although some wonderful portraits of eighteenth-century French gardens exist, a much greater creative energy was devoted to representing either the declining French gardens of the previous period, ideal images of fantasy gardens, or the romantically overgrown gardens of sixteenth-century Italy. Antoine Watteau's work from the early eighteenth century often includes motifs of imag-

82. Antoine Watteau (French, 1684–1721), *The Bower*, c. 1716, red chalk, 402 x 268 (15 7/8 x 10 1/2). National Gallery of Art, Ailsa Mellon Bruce Fund 1982.72.1

inary or idealized and neglected, ruined gardens. Born in Valenciennes in 1684, Watteau came to Paris as a student around 1712. In 1717, he was accepted into the French Academy as a painter of *fêtes galantes*.[91] The young Watteau was drawn irresistably to the unkempt gardens around Paris where the forces of nature were quickly gaining ground against the hand of man. He frequently visited the garden of his patron, Pierre Crozat, at Montmorency, which he portrayed in several of his works.[92] As William Howard Adams has stated, the disheveled state of Crozat's garden, which had originally been laid out for Charles Le Brun, must have reflected Crozat's taste; he had sufficient means to have maintained a tidy appearance, if he had wanted to.[93] In the more relaxed atmosphere of the régence period following Louis XIV's death, a softening of the tight outlines of the grand manner became fashionable among some of France's more affluent citizens.

One of Watteau's most appealing visualizations of the eighteenth-century Arcadian dream is his red chalk drawing, *The Bower* (cat. 82).[94] It is among the largest and most complete of his surviving drawings, probably made around 1716, when he was at the height of his creative powers.[95] In the drawing, the inhabitants of a bower of bliss, suspended in the decorative fantasy of an incorporeal Elysium, joyously pursue their sensual pleasures. It is, perhaps, an archetype of the garden for which this period yearned, a charmed sanctuary that generates perpetual joy, unaffected by the practical concerns of a mundane existence. Typical of Watteau's mature drawings, *The Bower* describes its forms with the greatest economy of line; each stroke is wonderfully suggestive and the overall effect conveys a sense of true enchantment.

As French gardens of the age of Louis XIV gradually sank into a magnificent decline, so did those of the Renaissance and baroque periods in Italy. French artists who journeyed to Italy beginning around 1760 found them wondrously appealing and recorded them in numerous drawings and prints. The two greatest French artists in Italy at this time were Hubert Robert, who was an informal student at the French Academy in Rome, and Jean-Honoré Fragonard, also a student at the Academy and winner of the Prix de Rome in 1752. The two artists went out sketching together from time to time, and their drawings are occasionally close enough in style to present some difficulty in distinguishing the work of one from the other.[96]

Robert was born in Paris in 1733. He earned the nickname "Robert des Ruines" from his enthusiasm for portraying ruined architecture and antiquities. One place where artists went to study such artifacts was the garden of the Medici palace on the Pincian Hill in Rome.[97] There French students could spend the day drawing ancient statuary, and Robert immortalized such an outing in his small painting, *Colonnade and Gardens of the Medici Palace*; this work subsequently became the model for a color print by Jean-François Janinet, part of a popular series of prints of the ruins and villas of Rome (cat. 83).[98] Janinet's printed version combined etching with the wash-manner technique of engraving that he had invented several years earlier, a technique that reproduced the effect of watercolor or ink washes and that helped to initiate a new interest in the production of color prints.[99]

Robert visited and drew not only the great gardens of Italy, but also the smaller ruined and abandoned gardens that existed in great abundance.[100] He depicts one such site in *The Garden Gate*, a red chalk drawing dated between c. 1760/1765 (cat. 84).[101] One has only a glimpse through an old, wooden gate into the garden, in which large, leaning trees and burgeoning shrubbery speak of a long period of neglect. Robert has discovered here a secret garden of poignant beauty. The scene seems to have been drawn either early in the morning or late in the afternoon when the sun was close to the horizon, illuminating the garden from a low angle.[102] Robert describes his forms with an unusually loose handling of the chalk and shows a special concern for recording light effects.[103] Robert's typically sawtoothed line outlined foliage, and hatched, parallel lines cover a large portion of the surface.[104] The almost mystical presence of light deepens a sense of three-dimensional space in this drawing.

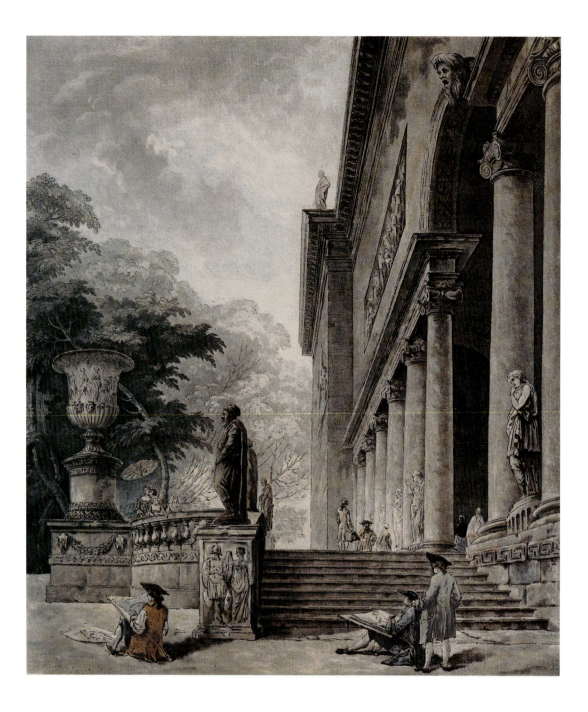

83. Jean-François Janinet
(French, 1752–1814), after Hubert
Robert, *Colonnade and Gardens
of the Medici Palace*, c. 1776,
etching and wash-manner en-
graving, 390 x 315 (15 3/8 x
12 3/8). National Gallery of Art,
Gift of Ivan Phillips 1986.30.1

After his return from Rome, Robert began to use the understanding of garden design he had gained in Italy to initiate a new career as a creator of gardens. In 1778, he was named *dessinateur des jardins du roi* and, at the behest of Louis XVI, he designed a new setting for the Baths of Apollo sculpture that had originally decorated the Grotto of Tethys at Versailles.[105] Among other projects, he assisted in the renovation of the gardens of the Petite Trianon—including Marie-Antoin-

ette's famous Hamlet—and contributed to the embellishment of Méréville and Betz.[106]

Fragonard, born in 1732, lived in Paris from 1738 and was apprenticed first to Jean-Baptiste-Siméon Chardin and then to François Boucher. Boucher was so impressed by the young artist's talent that he encouraged Fragonard to compete for the Prix de Rome, which he won in 1752. Like Robert, Fragonard was frequently attracted to gardens in Italy when he wished to practice and re-

84. Hubert Robert (French, 1733–1808), *The Garden Gate*, 1760/1765, red chalk, 455 x 353 (17 7/8 x 13 7/8). National Gallery of Art, Gift of Natalie Fuller Allen and her children 1987.72.1

fine his skills in drawing *en plein air*. Charles-Joseph Natoire, director of the French Academy in Rome, apparently encouraged both Robert and Fragonard in this activity, an indication that pure landscape, which had not previously been considered a particularly worthy subject in art, was now growing in stature in France, as it was in England. Robert and Fragonard influenced the development of each other's drawing styles, especially in red chalk, and mutually bene-

fited from each other's expertise during drawing excursions in gardens and the countryside. Fragonard did not share Robert's fascination for ruins, however, perhaps because he did not have Robert's classical education.[107] The Abbé de Saint-Non befriended both artists during his sojourn in Italy beginning in 1759. He invited him on trips around Italy—spending the summer at the Villa d'Este with Fragonard—and later published prints after their drawings in his

Voyage Pittoresque ou Description des Royaumes de Naples et de Sicile.[108]

Terrace and Garden of an Italian Villa (cat. 85) is one of the brilliantly executed, red chalk drawings of garden scenes that Fragonard produced during his first trip to Italy.[109] The garden has not yet been identified. It is typical of Fragonard's work in its representation of billowing, voluptuous masses of vegetation, here contrasting with the naked, clawlike branches of a dying tree that leans into the center of the composition. Altogether, it epitomizes the highly romantic response to nature that characterizes French art of the eighteenth century. Fragonard's hatching lines in this drawing are more controlled than those of Robert in *The Garden Gate*, although they are by no means rigid or lacking in spontaneity. They show a much clearer intention to describe specific forms

rather than to cover uniformly portions of the page. The description of space is also more coherent than that of Robert's work. Although the drawing seems to have been counterproofed, there is still a wide range of lights and darks, which help convey a sense of both three-dimensional form and palpable atmosphere.[110]

A black chalk and brown wash drawing of another unidentified Italian garden, *Park of an Italian Villa* (cat. 86), was once attributed to Fragonard.[111] The fountain, classical statuary, vases, and architectural motifs, all engulfed by luxuriant foliage, are indeed reminiscent of Fragonard's and Robert's garden scenes. However, the positive evocation of form, space, and atmosphere of Fragonard's *Terrace and Garden of an Italian Villa* are not apparent in this work, nor is the confidence of each hatching stroke and outline.

Colin Eisler suggested that the drawing may
have been the work of the Abbé de Saint-
Non or one of the other "gifted amateurs"
who produced drawings based on prints af-
ter Robert and Fragonard.[112]

The same type of tree seen in *Park of an
Italian Villa* appears in a wash drawing that
Fragonard produced during his second trip
to Italy in 1773–1774, *Gardens of an Italian
Villa* (cat. 87).[113] In this extraordinarily soft,
delicate work, Fragonard has painstakingly
observed and described the growth pattern
of the trees in their upward-reaching
branches.[114] Fragonard combined the use of
pale, transparent washes for light-reflecting
foliage with more opaque washes for tree
trunks and branches and other solid forms.
This genre scene portrays the daily activities
of laborers in an Italian garden with great
immediacy by means of small brushstrokes

freely and surely applied with the tip of the
brush.

During the eighteenth century, the concept
of Nature began to take sovereignty over
man's creative imagination. Eighteenth-
century philosophy, literature, and art of En-
gland and France now portrayed the natural
world as the realm of pure, unadorned vir-
tue in which humanity enjoyed both peace
and prosperity. The landscapes of Capability
Brown in England and the *jardin anglais* in
France epitomized the effect of this attitude
in the design of gardens. The context in
which illustrations of gardens are found also
reveals a greater concern for Nature. English
publications of the early part of the century
included representations of increasingly nat-
uralistic gardens associated with the classical

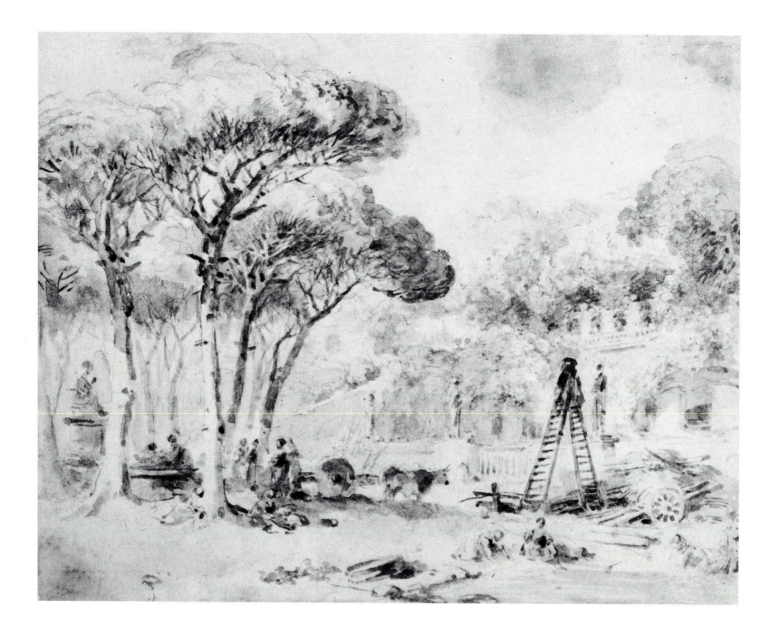

87. Jean-Honoré Fragonard (French, 1732–1806), *Gardens of an Italian Villa*, brush and brown ink over graphite, 143 x 175 (5 5/8 x 6 7/8). National Gallery of Art, Samuel H. Kress Collection 1963.15.7

revival and its spirit of cultural optimism. In France, there was a nostalgic desire to record poignant scenes of the neglected gardens of the past. Later in the century, both countries saw a tremendous new production of travel books extolling the magnificence of their own scenery; the illustrations included in these works often focused on the most beguiling "natural" gardens and the most picturesque views of the countryside. The sensibilities of Europe had changed dramatically in the course of the eighteenth century; the "natural" garden would henceforth persist as an image in works of art and have a thematic importance equivalent to that of the formal garden.

Notes

1. See below, 117–118.
2. Two of the standard works on Piranesi are: Arthur M. Hind, *Giovanni Battista Piranesi: A Critical Study* (New York, 1967); Henri Focillon, *Giovanni Battista Piranesi, 1720–1778* (Paris, 1918). See also: Peter Murray, *Piranesi and the Grandeur of Ancient Rome* (London, 1971); Andrew Robison, *Piranesi: Early Architectural Fantasies* (Washington, 1986).
3. See below, 122.
4. On Albani, see Albert Boime, *Art in an Age of Revolution, 1750–1800* (Chicago, 1987), 68–73.
5. This sponsorship of ancient Greek art, at the expense of Roman art, was not at all to Piranesi's liking. Winckelmann and Piranesi represent two opposing strains of neoclassicism current in Rome. See John Wilton-Ely, *The Mind and Art of Giovanni Battista Piranesi* (London, 1978), 38; Jonathan Scott, *Piranesi* (New York, 1975), 149, 159.
6. On the Villa Pamphili, see above, 129.
7. Scott 1975, 27. On Legrand, see Roseline Bacou, *Piranesi: Etchings and Drawings* (Boston, 1975), 7–8.
8. See Hunt and Willis 1975, parts II–IV, for excerpts of relevant passages from eighteenth-century texts relating to landscape design. For a survey of the vast bibliography on eighteenth-century gardens, see Morris R. Brownell, " 'Bursting Prospect': British Garden History Now," in *British and American Gardens in the Eighteenth Century: Eighteen Illustrated Essays on Garden History*, ed. Robert P. Maccubbin and Peter Martin (Williamsburg, VA, 1985). On the publication of architectural treatises at this time, see Rudolf Wittkower, "English Literature on Architecture" in *Palladio and Palladianism* (New York, 1974); John Archer, *The Literature of British Domestic Architecture 1715–1842* (Cambridge, MA, 1985). On gardening publications, see Rosemary Verey, "English Gardening Books," in John Harris, *The Garden, A Celebration of One Thousand Years of British Gardening* [exh. cat., Victoria and Albert Museum] (London, 1979), 117–122. On early eighteenth-century English books on gardening, see Hunt 1986, 184–192.
9. For a thorough discussion of Burlington, see James Lees-Milne, *Earls of Creation: Five Great Patrons of Eighteenth-Century Art* (London, 1962), 103–156.
10. See Lees-Milne 1962, 115–122, on the relationship of Burlington and Campbell.
11. Wittkower 1974, 179.
12. Wittkower 1974, 177–184; Joseph Burke, *English Art, 1714–1800* (London, 1976), 3–38; Kimberly Rorschach, *The Early Georgian Landscape Garden* [exh. cat., Yale Center for British Art] (New Haven, 1983), 6.
13. From *Letter Concerning the Art, or Science of Design* of 1712; quoted in Wittkower 1974, 180.
14. This characterization of ancient gardens was made by Alexander Pope in his *Guardian* essay of 1713. On Pope's leading role in the garden "revolution" of the early eighteenth century, see Peter Martin, *Pursuing Innocent Pleasures: The Gardening World of Alexander Pope* (Hamden, CT, 1984). The belief that ancient gardens were "natural" was partly the result of the English identification of ancient gardens, which no longer existed, with those of the Italian Renaissance, which had become somewhat overgrown—and thus a good deal more "natural" than their designers had intended—by the eighteenth century. On the English response to Ital-

ian gardens, see Hunt 1986, especially 11–29.
15. Archer 1985, 249–252. On Burlington and his sponsorship of classical culture, Castell wrote: "This Work is wholly founded on the Rules of the Ancients, for whom Your Lordship has on all Occasions manifested the greatest Regard." Burlington's support of Castell seems to have been withdrawn immediately upon the publication of his book; Castell died of smallpox in debtors' prison the following year.
16. Castell 1728, 116–118.
17. The plates were etched by Pierre Fourdrinier (active in London, 1720–1760), who specialized in book illustrations and architectural renderings. He also illustrated Sir William Chambers' 1759 *Treatise on Civil Architecture*.
18. Chiswick gardens are discussed in nearly all histories of eighteenth-century English gardens; see H. F. Clark, "Lord Burlington's Bijou, or Sharawaggi at Chiswick," *Architectural Review* 96 (1944), 125–129; Jacques Carré, "Lord Burlington's Garden at Chiswick," *Garden History* I, no. 3 (1973), 23–30.
19. Archer 1985, 197–198. John Harris, *The Artist and the Country House* (New York, 1985), 155–159, discussed *Vitruvius Brittanicus Volume the Fourth* and John Rocque.
20. See below, 117.
21. On Rocque, see Hugh Philips, "John Rocque's Career," *London Topographical Record* 20 (1952), 9–25; Jean O'Neill, "John Rocque as a Guide to Gardens," *Garden History* 16 (1988), 8–16.
22. On the classical attributes of Chiswick, see John Dixon Hunt "Gardening, and Poetry, and Pope," *The Art Quarterly* 37 (1974), 15–23.
23. On the continuing importance of geometry and regularity in English gardens of the early eighteenth century, see David Leatherbarrow, "Character, Geometry and Perspective: The Third Earl of Shaftesbury's Principles of Garden Design," *Journal of Garden History* 4 (1984), 332–358.
24. Alexander Pope may also have had a part in the early design work at Chiswick while he was working on his translation of Homer's *Iliad* (see Martin 1984, 24–36).
25. On Bridgeman, see Peter Willis, *Charles Bridgeman and the English Landscape Garden* (London, 1977).
26. Carré 1973, 24.
27. David Jacques, *Georgian Gardens: The Reign of Nature* (London, 1985), 15, wrote: "Lord Burlington's garden buildings were an essay in Palladian architecture."
28. Carré 1973, 27–28.
29. George Clark, "William Kent: Heresy in Stowe's Elysium," in *Furor Hortensis, Essays on the History of the English Landscape Garden in Memory of H. F. Clark* (Edinburgh, 1974), 49–56; Kenneth Woodbridge, "William Kent as Landscape-Gardener: A Re-Appraisal," *Apollo* 100 (July–September, 1974), 126–137; Hunt and Willis 1975, 312.
30. See John Dixon Hunt, *William Kent: Landscape Garden Designer, An Assessment and Catalogue of His Designs* (London, 1987); Margaret Jourdain, *The Work of William Kent* (London, 1948).
31. Hunt 1987, 15–29.
32. On the relationship between Kent and Burlington, see Wittkower 1974, 115–132; Lees-Milne 1962, 122–135.

33. Burlington may have had a role in creating the final design for the exedra (see Wittkower 1974, 131).

34. Martin 1984, 32.

35. Wittkower 1974, 130.

36. Later in the eighteenth century, the two were merged to form Kew Botanical Gardens.

37. For a reconstruction of the origin of the House of Confucius, see John Harris, *Sir William Chambers, Knight of the Polar Star* (London, 1970), 33–34. Chambers traveled to China twice in the service of the Swedish East India Company. The drawings he made while he was there were published in 1757 in his *Designs for Chinese Buildings*. The House of Confucius was built in 1749 and was the first Chinoiserie garden structure in England.

38. Harris 1970, 34–35.

39. Burlington obtained a copy of Ripa's work (Wittkower 1974, 185) and Castell, in his *Villas of the Ancients*, reported hearing that the Chinese style was similar to that of the ancient Romans.

40. Wittkower 1974, 184. An album of drawings and watercolors of gardens, many in the Chinese style, by Thomas Robins the Elder is reproduced in John Harris, *Gardens of Delight, the Rococo English Landscape of Thomas Robins the Elder* (London, 1978).

41. Archer 1985, 265.

42. Harris 1970, 32.

43. Richard T. Godfrey, *Printmaking in Britain* (New York, 1978), 39. On Sandby, see Bruce Robertson, *The Art of Paul Sandby* [exh. cat., Yale Center for British Art] (New Haven, 1985).

44. Godfrey 1978, 59–60.

45. David Alexander and Richard T. Godfrey, *The Reproductive Print from Hogarth to Wilkie* [exh. cat., Yale Center for British Art] (New Haven, 1980), 22–23.

46. The primary works on Brown include Dorothy Stroud, *Capability Brown* (London, 1975), and Edward Hyams, *Capability Brown and Humphry Repton* (New York, 1971).

47. On Brown and Chambers, see Jacques 1985, 68–89.

48. On travel in England in the eighteenth century, see J. H. Plumb, *The Pursuit of Happiness, A View of Life in Georgian England*, with entries by Edward J. Nygren and Nancy L. Pressly [exh. cat., Yale Center for British Art] (New Haven, 1977), 5–11. On this quest for picturesque scenery, see Jacques 1985, 95–101; Hunt and Willis 1975, 337–341; Jane Clark, *The Great Eighteenth Century Exhibition* [exh. cat., The National Gallery of Victoria] (Melbourne, New South Wales, 1983), 99. See also Christopher Hussey, *The Picturesque, Studies in a Point of View* (London, 1927), 83–127.

49. Plumb 1977, 9–10 wrote that "viewing such houses was a part of summer travel, not only for dilettantes such as Horace Walpole, who meticulously planned his summer jaunts to take in as many houses as possible, but also for many ordinary men and women."

50. The etching, like all those in the book, was made by Angus; the original drawing for this particular scene is by Lord Viscount Duncannon.

51. Following the publications of Gilpin's theories, a controversy arose at the end of the eighteenth century, centered around the writers Uvedale Price and Richard Payne Knight, concerning the picturesque in landscape painting and its application to garden design. The first modern study to systematically and thoroughly examine the concept of the "picturesque" was Christopher Hussey, 1927. The literature has become extensive since Hussey's publication. Among the works that discuss the "picturesque" are: Carl Paul Barbier, *William Gilpin: His Drawings, Teaching and Theory of the Picturesque* (Oxford, 1963); Nikolaus Pevsner, *Studies in Art, Architecture and Design* (London, 1968), 78–101; Martin Price, "The Picturesque Movement," in *From Sensibility to Romanticism*, Frederick Whiley and Harold Bloom, eds. (New York, 1965); John Sunderland, "Uvedale Price and the Picturesque," *Apollo* (1971), 197–203.

52. Watkin 1982, vii.

53. Claude Lorrain's seventeenth-century landscapes were idealized, serene, and spacious; they were also frequently pervaded with the soft light of early day or twilight. During the eighteenth century, English collectors avidly acquired Claude's work, and today a great number of his paintings are still in Great Britain. On Claude, see H. Diane Russell, *Claude Lorrain, 1600–1682* [exh. cat., National Gallery of Art] (Washington, 1982–1983).

54. Christopher White, *English Landscape 1630–1850: Drawings, Prints and Books from the Paul Mellon Collection* [exh. cat., Yale Center for British Art] (New Haven, CT, 1977), xiv.

55. On Parkyns, see Eleanor M. McPeck, "George Isham Parkyns, Artist and Landscape Architect, 1749–1820," *The Quarterly Journal of the Library of Congress* 30 (1973), 171–181. Thomas Jefferson tried unsuccessfully to acquire a copy of Parkyns' book and to solicit his aid in designing the gardens at Monticello during Parkyn's trip to America between 1794 and 1800; see Frederick Doveton Nichols and Ralph E. Griswold, *Thomas Jefferson, Landscape Architect* (Charlottesville, 1981), 86–88; William Howard Adams, *The Eye of Thomas Jefferson* [exh. cat., National Gallery of Art] (Washington, 1976), nos. 549, 562.

56. This plan can be compared to the drawing by Capability Brown for the park at Kirtlington, reproduced in Gervase Jackson-Stops, The Treasure Houses of Britain: Five Hundred Years of Private Patronage and Art Collecting [exh. cat., National Gallery of Art] (Washington, D.C., 1985–1986), no. 352.

57. Plumb 1977, 3.

58. The most important work on Laroon is Robert Raines, *Marcellus Laroon* (London, 1966).

59. Another drawing produced a year later appears in Raines 1966, fig. 67.

60. Raines 1966, 5, discussed Lauron, whose work he called "essentially Dutch in style."

61. Plumb 1977, 21: "The burgeoning of the print market was due to the development of the satirical print. The freedom of English life, the lack of any form of literary censorship, opened up a field of social and political satire that was quite unique in eighteenth-century Europe." A number of the print shops that flourished during the late eighteenth century specialized in caricature and satire: see Brenda D. Rix, *Our Old Friend Rolly, Watercolours, Prints, and Book Illustrations by Thomas Rowlandson in the Collection of the Art Gallery of Ontario* [exh. cat., The Art Gallery of Ontario] (Toronto, 1987), 1–2, 8.

62. Rowlandson was "the only Englishman of his time to draw the figure with the accurate ease of the French," according to Mayor 1971, on pages with illustrations 601–602. He owned prints after the works of Watteau, Fragonard, and Boucher and "never abandoned the curving lines, decorative colour, and overall surface patterning of the rococo style" (Rix 1987, 4).

63. See below, 143–144. Rowlandson died at the age of seventy in 1827.

64. Joseph Grego, *Rowlandson the Caricaturist* (New York, 1970), vol. 1, 156. There were apparently no less than sixty-four such public amusement gardens in London by the early 1780s (Rix 1987, 44); Vauxhall and Ranelagh, across the Thames in Chelsea, were two of the most popular. All classes of society came to the gardens; in the words of Horace Walpole, "You can't set your foot without treading on a Prince of Wales or Duke of Cumberland. The company is universal: there is from his Grace of Grafton down to the children out of the Foundling Hospital" (quoted by Clark 1983, 125). See also Warwick Wroth, *The London Pleasure Gardens* (Hamden, CT, 1979), 286–326; David Coke, "Pleasure Garden" in *The Oxford Companion to Gardens* (New York, 1986), 441–443; Michael Snodin, *Rococo Art and Design in Hogarth's England* [exh. cat., The Victoria and Albert Museum] (London, 1984), 75–81.

65. John Baskett and Dudley Snelgrove, *The Drawings of Thomas Rowlandson in the Paul Mellon Collection* (New York, 1978), 14.

66. Quoted in Grego 1970, 62–63. The figures are identified in Grego 1970, 158–160 and Baskett and Snelgrove 1978, 14.

67. The drawing is in the Victoria and Albert Museum; see Jonathan Mayne, "Rowlandson at Vauxhall," *Victoria and Albert Museum* 4 (1968), 77–81.

68. Rix 1987, 8.

69. Grego 1880, 62, and Rix 1987, no. 18.

70. It was only later in the eighteenth century that French architects began to feel the influence of and to express the new social ideas that finally culminated in the French Revolution, which in turn caused nearly all building activity to cease. On this period in the history of French architecture, see Allan Braham, *The Architecture of the French Enlightenment* (New York, 1980).

71. Contemporary writers, such as Jean-Jacques Rousseau, were important spokesmen for the idea of a return to a pastoral state of nature as a solution to civilized man's deep social problems. On Rousseau's connections with contemporaneous garden design, see Dora Wiebenson, *The Picturesque Garden in France* (Princeton, 1978), 29–30, 70.

72. On the earliest picturesque gardens in France, see Wiebenson 1978, 3–22.

73. For a thorough analysis of the connections between English and French gardens of this period, see Wiebenson 1978. The work of Sir William Chambers was more enthusiastically received in France than it had been in England (Wiebenson 1978, 20–22, 39, 42).

74. Wiebenson 1978, 44.

75. On Moulin-Joli, see Wiebenson 1978, 15–19.

76. Rousseau later befriended Louis-René Girardin, who also wrote an important treatise on landscape architecture and designed a picturesque garden at Ermenonville, where Rousseau spent his last days and was finally buried.

77. Laborde initiated the publication of several series of illustrated travel volumes with his *Voyage Pittoresque de la Suisse* in 1776. This was followed by the Abbé de Saint-Non's *Voyages Pittoresques* for Naples and Sicily in 1781–1786, and Choiseul-Gouffier's for Greece in 1782–1804. Laborde then produced two illustrated series on France, *Voyage Pittoresque de la France* and *Description Générale et Particulière de la France*, both appearing between 1781 and 1796. Another important source for illustrations of late eighteenth-century French gardens is Alexandre de Laborde's *Description des Nouveaux Jardins de la France*, Paris, 1808. Alexandre was the son of the vastly wealthy banker Jean-Joseph Laborde, who created the famous *jardin anglais* at Méréville between 1784 and 1794. On *Description de Nouveaux Jardins*, see Woodbridge 1986, 276–277.

78. Wiebenson 1978, 15.

79. Quoted by Wiebenson 1978, 17.

80. Plates 82–85 in volume 10.

81. Colin Eisler, *Paintings from the Samuel H. Kress Collection* (Washington, D.C., 1977), 345–346. The original gouache no longer survives—see Georges Wildenstein, *Un Peintre de Paysage au XVIIIe siècle: Louis Moreau* (Paris, 1923), 29.

82. Wildenstein 1923, 27.

83. On the pavilion and its garden, see Barbara Scott, "Bagatelle, Folie of the comte d'Artois," *Apollo* 95 (June, 1972), 476–485.

84. Blaikie's and Belanger's plans are illustrated in Scott 1972, figs. 17, 18.

85. Eisler 1977, 347.

86. *The Terrace of a Château* is so dated by Eisler 1977, 347.

87. Eisler 1977, 346–347. Wildenstein 1923 included twelve reproductions of Moreau drawings with monumental stairways in his monograph, but not the present work. Saint Cloud is not the subject of this drawing; for illustrations of Saint Cloud, see Hazelhurst 1980, 273–299.

88. Victor Carlson and John W. Ittmann, *Regency to Empire, French Printmaking 1715–1814* [exh. cat., Baltimore Museum of Art] (Baltimore, 1984), 234. Although Moreau preferred to work in gouache, he also executed sixty-nine etchings, mostly of gardens and idyllic landscapes.

89. See the bibliography in Eisler 1977, 345.

90. James G. Barber and Frederick S. Voss, *Blessed Are the Peacemakers* [exh. cat., National Portrait Gallery] (Washington, 1983), 18.

91. The *fête galante* is an idealized scene, usually out of doors, where figures—sometimes Arcadian—gather for "gallant and amorous" entertainments. On Watteau and the *fête galante*, see Donald Posner, *Antoine Watteau* (Ithaca, 1984), 128–181; Robert C. Cafritz, Lawrence Gowing, and David Rosand, *Places of Delight: The Pastoral Landscape* [exh. cat., The Phillips Collection in association with the National Gallery of Art] (Washington, 1988), 149–181.

92. The garden is the site of Watteau's painting *La Perspective*, illustrated in Margaret Morgan Grasselli and Pierre Rosenberg, *Watteau 1684–1721* [exh. cat., National Gallery of Art] (Washington, D.C., 1984), 301. Crozat's garden was also a favorite place, later in the century, of Rousseau, the great apostle of the Cult of Nature.

93. Adams 1979, 104. Posner 1984, 148, believed that Watteau, in his *La Perspective*, may have made Crozat's garden look more overgrown than it actually was in order to suit his own taste.

94. Grasselli and Rosenberg 1984, no. 70.

95. Grasselli and Rosenberg 1984, 137.

96. Victor Carlson, *Hubert Robert, Drawings and Watercolors* [exh. cat., National Gallery of Art] (Washington, D.C., 1978), 20, 54; Eunice Williams, *Drawings by Fragonard in North American Collections* [exh. cat., National Gallery of Art] (Washington, D.C., 1978), 20.

97. The same site that appears in Stefano Della Bella's *Medici Vase* (cat. 44).

98. Carlson and Ittmann 1984, 258.

99. Carlson and Ittmann 1984, 258.

100. See Jean de Cayeaux, *Hubert Robert et les Jardins* (Paris, 1987), 26–29.

101. The curatorial staff of the prints and drawings department and the staff of the paper conservation department at the National Gallery of Art agree that the drawing was probably counterproofed. This process, in which a wet piece of paper is pressed against the drawing to transfer the image, decreases the contrast of light and dark in the original.

102. In another drawing of what appears to be the same garden, Robert shows the sun coming into the garden from the opposite angle (see Cayeaux 1987, fig. 11).

103. Victor Carlson dated another drawing of a garden that is executed in a similar manner to 1783–1785 (Carlson 1978, no. 27).

104. On Robert's use of hatching lines, see Carlson 1978, 54.

105. Cayeaux 1987 summarized the connection between Robert's two careers: "Hubert Robert, après avoir peint des jardins italiens, soit devenu un maitre des jardins, un véritable peintre des jardins" (63).

106. Cayeaux 1987, 15–19, 63–69, 91–93.

107. Williams 1978, 20.

108. On Fragonard's stay at the Villa d'Este, see Williams 1978, 20; Pierre Rosenberg, *Fragonard* [exh. cat., The Metropolitan Museum of Art] (New York, 1987–1988), 94–96.

109. This drawing was attributed to Robert by Eisler 1977, 23.

110. See Williams 1978, 42, who believed that the work was counterproofed.

111. Eisler 1977, 23–24.

112. Eisler 1977, 24.

113. Williams 1978, 98; Williams also discussed Fragonard's development of his wash technique during this trip to Italy and stated that Fragonard "liberates brushstrokes from their conventional role of filling in areas of underdrawing," 22.

114. As shown by Williams 1978, 98.

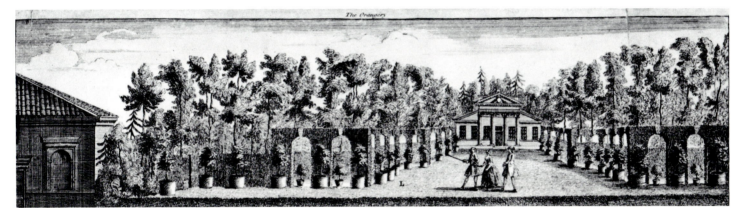

The Orangery

Cat. no. 73, detail

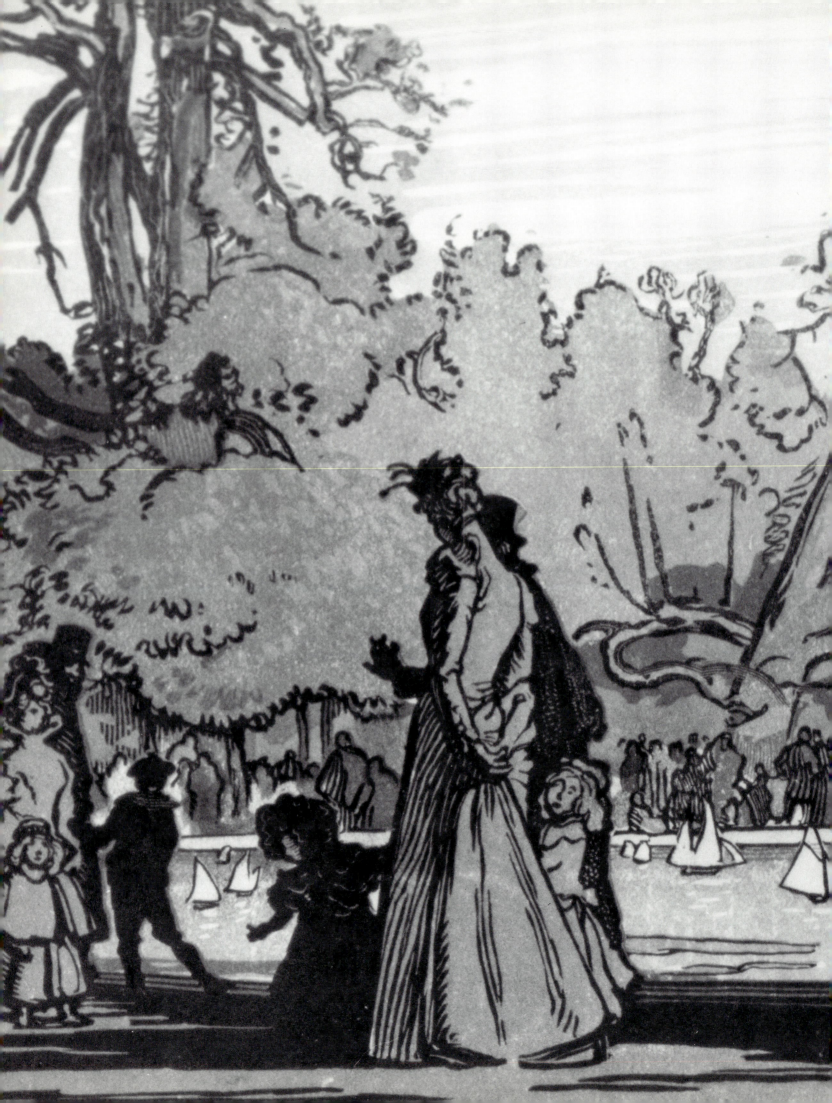

Chapter V

NINETEENTH-CENTURY GARDENS

The nineteenth century witnessed dramatic changes in the iconography of gardens in art, as well as in the graphic techniques that were used to represent these motifs. Nearly all the post-medieval gardens that we have discussed have been great estates or royal properties. In the nineteenth century, artists for the first time portrayed a preponderance of small middle class gardens and public parks. At the same time, artists began to experiment with graphic processes, inventing new techniques that allowed them to represent tonal qualities in addition to line, and color rather than merely black and white. The most significant new method of printmaking was lithography, a technique invented at the end of the eighteenth century that became an important vehicle of artistic expression in the nineteenth century. Although it fell into disuse during the middle of the century, major artists began to employ it again during the 1860s and to use color lithography in the 1880s and 1890s.[1]

The transition to new garden iconography in art reflected developments that were occurring in garden design as much wider concern was shown for the design and maintenance of small gardens for the rapidly growing middle class, and for the development of urban, public parks to provide healthful recreational spaces for the inhabit-

ants of dangerously overcrowded, post-industrial cities. Meeting the new demand from the middle classes for information about gardening, a tremendous surge occurred in the publication of illustrated garden books and journals, works that also frequently advocated the creation of public parks in modern cities. As the century progressed, these publications became increasingly inexpensive when new, economical techniques of printing text and color illustrations were developed. Foremost among the popular garden writers in England was John Claudius Loudon, who in 1822 published the *Encyclopedia of Gardening*—the "major gardening reference work of the age."[2] The success of Loudon's extremely influential *Gardener's Magazine*, published beginning in 1826, encouraged the emergence of numerous competitors.[3] In France, the amateur gardening craze was served by numerous periodicals on horticulture that were among the more than 1300 illustrated journals beginning publication between 1830 and 1900.[4] Americans read intently many of the English garden publications and began to produce a good number of their own during the nineteenth century. Andrew Jackson Downing, the first great landscape designer in the United States, was also the most influential garden writer. Downing edited the widely-read journal, *The Horticulturist*, from 1846

until his death in 1852, and wrote, among other books, the tremendously important *A Treatise on the Theory and Practice of Landscape Gardening* in 1841.[5]

Gardens in English Prints and Illustrated Books

Humphry Repton, the most successful garden designer in England during the early nineteenth century, was endowed with admirable skills in drawing and watercolor, and he put these talents to appropriate use both in furthering his landscape business and in creating illustrations for his five books on gardening.[6] He was initially a successor to and supporter of Capability Brown but later modified Brown's style significantly, allowing a certain formality in the garden near the dwelling in the form of parterres, fountains, and terraces.[7] Repton's outstanding success was partly due to his preparation for prospective clients of handsomely illustrated "Red Books." These oblong volumes, bound in red morocco, included watercolors of his clients' properties with movable flaps showing views before and after his proposed changes to the landscape.[8] In his *Observa-*

tions on the Theory and Practice of Landscape Gardening of 1805, Repton reused text and illustrations from a number of the Red Books he had put together for past clients.

In a passage from *Observations on the Theory and Practice of Landscape Gardening*, excerpted from his Red Book on Valley Field, Repton described his taste for flower gardens, the kind of decorative feature that distinguished his garden style:

> *Rare plants of every description should be encouraged . . .but above all, there should be poles or hoops for those kinds of creeping plants which spontaneously form themselves into graceful festoons, where encouraged and supported by art.*[9]

With this section of text, he included an illustration of Valley Field's rather formally arranged flower garden; it shows creeping vines growing vigorously upon poles and trellises, and glorious beds of brightly colored flowers flanking a rectangular pool (fig. 14). The print is primarily aquatint, with some etching for details such as the fence above the foreground cascade. No credit is given to the artist who made the print; the hand-coloring was done by a

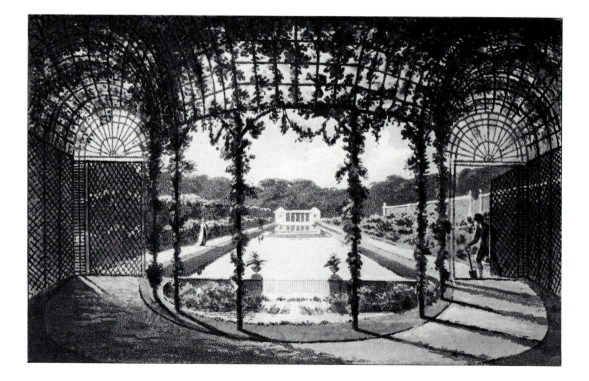

Fig. 14. Anonymous British 18th–19th Century, after Humphry Repton, *Flower Garden, Valley Field*, hand-colored etching and acquatint, 345 x 560 (13 ¹/₂ x 22), in Humphry Repton, *Observations on the Theory and Practice of Landscape Gardening* (London: J. Taylor, 1805). National Gallery of Art, Mark J. Millard Architectural Collection, David K. E. Bruce Fund 1985.61

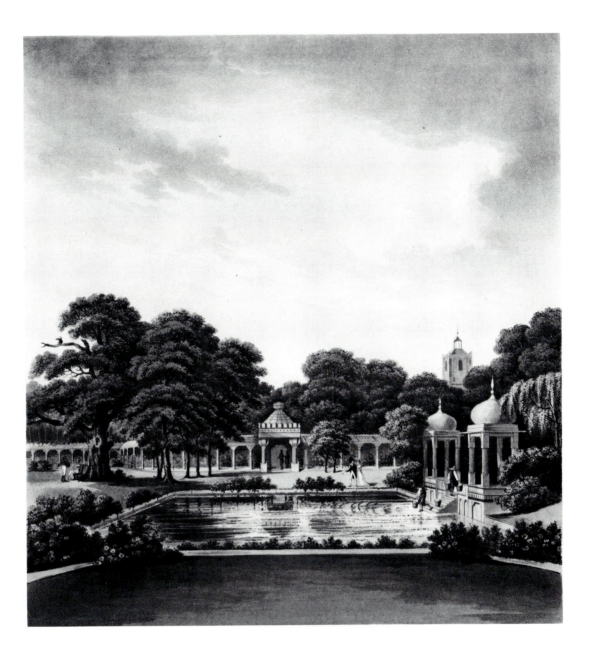

88. Anonymous after Humphry Repton (British, 18th–19th Century), *View from the Dome*, hand-colored etching and aquatint, 550 x 743 (21 5/8 x 29 1/4), in Humphry Repton, *Designs for the Pavilion at Brighton* (London: J. Taylor, 1806). National Gallery of Art, Mark J. Millard Architectural Collection 1985.61

workshop of children under the direction of a Mr. Clarke.[10]

Repton's garden style was readily adaptable to small spaces as well as great. He made a point of mentioning this in the text of his *Designs for the Pavilion at Brighton*, a deluxe, folio volume published in 1806, explaining that the garden he had designed for the Prince Regent could "be extended to every other place, from the ornamental cottage to the most superb mansion."[11] A view of this garden shows an enclosed area of limited size with a profusion of flowers in small beds, a geometric pool of reduced scale, and a bench, all of which would be suitable in

smaller, private gardens as well as that of the Prince Regent (cat. 88).[12]

Thomas Rowlandson, whose *Vauxhall Gardens* was discussed above in connection with eighteenth-century pleasure gardens, lived and worked long enough to caricature gardeners of the rising middle class in the early nineteenth century. His *Butterfly Hunting* (cat. 89), a hand-colored etching of 1806, shows geometric flower beds in a small garden beside a house—exactly the type of garden whose design was beginning to be discussed in contemporary garden books and journals.[13] In the corner of the garden there was a greenhouse, an impor-

143

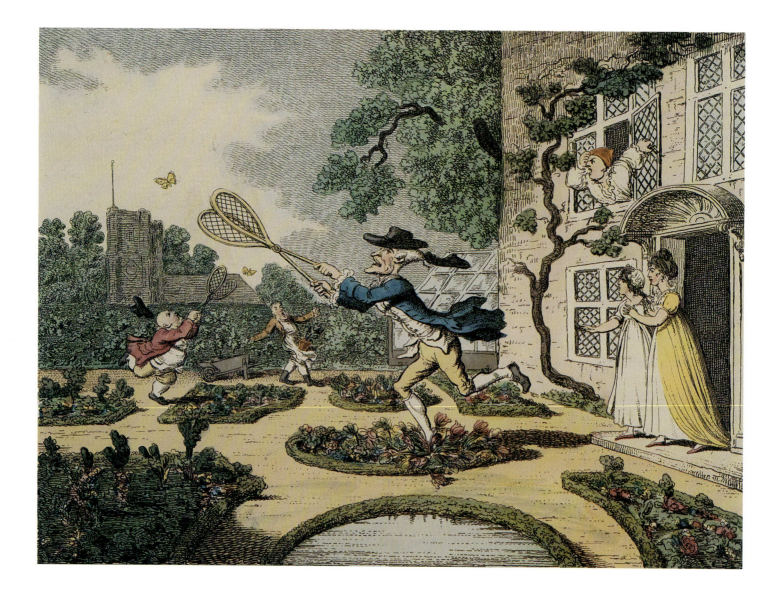

tant technical innovation of this era. Gardeners had nurtured tender plants in hothouses since the sixteenth century, but it was only in the late eighteenth and early nineteenth centuries—when enormous numbers of new, exotic plants were introduced into England from all over the world—that builders began to make these structures largely from glass. An enthusiastic, fashionable gardener of this period, like the frantic man at the window in Rowlandson's print, would likely have wanted to own a greenhouse in which he could raise special plants for his garden. In 1845, the tax on glass was lifted, and in 1847, a new process made possible the production of large sheets of glass. These tax changes and technical achievements helped make greenhouses afford-

able to reasonably affluent, middle-class gardeners.[14]

Two lithographs by James McNeill Whistler, *Confidences in the Garden* and *La Belle Jardinière*, show the artist's own small garden (cats. 90, 91).[15] In 1892, Whistler moved from London briefly to Paris and established residence on the rue du Bac.[16] It is the garden behind this house that is seen in these two lithographs. A city garden, small and walled, it is being enjoyed by members of the family. In *Confidences in the Garden*, Whistler's wife, Beatrix, is engaged in conversation with her sister Ethel; in *La Belle Jardinière*, Beatrix is attending a flowering plant held upright inside a support cage.

Public parks were the creation of the nineteenth century, and they were first estab-

90. James McNeill Whistler (American 1834–1903), *Confidences in the Garden*, 1894, lithograph, 324 x 206 (12 3/4 x 8 1/8). National Gallery of Art, Rosenwald Collection 1943.3.8720

91. James McNeill Whistler (American, 1834–1903), *La Belle Jardinière*, 1894, lithograph, 338 x 203 (13 1/4 x 8). National Gallery of Art, Rosenwald Collection 1943.3.8723

lished in England. There were antecedents to the public park in the promenades that royal or aristocratic proprietors graciously opened to the public and in privately owned pleasure gardens, like Vauxhall, that one could enter by paying a subscription or fee; but no parks were truly part of the public domain, accessible to all, until the forces of social reform in England began to rally on behalf of parks in the 1820s.[17] The evils of industrial society—the rampant spread of disease and crime in wretched mill towns and major cities—caused great alarm throughout England at this time. Public reformers believed that introducing an element of the countryside into industrial towns by means of public parks would help alleviate these problems by offering the working

classes the opportunity to improve their health, spirits, and morals in wholesome communication with nature.[18] By the middle of the nineteenth century, the parks movement was flourishing in England; the impact of garden design, once the exclusive province of the very rich, "was now extending down to the lowest classes, and was becoming a matter of public policy."[19]

The first public parks in working-class neighborhoods in London were built during the middle decades of the nineteenth century. Prior to that time, most of the city's parks were in the more affluent West End, and some of these were not public. Kensington, one of the most popular West End parks, had been a royal property since the late seventeenth century. The neighborhood sur-

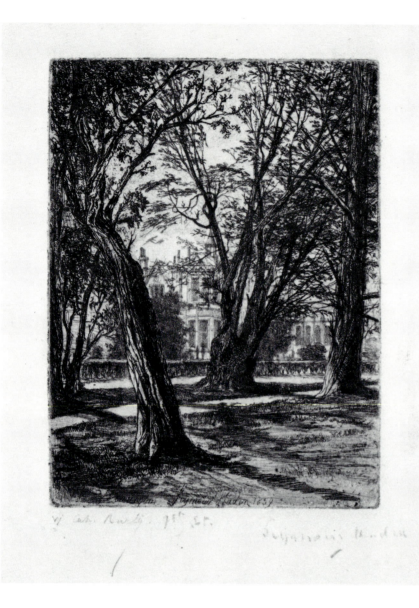

and shade cast by the branches of venerable trees. The twisted, gnarled trunks on which he has focused possess the noble character of great antiquity. In the background of Haden's print is Lord Harrington's house, one of the neighborhood's fashionable residences.

Gardens in French Graphic Art

The revolutionary change in the iconography of gardens in art is especially evident in the last decades of the nineteenth century in France. For the first time, bourgeois gardens and public parks took priority as subjects over the great private gardens. These new garden themes were the contribution primarily of French impressionist artists who departed from the traditional manner of representing the world to seek both fresh motifs and novel modes of visual expression. Images from the daily life of the modern middle class offered much greater appeal to impressionist artists than heroic, classical landscapes and historical themes. Even more radical was their method of representing their subjects. The impressionists tried to recreate the sensation that light produces as it becomes optical perception. In their paintings and color prints, this led to the application of discrete strokes of pure, unmixed colors that appear to shimmer before the viewer's eye like sunlight reflecting off the surfaces of the objects portrayed. Even in their black and white drawings and prints, light-filled atmosphere seems to be an almost tangible presence and solid form appears to consist of reflected sunlight.

With their affection for scenes of familiar bourgeois life and their commitment to depicting the light and atmosphere of the outdoor world, impressionists favored gardens as subjects, often their own or those of their friends.[23] Claude Monet, whose garden at Giverny was the subject of many of his late paintings, reportedly said, "I perhaps owe having become a painter to flowers."[24]

When Camille Pissarro arrived in France in 1855, he felt an immediate affinity with the painters of the Barbizon School.[25] This group of artists prepared the way for the im-

92. Francis Seymour Haden (British, 1818–1910), *Kensington Gardens, The Small Plate (Lord Harrington's House from Kensington Gardens)*, 1859, etching with drypoint, 159 x 118 (6 1/4 x 4 3/4). National Gallery of Art, Gift of Miss Elisabeth Achelis 1942.6.41

rounding the park was the home of upper middle class citizens, including many of the more successful artistic and literary figures of the day.[20] In 1859, Francis Seymour Haden, Whistler's brother-in-law and president of the Royal Society of Painter-Etchers, made two splendid prints of Kensington Park in etching and drypoint.[21] One of these—entitled *Kensington Gardens, The Small Plate*—was published in *A Selection of Etchings by the Etching Club* in 1865 (cat. 92). Around 1858, Haden had begun to specialize in depictions of landscape, working in a style that has been called "romantic naturalism."[22] This print exemplified Haden's approach to nature in its charming evocation of the fluctuating pattern of sunlight

93. Jean-Baptiste Millet (French, 1831–1906), *A Sunlit Garden*, black chalk with gray wash, 267 x 360 (10 1/2 x 14 1/8). National Gallery of Art, Julius S. Held Collection, Ailsa Mellon Bruce Fund 1984.3.20

pressionists in their preference for rustic landscapes and scenes of peasant life— subjects that Pissarro would continue to portray throughout his career. Jean-Baptiste Millet's *A Sunlit Garden* (cat. 93), a black chalk and gray wash drawing of a humble backyard garden in a rural village, typifies the environment that the Barbizon artists chose to depict.[26] But Pissarro differed from the Barbizon painters in that he preferred to take a more modern, direct approach to his subjects rather than appealing to his viewers with the sentimental attitude that sometimes characterized the works of the Barbizon School.[27] During the 1870s, he came under the influence of Monet and adopted his impressionist theories; in the 1880s, he revised his style again according to the ideas of Georges Seurat and the neo-impressionists,

who further refined impressionist color theory according to contemporary developments in the science of optics. It was probably in the late 1880s that Pissarro made his exceedingly delicate and lovely watercolor, *Woman Weeding in a Garden* (cat. 94). During this period, he began to bring his figures into the foreground and to emphasize their connection with the earth, as with the woman in this drawing. Also typical of this period, the ground plane is tilted, the atmosphere is flooded with form-dissolving light, and the pale colors are applied in distinct, choppy brushstrokes.

Pissarro was also an avid printmaker. He tried all the graphic media at one time or another and struggled mightily with the sometimes recalcitrant processes, often reworking his plates again and again.[28] Some of his

94. Camille Pissarro (French, 1830–1903), *Woman Weeding in a Garden*, watercolor over black chalk, 252 x 174 (10 x 6 7/8). National Gallery of Art, Ailsa Mellon Bruce Collection 1970.17.167

95. Camille Pissarro (French, 1830–1903), *Woman Emptying a Wheelbarrow*, 1880, aquatint and drypoint, 460 x 356 (18 x 14). National Gallery of Art, Rosenwald Collection 1943.3.7311

most successful efforts were made in aquatint. His *Woman Emptying a Wheelbarrow* of 1880 (cat. 95), which combines aquatint and some drypoint, shows why this medium was so eminently suitable to his impressionist style.[29] The inherently grainy texture of aquatint, which Pissarro managed to intensify in many areas of his plate, creates an almost pointillist effect of glimmering light. Forms depicted in this technique, which Pissarro sometimes outlined in white, seem to lose their solid, material presence. Uniform, unifying light creates a scene that appears to radiate from the surface of the sheet.

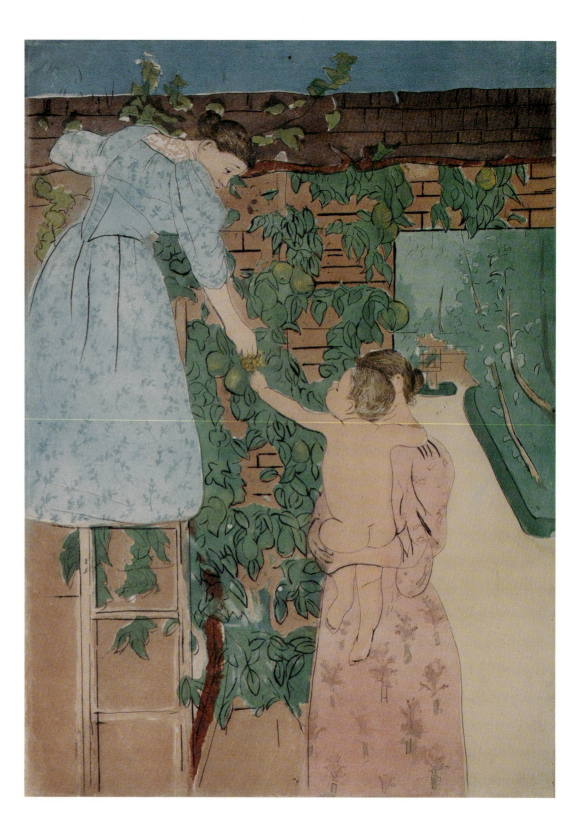

96. Mary Cassatt (American, 1844–1926), *Gathering Fruit*, c. 1893, drypoint and aquatint in color, 423 x 300 (16 5/8 x 11 3/4). National Gallery of Art, Rosenwald Collection 1943.3.2757

The American artist Mary Cassatt lived and worked in Paris starting in 1865, when she was twenty-two years old. She became closely involved with the impressionist artists whose work she had seen soon after her arrival in Paris. She began exhibiting with them in 1877 and was especially influenced by Degas, who became her frequently difficult but generally inspiring friend. Around 1879, Cassatt, Degas, and Pissarro began to experiment with printmaking techniques. In 1890, Cassatt and Degas visited an exhibition of Japanese prints that profoundly impressed both artists and had a great impact on Cassatt's work. This impact appears mainly in her graphic art and specifically in her development of an original color-printing process in which she used metal plates to imitate the Japanese color woodblock technique.[30] When she exhibited a set of ten color prints in 1891, it was clear that these graphic works would number among her greatest creative efforts. Her brilliantly colored *Gathering Fruit* of 1893 (cat. 96) reveals the continuing influence of Japanese art in the bold flattening of form and purified, sinuous line.[31]

Like Pissarro's two works, this print displays the frequent impressionist image of women in a garden. But Cassatt's garden is more *haute-bourgeois*, and the women are clearly here for pleasure, to pick ripe fruit for the baby, rather than to perform manual labor like Pissarro's peasant women. It is a small, walled garden—possibly the one attached to Cassatt's villa at Marly-le-roi—with fruit espaliered for the household's visual and gustatory pleasure. A path leads into a further garden space flanked by flower beds and terminating at a sundial. *Gathering Fruit* is typical of Cassatt's work in its direct focus upon the human figures and its use of landscape only as a background for tender scenes of domestic life. Cassatt often used members of her own family as models; the figures in this print may be her sister-in-law and niece or nephew with her maid, Mathilde.

Two of the most important French artists to employ color lithography were Pierre Bonnard and Edouard Vuillard. Bonnard, who was born in 1867, was the first to ex-periment with color lithography. In 1891, he produced a series of advertising posters that drew broad acclaim and interest from fellow artists. The creative milieu in Paris was especially diverse and stimulating at the time as painters who had worked in the impressionist style were seeking a more complex and profound language of visual communication. It was, in part, Bonnard's success with lithography that led other artists, like Toulouse-Lautrec, to adopt it as the graphic medium most suitable to their new modes of expression. Bonnard belonged to a group of artists who called themselves the nabis—from the Hebrew word for "prophets"—and who delighted in the use of strong colors and bold, linear patterns, often conveyed through the medium of lithography.

Bonnard's five-color lithograph, *The Orchard* (cat. 97), was printed in 1899 for publication in an album entitled *Germinale* that also included works by Renoir, Vuillard, and Toulouse-Lautrec.[32] It portrays an idyllic garden, a simple country orchard that dazzles the viewer with brilliant, alluring color and charms with a sense of comfortable well-being in domestic pleasures. Bonnard conveyed his content through the use of intense color, giving it an almost spiritual energy. Space and form were clearly nonessential elements, and the figures were sometimes nearly indistinguishable from their setting. The orchard was precisely the type of garden that had the greatest appeal to artists in the nineteenth century: a setting both familiar to ordinary life and beguiling in its abundance of light and color.

Vuillard represented his own garden in his eight-color lithograph of 1901, *The Garden Outside the Studio* (cat. 98).[33] Looking down from his window, he pictured his verdant, urban oasis with a woman, probably his mother, seated on a chair, sewing. Because many of the artists of this period worked almost exclusively in the city of Paris, such small, urban gardens were an important subcategory in the representation of gardens in nineteenth-century art. Vuillard, like his friend Bonnard, belonged to the nabi group and preferred to choose subjects from the familiar world around him. Also like Bonnard, his figures tended to blend into his

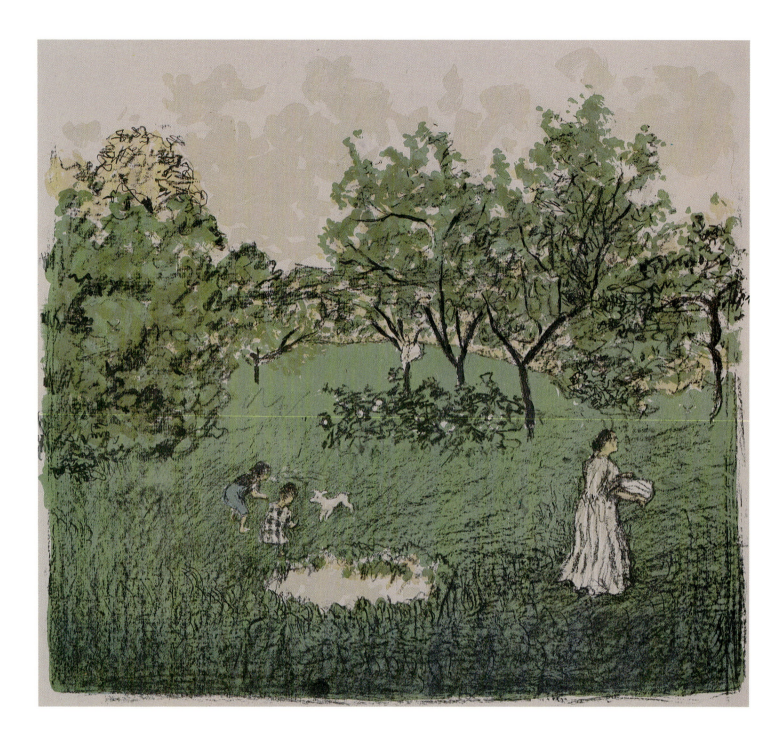

97. Pierre Bonnard (French, 1867–1947), *The Orchard*, 1899, five-color lithograph, 336 x 365 (13 ¼ x 14 ⅜). National Gallery of Art, Rosenwald Collection 1951.16.10

decorative schemes, to become part of his abstract color harmonies. These color harmonies were sometimes much lower keyed than those of Bonnard, however, and have been compared to a "whispered chorus of low notes in a minor key."[34] In this lithograph, grays and gray-greens are predominant, with just a few significant touches of

orange and pink. Gray and green are overlayed with orange and pink to create mixed tones.

The movement for public parks in England quickly spread to other countries, particularly France and the United States. Napoleon III spent part of the 1840s in exile in London and observed the parks move-

98. Edouard Vuillard (French, 1868–1940), *The Garden Outside the Studio*, 1901, eight-color lithograph, 630 x 480 (24 3/4 x 18 7/8). National Gallery of Art, Rosenwald Collection 1952.8.537

ment in its early, developing stages. On becoming emperor in 1852, he decided to redesign Paris with a network of broad avenues—partly for added security and crowd control—and to incorporate a system of parks, both large and small, for the benefit of the city's inhabitants.[35] He appointed Baron Georges Eugène Haussmann as Pre-

fect of the Seine in 1853 to carry out his proposals. Haussmann and his engineer, Jean-Charles-Adolphe Alphand, began immediately to alter the face of Paris, to transform the squalid, crowded city into the City of Light. The grand, tree-lined boulevards and 4,500 acres of parks that have epitomized the city's character ever since are

99. Auguste Lepère (French, 1849–1918), *The Pond in the Tuileries*, 1898, chiaroscuro woodcut, 218 x 335 (8 5/8 x 13 1/4). National Gallery of Art, Ailsa Mellon Bruce Fund 1975.33.4

100. Edouard Vuillard (French, 1868–1940), *The Tuileries*, 1896, four-color lithograph, 396 x 251 (15 3/4 x 9 7/8). National Gallery of Art, Rosenwald Collection 1943.3.9061

154

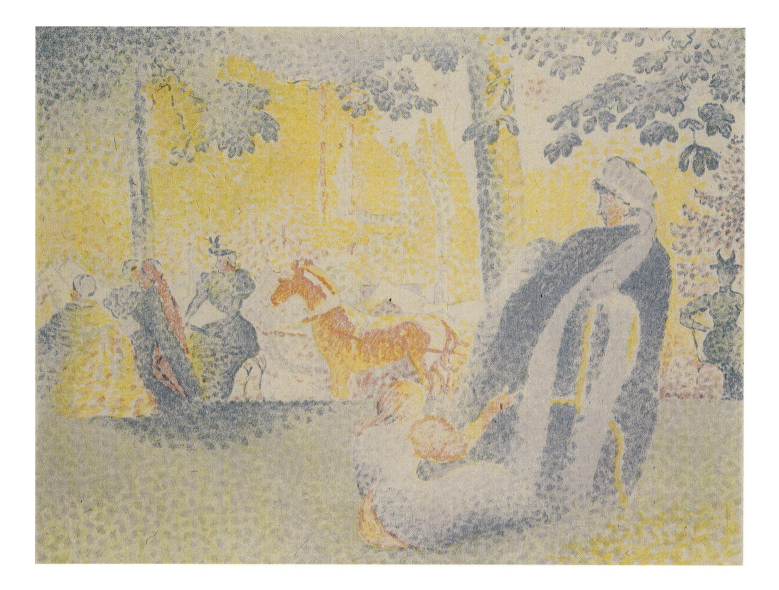

101. Henri-Edmond Cross (French, 1856–1910), *Les Champs-Elysées*, 1898, five-color lithograph, 259 x 316 (10 1/4 x 12 1/2). National Gallery of Art, Gift of Mr. and Mrs. Burton Tremaine 1971.86.8

the result of this enormously successful effort. By the 1860s, Paris was Europe's preeminent city for walking and sightseeing.

At the end of the nineteenth century, Parisian artists were irresistably drawn to the city's parks, where they found endless opportunities to depict familiar outdoor activities that had always inspired them. Of all the city's parks, the gardens of the Tuileries were a favorite among artists of the day. Unlike the parks in the working-class areas of Paris, the Tuileries attracted a fashionable, affluent crowd. Here polite society would meet and converse while well-bred children engaged in gentle play. A color woodcut by Auguste Lepère, *The Pond in the Tuileries* of 1898 (cat.

99), recorded such a scene of gracious deportment. Lepère, who is best known for his highly accomplished wood engravings in illustrated journals of the period, used six color blocks to print this woodcut, an elegant expression of the pursuit of pleasure in the brilliant sunlight of the late afternoon. Deep shadows heightened the effect of the dazzling light that spread across the landscape from a low angle in the sky. Another depiction of this park, Vuillard's *The Tuileries* (cat. 100), appeared in the *Album des Peintres-Graveurs* published by Edouard Vollard in 1896.[36] This four-color lithograph also focused on the human activity that enlivened the park, although—typical of Vuil-

102. Edouard Vuillard (French, 1868–1940), *The Square*, brush and black ink, 646 x 500 (25 ½ x 19 ¾). National Gallery of Art, Collection of Mr. and Mrs. Paul Mellon 1985.64.116

lard's style—the human presence merged with the intense light characterized by the somewhat pungent yet subtle color harmony.

The avenue of the Champs-Elysées continued the central axis of the Tuileries westward, beyond the garden, for a mile and a quarter to the Arc de Triomphe at the Place de l'Etoile. The Champs-Elysées, or Elysian Fields, had been the property of the city of Paris since 1828, and thus one of the few parks in Paris before the construction program of Napoleon III. It was a favorite promenade for Parisians and one of the sites that was improved by Alphand. In 1898, *Pan*, an international periodical of art and

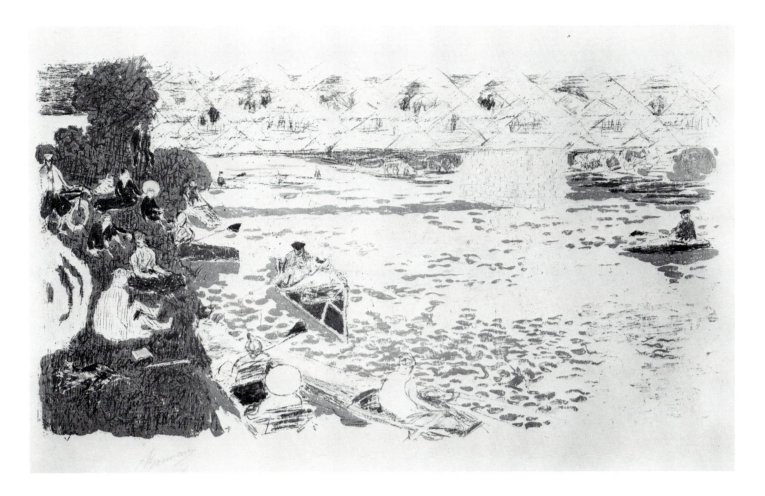

literature, published a five-color lithograph of the Champs-Elysées by Henri-Edmond Cross (cat. 101).[37] Cross, who came to Paris in 1881, became involved with the impressionists and exhibited at the Salon des Indépendants starting in 1884. By 1891, he came under the influence of Georges Seurat and his neo-impressionist style. Following Seurat's methods, Cross has arranged small dots of colors on his surface, allowing the viewer's eye to mix them and thus, he believed, experience a sensation that would evoke a truer, more intense perception of color.

In addition to the vast park and boulevard system, Haussmann adorned Paris with an assortment of lovely, landscaped squares. These too, in conjunction with views of the city's streets, became a favorite subject of late nineteenth-century French artists. One of the most charming depictions of a city

square is Vuillard's undated brush and black ink drawing, *The Square* (cat. 102). The simplicity of his execution adroitly conveys the sense of a light-filled, salubrious space that such verdant intervals in the city created. There is an irrepressible cheerfulness in the busy, sparkling foliage that amply bedecks the trees and beds of the square.

The rivers of Paris became yet another popular theme for such artists as Bonnard, who in 1897 made the splendid, four-color lithograph, *Boating* (cat. 103). The urban reformers' vision of healthful recreation for the lower and middle classes would seem to have been realized in this light-filled, cheerful scene of wholesome escape from the hazards of urban, industrial life.

Gardens were not a common subject in American graphic art in the first half of the nineteenth century, though they sometimes appeared as secondary motifs in works devoted to other subjects. The writings of the English aesthetician, John Ruskin, closely read by American artists following the introduction of the texts in the United States after 1847, seem to have effected an increased production of scenes of gardens and of wild flowers growing in fields and meadows.[38] Ruskin, who had a profound appreciation for floral beauty, recommended both careful fidelity to nature in the depiction of flowers and the portrayal of flowers in their natural settings.

Another likely source for the introduction of garden scenes in American art was French impressionism. American artists and collectors became acquainted with impressionism both through their travels in France, and through exhibitions of impressionist paintings held in the United States, such as the important show organized by the French art dealer Paul Durand-Ruel in New York in 1886. American artists added impressionist subjects, such as small gardens and parks, to their repertoire of favorite motifs as they began to adopt certain aspects of the impressionist style.

The type of domestic garden that most often figured in late nineteenth-century American art was the "wild" or "old-fashioned" flower garden that was actively promoted in contemporaneous gardening articles and books by American authors. The advocates of this style of gardening recommended planting the kinds of flowers "that grandmother grew"—which, for this generation, meant early American flowers—to create the effect of a bursting, natural bouquet of mixed colors.[39] This informal, closely planted type of flower garden, carrying sentimental associations with gardens of earlier times, and with the unspoiled, natural beauty long considered a primary asset of America, captivated the imagination of not only gardeners, but artists and writers during the late nineteenth and early twentieth centuries. Typical of the genre of garden

writing expressing this ideal was Alice Morse Earle's book, *Old Time Gardens*, published in 1901, following her 1896 article, "Old Time Flower Gardens."[40] Throughout the book, Earle made reference to her love of "old flower favorites":

> I find that my dearest flower loves are
> the old flowers,—not only old to me
> but old in cultivation.
> 'Give me the good old weekday blos-
> soms,
> I used to see so long ago,
> With hearty sweetness in their blooms,
> Ready and glad to bud and blow.'[41]

Similarly, W. Hamilton Gibson rhapsodized on the natural garden at the end of his article, "The Wild Garden":

> Verily may I say with Goethe, 'Some
> flowers are lovely only to the eye, but
> others are lovely to the heart.' Others,
> again, are lovely to the soul, and it is
> the wild garden alone that leads us into
> the clouds.[42]

It is precisely this type of natural garden, planted with old-fashioned flowers, that is portrayed in James Wells Champney's splendid gouache, *Garden in Old Deerfield* (cat. 104). Champney was born in Boston in 1843, and started working as an apprentice to a wood engraver when he was sixteen years old. He went to Europe in 1866 and studied both in Paris and Antwerp. In 1869, he exhibited in the Salon in Paris, and by 1873 he was back in the United States. He is best known for his genre scenes and portraits, but was also adept at the rendering of small-scale landscape vignettes, such as this humble flower garden in Deerfield, Massachusetts. Champney and his wife, Elizabeth, who wrote romantic novels about the American colonial period, were among the artists who settled, around the turn of the century, in Deerfield, an important center for both the Arts and Crafts Movement in America and the Colonial Revival.[43] Significantly, it was the hollyhocks and poppies—two favorite choices among the "old time" flowers of simple virtue—that had pride of place in Champney's garden. Far from a formally arranged garden, which would not have been

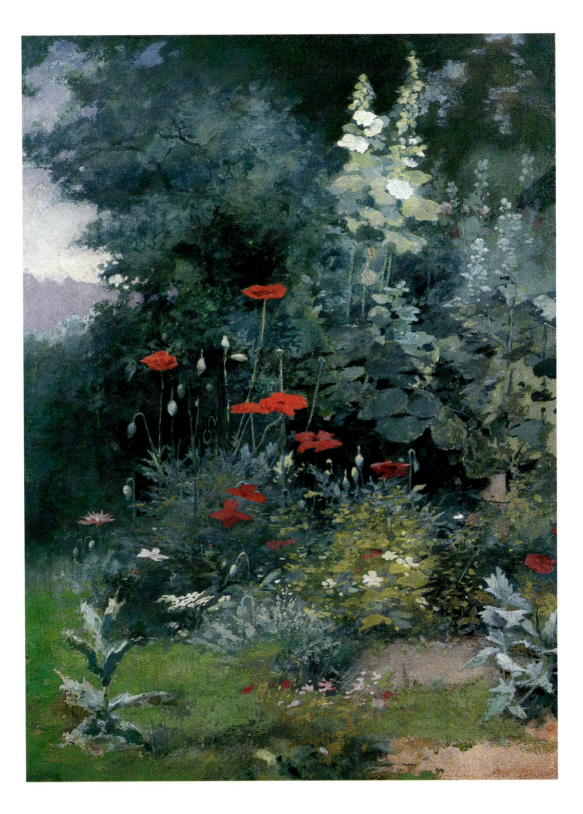

104. James Wells Champney
(American, 1843–1903), *Garden
in Old Deerfield*, c. 1900,
gouache, 384 x 274 (15 1/8 x
10 3/4). Private collection

105. Childe Hassam (American, 1859–1935), *Garden, Appledore*, c. 1890, watercolor, 335 x 254 (13 3/16 x 10). Mead Art Museum, Amherst College, Gift of William MacBeth, Inc. [1950.9]

particularly suitable for these homely specimens, this charming, flowering corner seems to have been left to follow its own fancy; the flowers in the foreground appear to have casually seeded themselves in the grass.[44]

Another small, private garden of the same general style was the subject of *Garden, Appledore* (cat. 105), by the American impressionist Childe Hassam. Hassam, who was born in Massachusetts in 1859, studied in Paris from 1886 to 1889.[45] Although his training there was academic, it was the work of the impressionist artists that most interested him and that served to inspire his own stylistic development. When he returned to the United States, he was quickly recognized as one of America's foremost impressionists. Hassam was relatively unconcerned with the theory behind impressionism; although he eagerly adopted the brilliant palette and distinctive brushstrokes, he did not systematically endeavor to evoke the optical sensation of light. He did, however, follow the impressionists in their choice of gardens as an especially worthy subject; he portrayed French gardens while he was still in Paris and returned to this theme with great success after arriving back in the United States.

Around 1884, Hassam began to spend his summers in a resort inn on Appledore Island, one of the Isles of Shoals off the coast of Maine and New Hampshire. The inn belonged to his friend Celia Thaxter, who had once taken watercolor lessons from him. Thaxter was a poet, well known in her day, and a devoted gardener; her inn was a sort of summer "salon" where American writers and artists congregated each year.[46] In Thaxter's garden, Hassam painted works that have been described as "his richest and most colorful excursions into this genre" and perhaps the most beautiful of his career.[47] In 1894, Thaxter published a book in which she described in wonderfully evocative language the joy and fulfillment she experienced in the endless toils that her garden exacted from her each year.[48] She, too, preferred the old flowers: "The list of flowers in my island garden is by no means long, but I could discourse of them forever! They are mostly the old-fashioned flowers our grandmothers loved. . .These are enough for a most happy little garden."[49] Hassam made a series of twenty-two watercolors for this book, to be used in the production of color-lithographic illustrations by Armstrong and Co., which in 1875 had merged with the book's publisher, Houghton Mifflin. *Garden, Appledore* (cat. 105) is one of these watercolors; the lithographic illustration made after it is called *Poppy Banks in the Early Morning* in the book, and it shows poppies, which, in their many varieties, were one of Thaxter's favorite flowers. She wrote of her Shirley Poppies: "I finished the afternoon by planting Shirley Poppies all up and down the large bank at the southwest of the garden, outside. I am always planting Shirley Poppies somewhere! One never can have enough of them."[50] In his watercolor, Hassam applied brilliant, vibrant colors in strokes filled with the kind of vital energy the garden itself seems to have generated. For the publisher, its translation into a color lithograph was clearly a labor of love that required immense effort in the preparation and printing of dozens of separate stones, one for each color.

A public parks movement began in America at about the time that it did in France, as industrialization caused the same social problems in American cities that had given rise to the parks movement in Europe. In America, the rural cemetery movement led the way for a recognition of the need for public parks.[51] Rural cemeteries were designed to provide beautiful, pastoral settings where the bereaved might find solace and moral upliftment in the combined presence of natural beauty and remembrance of human mortality. The extraordinary popularity of rural cemeteries, not just for burials but as places to escape the congestion and blight of cities, was an important factor in convincing city fathers that there was a need for public parks. Finally, in 1851, the mayor of New York officially called for the establishment of a park, and in 1853 the state legislature passed a bill providing for the creation of Central Park, the first great public park in America. An eleven-man commission was appointed to oversee the development of the Central Park with Frederick Law Olmsted as superintendent. A design compe-

106. Maurice Prendergast (American, 1858–1924), *Central Park, 1900*, 1900, watercolor, 365 x 545 (14 3/8 x 21 1/2). Collection of the Whitney Museum of American Art, N.Y., 32.41

tition was held and Olmsted, working with Calvert Vaux, former partner of the now-deceased Downing, designed the winning plan. Their vision of Central Park included extensive woodland and meadows with picturesque views throughout.[52]

As a center of leisure activity in New York, Central Park, like the Tuileries in Paris, became a favorite place for artists to portray the joyful, colorful aspects of contemporary life. American impressionists and post-impressionists like Maurice Prendergast were among those who made parks a frequent setting for their work.[53] Prendergast, who was born in Saint Johns, Newfoundland in 1859, studied in Paris from 1890 to 1891 and was profoundly influenced by the work of Vuillard and Bonnard. He adopted their use of flat areas of color, high horizons, and ambiguities of space and form. When he returned to America in 1894 or 1895, he fa-

vored beach and park scenes in which he could indulge his taste for brilliant, sunlight-washed color. During the last years of the nineteenth century, Prendergast was in New York and naturally found Central Park a subject much to his liking. Around 1900, he painted a series of watercolors of the park, including *Central Park, 1900* (cat. 106). He composed this scene in horizontal bands, a device he used frequently, and minimized spatial recession. Both the subject and his somewhat abstract method of presenting it indicate a close connection with the nabi group in France.

Central Park, 1900 clearly illustrates the separation of different types of traffic within the park, one of the most brilliant features of Olmsted's and Vaux's plan.[54] There were grand drives between the east and west sides for carriages and hackney coaches. Footpaths for pedestrians generally stayed close

to these carriage drives, "so that pedestrians may have ample opportunity to look at the equipages and their inmates."[55] A number of bridle trails also passed nearby and were carefully provided with underpasses when they crossed the carriage trails and footpaths.

Tremendous upheavals in the social order, occurring as the result of industrialization and a new political environment in the nineteenth century, were reflected in fundamental changes in the arts. New modes of representation evolved and were used to depict subjects directly related to the artist's experience of the world in which he lived. As the modern world began, new types of garden subjects emerged in the graphic arts—the small garden, tended by the newly-enfranchised middle classes of the industrialized, urbanized world, and the public park as an urban oasis for pleasant and healthful passage of leisure time. These garden images inspired some of the most splendid, colorfully appealing artistic efforts of the nineteenth century.

Notes

1. Among the histories of lithography in the nineteenth century, see Phillip Dennis Cate and Sinclair Hamilton Hitchings, *The Color Revolution: Color Lithography in France, 1890–1900* (Santa Barbara, CA, 1978); Phillip Dennis Cate, *Circa 1800: The Beginnings of Modern Printmaking, 1775–1835* [exh. cat., Baltimore Museum of Art] (Baltimore, 1981).

2. On the *Encyclopedia of Gardening*, see Brent Elliott, *Victorian Gardens* (Portland, OR, 1986), 12.

3. See Ray Desmond, "Loudon and Nineteenth-Century Horticultural Journalism," in MacDougall, 1980, 79–103.

4. On the amateur gardening craze and associated journals in France, see Sylvia Gache-Patin, "Private and Public Gardens," in Andrea P. A. Belloli, *A Day in the Country: Impressionism and the French Landscape* [exh. cat., Los Angeles County Museum of Art] (Los Angeles, 1984), 202–205. On French illustrated periodicals, see Colta Ives, "French Prints in the Era of Impressionism and Symbolism," *The Metropolitan Museum of Art Bulletin* 46 (1988), 4.

5. On Downing, see George Bishop Tatum, *Andrew Jackson Downing: Arbiter of American Taste, 1815–1852* (Ph.D. diss., Princeton, 1949).

6. His five books were: *Sketches and Hints on Landscape Gardening*, 1795; *Observations on the Theory and Practice of Landscape Gardening*, 1803; *An Inquiry into the Changes of Taste in Landscape Gardening*, 1806; *Designs for the Pavilion at Brighton*, 1806; *Fragments on the Theory and Practice of Landscape Gardening*, 1816.

7. In his *Observations on the Theory and Practice of Landscape Gardening*, first published in 1803, he wrote that it was a "false and mistaken taste" to put a "naked grass field" around a large house, that near the house one might "ornament the lawn with flowers and shrubs, and . . . attach to the mansion that scene of 'embellished neatness' that is usually called the Pleasure Ground," in Humphry Repton, *Observations on the Theory and Practice of Landscape Gardening* (London, 1805), 99. On the survival of the flower garden in eighteenth-century landscape design, see John Harris, "The Flower Garden, 1730–1830," in Harris 1979, 40–46. On Repton, see Dorothy Stroud, *Humphry Repton* (London, 1962); Edward Hyams, *Capability Brown and Humphry Repton* (New York, 1971), 115–216.

8. An illustration from the Red Book for Courteenhall is presented in Gervase Jackson-Stops 1985–1986, no. 354.

9. Repton 1805, 101.

10. Repton 1805, n. 7: "The art of colouring plates in imitation of drawings has been so far improved of late, that I have pleasure in recording my obligations to Mr. Clarke, under whose directions a number of children have been employed to enrich this volume."

11. Humphry Repton, *Designs for the Pavilion at Brighton* (London, 1806), iii.

12. The print, a hand-colored aquatint and etching, was made by J. C. Stadler after a drawing by Repton. Unfortunately, although the Prince was enthusiastic about Repton's plans, he could not afford to install the garden for ten years; at that time he turned the project over to Repton's former associate, John Nash, rather than using Repton's design. See Stroud 1972, 138–145.

13. Grego 1970, vol. 2, 61.

14. Elliott 1986, 17, 28–29.

15. Susan Hobbs, *Lithographs of James McNeill Whistler* [exh. cat., Smithsonian Institution Traveling Exhibition Service] (Washington, D.C., 1982), nos. 66, 67.

16. Hobbs 1982, 15–29.

17. On public parks in the nineteenth century, see Frank Clark, "Nineteenth-Century Public Parks from 1830," *Garden History* 1 (1973), 31–41. For a concise history of the public park, see Goode and Lancaster, in *The Oxford Companion to Gardens* 1986, 456–461.

18. Loudon was an important leader in the parks movement, publicizing it through articles in his *Gardener's Magazine* and *Encyclopedia of Gardening*. Apparently the death rate and incidence of crime were actually lowered in Macclesfield after a public park was built there in 1848, the same year that the Public Health Act was passed (Clark 1973, 34).

19. Elliott 1986, 54.

20. Donald Eager, *The Royal Parks* (London, 1986), 59–62.

21. Haden was a surgeon with an active, lucrative practice who etched only in his spare time. On Haden, see Malcolm C. Salaman, *The Etchings of Sir Francis Seymour Haden, P.R.E.* (London, 1923), 9; Richard S. Schneiderman, *A Catalogue Raisonné of the Prints of Sir Francis Seymour Haden* (London, 1983), 26.

22. Schneiderman 1983, 25.

23. See Gache-Patin 1984, 201–240.

24. On Monet and his garden at Giverny, see Claire Joyes and Andrew Forge, *Monet at Giverny* (London, 1975); Charles S. Moffett, James N. Wood, and Daniel Wildenstein, *Monet's Years at Giverny, Beyond Impressionism* [exh. cat., The Metropolitan Museum of Art] (New York, 1978).

25. On Pissarro, see Christopher Lloyd, *Pissarro* (London, 1979); Françoise Cachin et al., *Camille Pissarro, 1830–1903* [exh. cat., Museum of Fine Arts] (Boston, 1980).

26. Jean-Baptiste was the younger brother and student of Jean-François Millet, one of the leading members of the Barbizon School; he was born in 1831 and died in 1906.

27. Jean Leymarie and Michel Melot, *The Graphic Works of the Impressionists* (New York, 1971), 19–20. On Impressionist printmakers, see also Colta Ives, "French Prints in the Era of Impressionism and Symbolism," *The Metropolitan Museum of Art Bulletin* 46 (1988), 4–55.

28. Leymarie and Melot 1971, 19–25.

29. This is the twelfth and final state of this print.

30. *Mary Cassatt, A Catalogue Raisonné of the Graphic Work* (Washington, D.C., 1979), 21, called this "her most original contribution, adding a new chapter to the history of graphic art" and described the process, 36–37. On Cassatt's color prints, see also Nancy Mowll Mathews and Barbara Stern Shapiro, *Mary Cassatt: The Color Prints* [exh. cat., National Gallery of Art] (Washington, D.C., 1989).

31. Adolyn Dohme Breeskin, *Mary Cassatt, A Catalogue Raisonné of the Graphic Work* (Washington, D.C., 1979), no. 157; Mathews and Shapiro 1989, no. 15.

32. Claude Roger-Marx, *Bonnard Lithographie* (Monte-Carlo, 1952), no. 48; Francis Bouvet, *Bonnard, The Complete Graphic Work* (New York, 1981), no. 56.

33. Claude Roger-Marx, *L'Oeuvre Grave de Vuillard* (Monte-Carlo, 1948), no. 45.

34. Andrew Carnduff Ritchie, *Edouard Vuillard* (New York, 1954), 14.

35. On the renovation of the city of Paris, see David H. Pinkey, *Napoleon III and the Rebuilding of Paris* (Princeton, 1972); Bonnie L. Grad and Timothy Riggs, *Visions of City and Country: Prints and Photographs of Nineteenth-Century France* [exh. cat., American Federation of Arts] (Washington, D.C. 1982), 188–228

36. Roger-Marx 1948, no. 28.

37. Isabelle Compin, *H. E. Cross* (Paris, 1964), 48, 338.

38. On the impact of Ruskin's ideas on American artists, see Roger Stein, *John Ruskin and Aesthetic Thought in America* (Cambridge, MA, 1967); Ella M. Forshay, *Reflections of Nature: Flowers in American Art* (New York, 1984), 46–48; William Gerdts, *Down Garden Paths: The Floral Environment in American Art* (Rutherford, NJ, 1983), 15–18.

39. This enthusiasm in the United States for "wild" gardens may in part have resulted from the writings of the Irish gardener and author, William Robinson, especially his book *The Wild Garden*, published in London in 1870. On Robinson and the influence of his writings, as well as those of the English garden designer Gertrude Jekyll, whose first book, *Wood and Garden*, was published in 1899, see the introduction by Deborah Nevins to the 1984 edition of William Robinson's *The English Flower Garden* (New York, 1984). Nevins explained: "In the 1890s neither William Robinson nor Gertrude Jekyll were household words among American gardeners, although they did influence the most sophisticated designers of the period," (xx). Nevins also remarked on the connection between the natural garden and the Arts and Crafts movement (xviii–xx).

40. Alice Morse Earle, "Old Time Flower Gardens," *Scribner's Magazine* 20 (August, 1896), 161–178.

41. Alice Morse Earle, *Old Time Gardens* (New York, 1901), 165.

42. W. Hamilton Gibson, "The Wild Garden," *Harper's New Monthly Magazine* 81 (September, 1890), 631.

43. See Jane Pratt, "From Merton Abbey to Old Deerfield," *Craftsman* 5 (1903), 183–191.

44. For a photo of Champney's house and garden in Deerfield, see Emma Lewis Coleman, *A Historic and Present Day Guide to Old Deerfield* (Boston, 1907), 96–97.

45. One of the best sources on Hassam and the American impressionists is William H. Gerdts, *American Impressionism* (New York, 1984).

46. Katherine L. Jacobs, "Celia Thaxter and Her Island Garden," *Landscape* 24 (1980), 12–17.

47. Gerdts 1984, 102. See also: Gerdts 1983, 61–70; Foshay 1984, 63–67.

48. It has recently been reissued in facsimile with an introduction by Alan Lacy: Celia Thaxter, *An Island Garden* (Boston, 1988).

49. Thaxter 1988, 44–45.

50. Thaxter 1988, 50.

51. The idea of building cemeteries in rural, picturesque settings was international during the late eighteenth and early nineteenth centuries; see David Schuyler, "The Evolution of the Anglo-American Rural Cemetery: Landscape Architecture as Social and Cultural History," *Journal of Garden History* 4 (1984), 294; Brent Elliott in *The Oxford Companion to Gardens* 1986, 101–102. See also: Keith N. Morgan, "The Emergence of the American Landscape Professional: John Notman and the Design of Rural Cemeteries," *Journal of Garden History* 4 (1984), 269–289; Barbara Rotunda, "Mount Auburn: Fortunate Coincidences and Ideal Solution," *Journal of Garden History* 4 (1984), 255–267.

52. Elizabeth Barlow, *Frederick Law Olmsted's New York* (New York, 1972), 10–14, discussed the influence of the picturesque tradition on Olmsted.

53. Gerdts 1984, 282–287.

54. Barlow 1972, 22.

55. Quoted in Barlow 1972, 22.

LIST OF WORKS IN THE EXHIBITION

Gardens in Medieval Art

1. Anonymous German 13th Century (Lower Saxony), *Heavenly Paradise with Christ in the Lap of Abraham*, c. 1239, tempera and gold leaf on vellum, 224 x 157 (8 7/8 x 6 1/4). National Gallery of Art, Rosenwald Collection 1946.21.11

2. Anonymous German 15th Century (Augsburg?), *Map of the World*, c. 1480, hand-colored woodcut, 273 x 190 (10 3/4 x 7 7/8). National Gallery of Art, Rosenwald Collection 1943.3.645

3. Anonymous Flemish 15th Century, *The Fall of Man*, tempera on vellum, 101 x 80 (4 x 3 1/8), in *The Warburg Hours*, late 15th century. Library of Congress, Washington, D.C., Rare Books and Special Collections Division

4. Workshop of the Master of the Borders (German, 15th Century), *The Oxford Passion: The Fall of Man*, 1460/1480, metalcut, 62 x 47 (2 3/8 x 1 3/4). National Gallery of Art, Rosenwald Collection 1943.3.680

5. Workshop of the Master of the Borders (German, 15th Century), *The Oxford Passion: The Expulsion from the Garden of Eden*, 1460/1480, metalcut, 64 x 48 (2 1/2 x 1 3/4). National Gallery of Art, Rosenwald Collection 1943.3.681

6. Workshop of the Master of the Borders (German, 15th Century), *The Oxford Passion: Christ in the Garden of Gethsemane*, 1460/1480, metalcut, 63 x 48 (2 1/2 x 1 3/4). National Gallery of Art, Rosenwald Collection 1943.3.688

7. Workshop of the Master of the Borders (German, 15th Century), *The Oxford Passion: Christ Appearing to the Magdalene as a Gardener*, 1460/1480, metalcut, 63 x 47 (2 1/2 x 1 3/4). National Gallery of Art, Rosenwald Collection 1943.3.676

8. Anonymous French 15th Century, *Christ Appearing to the Magdalene*, c. 1500, hand-colored woodcut, 200 x 150 (7 7/8 x 5 7/8). National Gallery of Art, Rosenwald Collection 1943.3.497

9. Anonymous German 15th Century (Swabian, Ulm?), *Christ in the Garden of Gethsemane*, c. 1450/1460, hand-colored woodcut, 273 x 190 (10 3/4 x 7 1/2). National Gallery of Art, Rosenwald Collection 1943.3.463

10. Anonymous German 15th Century (Swabian or Franconian), *Madonna in a Closed Garden*, 1450/1470, hand-colored woodcut, 189 x 130 (7 1/2 x 5 1/8). National Gallery of Art, Rosenwald Collection 1943.3.562

11. Belbello de Pavia (Italian, active 1448/1462), *Annunciation to the Virgin*, 1450/1460, tempera and gold leaf on vellum, 589 x 425 (23 1/8 x 16 3/4). National Gallery of Art, Rosenwald Collection 1948.11.21

12. Anonymous German 15th Century (Ulm, Augsburg, or Cologne), *Madonna with the Rosary*, 1485, hand-colored woodcut, 372 x 248 (14 5/8 x 9 3/4). National Gallery of Art, Rosenwald Collection 1943.3.564

13. Anonymous German 15th Century (Upper Rhine ?), *Saint Dorothy*, 1440/1460, hand-colored woodcut, 186 x 125 (7 1/4 x 4 7/8). National Gallery of Art, Rosenwald Collection 1943.3.600

14. Anonymous German 15th Century (Bavarian), *Saint Alto*, c. 1500, hand-colored woodcut, 135 x 185 (5 1/4 x 7 1/4). National Gallery of Art, Rosenwald Collection 1943.3.580

15. Anonymous German 15th Century (Augsburg?), *The Franciscan Pelbartus of Temesvar in a Garden*, c. 1500, woodcut, 178 x 117 (7 x 4 5/8). National Gallery of Art, Rosenwald Collection 1943.3.658

16. Anonymous Flemish or Dutch 15th Century, *The Genealogical Tree of the Dominicans*, 1480/1490, hand-colored woodcut, 297 x 205 (11 3/4 x 8), National Gallery of Art, Rosenwald Collection 1964.8.11

17. Anonymous German 15th Century (Augsburg or Mariamünster), *Saint Alto, Saint Bridget and the Founders of the Mariamünster*, c. 1500, hand-colored woodcut, 121 x 90 (4 3/4 x 3 1/2). National Gallery of Art, Rosenwald Collection 1943.3.579

18. Israhel van Meckenem (German, c. 1445–1503), *Ornament with the Tree of Jesse*, c. 1490/1500, engraving, 115 x 269 (4 1/2 x 10 5/8). National Gallery of Art, Rosenwald Collection 1943.3.169

19. Anonymous German 15th Century (Ulm), *Genealogical Tree of Christ*, c. 1470, hand-colored woodcut, 178 x 126 (7 x 5). National Gallery of Art, Rosenwald Collection 1943.3.865

20. Anonymous German 15th Century (Augsburg), *The Way to Salvation*, c. 1490, hand-colored woodcut, 262 x 181 (10 1/4 x 7 1/8). National Gallery of Art, Rosenwald Collection 1943.3.640

21. Anonymous French 15th Century, *The Lover Plucks the Rose*, hand-colored woodcut, 271 x 192 (10 5/8 x 7 1/2), in Guillaume de Lorris and Jean de Meun, *Roman de la Rose* (Paris: Antoine Verard, 1494–1495). Library of Congress, Washington, D.C., Rare Books and Special Collections Division

22. Israhel van Meckenem (German, c. 1445–1503), *Ornamental Panel with Two Lovers*, c. 1490/1500, engraving, 164 x 242 (6 1/2 x 9 1/2). National Gallery of Art, Rosenwald Collection 1943.3.170

23. Israhel van Meckenem (German, c. 1445–1503), *Ornament with Flower and Eight Wild Folk*, c. 1490/1500, engraving, 200 x 131 (7 7/8 x 5 1/8). National Gallery of Art, Rosenwald Collection 1943.3.173

24. Israhel van Meckenem (German, c. 1445–1503), *Circular Ornament with Musicians Playing near a Well*, c. 1495/1503, engraving, diam. 174 (6 7/8). National Gallery of Art, Rosenwald Collection 1943.3.163

25. Israhel van Meckenem (German, c. 1445–1503), *Ornament with Morris Dancers*, c. 1490/1500, engraving, 114 x 265 (4 1/2 x 10 1/2). National Gallery of Art, Rosenwald Collection 1947.7.186

26. Wenzel von Olmütz (German, active 1481/1497), after the Housebook Master, *The Lovers*, c. 1490, engraving, 171 x 113 (6 3/4 x 4 1/2). National Gallery of Art, Rosenwald Collection 1943.3.8324

Renaissance and Mannerist Gardens

27. Pieter van der Heyden (Flemish, 1551–1572), after Pieter Bruegel the Elder, *Spring*, 1570, engraving, 228 x 287 (9 x 11 3/8). National Gallery of Art, Rosenwald Collection 1980.45.235

28. Sebastian Vrancx (Flemish, 1573–1647), *Three Revelers and a Gardener*, 1600/1650, pen and brown ink with brown wash over black chalk, 172 x 250 (6 3/4 x 9 7/8). National Gallery of Art, Julius S. Held Collection, Ailsa Mellon Bruce Fund 1984.3.71

29. David Vinckboons (Dutch, 1576–c. 1632), *Venetian Party in a Château Garden*, c. 1602, pen and brown ink, brown and gray wash, with white heightening, 425 x 705 (16 3/4 x 27 3/4). National Gallery of Art, Gift of Robert H. and Clarice Smith 1986.76.1

30. Hendrick Goltzius (Dutch, 1558–1617), *Persephone*, probably c. 1594, chiaroscuro woodcut, oval, 345 x 255 (13 5/8 x 10). National Gallery of Art, Print Purchase Fund

(Rosenwald Collection) 1982.70.1

31. Cornelis Cort (Flemish, 1533–1578), after Frans Floris I, *Odoratus*, 1561, engraving, 205 x 268 (8 1/4 x 10 5/8). National Gallery of Art, Andrew W. Mellon Fund 1975.70.3

32. Jacques Androuet Du Cerceau I (French, 1510/1512–in or after 1584), *Fontainebleau*, etching, 405 x 665 (16 x 26 1/4), in *Le premier (et second) volume de plus excellents bastiments de France* (Paris, 1607). National Gallery of Art, Mark J. Millard Architectural Collection 1985.61

33. Jean Mignon (French, active 1543–c. 1545), *Pan*, 1543/1545, etching, oval, 243 x 147 (9 1/2 x 5 3/4). National Gallery of Art, Rosenwald Collection 1964.8.865

34. Jacques Callot (French, 1592–1635), *The Palace Gardens at Nancy*, 1625, etching, 255 x 381 (10 x 15). National Gallery of Art, Gift of Miss Ellen T. Bullard 1941.4.2

35. Jacques Callot (French, 1592–1635), *Lux Claustri: Gardener Grafting a Tree*, 1628, etching, 57 x 81 (2 1/4 x 3 1/4). National Gallery of Art, R. L. Baumfeld Collection 1969.15.579

36. Jacques Callot (French, 1592–1635), *Lux Claustri: Gardener Contemplating a Lily*, 1628, etching, 62 x 84 (2 1/2 x 3 1/4). National Gallery of Art, Rosenwald Collection 1949.5.447

37. Master HS (French, active 1566), *Banquet in the Garden of a French Château*, c. 1550, etching, 219 x 287 (8 5/8 x 11 3/8). National Gallery of Art, Rosenwald Collection 1961.17.62

38. Matthaeus Merian the Elder (German, 1593–1650), *Hortus Palatinus*, etching, 249 x 349 (9 3/4 x 13 3/4), in *Topographia Palatinatus Rheni et Vicinarum Regionum* (Frankfurt, 1645). National Gallery of Art, Mark J. Millard Architectural Collection, David K. E. Bruce Fund 1985.61

39. David Loggan (German, 1633/1635–1692), *Wadham College*, etching and engraving, 346 x 422 (13 5/8 x 16 5/8), in *Oxonia Illustrata* (Oxford, 1675). National Gallery of Art, Mark J. Millard Architectural Collection, David K. E. Bruce Fund 1985.61

40. Wendel Dietterlin (German, 1550/1551–1599), *Corinthian*, etching and engraving, 250 x 184 (9 7/8 x 7 1/4), in *Architectura von Ausztheilung Symmetria und Proportion der Funff Seulen und aller darausz volgender Kunst Arbeit von Fenstern Caminen Thurgerichten Portalen Bronnen und Epitaphien* (Nuremberg: Caymox, 1598), plate 152. Mark J. Millard Architectural Collection, David K. E. Bruce Fund 1985.61

41. Jacob Custodis (German, active 1600–1650), after Joseph Fürttenbach the Elder, *Pleasure Garden with Park for Animals*, etching and engraving, 285 x 370 (11 1/4 x 14 1/2), in Joseph Fürttenbach the Elder, *Architectura Civilis das ist Eigenlich Beschreibung wie Man nach Bester Form und Gerechter Regul* (Ulm: Jonas Sauer, 1628), plate 13. National Gallery of Art, Mark J. Millard Architectural Collection, David K. E. Bruce Fund 1983.49.22

42. Giacomo Lauro (Italian, c. 1550–1605), *Varro's Aviary*, etching and engraving, 178 x 234 (7 x 9 1/4), in *Antiquae Urbis Splendor hoc est Praecipua eiusdem Templa Amphitheatra, Theatra Circi, Navmachiae, Arcus Triumphales, Mausolea, Aliaque, Sumptuosiora Aedificia Pompae, Item Triumphalis et Colossae Arum Imaginum Descriptio* (Rome, 1612). National Gallery of Art, Mark J. Millard Architectural Collection, David K. E. Bruce Fund 1985.61

43. Etienne Du Pérac (French, c. 1525–1604), *Map of Ancient Rome*, etching and engraving, 1058 x 1558 (41 5/8 x 61 3/8). National Gallery of Art, Mark J. Millard Architectural Collection, David K. E. Bruce Fund 1985.61

44. Stefano Della Bella (Italian, 1610–1664), *The Vase of the Medici*, 1656, etching, 305 x 275 (12 x 10 7/8). National Gallery of Art, Andrew W. Mellon Fund 1977.12.2

45. Stefano Della Bella (Italian, 1610–1664), *The Colossus of Pratolino*, probably 1653, etching, 258 x 382 (10 x 15). National Gallery of Art, Rosenwald Collection 1964.8.322

46. Stefano Della Bella (Italian, 1610–1664), *The Tree House, Medici Villa at Pratolino*, c. 1652, etching, 252 x 371 (10 x 14 1/2). Private collection

47. Annibale Carracci (Italian, 1560–1609), *Susanna and the Elders*, c. 1590/1595, etching and engraving, 345 x 312 (13 1/2 x 12 1/4). National Gallery of Art, Andrew W. Mellon Fund 1976.48.1

48. Pirro Ligorio (Italian, c. 1513–1583), *A*

Party in a Roman Villa, pen and brown ink, 280 x 213 (11 x 8 3/8). National Gallery of Art, Ailsa Mellon Bruce Fund 1986.38.1a

49. Francesco Corduba (Italian, 17th Century), after Etienne Du Pérac, *Villa d'Este*, etching, 237 x 347 (9 1/4 x 13 5/8), in *Nuova Rocolta di Fontane che si Vedano nel Alma Citta di Roma Tivoli e Frascati* (Rome: Giovanni Giacomo de' Rossi, 16th century). National Gallery of Art, Mark J. Millard Architectural Collection, David K. E. Bruce Fund 1985.61

Gardens in Baroque Art

50. Giovanni Battista Falda (Italian, 1648–1678), *Water Theater, Villa Aldobrandini*, etching and engraving, 246 x 395 (9 3/4 x 15 1/2), in *Le Fontane delle Ville di Frascati, nel Tusculano, con li loro prospetti* (Rome: Giovanni Giacomo de' Rossi, 1675–c. 1690). National Gallery of Art, Mark J. Millard Architectural Collection, David K. E. Bruce Fund 1985.61

51. Giovanni Battista Falda (Italian, 1648–1678), *Villa Pamphili*, etching and engraving, 355 x 650 (14 x 25 1/2), in *Villa Pamphilia eiusque Palatium cum suis Prospectibus, Statuae, Fontes, Vivaria, Theatra, Areolae, Plantarum, Viarumque Oridines, Cum eiusdem Villae absoluta Delineatione* (Rome: Giovanni Jacobi de Rubeis, 1660). National Gallery of Art, Gift of Mr. and Mrs. Arthur Vershbow 1983.119.1

52. Melchior Küsell I (German, 1626–c. 1683), after Johann Wilhelm Baur, *Underschidliche Prospecten: Title Page*, 1636, etching and engraving, 105 x 115 (4 1/8 x 4 1/2), National Gallery of Art, Ailsa Mellon Bruce Fund 1975.23.8

53. Melchior Küsell I (German, 1626–c. 1683), after Johann Wilhelm Baur, *Underschidliche Prospecten: Villa Borghese*, 1636, etching and engraving, 105 x 115 (4 1/8 x 4 1/2). National Gallery of Art, Ailsa Mellon Bruce Fund 1975.23.12

54. Melchior Küsell I (German, 1626–c. 1683), after Johann Wilhelm Baur, *Underschidliche Prospecten: Garden of Duke of Altems*, 1636, etching and engraving, 105 x 115 (4 1/8 x 4 1/2). National Gallery of Art,

Ailsa Mellon Bruce Fund 1975.23.23

55. Melchior Küsell I (German, 1626–c. 1683), after Johann Wilhelm Baur, *Underschidliche Prospecten: Garden of Duke of Sora*, 1636, etching and engraving, 105 x 115 (4 1/8 x 4 1/2). National Gallery of Art, Ailsa Mellon Bruce Fund 1975.23.16

56. Carlo Fontana (Italian, 1634–1714), *Fountain*, etching and engraving, 383 x 545 (15 1/8 x 21 1/2), in *Ultilissima Trattato dell' Acque Correnti* (Rome: Giovanni Francesco Buagni, 1696). National Gallery of Art, Mark J. Millard Architectural Collection, David K. E. Bruce Fund 1985.61

57. Jean Marot (French, probably 1619–1679), after Israel Silvestre, *The Tuileries*, 1666/1671, etching and engraving, 124 x 244 (5 x 9 5/8). National Gallery of Art, Gift of Robert H. Thayer 1981.69.24

58. Adam Perelle (French, 1638–1695), after Israel Silvestre, *The Petites Cascades at Vaux le Vicomte*, c. 1650, etching, 120 x 203 (4 3/4 x 8). National Gallery of Art, Gift of Robert H. Thayer 1981.69.36

59. Jean Le Pautre (French, 1618–1682), *Fireworks at the Versailles Festival of 1668*, etching and engraving, 302 x 417 (11 7/8 x 16 3/8), in André Félibien, *Relation de la Feste de Versailles* (Paris: Cabinet du Roi, 1679). National Gallery of Art, Mark J. Millard Architectural Collection 1985.61

60. Jean Le Pautre (French, 1618–1682), *Grotto of Versailles*, etching and engraving, 210 x 283 (8 1/4 x 11 1/8), in André Félibien, *Description de la Grotte de Versailles* (Paris: Cabinet du Roi, 1675–1685). National Gallery of Art, Mark J. Millard Architectural Collection 1985.61

61. Israel Silvestre (French, 1621–1691), *Saint-Germain-en-Laye*, etching and engraving, 520 x 750 (20 1/2 x 29 1/2), in *Les Veües de Maisons Royales et des Villes conquises par Louis XIV* (Paris: Cabinet du Roi, c. 1675–1685). National Gallery of Art, Mark J. Millard Architectural Collection 1985.61

62. Abraham Genoels II (Flemish, 1640–1723), *The Two Statues*, 1665/1690, etching, 316 x 483 (12 3/8 x 19). National Gallery of Art, Andrew W. Mellon Fund 1978.25.5

63. Adriaen Frans Boudewyns (Flemish, 1644–1711), after Abraham Genoels II, *Large*

Landscape—Two Men in a Garden, 1665/ 1690, etching, 646 x 499 (28 3/8 x 19 5/8). National Gallery of Art, Andrew W. Mellon Fund 1976.20.1

64. Isaac de Moucheron (Dutch, 1667– 1744), *An Italianate Garden with a Parrot, a Dog, and a Man*, 1730s, pen and brown ink and watercolor over black chalk, 250 x 382 (9 7/8 x 15). National Gallery of Art, Gift of Anne Eustis Emmet in Memory of David E. Finley 1987.11.1

65. Jan van Call I (Dutch, 1656–1703), *Labyrinth*, etching and engraving, 130 x 167 (5 1/8 x 6 5/8), in *Admirandorum Quadruplex Spectaculum* (Amsterdam: Petrus Schenk I, c. 1700). National Gallery of Art, Mark J. Millard Architectural Collection 1983.49.103

66. Jan Goeree (Dutch, 1670–1731), after Leonard Knyff, *Hampton Court*, etching, 130 x 156 (5 1/8 x 6 1/8), *Les Delices de la Grand Bretagne et de L'Irlande* (Leyden: Beeverell, c. 1707). National Gallery of Art, Mark J. Millard Architectural Collection, David K. E. Bruce Fund 1985.61

67. Henry Hulsbergh (Dutch, d. 1729), after Colen Campbell, *Plan of Longleat*, etching and engraving, 298 x 497 (11 3/4 x 19 5/8), in Colen Campbell, *Vitruvius Britannicus, or the British Architect* (London, c. 1735), vol. III, plate 63. National Gallery of Art, Mark J. Millard Architectural Collection, David K. E. Bruce Fund 1985.61

68. Henry Hulsbergh (Dutch, d. 1729), after Colen Campbell, *Castle Howard*, etching and engraving, 380 x 525 (15 x 20 5/8), in Colen Campbell, *Vitruvius Britannicus, or the British Architect* (London, 1725), vol. III, plate 5. National Gallery of Art, Mark J. Millard Architectural Collection, David K. E. Bruce Fund 1985.61

The Eighteenth-Century Garden

69. Giovanni Battista Piranesi (Italian, 1720–1778), *View of the Villa Albani*, 1769, etching and engraving, 441 x 692 (17 3/8 x 27 1/4). National Gallery of Art, Mark J. Millard Architectural Collection, acquired with assistance from the Morris and Gwendolyn Cafritz Foundation 1985.61.108

70. Giovanni Battista Piranesi (Italian,

1720–1778), *View of the Villa d'Este*, 1773, etching and engraving, 467 x 699 (18 3/8 x 27 1/2). National Gallery of Art, Mark J. Millard Architectural Collection, acquired with assistance from the Morris and Gwendolyn Cafritz Foundation 1985.61.108

71. Giovanni Battista Piranesi (Italian, 1720–1778), *View of the Villa Pamphili*, 1776, etching and engraving, 486 x 700 (19 1/8 x 27 5/8). National Gallery of Art, Mark J. Millard Architectural Collection, acquired with assistance from the Morris and Gwendolyn Cafritz Foundation 1985.61.127

72. Pierre Fourdrinier (French, c. 1720– c. 1760), after Robert Castell, *Laurentium*, etching and engraving, 505 x 685 (19 7/8 x 27), in Robert Castell, *The Villas of the Ancients Illustrated* (London: Robert Castell, 1728). National Gallery of Art, Mark J. Millard Architectural Collection, David K. E. Bruce Fund 1985.61

73. John Rocque (French, 1704/1705?– 1762), *Chiswick House*, 1739, etching and engraving, 615 x 778 (24 1/4 x 30 5/8). The Yale Center for British Art, Paul Mellon Collection

74. Paul Sandby (British, 1725–1809), after William Marlow, *A View of the Lake and Island at Kew*, etching, 308 x 467 (12 1/8 x 18 3/8), in Sir William Chambers, *Plans, Elevations, Sections and Perspective Views of the Gardens and Buildings at Kew in Surrey, the Seat of Her Royal Highness, the Princess Dowager of Wales* (London: J. Haberkorn for Sir William Chambers, 1763). National Gallery of Art, Mark J. Millard Architectural Collection, David K. E. Bruce Fund 1985.61

75.a, b George Isham Parkyns (British, 1749/1750–1820), *Belmont, Plan for 60 Acres*, and *Sectional Geometrical Views*, etching, plan: 227 x 290 (8 7/8 x 11 3/8); sections: 202 x 272 (8 x 10 3/4), in *Six Designs for Improving and Embellishing Grounds. With Sections and Explanations* (London: I. and J. Taylor, 1793). National Gallery of Art, Mark J. Millard Architectural Collection 1983.61

76. Marcellus Laroon II (British, 1679– 1774), *Garden Party at a Country House*, 1771, pen and brown ink with gray wash

over graphite, 471 x 693 (18 1/2 x 27 1/4). National Gallery of Art, Ailsa Mellon Bruce Fund 1981.23.1

77. Robert Pollard (British, 1797–after 1859) and Francis Jukes (British, 1747–1812), after Thomas Rowlandson, *Vauxhall Gardens*, British, 1785, hand-colored etching and aquatint, 539 x 755 (21 1/4 x 29 3/4). Private collection

78. Louis-Gabriel Moreau the Elder (French, 1740–1806), *Park View*, 1806, gouache over graphite, 280 x 225 (11 x 8 7/8). National Gallery of Art, Samuel H. Kress Collection 1963.15.22

79. Louis-Gabriel Moreau the Elder (French, 1740–1806), *Terrace of a Château*, c. 1790, gouache, 310 x 464 (12 1/4 x 18 1/4). National Gallery of Art, Samuel H. Kress Collection 1963.15.20

80. Louis-Gabriel Moreau the Elder (French, 1740–1806), *Park with Terrace and a Balustrade with Statues*, after 1779, etching, 79 x 113 (3 1/8 x 4 1/2). National Gallery of Art, Rosenwald Collection 1964.8.1304

81. Attributed to Alexis Nicolas Perignon the Elder (French, 1726–1782), *Vegetable Garden (Potager) of the Château Valentinois, Passy*, gouache on canvas, 442 x 527 (17 1/2 x 20 3/4). National Gallery of Art, Samuel H. Kress Collection 1963.15.23

82. Antoine Watteau (French, 1684–1721), *The Bower*, c. 1716, red chalk, 402 x 268 (15 7/8 x 10 1/2). National Gallery of Art, Ailsa Mellon Bruce Fund 1982.72.1

83. Jean-François Janinet (French, 1752–1814), after Hubert Robert, *Colonnade and Gardens of the Medici Palace*, c. 1776, etching and wash-manner engraving, 390 x 315 (15 3/8 x 12 3/8). National Gallery of Art, Gift of Ivan Phillips 1986.30.1

84. Hubert Robert (French, 1733–1808), *The Garden Gate*, 1760/1765, red chalk, 455 x 353 (17 7/8 x 13 7/8). National Gallery of Art, Gift of Natalie Fuller Allen and her children 1987.72.1

85. Jean-Honoré Fragonard (French, 1732–1806), *Terrace and Garden of an Italian Villa*, red chalk over touches of black chalk, 249 x 376 (9 3/4 x 14 3/4). National Gallery of Art, Samuel H. Kress Collection 1963.15.11

86. Anonymous French 18th Century, *Park of an Italian Villa*, black chalk with brown wash, 248 x 370 (9 3/4 x 14 1/2). National Gallery of Art, Samuel H. Kress Collection 1963.15.12

87. Jean-Honoré Fragonard (French, 1732–1806), *Gardens of an Italian Villa*, brush and brown ink over graphite, 143 x 175 (5 5/8 x 6 7/8). National Gallery of Art, Samuel H. Kress Collection 1963.15.7

The Nineteenth Century

88. Anonymous after Humphry Repton (British, 18th–19th Century), *View from the Dome*, hand-colored etching and aquatint, 550 x 743 (21 5/8 x 29 1/4), in Humphry Repton, *Designs for the Pavilion at Brighton* (London: J. Taylor, 1806). National Gallery of Art, Mark J. Millard Architectural Collection 1985.61

89. Thomas Rowlandson (British, 1756–1827), *Butterfly Hunting*, 1806, hand-colored etching, 230 x 285 (9 x 11 1/4). National Gallery of Art, Rosenwald Collection 1945.5.890

90. James McNeill Whistler (American 1834–1903), *Confidences in the Garden*, 1894, lithograph, 324 x 206 (12 3/4 x 8 1/8). National Gallery of Art, Rosenwald Collection 1943.3.8720

91. James McNeill Whistler (American, 1834–1903), *La Belle Jardinière*, 1894, lithograph, 338 x 203 (13 1/4 x 8). National Gallery of Art, Rosenwald Collection 1943.3.8723

92. Francis Seymour Haden (British, 1818–1910), *Kensington Gardens, The Small Plate (Lord Harrington's House from Kensington Gardens)*, 1859, etching with drypoint, 159 x 118 (6 1/4 x 4 3/4). National Gallery of Art, Gift of Miss Elisabeth Achelis 1942.6.41

93. Jean-Baptiste Millet (French, 1831–1906), *A Sunlit Garden*, black chalk with gray wash, 267 x 360 (10 1/2 x 14 1/8). National Gallery of Art, Julius S. Held Collection, Ailsa Mellon Bruce Fund 1984.3.20

94. Camille Pissarro (French, 1830–1903), *Woman Weeding in a Garden*, watercolor over black chalk, 252 x 174 (10 x 6 7/8). National Gallery of Art, Ailsa Mellon Bruce Collection 1970.17.167

95. Camille Pissarro (French, 1830–1903),

Woman Emptying a Wheelbarrow, 1880, aquatint and drypoint, 460 x 356 (18 x 14). National Gallery of Art, Rosenwald Collection 1943.3.7311

96. Mary Cassatt (American, 1844–1926), *Gathering Fruit*, c. 1893, drypoint and aquatint in color, 423 x 300 (16 5/8 x 11 3/4). National Gallery of Art, Rosenwald Collection 1943.3.2757

97. Pierre Bonnard (French, 1867–1947), *The Orchard*, 1899, five-color lithograph, 336 x 365 (13 1/4 x 14 3/8). National Gallery of Art, Rosenwald Collection 1951.16.10

98. Edouard Vuillard (French, 1868–1940), *The Garden Outside the Studio*, 1901, eight-color lithograph, 630 x 480 (24 3/4 x 18 7/8). National Gallery of Art, Rosenwald Collection 1952.8.537

99. Auguste Lepère (French, 1849–1918), *The Pond in the Tuileries*, 1898, chiaroscuro woodcut, 218 x 335 (8 5/8 x 13 1/4). National Gallery of Art, Ailsa Mellon Bruce Fund 1975.33.4

100. Edouard Vuillard (French, 1868–1940), *The Tuileries*, 1896, four-color lithograph, 396 x 251 (15 3/4 x 9 7/8). National Gallery of Art, Rosenwald Collection 1943.3.9061

101. Henri-Edmond Cross (French, 1856–1910), *Les Champs-Elysées*, 1898, color lithograph, 259 x 316 (10 1/4 x 12 1/2). National Gallery of Art, Gift of Mr. and Mrs. Burton Tremaine 1971.86.8

102. Edouard Vuillard (French, 1868–1940), *The Square*, brush and black ink, 646 x 500 (25 1/2 x 19 3/4). National Gallery of Art, Collection of Mr. and Mrs. Paul Mellon 1985.64.116

103. Pierre Bonnard (French, 1867–1947), *Boating*, 1897, four-color lithograph, 268 x 477 (10 5/8 x 18 3/4). National Gallery of Art, Rosenwald Collection 1950.16.8

104. James Wells Champney (American, 1843–1903), *Garden in Old Deerfield*, c. 1900, gouache, 384 x 274 (15 1/8 x 10 3/4). Private collection

105. Childe Hassam (American, 1859–1935), *Garden, Appledore*, c. 1890, watercolor, 335 x 254 (13 3/16 x 10). Mead Art Museum, Amherst College, Gift of William MacBeth, Inc. [1950.9]

106. Maurice Prendergast (American, 1858–1924), *Central Park, 1900*, 1900, watercolor, 365 x 545 (14 3/8 x 21 1/2). Collection of the Whitney Museum of American Art, N.Y., 32.41

SELECTED BIBLIOGRAPHY

Ackerman 1954 Ackerman, James S. *The Cortile del Belvedere*. Rome, 1954.

Adams 1979 Adams, William Howard. *The French Garden: 1500–1800*. New York, 1979.

Alexander/ Alexander, David, and Richard T. Godfrey. *The Reproductive*
Godfrey 1980 *Print from Hogarth to Wilkie*. Exh. cat., Yale Center for British Art. New Haven, 1980.

Allen 1958 Allen, B. Sprague. *Tides in English Taste*. New York, 1958.

Andres 1976 Andres, Glenn M. *The Villa Medici in Rome*. New York, 1976.

Archer 1985 Archer, John. *The Literature of British Domestic Architecture, 1715–1842*. Cambridge, MA, 1985.

Bagrow 1950 Bagrow, Leo. "Rust's and Sporer's World Maps." *Imago Mundi 7* (1950), 32–36.

Barlow 1972 Barlow, Elizabeth. *Frederick Law Olmsted's New York*. New York, 1972.

Batey 1982 Batey, Mavis. *Oxford Gardens: The University's Influence on Garden History*. London, 1982.

Belloli 1984 Belloli, Andrea P. A. *A Day in the Country: Impressionism and the French Landscape*. Exh. cat., Los Angeles County Museum of Art. Los Angeles, 1984.

Berger 1985 Berger, Robert W. *In the Garden of the Sun King*. Washington, 1985.

Berns 1978 Berns, Emily, et al. *The Origins of the Italian Veduta*. Exh. cat., Bell Gallery, Brown University. Providence, 1978.

Bonnin 1973 Bonnin, Georges, ed. *L'Art du Livre a l'Imprimerie nationale*. Paris, 1973.

Bouvet 1981 Bouvet, Francis. *Bonnard: The Complete Graphic Work*. New York, 1981.

Breman/ Breman, Paul, and Denise Addis. *Guide to Vitruvius Britannicus:*
Addis 1972 *Annotated and Analytical Index to the Plates*. New York, 1972.

Cachin 1980 Cachin, Françoise, et al. *Camille Pissarro, 1830–1903*. Exh. cat., Museum of Fine Arts. Boston, 1980.

Cafritz/Gowing/ Cafritz, Robert C., Lawrence Gowing, and David Rosand. *Places*

Rosand 1988 *of Delight: The Pastoral Landscape*. Exh. cat., The Phillips Collection in association with the National Gallery of Art. Washington, 1988.

Carlson 1978 Carlson, Victor. *Hubert Robert: Drawings and Watercolors*. Exh. cat., National Gallery of Art. Washington, 1978.

Carlson/Ittmann 1984 _____, and John W. Ittmann. *Regency to Empire: French Printmaking, 1715–1814*. Exh. cat., Baltimore Museum of Art. Baltimore, 1984.

Carré 1973 Carré, Jacques. "Lord Burlington's Garden at Chiswick." *Garden History* 1 (1973), 23–30.

Cate/Hitchings 1978 Cate, Phillip Dennis, and Sinclair Hamilton Hitchings. *The Color Revolution: Color Lithography in France, 1890–1900*. Santa Barbara, 1978.

Cate 1981 _____. *Circa 1800: The Beginnings of Modern Printmaking, 1775–1835*. Exh. cat., Baltimore Museum of Art. Baltimore, 1981.

Cayeaux 1987 Cayeaux, Jean de. *Hubert Robert et les Jardins*. Paris, 1987.

Clark 1987–1988 Clark, Alvin L., Jr. *From Mannerism to Classicism*. Exh. cat., Yale University Art Gallery. New Haven, 1987–1988.

Clark 1973 Clark, Frank. "Nineteenth-Century Public Parks from 1830," *Garden History* 1 (1973), 31–41.

Clark 1944 Clark, H. F. "Lord Burlington's Bijou, or Sharawaggi at Chiswick." *Architectural Review* 96 (1944), 125–129.

Clark 1983 Clark, Jane. *The Great Eighteenth Century Exhibition*. Exh. cat., The National Gallery of Victoria. Melbourne, 1983.

Coffin 1960 Coffin, David. *The Villa d'Este at Tivoli*. Princeton, 1960.

Coffin 1982 _____. "The 'Lex Hortorum' and Access to Gardens of Latium during the Renaissance." *Journal of Garden History* 2 (1982), 201–232.

Comito 1978 Comito, Terry. *The Idea of the Garden in the Renaissance*. New Brunswick, 1978.

Crisp 1924 Crisp, Frank. *Mediaeval Gardens*. London, 1924.

Curtius 1963 Curtius, Ernst Robert. "The Ideal Landscape," in *European Literature and the Latin Middle Ages*, trans. Willard R. Trask. New York, 1963, 183–202.

Dronke 1968 Dronke, Peter. *Medieval Latin and the Rise of the European Love Lyric*. Oxford, 1968.

Eisenstein 1982 Eisenstein, Elizabeth L. *The Printing Press as Agent of Change*. New York, 1982.

Eisler 1977 Eisler, Colin. *Paintings from the Samuel H. Kress Collection*. Washington, 1977.

Elliott 1986 Elliott, Brent. *Victorian Gardens*. Portland, 1986.

Faucheux 1857 Faucheux, L. E. *Catalogue raisonné de toutes les estampes qui forment l'oeuvre d'Israel Silvestre*. Paris, 1857.

Ferguson/Schaff/Vikan 1975 Ferguson, Carra, David S. Stevens Schaff, and Gary Vikan (under the direction of Carl Nordenfalk). *Medieval and Renaissance Miniatures from the National Gallery of Art*. Exh. cat., National Gallery of Art. Washington, 1975.

Flavis 1974 Flavis, Roberta Smith. *The Garden of Love in Fifteenth Century Netherlandish and German Engravings: Some Studies in Secular Iconography in the Late Middle Ages and Early Renaissance*. Ph.D. diss., University of Pennsylvania, 1974.

Fleming 1969 Fleming, John V. *The Roman de la Rose: A Study in Allegory and Iconography*. Princeton, 1969.

Field 1965 Field, Richard S. *Fifteenth Century Woodcuts and Metalcuts from the National Gallery of Art*. Exh. cat., National Gallery of Art. Washington, 1965.

Field 1969 _____. "Woodcuts from Altomünster." In *Gutenberg Jahrbuch*. Mainz, 1969, 183–212.

Foshay 1984 Foshay, Ella M. *Reflections of Nature: Flowers in American Art*. New York, 1984.

Franck 1966 Franck, Carl L. *The Villas of Frascati*. New York, 1966.

Freedberg 1980 Freedberg, David. *Dutch Landscape Prints of the Seventeenth Century*. London, 1980.

Gerdts 1983 Gerdts, William. *Down Garden Paths: The Floral Environment in American Art*. Rutherford, 1983.

Gerdts 1984 _____. *American Impressionism*. New York, 1984.

Geymuller 1887 Geymuller, Le Baron Henry de. *Les Cerceaux: Leur Vie et leur Oeuvre*. Paris, 1887.

Giamatti 1966 Giamatti, A. Bartlett. *The Earthly Paradise and the Renaissance Epic*. Princeton, 1966.

Glassman 1985 Glassman, Elizabeth. *Reading Prints: A Selection of 16th- to Early 19th-Century Prints from the Menil Collection*. Houston, 1985.

Godfrey 1978 Godfrey, Richard T. *Printmaking in Britain*. London, 1978.

Gothein 1979 Gothein, Marie Luise. *A History of Garden Art*, trans. Mrs. Archer-Hind. New York, 1979.

Grad/
Riggs 1982 Grad, Bonnie L., and Timothy Riggs. *Visions of City and Country: Prints and Photographs of Nineteenth-Century France*. Exh. cat., American Federation of Arts. Washington, 1982.

Grasselli/
Rosenberg 1984 Grasselli, Margaret Morgan, and Pierre Rosenberg. *Watteau, 1684–1721*. Exh. cat., National Gallery of Art. Washington, 1984.

Grego 1970 Grego, Joseph. *Rowlandson the Caricaturist*. New York, 1970.

Griffiths/
Kesnerova 1983 Griffiths, Antony, and Gabriela Kesnerova. *Wenceslaus Hollar: Prints and Drawings*. London, 1983.

Grimal 1969 Grimal, Pierre. *Les Jardins Romains*. Paris, 1969.

Griswold 1987 Griswold, Mac. *Pleasures of the Garden*. New York, 1987.

Harris 1970 Harris, John. *Sir William Chambers: Knight of the Polar Star*. London, 1970.

Harris 1978 _____. *Gardens of Delight: the Rococo English Landscape of Thomas Robins the Elder*. London, 1978.

Harris 1979 _____, ed. *The Garden: A Celebration of One Thousand Years of British Gardening*. Exh. cat., Victoria and Albert Museum. London, 1979.

Harris 1981 _____. *The Artist and the Country House*. London, 1981.

Hazelhurst 1980 Hazelhurst, F. Hamilton. *Gardens of Illusion*. Nashville, 1980.

Hellerstedt 1986 Hellerstedt, Kahren Jones. *Gardens of Earthly Delights: Sixteenth and Seventeenth-Century Netherlandish Gardens*. Exh. cat., The Frick Art Museum. Pittsburgh, 1986.

Hind 1963 Hind, Arthur M. *A History of Engraving and Etching from the Fifteenth Century to the Year 1914*. New York, 1963.

Hind 1967 _____. *Giovanni Battista Piranesi: A Critical Study*. New York, 1967.

Hindman 1982 Hindman, Sandra, ed. *The Early Illustrated Book: Essays in Honor of Lessing J. Rosenwald*. Washington, 1982.

Hobbs 1982 Hobbs, Susan. *Lithographs of James McNeill Whistler*. Exh. cat.,

Smithsonian Institution Traveling Exhibition Service. Washington, 1982.

Hofer 1970 Hofer, Philip. *Baroque Book Illustration.* Cambridge, MA, 1970.

Honour 1954 Honour, Hugh. "Leonard Knyff." *Burlington Magazine* 96 (1954), 337–338.

Hopper 1981 Hopper, Florence. "The Dutch Regency Garden." *Garden History* 9 (1981), 119–121.

Hopper 1982 _____. "The Dutch Classical Garden and André Mollet." *Journal of Garden History* 2 (1982), 25–40.

Hunt 1974 Hunt, John Dixon. "Gardening, and Poetry, and Pope." *The Art Quarterly* 37 (1974), 15–23.

Hunt/ Willis 1975 _____, and Peter Willis, eds. *The Genius of the Place: The English Landscape Garden, 1620–1820.* London, 1975.

Hunt 1986 _____. *Garden and Grove: The Italian Renaissance Garden in the English Imagination, 1600–1750.* Princeton, 1986.

Hunt 1987 _____. *William Kent: Landscape Garden Designer, An Assessment and Catalogue of His Designs.* London, 1987.

Hunt/de Jong 1988–1989 _____, and Erik de Jong. *The Anglo-Dutch Garden in the Age of William and Mary.* Exh. cat., Rijksmuseum Paleis, Het Loo. Apeldoorn, 1988–1989.

Husband 1980 Husband, Timothy. *The Wild Man: Medieval Myth and Symbolism.* Exh. cat., Metropolitan Museum of Art. New York, 1980.

Hussey 1927 Hussey, Christopher. *The Picturesque: Studies in a Point of View.* London, 1927.

Hussey 1967 _____. *English Gardens and Landscapes, 1700–1750.* New York, 1967.

Hyams 1964 Hyams, Edward. *The English Garden.* London, 1964.

Hyams 1971 _____. *Capability Brown and Humphry Repton.* New York, 1971.

Ives 1988 Ives, Colta. "French Prints in the Era of Impressionism and Symbolism." *The Metropolitan Museum of Art Bulletin* 46 (1988), 4–57.

Ivins 1953 Ivins, William M., Jr. *Prints and Visual Communication.* Cambridge, MA, 1953.

Jackson/ Clow 1975 Jackson, Mary, and Cynthia Clow. *Inhabitants of the Enchanted Isle.* Exh. cat., University Gallery, University of Minnesota. Minneapolis, 1975.

Jackson-Stops 1985–1986 Jackson-Stops, Gervase, ed. *Treasure Houses of Britain.* Exh. cat., National Gallery of Art. Washington, 1985–1986.

Jacques 1985 Jacques, David. *Georgian Gardens: The Reign of Nature.* London, 1985.

Jacobs 1980 Jacobs, Katherine L. "Celia Thaxter and Her Island Garden." *Landscape* 24 (1980), 12–17.

Jellicoe et al. 1986 Jellicoe, Sir Geoffrey, Susan Jellicoe, Patrick Goode, and Michael Lancaster, eds. *The Oxford Companion to Gardens.* Oxford, 1986.

Jourdain 1948 Jourdain, Margaret. *The Work of William Kent.* London, 1948.

Kuhnmunch 1981 Kuhnmunch, Jacques. "Le commerce de la gravure à Paris et à Rome au XVIIe siècle." *Nouvelles de l'estampe* 55 (1981), 6–17.

Kuyper 1980 Kuyper, W. *Dutch Classicist Architecture.* Delft, 1980.

Lacy 1988 Lacy, Allen. "Introduction." In Celia Thaxter, *An Island Garden.* Boston, 1988 (facsimile reproduction of 1894 ed.).

Leatherbarrow 1984 — Leatherbarrow, David. "Character, Geometry and Perspective: the Third Earl of Shaftesbury's Principles of Garden Design." *Journal of Garden History* 4 (1984), 332–358.

Leymarie/ Melot 1971 — Leymarie, Jean, and Michel Melot. *The Graphic Works of the Impressionists*. New York, 1971.

Lieure 1927 — Lieure, J. *Jacques Callot*. Paris, 1927.

Lloyd 1979 — Lloyd, Christopher. *Pissarro*. London, 1979.

Lowry 1952 — Lowry, Bates. "Notes on the *Speculum Romanae Magnificentiae* and Related Publications." *Art Bulletin* 34 (1952), 46–50.

Maccubbin/ Martin 1985 — Maccubbin, Robert P. and Peter Martin. *British and American Gardens in the Eighteenth Century: Eighteen Illustrated Essays on Garden History*. Williamsburg, 1985.

MacDougall 1972 — MacDougall, Elisabeth B., ed. *The Italian Garden*. Washington, 1972.

MacDougall/ Hazelhurst 1974 — _____, and F. Hamilton Hazelhurst, eds. *The French Formal Garden*. Washington, 1974.

MacDougall/ Miller 1977 — _____, and Naomi Miller. *Fons Sapientia: Garden Fountains in Illustrated Books, Sixteenth-Eighteenth Centuries*. Exh. cat., Dumbarton Oaks. Washington, 1977.

MacDougall 1986 — _____, ed. *Medieval Gardens*. Washington, 1986.

McPeck 1973 — McPeck, Eleanor M. "George Isham Parkyns, Artist and Landscape Architect, 1749–1820." *The Quarterly Journal of the Library of Congress* 30 (1973), 171–181.

Martin 1984 — Martin, Peter. *Pursuing Innocent Pleasures: The Gardening World of Alexander Pope*. Hamden, 1984.

Masson 1961 — Masson, Georgina. *Italian Gardens*. New York, 1961.

Mathews/ Shapiro 1989 — Mathews, Nancy Mowll, and Barbara Stern Shapiro. *Mary Cassatt: The Color Prints*. Exh. cat., National Gallery of Art. Washington, 1989.

Mayor 1980 — Mayor, A. Hyatt. *Prints and People: A Social History of Printed Pictures*. Princeton, 1980.

Miller 1982 — Miller, Naomi. *Heavenly Caves: Reflections on the Garden Grotto*. New York, 1982.

Mitchell 1963 — Mitchell, Charles. *Pirro Ligorio's Roman Antiquities*. London, 1963.

Mongan/ Schniewind 1941 — Mongan, Elizabeth, and Carl O. Schniewind. *The First Century of Printmaking*. Exh. cat., The Art Institute of Chicago. Chicago, 1941.

Murray 1971 — Murray, Peter. *Piranesi and the Grandeur of Ancient Rome*. London, 1971.

Nevins 1984 — Nevins, Deborah. "Introduction to the 1984 Edition." In William Robinson, *The English Flower Garden*. New York, 1984.

Ogden 1955 — Ogden, Henry V. S., and Margaret S. Ogden. *English Taste in Landscape in the Seventeenth Century*. Ann Arbor, 1955.

O'Neill 1988 — O'Neill, Jean. "John Rocque as a Guide to Gardens." *Garden History* 16 (1988), 8–16.

Patch 1950 — Patch, Howard Rollin. *The Other World According to Descriptions in Medieval Literature*. Cambridge, MA, 1950.

Patterson 1981, I — Patterson, Richard. "The 'Hortus Palatinus' at Heidelberg and the Reformation of the World. Part I: The Iconography of the Garden." *Journal of Garden History* I (1981), 67–104.

Patterson 1981, II _____. "The 'Hortus Palatinus' at Heidelberg and the Reformation of the World. Part II: Culture as Science." *Journal of Garden History* 1 (1981), 179–202.

Pearsall/ Pearsall, Derek, and Elizabeth Salter. *Landscapes and Seasons of*
Salter 1973 *the Medieval World.* Toronto, 1973.

Pennington 1982 Pennington, Richard. *A Descriptive Catalogue of the Etched Work of Wenceslaus Hollar, 1607–1677.* New York, 1982.

Pfister 1909 Pfister, Christian. *Histoire de Nancy.* Paris, 1909.

Philips 1952 Philips, Hugh. "John Rocque's Career." *London Topographical Record* 20 (1952), 9–25.

Pinkey 1972 Pinkey, David H. *Napoleon III and the Rebuilding of Paris.* Princeton, 1972.

Plumb 1977 Plumb, J. H. *The Pursuit of Happiness: A View of Life in Georgian England*, with entries by Edward J. Nygren and Nancy L. Pressly. Exh. cat., Yale Center for British Art. New Haven, 1977.

Raines 1966 Raines, Robert. *Marcellus Laroon.* London, 1966.

Riggs 1977 Riggs, Timothy. *Hieronymus Cock: Printmaker and Publisher.* New York, 1977.

Rix 1987 Rix, Brenda D. *Our Old Friend Rolly: Watercolors, Prints, and Book Illustrations by Thomas Rowlandson in the Collection of the Art Gallery of Ontario.* Exh. cat., The Art Gallery of Ontario. Toronto, 1987.

Robertson 1985 Robertson, Bruce. *The Art of Paul Sandby.* Exh. cat., Yale Center for British Art. New Haven, 1985.

Roger-Marx 1948 Roger-Marx, Claude. *L'Oeuvre Grave de Vuillard.* Monte Carlo, 1948.

Rosenberg 1987–1988 Rosenberg, Pierre. *Fragonard.* Exh. cat., Metropolitan Museum of Art. New York, 1987–1988.

Rothlisberger 1967 Rothlisberger, Marcel. "The Perelles." *Master Drawings* 5 (1967), 283–286.

Rorschach 1983 Rorschach, Kimberly. *The Early Georgian Landscape Garden.* Exh. cat., Yale Center for British Art. New Haven, 1983.

Russell 1975 Russell, H. Diane. *Jacques Callot: Prints and Related Drawings.* Exh. cat., National Gallery of Art. Washington, 1975.

Salaman 1923 Salaman, Malcolm C. *The Etchings of Sir Francis Seymour Haden, P.R.E.* London, 1923.

Schneiderman 1983 Schneiderman, Richard S. *A Catalogue Raisonné of the Prints of Sir Francis Seymour Haden.* London, 1983.

Scott 1972 Scott, Barbara. "Bagatelle, Folie of the comte d'Artois." *Apollo* 95 (1972), 476–485.

Seward 1960 Seward, Barbara. *The Symbolic Rose.* New York, 1960.

Shestack 1967–1968 Shestack, Alan. *Fifteenth Century Engravings of Northern Europe from the National Gallery of Art.* Exh. cat., National Gallery of Art. Washington, 1967–1968.

Smith 1961 Smith, Webster. "Pratolino." *Journal of the Society of Architectural Historians* 20 (1961), 155–168.

Sopher/Lazzaro- Sopher, Marcus S., with Claudia Lazzaro-Bruno. *Seventeenth-*
Bruno 1978 *Century Italian Prints.* Exh. cat., Stanford Art Gallery, Stanford University. Stanford, 1978.

Stein 1967 Stein, Roger. *John Ruskin and Aesthetic Thought in America.* Cambridge, MA, 1967.

Steinberg 1965 Steinberg, Ronald Martin. "The Iconography of the Teatro Dell'

Acqua at the Villa Aldobrandini." *Art Bulletin* 47 (1965), 453–463.

Stokstad/ Stannard 1983 Stokstad, Marilyn, and Jerry Stannard. *Gardens of the Middle Ages*. Exh. cat., Spencer Museum of Art, University of Kansas. Lawrence, 1983.

Strauss 1977 Strauss, Walter. *Hendrick Goltzius, 1558–1617: The Complete Engravings and Woodcuts*. New York, 1977.

Strong 1979 Strong, Roy. *The Renaissance Garden in England*. London, 1979.

Stroud 1962 Stroud, Dorothy. *Humphry Repton*. London, 1962.

Stroud 1975 _____. *Capability Brown*. London, 1975.

Summerson 1954 Summerson, John. *Architecture in Britain, 1530–1830*. Baltimore, 1954.

Tatum 1949 Tatum, George Bishop. *Andrew Jackson Downing: Arbiter of American Taste, 1815–1852*. Ph.D. diss., Princeton, 1949.

Thacker 1979 Thacker, Christopher. *The History of Gardens*. Berkeley, 1979.

Vesme/ Massar 1971 Vesme, Alexandre de, and Phyllis Dearborn Massar. *Stefano Della Bella*. New York, 1971.

Vetter 1965 Vetter, Ewald M. *Maria im Rosenhag*. Düsseldorf, 1965.

Watson 1934 Watson, Arthur. *The Early Iconography of the Tree of Jesse*. London, 1934.

Wiebenson 1978 Wiebenson, Dora. *The Picturesque Garden in France*. Princeton, 1978.

Wildenstein 1923 Wildenstein, Georges. *Un Peintre de Paysage au XVIIIe siècle: Louis Moreau*. Paris, 1923.

Wiles 1933 Wiles, Bertha Harris. *The Fountains of Florentine Sculptors and their Followers from Donatello to Bernini*. Cambridge, MA, 1933.

Wilkins 1969 Wilkins, Eithne. *The Rose Garden Game: The Symbolic Background of the European Prayer-Beads*. London, 1969.

Williams 1978 Williams, Eunice. *Drawings by Fragonard in North American Collections*. Exh. cat., National Gallery of Art. Washington, 1978.

Willis 1977 Willis, Peter. *Charles Bridgeman and the English Landscape Garden*. London, 1977.

Willis 1974 _____, ed. *Furor Hortensis: Essays on the History of the English Landscape Garden in Memory of H. F. Clark*. Edinburgh, 1974.

Wittkower 1974 Wittkower, Rudolf. *Palladio and Palladianism*. New York, 1974.

Woodbridge 1974 Woodbridge, Kenneth. "William Kent as Landscape-Gardener: A Re-Appraisal." *Apollo* 100 (1974), 126–137.

Woodbridge 1986 _____. *Princely Gardens: The Origin and Development of the French Formal Style*. New York, 1986.

Wuthrich 1966 Wuthrich, Lukas Heinrich. *Das druckgraphische Werk von Matthaeus Merian dem Aelteren*. Basel, 1966.

Zerner 1969 Zerner, Henri. *The School of Fontainebleau*. New York, 1969.